Art, when really understood, is the province of every human being . . .
When the artist is alive in any person, whatever his kind of work may be,
he becomes an inventive, searching, daring, self-expressing creature.

—ROBERT HENRI, *The Art Spirit*, 1923

prints

the facts and fun of collecting

by Randy Rosen

a dutton paperback ▪ e. p. dutton ▪ new york

prints

the facts and fun of collecting

by Randy Rosen a dutton paperback ■ e. p. dutton ■ new york

ACKNOWLEDGMENTS

Many people beside the author contribute to the long process of completing a book of this nature. It is impossible to enumerate all the good advice and encouragement offered so generously along the way by family and friends. However, I am especially grateful for the professional guidance and support given to me by Dorothea Carus, Marc Rosen, Nicholas Stogdon, Richard Curtis, my agent, Cyril I. Nelson and Julie McGown of E. P. Dutton, and to Linda Dishy, without whom this book might never have seen the light of day. Greatly appreciated as well were the hours and insights shared with me by Donald Marron, Jasper Johns, Richard Anuszkiewicz, and Donald Karshan in taped interviews, only a small fraction of which could be excerpted for this book.

Color insert printed in Japan.

ISBN: 0–525–47476–5 (DP) · Published simultaneously in Canada by Clarke, Irwin & Company Limited, Toronto and Vancouver · 10 9 8 7 6 5 4 3 2 1 · First Edition · Designed by The Etheredges

contents

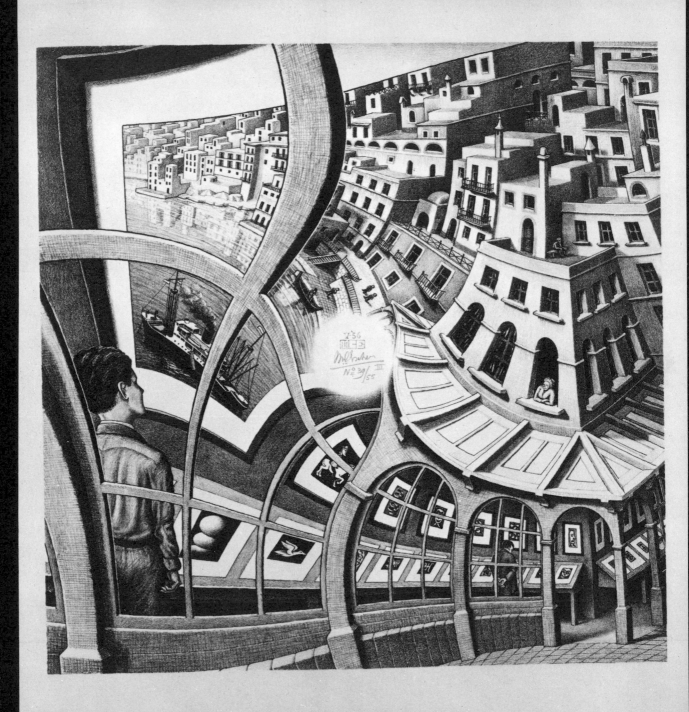

1. **M. C. Escher** (1898–). *Print Gallery.* 1956. Lithograph. 12½″ x 12½″. Courtesy Sotheby Parke Bernet Inc., New York.

An early impression of Rembrandt's seventeenth-century etching *The Agony in the Garden*, shown close to its actual size (4⅜" x 3¼"), went on the auction block at New York's Sotheby Parke Bernet auction galleries in 1973. There was a slight repair at the upper left corner and the print was not signed. When the auctioneer's gavel fell for the final time, bidding on *The Agony in the Garden* had reached $70,000.

What turns an ordinary piece of paper into a valuable work of art? The German Expressionist artist Ernst-Ludwig Kirchner offered perhaps one of the most compelling answers: "Nowhere does one get to know an artist better than in his prints." This book is about such extraordinary "pieces of paper," original prints: how they are created, why they are valued, and how to understand, select, care for, and collect them.

Lessing J. Rosenwald, whose stunning collection of over twenty-six thousand prints and drawings now forms a permanent addition to America's National Gallery of Art (fig. 3), was asked in an interview[1] how he came to collect prints: "I saw a print in the window of Sessler's [in Philadelphia]. . . . I took it home and enjoyed looking at it. This was the beginning of my collection." The first print that Mr. Rosenwald brought home was the *Royal Scottish Academy* by D. Y. Cameron (fig. 4). Looking back at his early acquisitions of such British prints, Mr. Rosenwald admits, "I would not get nearly as many." One should certainly feel a strong inner response toward any print he intends to bring into his life. But seemingly "natural" inclinations in art can be as deceptive as "love at first sight" and, like it, may not survive the test of time. People often justify their choice of prints, insisting, "I know what I like." But what does that statement really mean? Commenting on a fascination with fifteenth-cen-

1

"I like what I *know*."

2. **Rembrandt van Rijn** (1606–1669). *The Agony in the Garden.* c. 1657. Etching and drypoint. 4⅜″ x 3¼″. Courtesy Sotheby Parke Bernet Inc., New York.

3. **Hans Holbein,** the Younger (1497–1543). *The Alphabet of Death.* c. 1524. Woodcuts. 1″ x 1″. Courtesy National Gallery of Art, Washington, D.C., Rosenwald Collection.

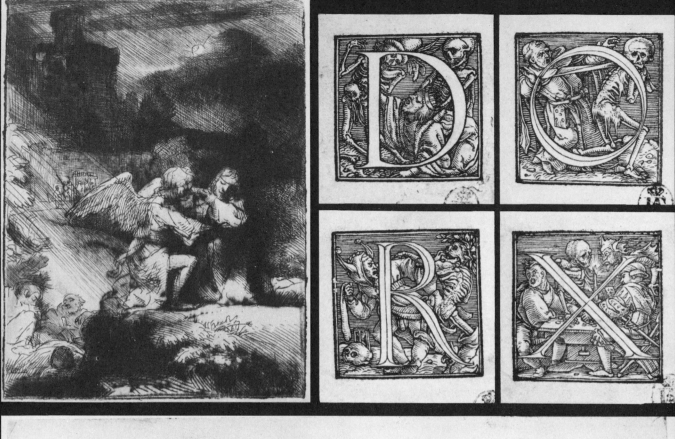

4. **D. Y. Cameron** (1865–1945). *Royal Scottish Academy.* Etching and drypoint. 9½″ x 16½″. Courtesy National Gallery of Art, Washington, D.C., Rosenwald Collection.

tury prints that deepened over the years, Mr. Rosenwald remarked, "When you first look at fifteenth-century woodcuts (fig. 5), they're the sort of prints that only a mother could love." As one delves more deeply into the history of print-making and begins to discover the significance of various epochs and artists, such initial prejudices have a remarkably consistent habit of changing course. Although there is no better reason for selecting a print than "I know what I like," a more enlightening explanation of why new collectors often choose the works they do might be "I like what I *know*."

One hears talk of the "born" collector. Do such genetically prepackaged art experts really exist? If he exists at all, the "born" collector is either the rarest phenomenon or the fictitious invention of an overly flattering art dealer. The collecting *instinct,* however, is probably endemic to man. Witness the rapid evolution of any ambitious eight-year-old building his first marble collection. In the initial swapping, a more expert collector shrewdly barters three commonplace "immies" for the beginner's prize jumbo "aggie." But soon our novice begins to differentiate between mere acquisition of quantity and those marbles that are highly prized for their specific characteristics. Before long, he is trading up: unloading run-of-the-mill specimens for finer examples. Along with his newly found business acumen, our aspiring marble collector has acquired a degree of connoisseurship in his field—*knowledge*—the ability to discern quality and to discriminate between various levels of it. In print collecting, this is called developing a good "eye." Basically, the process involves learning to differentiate the "aggies" from the "immies" in graphics.

Art has to do with discovery. At its best, contact with a work of art changes us, altering our perception of reality from what it was only moments before confrontation with the artist's vi-

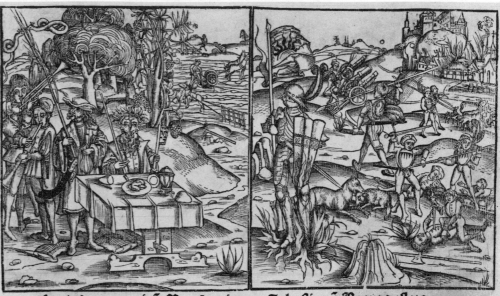

Paris in germanicū Marrē nenia:per Sebastianū Brant.defleta.

5. **Anonymous,** Basel. *An Allegory of War and Peace.* 1499. Woodcut. Two blocks printed side by side: 8⅝" x 13⅝". Courtesy National Gallery of Art, Washington, D.C., Rosenwald Collection.

sion. Once seen, the imprint of Francisco Goya's *Wonderful Heroism! Against Dead Men!* (fig. 143) lurks in the mind for a lifetime as an image of man's potential for depravity.

Indeed, the concept of discovery is implicit even in the term we use to designate those most qualified to judge and evaluate works of art: *connoisseur* comes from the Latin *cognoscere,* which does not mean "to know" but rather "coming to know." Possibly no other area of art offers people as many opportunities for discovery—"coming to know"—as the field of prints.

Since they first appeared in the Western world in the fifteenth century, prints have been prized and garnered by collectors. By the seventeenth century, collecting was widespread among the aristocracy. The scholar-writer Abbé Michel de Marolles accumulated over 123,000 examples. For thirty years, between 1635 and 1665, the Abbé patiently filled 520 volumes with the work

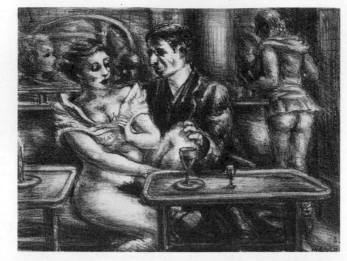

6. **Reginald Marsh** (1898–1954). *The Courtship.* 1932. Lithograph. 7½″ x 9½″. Courtesy Sotheby Parke Bernet Inc., New York.

of 6,000 printmakers, including examples by his Dutch contemporary Rembrandt. This colossal aggregation of prints formed the nucleus of the world's first museum of prints, the Cabinet des Estampes at the Bibliothèque Nationale in Paris. In 1667, Louis XIV acquired the Abbé's collection for the sum of 28 livres, which in terms of the value of silver at the time would come to roughly under $100, or about a half-dozen prints for a penny.

Unlike a painting or a drawing, original

7. **Winslow Homer** (1836–1910). *Eight Bells.* 1887. Etching. 19¼″ x 24¾″. Courtesy Sotheby Parke Bernet Inc., New York.

prints are not unique. Each image exists in more than one example (see chap. 2) and as one author noted, "There have been multiples for a long time: books could be called author's multiples; gramophone records, composer's multiples; and films, playwright's multiples; all interestingly enough, dependent on print processes." This *plurality* disturbs some people, while others recognize that the print's very lack of exclusivity is in itself unique, offering rare opportunities for collecting and study. One collector observed:

When you learn art in school, they don't show you the bad pictures. They show you the best pictures by the best known artists. This creates a feeling of unavailability. A person's earliest idea is that really good artworks are inaccessible. The day a person realizes that the artist he has read about in a book, or whose works he has admired in a museum, has made original prints that can hang in his own living room or office, his perspective on art totally changes. Not until that moment does he really begin "looking" at art, experiencing it in terms of living with it and what it means to him. The dispassionate reverence toward a time-honored museum piece gives way to genuine personal reaction, involvement, and observation.

Collector Donald Marron discovered the advantages of collecting art that exists in more than one impression

Prints are the only art form where you can build a collection of original art with some kind of consistent logic. . . . You can decide on an artist you like, you can often check his whole body of work in a catalogue raisonné [see page 207]. Then barring the print being extraordinarily rare or prohibitively priced, and assuming you have patience to wait, you can wind up owning precisely the art you want. That's certainly not possible with painting. When somebody else buys what you want, chances are you'll never get it.[2]

Already conversant with American painters, Marron and his wife approached collecting methodi-

cally, beginning with painters they admired, and researching whether they had also made any prints (figs. 6, 7). If they had, the Marrons studied the artist's overall graphic output, be it one or one hundred, and then diligently tracked down the best examples. As Donald Marron learned:

Collecting paintings and collecting prints are two different things. In the course of collecting paintings we found that most artists, both good and bad, had at least one good picture. If they didn't have one good painting, they never achieved the status of being an established artist. So that it is entirely possible to come across one good picture by someone. My own view is that that's not enough reason to collect an artist. You have to see the body of a person's work in order to form an intelligent judgment about them as an artist. In painting that's a very difficult thing to do. Physically, the works are scattered. Economically many are out of range. . . . But when you get into original prints, you usually come across a group of the artist's images and get an idea of his quality quickly. . . . The first time I saw the etchings of Martin Lewis [figs. 8, 9], there were at least fifty different examples to look at.

Occasionally, fate lends a hand in determining a collector's special interest. The first sight Lessing Rosenwald had of the now famous group of prints that inaugurated his lifelong interest in fifteenth-century graphics (fig. 10) was a bedraggled package tucked under the arm of a young man from Holland. The young man's father, a Munich banker named Aufhäuser, had decided to remove the prints from Germany when Hitler came to power. Aufhäuser's son wrote to Rosenwald from Holland telling him about the prints, and the collector, in a return note, casually invited him to stop by "whenever he was in town." One day the young man showed up. "He brought a package which looked like he was coming from a delicatessen," remembers Rosenwald. "And I thought to

8. **Martin Lewis** (1881–1962). *Spring Night, Greenwich Village.* 1930. Drypoint. 9⅞″ x 12⅜″. Courtesy Sotheby Parke Bernet Inc., New York.

9. **Martin Lewis.** *Late Traveler.* 1948. Drypoint with sandpaper ground. 10″ x 11⅞″. Courtesy Sotheby Parke Bernet Inc., New York.

myself, this is going to be terrible." But the delicatessen proved to be a delicacy: impeccably preserved and very rare fifteenth-century metal cuts and woodcuts. After much correspondence, a price was agreed on, and Rosenwald acquired his incomparable German collection. When Aufhäuser, a Jew, was forced to flee Germany and later Europe, he visited Rosenwald: "My purchase was the only thing he saved from his entire fortune." It must have been a touching moment between the two men when Aufhäuser learned that Rosenwald had stamped the back of each print not only with his own collector's mark but with a specially made design—an *A* inside an oval—in respect for both Aufhäuser's connoisseurship and the integrity of the collection assembled by him.

"The love of anything," wrote Leonardo da Vinci, "is the fruit of our knowledge of it, and grows as our knowledge becomes more certain." Print collecting is an ongoing education, and the astute print collector soon begins to see himself as something of a perpetual student.

Over the years, collector Donald Karshan has accumulated what amounts to a minimuseum survey of five centuries of printmaking. He is fascinated by artists as diverse as Martin Schongauer (fig. 11), Edgar Degas (fig. 12), and Jasper Johns (pl. 1), and one senses that Karshan approaches each new encounter as a fresh challenge. Describing his involvement with American posters of the 1890s, Karshan said:

> *It became an area of discovery for me because up until that time I was aware mainly of the posters of the French School, such as Lautrec, Mucha, Cheret and the like. As I became more curious about the American aspect of the period, I realized that there was a certain inimitable flavor of inventiveness and avant-gardism in American artists such as Penfield [fig. 13], Bradley and Parrish,*

6

and that this flavor was quite different from the Europeans. In the process of collecting these artists, I read about them. I read about the epoch which produced the Golden Age of the American Poster, and I became a student of that period. As a result I ended up championing them [and] . . . my collection toured the museums of France.[3]

How does one know what to collect? How does one measure the worth of a particular work of art? Specific factors contribute to or detract from a print's immediate market value. These are discussed in chapter 9, on auctions. The value of a work of art involves calculations that one cannot determine merely by punching the correct buttons on an adding machine or scrutinizing the artist's most recent auction prices. Art values are inexorably tied to elusive aesthetic criteria and cultural influences, both long-range and short-range. Albrecht Dürer's depiction of *The Four Horsemen of the Apocalypse* (fig. 24), unforgettable and awesome, has dominated our Western conception of that biblical event for over four hundred years. Was Dürer's woodcut of *The Four Horsemen* truly less "valuable" in the eighteenth century, when

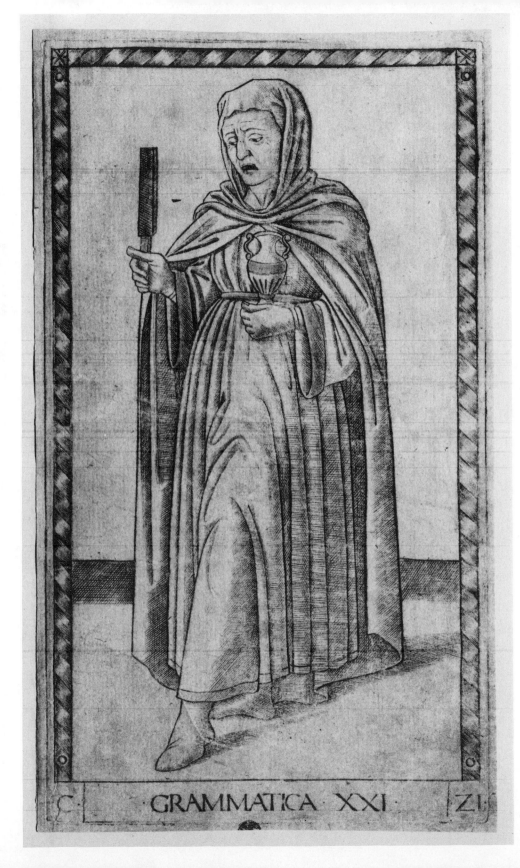

10. **Master of the E-Series.** c. 1465. *Grammar* from the *Tarocchi.* Engraving. 7¼″ x 4⅛″. The "Tarocchi (tarot cards) of Mantegna," a set of 50 engravings that are neither tarot cards nor the designs of Mantegna, revolve around five classic-medieval iconographic themes consisting of 10 cards for each concept: Conditions of Man; Apollo and the Muses; Liberal Arts; Cosmic Principles; and Firmaments of the Universe. Jean Seznec's comment quoted in the fine National Gallery of Art catalogue *Early Italian Engravings* suggests that the Tarocchi were designed for instruction rather than card-playing: "The lesson which the images teach is the Medieval notion of the universe as a 'great chain of Being,' in which every component part is assigned its rightful place in the hierarchy." *Grammar* (shown), from the Liberal Arts section of the set, derives symbolically from a fifth-century allegory in which Grammar is depicted as carrying a vessel filled with medicine to correct children's pronunciation and a file for removing errors from their tongues. Courtesy National Gallery of Art, Washington, D.C., Rosenwald Collection.

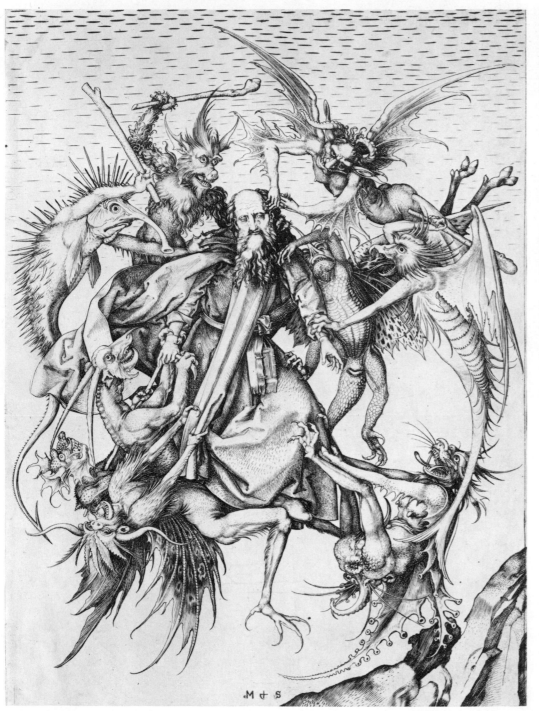

12. **Edgar Degas** (1834–1917). *Aux Ambassadeurs.* c. 1877. Etching, aquatint, and drypoint. 10⅝″ x 11¾″. Courtesy National Gallery of Art, Washington, D.C., Rosenwald Collection.

11. **Martin Schongauer** (1445–1491). *The Temptation of Saint Anthony.* 1470–1475. Engraving. 12⅜″ x 9⅛″. Courtesy National Gallery of Art, Washington, D.C., Rosenwald Collection.

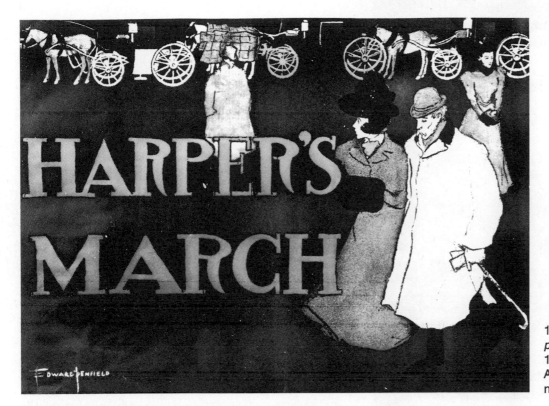

13. **Edward Penfield** (1866–1925). *Harper's March.* 1897. Lithograph. 14" x 19". Courtesy The Museum of Modern Art, New York; Gift of Poster Originals.

the artist's works momentarily fell from favor, than it is in ours, when one example of *The Four Horsemen* brought $17,500 at auction? As a rule of thumb, people who choose prints based on an informed judgment of their aesthetic quality, rather than on conformity to momentary market trends, come out ahead—if not always in dollars, then in the pleasures that owning truly great art affords. When a person's major concern lies in the investment potential of a print—whether or not it will appreciate in price—he would probably find his energies more profitably engaged in collecting stock certificates.

Still, no one wants to throw his money down the drain. And rightly so. But with knowledgeable collectors, quality often overrides price considerations. The reasons are important for the novice to

understand, even though it may be sometime before he is confident enough to act on the implications. Beginners, insecure in their innate sense of what constitutes good or bad art, have a tendency to bargain-hunt. But often an artist's strongest images cost more. If affordable, they are the better buy both aesthetically and in terms of any future appreciation. "I was never able to find a Gauguin for $5," remarked a collector who insists that he has never had collecting coups in terms of "bargains." "I have always had to pay the going market price for a print whether it was $64 or $6,400. But I never regretted it because the rarity factor kept curving up on the prints that I bought, so whatever I paid for a particular piece, when I looked back on it a scant year or two later, it never seemed so expensive."[4] The same collector paid in

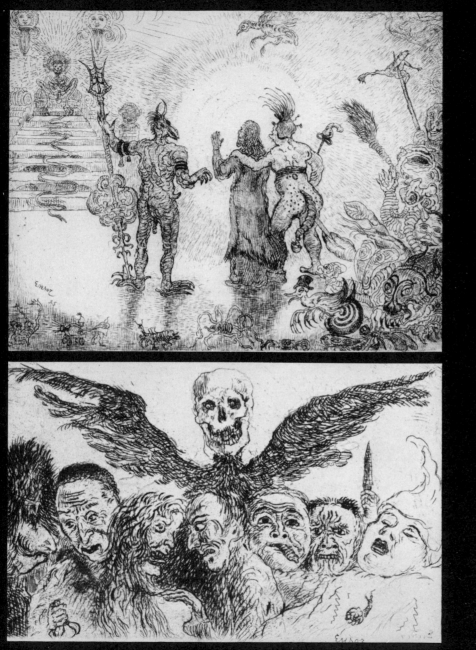

14. **James Ensor** (1860–1949). *Christ in Hell*. 1895. Etching. 5½″ x 7″. Courtesy Sotheby Parke Bernet Inc., New York.

15. **James Ensor.** *The Deadly Sins Dominated by Death*. 1904. Etching. 3½″ x 5¼″. Courtesy Sotheby Parke Bernet Inc., New York.

the neighborhood of $20,000 for an example of Degas's acquatint *Aux Ambassadeurs* (fig. 12), of which four of the five known impressions were locked away in museums: "I knew that it was Degas' largest and perhaps his most powerful statement in [an] intaglio [print] . . . and I paid [what was] in the 60's, probably the highest price ever paid for a multiple work on paper by Degas."

While experienced collectors are confident enough to pay "top price" for a major print, newcomers to collecting often harbor unlikely fantasies, the most prevalent being the discovery of an artist on the brink of fame or reevaluation by the art establishment (the Picasso bought for $150 that soars to $15,000). Is there some special clairvoyance that guides such Isaiahs toward artists before they become costly and popular? With the exception of occasional "flukes" or lucky timing most print prophets devote many hours to ferreting out international trends in museum and gallery exhibitions, talking with dealers, reading articles in major art journals, and analyzing the auction, exhibition, and publication patterns emerging in international art. Few collectors have the art background or time to spend immersing themselves to this degree. Wisely, they rely on their best instincts and the expertise of reliable dealers and leave the possibility of discovering the world's next Rembrandt to the vicissitudes of fate. Occasionally, fate complies. One young collector, working with limited funds in the early 1960s, decided to concentrate on the prints of a single artist, James Ensor (figs. 14, 15), an artist who had solid credentials but was momentarily undercollected. Ensor's demonic dream visions, filled with nightmarish and fantastic creatures betokening a world threatened, hark back to traditions originating in the late medieval images of Hieronymus Bosch and the works of Goya (fig. 16). The prices

of Ensor at the time were not high, so that in spite of meager funds, the young man was able to cover his walls with what was virtually a complete retrospective of Ensor's career as a printmaker. In time, the prices of Ensor's prints rose dramatically. More important, the young man's singular approach afforded him rare insight into this unusual talent. Seeing all of an artist's works, one becomes intimately acquainted with his development, how he expands his imagery, how he experiments and grows from print to print.

Few new collectors would consider themselves as creative as the Ensor collector, whose concept of focusing his interest and funds rather than scattering them piecemeal produced a museum-caliber grouping. In fact, the thought of a collector's being "creative" at all may strike many people as somewhat unusual. Yet the most persistent impression one gets in talking with knowledgeable print collectors is how often their enthusiasm lies less in accumulation than in the exhilarating process of discovery and learning that sooner or later becomes basic to the print experience. Creativity in collecting surfaces only with time, much as it does in art. An artist devotes years to developing his talents and often spends many months on a single print. He begins without any guarantee of the outcome and must derive satisfaction solely from the process itself. Perhaps the best answer to the two questions most anxiously asked by those new to prints—"What should I collect?" and "Is it a good investment?" —was given by the artist–collector William Copley, who astutely observed: "The urge to collect art is part of the urge to create art." If collecting truly represents the companion side to man's creativity, then the print collector, like his artist counterpart, will find the adventure of "coming to know" rewarding in and of itself.

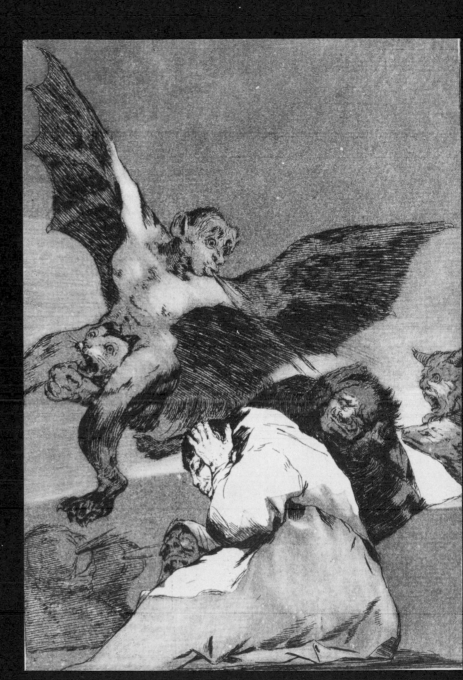

16. **Francisco Goya** (1746–1828). *The Blowers* (*Tale-Bearers—Blasts of Wind*), Plate 48 from *Los Caprichos.* 1799. Etching. 8¼″ x 4¼″. Courtesy Sotheby Parke Bernet Inc., New York.

2

the
numbers
game

I made each of the fingerprints shown below by inking my thumb and pressing it onto a piece of paper. If you were holding that paper before you now, which impression would you select as the "original" fingerprint? Or would you call *each* of

17. *Three* fingerprints exactly alike.

the impressions pulled from the master image—my thumb—an original print? In barest terms, this is the process that we are dealing with in printmaking: art that can be duplicated from a master image. As Carl Zigrosser points out, "The unique thing about original prints is that they are not unique."[5] Nor is the master image—my thumb, for example—the "real" original. My thumb may be the tool for producing the impression on paper, just as a pencil is the tool for producing a drawing. They are inextricably linked. But the master image and the final image are quite separate things, literally and aesthetically. One need only place an etched metal plate (or lithographic stone, wood block, or silk-screen stencil) next to the finished image pulled from it on paper to verify just how different they are—as different as my flesh-and-blood thumb from the two-dimensional impressions reproduced on this page.

Having come this far in the idea of more-than-one-of-a-kind originals as distinct from a singular painting or drawing, one would like to drop the whole subject. But between this simple

16. **Master of 1446.** *Flagellation of Christ.* 1446. Engraving. 4″ x 3½″. Earliest known dated engraving. Attribution to the "Master of 1446" based on the date that appears in Roman numerals above the pillar. Courtesy Kupferstichkabinett, Staatliche Museum, Berlin.

distinction and an actual understanding of multiple original art, the collector gets bogged down in a numbers game: sorting out editions, states, re-strikes, reproductions, signed and unsigned impressions, numbered and unnumbered impressions, artist's proofs, *hors de commerce,* and so on.

At a recent exhibition of woodcuts by the fifteenth-century print master Albrecht Dürer, one woman commented on what a shame it was

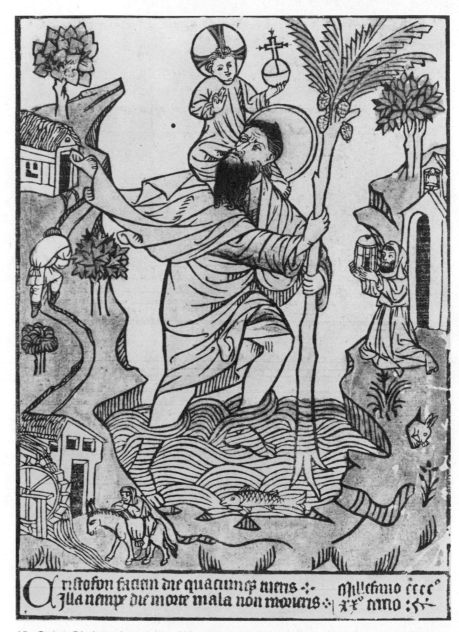

19. *Saint Christopher.* 1423. Woodcut, hand-colored. 11⅜″ x 8⅛″. This is considered one of the earliest prints in existence that can be dated. Script reads: "If you Saint Christopher should see/That day you'll not die suddenly." Courtesy John Rylands University Library, Manchester, England.

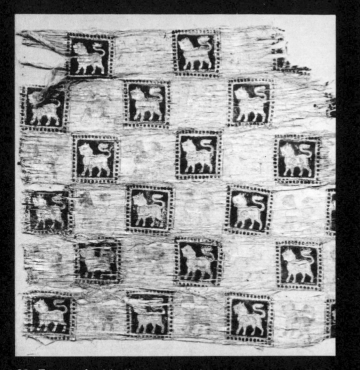

20. Egypto-Arabic linen cloth with stamped and gilded decoration of lions. Late tenth century. Courtesy The Metropolitan Museum of Art, New York; Gift of George D. Pratt, 1931.

21. **The Housebook Master** (Erhard Renwick?, 1475–1500). *Death and the Young Man.* Drypoint. 5½″ x 3⁵/₁₆″. Early printmakers were anonymous craftsmen. The Housebook Master (also called "The Master of the Amsterdam Cabinet," where most of his prints are lodged) derives his name from a medieval manuscript that contains his drawings of everyday household items, known as *The Housebook.* Hyatt Mayor speculates that he was probably a painter, since his style avoids the finicky decorative detailing typical of many early printmakers trained in goldsmith shops. The Housebook Master is credited with inventing drypoint, a method of cutting the plate without acid, which produces a velvety inked line and soft, rich texturing in the image. Courtesy Rijksprentenkabinet, Rijksmuseum, Amsterdam.

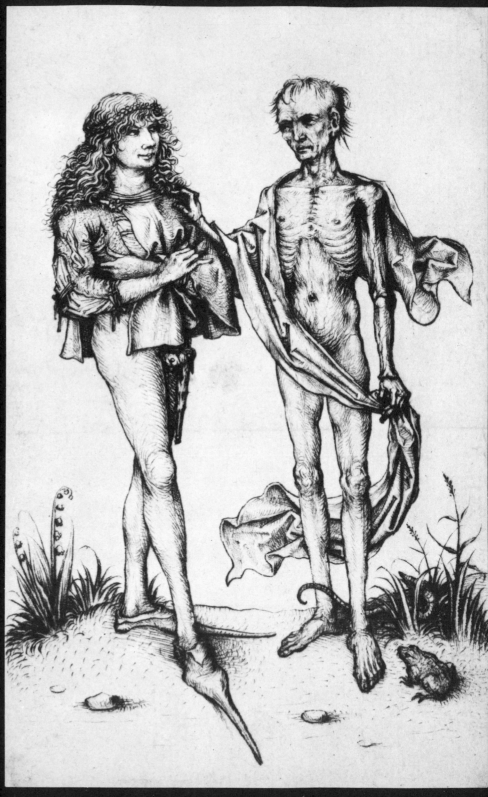

that the museum had not obtained the originals for display. When it was explained that every piece in the exhibition *was* an original, she protested, "But they're not signed!" A common misconception about original prints is that all of them are signed by the artist. Early prints were not signed, nor were many of the fine prints made in this century. Monograms such as the *AD* (fig. 25) printed right into the image area in the case of the Dürers on exhibit were not "signatures" as we understand the term today. More likely they were a carry-over from the goldsmith's tradition of identifying his craftsmanship with a hallmark —or quality stamp—on his work. Many of the earliest printmakers began their careers in goldsmith shops and probably transferred the hallmarking custom to paper.

Our concepts of originality are quite different today from what they were when European printmaking first began in the 1400s (figs. 18, 19). In the beginning, prints were less an "art" than an extension of existing crafts: engraving probably grew from the decoration of metals in goldsmith shops; etching, from the armorer's practice of acid-biting patterns into steel; and woodcut, from the blocks used by clothmakers to stamp a design onto their fabrics (fig. 20). The use of a signature to indicate the artistic authorship of a print would probably never have occurred to the medieval, guild-minded craftsman, who was, by and large, an anonymous talent. We find the majority of prints from this early period attributed only to ambiguous "masters," such as the Housebook Master (fig. 21) or the Master of the Playing Cards, names assigned by scholars for grouping together works with stylistic similarities.

Today's art needn't fill any practical end (that is, illustrate a book, decorate architecture, or illuminate a technical or religious manual). We value "art for art's sake" and often attribute shamanic powers to our artists, placing them in a special category outside the mundane trades and everyday behavioral constraints. We nourish the romantic notion of the artist—half renegade, half oracle—alone in his studio thunderstruck by insights denied to ordinary men. Dürer, by virtue of his genius and drive, was a great originator. But such originality and individual artistic identity were not part of the mentality of his age. On the contrary. Artists freely copied one another's works and felt no requirement to originate fresh, raw material for their images. They worked mainly from what might be called "public domain" themes, largely religious, as was most of the church-supported art of the time. These visual conventions were recycled from one artist to the next, with only occasional variation in composition or interpretation. We find examples of The Baptism of Christ executed over and over again with little alteration in conception (figs. 22, 23). The utilitarian emphasis on devotional and instructional subjects narrowed the artist's imagery. Repetition and tradition, not imagination, were his stock-in-trade. As long as art remained primarily an adjunct craft for church purposes (as so much of it was during the Middle Ages), artistic identity was "lost in the woodwork," so to speak. With the Renaissance, the artist moved from his status as anonymous craftsman to that of companion and confidant of kings. The Renaissance emphasis on ingenuity, individualism, and commercialism transformed the artist's name and individual style, or trademark, into a marketable asset. It was also in the Renaissance (with the appearance of portable easel paintings) that art became "property" and the artist's trademark a negotiable "commodity."

Dürer, who made several trips to Italy and came to be known as the "Leonardo of the North," is credited with importing Renaissance concepts

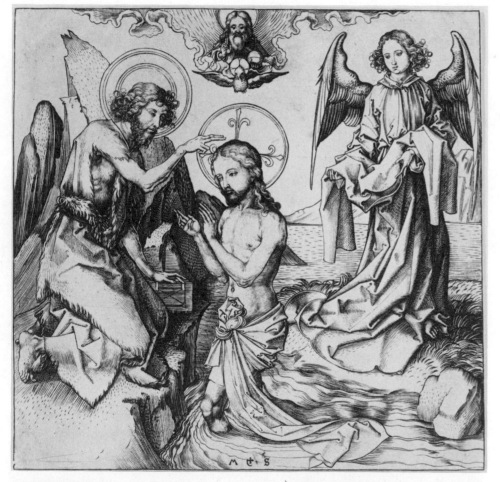

22. **Martin Schongauer.** *The Baptism of Christ.* c. 1480. Engraving. 6⅜″ x 6¼″. Engravings were often employed in sculptors' workshops as guides for apprentices. Schongauer's engraving appears to have been the model for the wood carving illustrated in figure 23. Courtesy National Gallery of Art, Washington, D.C., Rosenwald Collection.

into northern Europe and with applying them to printmaking. In his *Lives of Artists,* John Canaday notes the tremendous gap that existed between the Gothic, still medieval north and the Renaissance south. For a German artist to make a trip to Italy was "a matter not only of crossing the Alps but of crossing a century in time." A contemporary of Michelangelo and Raphael, and only twenty years younger than Leonardo, Dürer, in the entrepreneurial spirit of the Renaissance, was the first artist to publish and market his own prints. His personal style became famous and lucrative. A note was sent by Dürer to a friend in which he explained that he was abandoning commissions for paintings and returning to engravings because "it is much more profitable." In 1498, in his first free-lance enterprise at the age of twenty-seven, Dürer produced the gripping impression of *The Four Horsemen of the Apocalypse* (fig. 24). Once seen, the image is unforgettable. It went so far beyond Saint John's verbal description of the revelation—and any visualizations prior to Dürer's—that this woodcut, more than the text, has come to be the universal symbol for troubled times. In creating this masterpiece, and the entire Book of the Revelation project, Dürer set his eye on a mass market. There was not yet a thought of "rarity" or limited editions in printmaking. The entire family participated in Dürer's ventures. His wife, Agnes, peddled the prints from booths at local fairs, and his aging mother once ran a special sale at one of the annual relics fairs held in Nuremberg. One could own eight full-sized sheets of Dürer's works for one florin, half of what it had cost the artist to treat himself to a new beret in 1521. Quite a bargain, considering that a single sheet like the *Adam and Eve* (fig. 25) sold for $48,000 at Sotheby Parke Bernet in 1973.

Dürer's prints sold in the thousands through-

out Europe. In line with his modern individualism, initiative, and plain good business sense, Dürer took the first step toward establishing criteria for originality in prints. In 1505, he made a hazardous journey to Venice to protest personally the outright plagiarism of his designs by Marcantonio Raimondi. Italian authorities did nothing to inhibit the imitator but did give a small nod to the modern notion of "originality" by prohibiting Raimondi from incorporating Dürer's famous *AD* monogram into his copies.

Of the three hundred woodcuts, ninety-six engravings, three drypoints, and six etchings made during the lifetime of this great printmaker, none was pencil-signed or numbered. The custom of signing and numbering prints evolved gradually. A crucial turning point occurred in 1732, when William Hogarth published a spicy series of engravings chronicling the adventures of Moll, a London whore (fig. 26). Hogarth's depiction of the disreputable Moll in *The Harlot's Progress* was instantly successful. A blend of morality play and novel compressed into six plates, the tale promulgates an essentially puritanical view of life in spite of its racy subject matter. A Bridewell prison cell and a terrible death from venereal disease await the heroine. Virtue is rewarded and vice punished. In the third plate (fig. 26), Moll's downfall begins as several bailiffs, led by Sir John Gonson, a London magistrate noted for his vigorous action against prostitution, enter Moll's love nest. She sits on her bed admiring a watch presumably pilfered from her latest client. This print was passed around the chamber of London's Board of Treasury, and reportedly, the likeness of Gonson so impressed the lords that "each one repaired to the print shop for a copy of it," according to Ronald Paulson's *Hogarth's Graphic Works*. The set, which Hogarth offered to the public by subscription in the press, produced 1,240 recorded

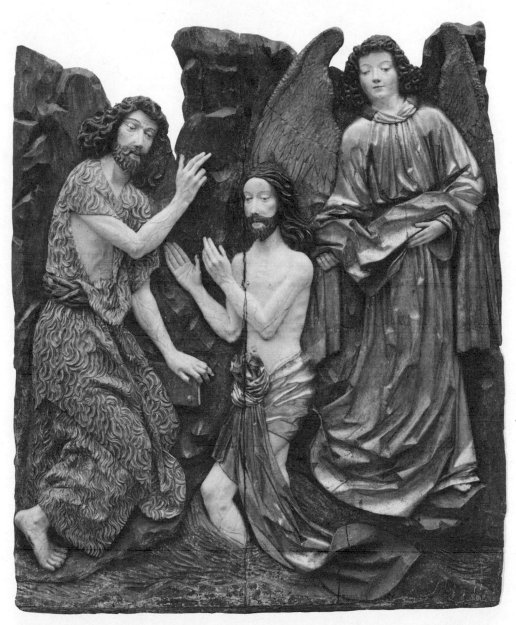

23. **Veit Stoss** or School of (1440–1533). *The Baptism of Christ*. Late fifteenth century. Carved wood relief. Nuremberg. H. 47″. Courtesy The Metropolitan Museum of Art, New York; Rogers Fund, 1912.

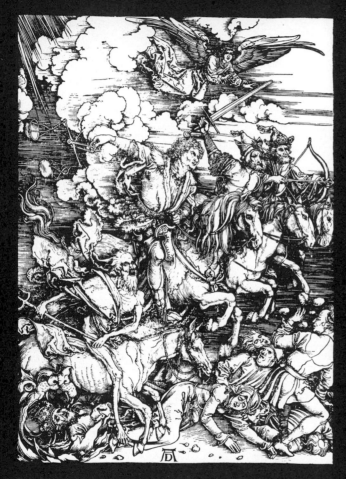

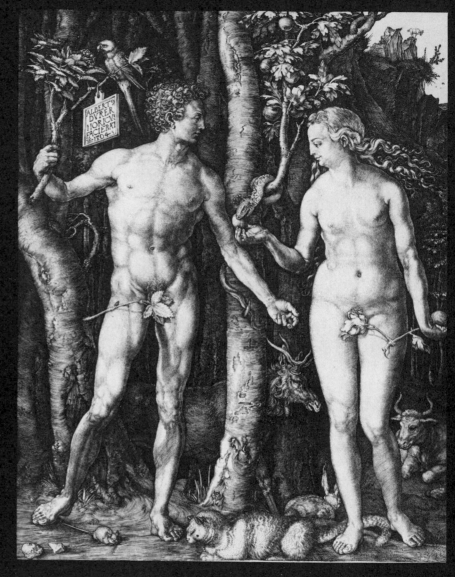

24. **Albrecht Dürer** (1471–1528). *The Four Horsemen of the Apocalypse*. 1498. Woodcut. 15½" x 11⅛". One from a series of 15 woodcuts published in 1498 to illustrate the Book of Revelations. Text was printed on the reverse of each woodcut, which were unusually large for their day (about 15" high). Where Saint John's vision was explicit about only one of the horsemen, Death, Dürer delineates four: Conquest, War, Pestilence, and Death. His image was so universally accepted that the woodcut is now a synonym for John's vision. The series brought Dürer immediate fame throughout Europe. Courtesy Sotheby Parke Bernet Inc., New York.

25. (Right) **Albrecht Dürer.** *Adam and Eve.* 1504. Engraving. 10" x 7¾". Courtesy Sotheby Parke Bernet Inc., New York.

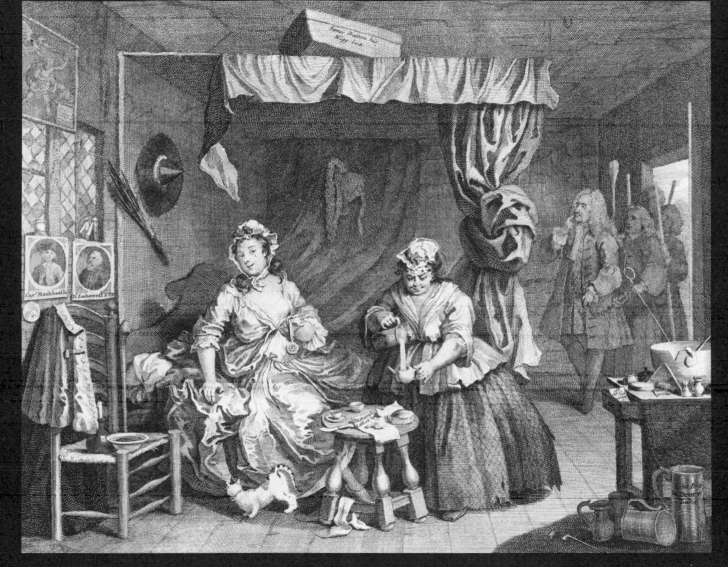

26. **William Hogarth** (1697–1764). *Apprehended by the Magistrate,* Plate 3 from *The Harlot's Progress.* 1732. Engraving. 11¹³/₁₆″ x 14⅞″. Courtesy National Gallery of Art, Washington, D.C., Rosenwald Collection.

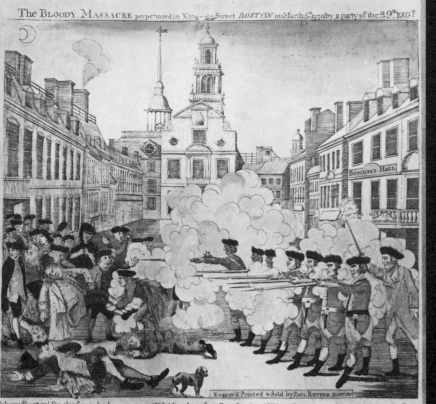

The BLOODY MASSACRE perpetrated in King·─·Street BOSTON on March 5ᵗʰ 1770 by a party of the 29ᵗʰ REGᵗ.

Engrav'd Printed & Sold by PAUL REVERE BOSTON

Unhappy Boston! see thy Sons deplore,
Thy hallow'd Walks besmear'd with guiltless Gore:
While faithless P——n and his savage Bands,
With murd'rous Rancour stretch their bloody Hands;
Like fierce Barbarians grinning o'er their Prey,
Approve the Carnage, and enjoy the Day.

If scalding drops from Rage from Anguish Wrung
If speechless Sorrows lab'ring for a Tongue,
Or if a weeping World can ought appease
The plaintive Ghosts of Victims such as these;
The Patriot's copious Tears for each are shed,
A glorious Tribute which embalms the Dead.

But know, Fate summons to that awful Goal.
Where Justice strips the Murd'rer of his Soul:
Should venal C——ts the scandal of the Land,
Snatch the relentless Villain from her Hand,
Keen Execrations on this Plate inscrib'd,
Shall reach a Judge who never can be bribd.

The unhappy Sufferers were Messʳˢ Samˡ Gray, Samˡ Maverick, Jamˢ Caldwell, Crispus Attucks & Patˢ Carr
Killed. Six wounded; two of them (Christʳ Monk & John Clark) Mortally

27. **Paul Revere** (1735–1818). *The Bloody Massacre Perpetrated in King Street, Boston, on March 5th, 1770.* 1770. Engraving, hand-colored second state. 9⅝″ x 8⅝″. Courtesy Sotheby Parke Bernet Inc., New York.

sales, bringing the artist overnight fame and fortune. The success of the series also spawned an army of imitators who rushed in with "Harlots" of their own. Hogarth launched a campaign to protect his lucrative brainchild. Two hundred and thirty years after Dürer crossed the Alps to protect his ideas from plagiarists, the English Parliament bowed to Hogarth by passing the copyright law of 1735, reserving to the artist the exclusive production rights to his work for a period of fourteen years. Hogarth immediately released his new series, *The Rake's Progress,* which bore the copyright "published according to Act of Parliament," identifying the series as a Hogarth "original." A step in the right direction, but it took a full century more before prints would bear the artist's hand signature, a factor that nearly tarnished the impeccable reputation of Paul Revere. The famous Revolutionary print *The Bloody Massacre Perpetuated in King Street* (fig. 27), commonly credited to Revere, elicited an outraged cry of "plagiarism" from Henry Pelham, who in an angry note insisted that Revere had copied his engraving of the murder: "after being at the great trouble and expense of making a design, paying for paper, printing, etc. [I] find myself in the most ungenerous manner deprived not only of any proposed advantage but even of the expense I have been at, as truly as if you had plundered me on the highway."[6] Actually there are many different versions of the famous event that appear to have had a single source (fig. 28).

By making its initial appearance in fifteenth-century Europe, Western printmaking suffered the ill fortune of an ingenue thrust onto the stage with too little time to learn her lines. The debut of printmaking collided with two monumental breakthroughs in the West: Gutenberg's movable-type press (1450–1455) and the availability of inexpensive papers for printing. Together they were

instrumental in shifting society from an insular, land-based feudal orientation to our modern commercial and international one. The infant art of printmaking was swooped up in this societal metamorphosis and became one of the key tools for implementing it, playing a major role before its basic creative character had time to form. From the vantage point of today's picture-saturated, TV-screened, multimedia world, it is often hard to imagine a time when words were the primary vehicle for information exchange. A time before *People* magazine and the six o'clock news, when the secrets of whole trades passed from master to apprentice by word of mouth and costly handwritten manuscripts were prized as family treasures. For the first time in history, prints and the printing press made it possible to communicate an idea to many people at one time. The profound impact becomes clear from even the smallest example. In 1269, before the press and before print, the French natural philosopher Peregrinus communicated instructions for making his simple compass with the following pictureless description:

> *Let a vessel be made of wood or brass or of any solid material and let it be formed and turned in the fashion of a box not very deep . . . and let there be fitted over it a lid of transparent material such as glass or crystal . . . so let there be arranged in the middle of the vessel itself a slender axis of brass or of silver fitting at its two extremities to the two parts of the box, namely the upper and the lower. And let there be two holes in the middle of the axis in direction at right angles to one another and let an iron wire in the fashion of a needle be passed through one of the holes. And through the other let another wire of silver or brass be passed intersecting the iron at right angles.*[7]

One good picture is "worth a thousand words," which is why prints became the "photographs" of their day (fig. 29). For hundreds of

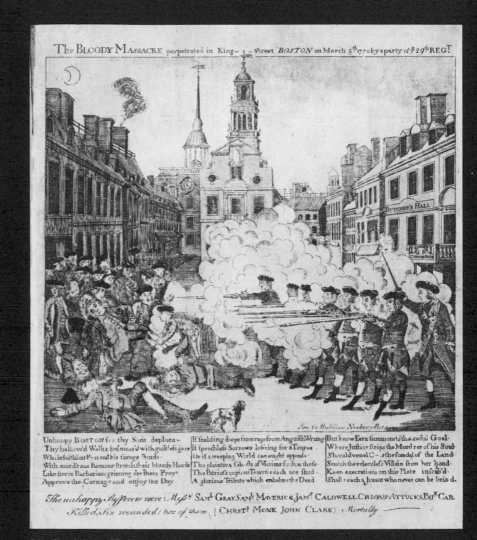

28. Jonathan Mulliken (1746–1782). *The Bloody Massacre Perpetrated in King Street, Boston, on March 5th, 1770.* 1770. Engraving, hand-colored. 9¾" x 8⅜". The famous print attributed to Paul Revere actually exists in a number of versions by various printmakers. The most obvious differences between the examples shown here are the dogs in the foreground, the smoke at the upper left, and the richer depiction of facial detail and character in the Revere rendering. Overall, Revere keeps a lighter hand, modulating tonal qualities, background architecture, and billowing smoke in a way that concentrates the picture's energy around the "event." The version by Mulliken, a clockmaker, fetched $3,250 at a 1973 auction. The Revere example brought $15,000 at the same sale. Courtesy Sotheby Parke Bernet Inc., New York.

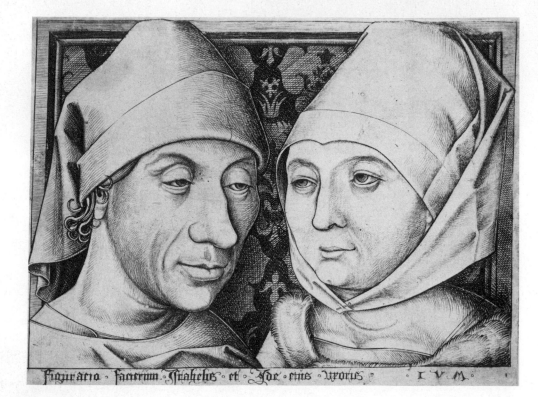

**29. Israhel van Meck-
enem** (1450–1503).
*The Artist with His
Wife Ida.* 1485–1490.
Engraving. 4⅞″ x
6¾″. This is consid-
ered the first self-por-
trait in printmaking.
Courtesy the Trustees
of The British Mu-
seum, London.

of the Papacy is shown in this horrible picture. It should frighten everyone who takes it to heart."[8] The Pope's heraldic shield flies from the tower in the background. Perhaps because people tend to believe the worst about those who disagree with them, the fictitious, scaled monster was really thought to have been found dead in the Tiber.

Prints continually document the propaganda and the issues of their day. They played an incendiary role during the American Revolution at a time when newspaper and periodical illustrations were sparse. Prints provided the communi-

30. *Interpretation of the Horrible Figure of the Pope–Ass.* Protestant broadsheet. Sixteenth century. Woodcut. 5⅝″ x 4″. Courtesy Zentralbibliothek, Zurich.

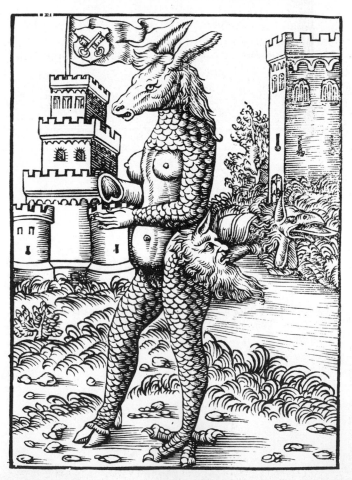

years, people received their visual impressions of the world largely through prints. With the help of prints and the printing press, great minds and movements made their way over national boundaries to cross-pollinate, and the march toward complex modern civilization, for good or ill, was set in motion.

Although Martin Luther frowned on church art as a form of idol worship, he was quick to recognize the print's potential for disseminating his Reformation, and he contributed concepts and the accompanying texts for many Protestant broadsheets. Inflammatory broadsheets such as *Interpretation of the Horrible Figure of the Pope–Ass* (fig. 30) were typical of the propaganda prints employed by both sides. One writer points out that the cloven-hoofed monster represented here grew out of an epigrammatic allusion of Luther's: "Roman Monster Found Dead in the Tiber, in the year 1496. What God himself thinks

EARLY PRINTS SERVED AS THE "PHOTOGRAPHS" OF THEIR DAY

31. *Venetian Coin,* obverse and reverse from Coin Book: *Les Monnoyes d'Or et d'Argent,* Ghent. 1544. Woodcut. When Europe changed from a land-based economy to a cash-and-carry status in the sixteenth century, negotiable coinage became an important factor in buying and selling. Numerous types of currencies flooded the market, opening the way for forgery. Antwerp money-changers coped with conmen by carrying small pocket-sized directories filled with woodcuts like the one here, illustrating authentic coins and their going value in guilders. Courtesy The Metropolitan Museum of Art, New York; Harris Brisbane Dick Fund, 1932.

32. **Andreas Vesalius** (1514–1564). Page from *de Humani Corporis Fabrica.* 1543. Facsimile edition published Basel, 1555. Woodcut after John Stephan of Calcar. 13⅛" x 24". In the sixteenth century, medical students were still laboring under the handicap of inaccurate diagrams of the human body. The Flemish anatomist Andreas Vesalius fused his knowledge of the human structure with the artistic skills of John Stephan of Calcar to create the famous anatomy book that established the Roman body type as our Western ideal. The artist's poetic approach to anatomy produces a real unreal quality as the powerful, almost decoratively flayed figures posture, flex, and expose intricate dissections against gracefully articulated landscapes. Courtesy The Metropolitan Museum of Art, New York.

33. **Filippo Calandri,** page from *Arithmetica.* 1491. Woodcut. Courtesy The Metropolitan Museum of Art, New York; Rogers Fund, 1919.

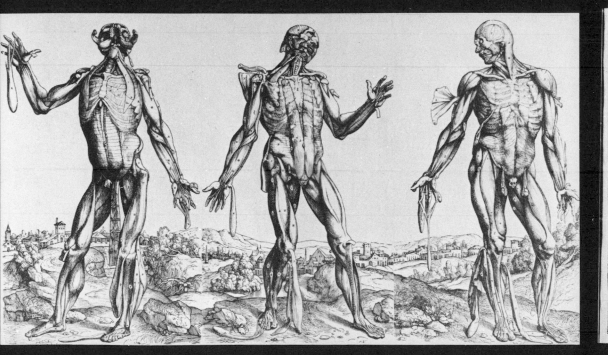

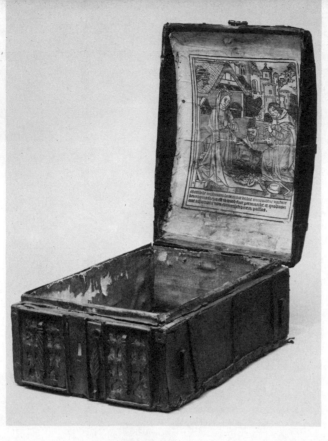

34. *The Nativity.* Fifteenth century. Paris. Woodcut. The owner of this fifteenth-century traveling case pasted a religious woodcut inside the lid, probably as a protective amulet against the marauders and highwaymen that plagued the roads. Courtesy The Metropolitan Museum of Art, New York; Harris Brisbane Dick Fund, 1928.

cation link, informing people of newsworthy events, such as battle scenes and public figures (for example, What does General Washington look like?). Propaganda prints, issued as single sheets or in almanacs or in broadsides, were common, and many such as Paul Revere's *Boston Massacre* no doubt contributed to the fervor for liberty.

The insatiable hunger for information kept printmakers busy illustrating technical manuals; copying paintings and sculptures; recording furniture designs, plant life, and animal life; designing decorative motifs; making maps; and so on (figs. 31, 32, 33, 34). Creative prints were being made (by Dürer, Hercules Seghers, Rembrandt, and Goya, for example) along with the informational type, but "originality" in contemporary terms was the exception and often scorned. Rembrandt's most innovative etchings, highly idiosyn-

cratic personal interpretations, were ridiculed by some for their "poor craftsmanship." In deviating from the rigid seventeenth-century reproductive engraving line, Rembrandt was "original" but out

35. **Georges Rouault** (1871–1958). *Who Does Not Wear a Mask?*, Plate 8 from *Miserere Suite.* 1922. Etching, aquatint, and heliogravure published in 1948. 25¾″ x 20″. What is an *original* print? Definitions are not always simple or clear cut. Rouault's masterpiece, the *Miserere Suite,* is a case in point. In an attempt to expedite the series, the artist's dealer, Ambroise Vollard, had mechanical photoetchings made from Rouault's preliminary drawings. The heliogravure plates were so distasteful to Rouault that he reworked them extensively by hand with roulette, aquatints, files, and glass paper until the heliogravure base was hardly discernible. Today, the 58 large black-and-white plates on the theme of man's sorows and rejuvenation are greatly prized. The plates were executed between 1916 and 1927, but were not published until 1948. Plate 8 (shown) is usually considered a self-portrait. Courtesy Sotheby Parke Bernet Inc., New York.

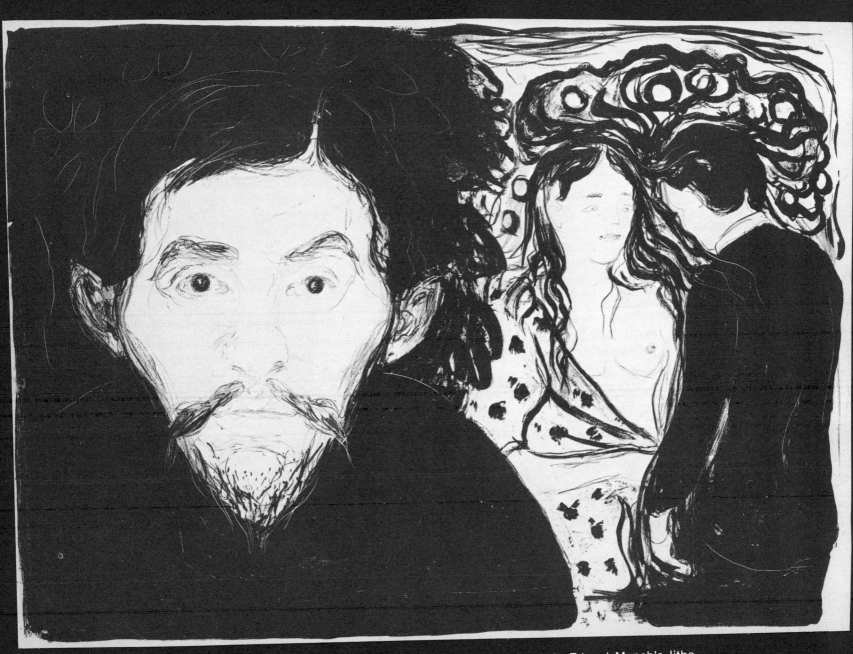

36. **Edvard Munch** (1863–1944). *Jealousy.* 1896. Lithograph. 12¾″ x 17⅞″. The jealousy in Edvard Munch's litho-graph was rooted in real life. On a visit to Berlin Munch and his friend August Strindberg fell in love with the same woman, the Norwegian wife of Przbyszewsky. Munch wrote: "I can't understand how my nerves stood the strain . . ." The artist later arranged a Paris show in which he included the painting *Jealousy* on which this print is based. Munch fled Paris when Przbyszewsky and his wife appeared, "Because it was just those two I'd painted, her naked and him green." Munch's impassioned but unhappy encounters with women vibrate throughout his work. One woman friend shot the artist with a revolver, wounding his fingers, after which he almost always wore gloves. Courtesy Carus Gallery, New York.

of step with a society seeking the kind of naturalistic fidelity achieved with the camera. As late as the nineteenth century, spontaneous, original etchers were refused exhibition space at England's Royal Academy, where only the works of reproductive engravers were officially sanctioned. Against this pragmatic backdrop, "originality" as we value it today would have appeared as absurd as an Andy Warhol Madonna in a medieval monastery. It was not until well into the nineteenth century that the emphasis swung from utilitarian and reproductive printmaking to an "art for art's sake" in which the artist's inventiveness was prized on its own merit (fig. 35).

The discovery of lithography in the late eighteenth century proved a step in this direction. Lithography removed many of the technical barriers facing an artist interested in making prints. Any artist who could draw with a pencil or paint

37. **Andy Warhol** (1931–). *Jackie* from *Eleven Pop Artists* portfolio. 1966. Screen print. 24″ x 30″. Courtesy Leo Castelli Gallery, New York.

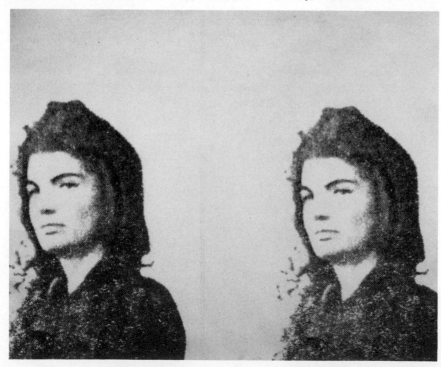

with a brush could make a print on stone. This directness attracted first-rate talents to printmaking—Goya, Eugène Delacroix, Honoré Daumier, and Henri de Toulouse-Lautrec, for example. They, in turn, demonstrated the aesthetic potential of prints. As these creators began to ease the reins of printmaking out of the hands of copyists, the new democratic economic systems gaining hold in Europe were laying the foundation for the large, affluent, culture-conscious middle classes who would eventually absorb the outpouring of multiple original art.

But the crucial coefficient that finally tilted the print-equals-illustration equation in favor of prints-as-art was the introduction of photography in the nineteenth century and, later, of the photomechanical reproductive systems. Purged of reproductive obligations, the vibrancy of lithographic lines, the grain of wood blocks, the tones of aquatint could all be exploited creatively. Paul Gauguin (fig. 65), Edvard Munch (fig. 36), and Toulouse-Lautrec (figs. 92, 93) all produced major prints by the turn of the century. The German Expressionists followed with some of the most powerful graphics ever made (figs. 67, 68). Yet printmaking remained a muffled voice in the art world. Two world wars, a Depression, and perhaps the uninterrupted wave of visual upheavals (Impressionism, post-Impressionism, Expressionism, Fauvism, Suprematism, Futurism, Cubism, Constructivism, Dada, Surrealism) taking place in the established areas of sculpture and painting siphoned energy from the incipient print explosion.

Widespread interest in printmaking accelerated in America in the late 1950s and early 1960s. As modern canvases grew larger and costlier, the contemporary print moved up as a strong alternative. In 1964, Pablo Picasso released a bold, painterly series of large linocuts (figs. 76, 77);

that same year, Rosa Esman issued the first signed and numbered portfolio of prints by contemporary painters in America (fig. 37). Print collections sprouted in museums and universities across the country. Serious collectors hung prints where once they considered only paintings. Prices soared. In the 1966/67 season, an annual volume of $160,000 in print sales passed through the famous New York auction house of Sotheby Parke Bernet. By 1975/76, gross annual print sales had rocketed to $2,797,330, an increase of more than 1700 percent in less than a decade.

An affluent public, unbaptized and ill-informed in the subtleties of print buying, leaped enthusiastically into the print boom of the 1960s. In an effort to head off unscrupulous artists and dealers, the Print Council of America issued its often-quoted *Guide to the Collecting and Care of Original Prints*, establishing criteria for an original:

1. The artist alone must create the master image on the stone, plate, or block or whatever material would be used to make the prints.

2. The prints, if not printed by the artist, should be hand-printed by someone working under his close and direct supervision.

3. Each impression should be inspected, approved, and signed by the artist, and the master image should be destroyed or canceled so that no unauthorized prints could be taken after the edition had been pulled.

Acording to these guidelines, a $3.98 reproduction of a famous painting run off on a high-speed mechanical press was clearly not to be considered an original print. Color values, clarity of line, and often size were at best only weak approximations of the original work. But what about the eighteenth-century made-by-hand copy-ist's engraving of a seventeenth-century Rembrandt etching? This too would qualify as a reproduction, since Rembrandt had nothing to do with originating the master image on the plate. The original print, the council was saying, *was not a copy of anything else:* not of a drawing, a painting, or another print. If an artist chose to copy his own work, done originally in another medium, such as oils, this was properly called "a design after an oil by . . ."—not an original. The council's definition attempted to place the original print firmly on creative turf and as far as possible from its centuries-old and outgrown reproductive past, an attitude shared by modern printmakers themselves. "I make prints," said Gabor Peterdi, "because in using the metal, the wood, and all other materials available, I can express things that I cannot express by any other means. In other words, I am interested in printmaking not as a means of reproduction, but as an original creative medium. *Even if I could pull only one print from each of my plates, I would still make them*"[9] (italics mine).

As long as an artist toed the classic line, executing each step by hand, the council's definition sufficed, although even here, it had to bend a little to accommodate actual history. Dürer, for example, cut his own engraving plates but few if any of his own wood blocks, which were executed by a master craftsman following Dürer's design. More importantly, the council did not anticipate an unexpected development: the unorthodoxy of the new breed of printmakers emerging in the 1960s. Most were painters and sculptors. They came to the print medium with few presumptions or preconceptions about what should or should not constitute an "original print." The new generation had been brought up with twentieth-century technology; TV, cameras, photographs, newspapers, telegraph, and computers were as

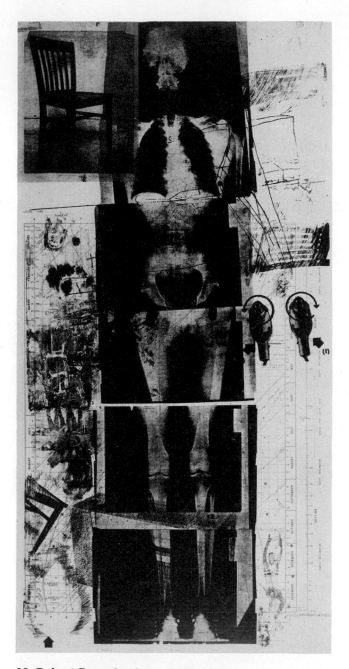

38. **Robert Rauschenberg** (1925–). *Booster*. 1967. Lithograph and silk screen. 72″ x 32½″. Courtesy Sotheby Parke Bernet Inc., New York.

natural a part of their way of "seeing" as religious themes were to the medieval printmaker. It was almost predictable that these artists would seek a way to introduce something of our modern technologically spawned visual experiences into the new print images. To achieve the image for his now-classic print *Booster* (fig. 38), for example, Robert Rauschenberg called less on his drawing talents than on his ability to assemble already-manufactured pictures—"documents" if you will, of contemporary society. *Booster* incorporates zinc cuts from a newspaper, rubbings from newsprint that were silk-screened onto the lithographic stone, technical-manual illustrations, and a complete set of X-ray photographs of the artist. After the basic images were printed, an astronomical chart was superimposed over them in red enamel, again by the silk-screen process. Rauschenberg's *Booster* is a far cry from the traditional hand-drawn lithographs of a Daumier (figs. 88, 89, 90). It is more like an "invention" or a printed collage. Such hybrid prints are difficult to pigeonhole. They do not fit neatly into the Print Council's criteria, since many use photo-mechanically produced images. Yet it is these hybrids, more than prints made along more traditionalist lines, that now come to mind when we think of "contemporary" prints. According to the Print Council, the artist must create the master image himself. How can a print using reproductions, such as Richard Hamilton's (pl. 16), still be an original?

While an increasing number of modern printmakers incorporate preprinted, mechanically made images (that is, photographs) into their work, they are not making copies of anything. Nor is it their intention to use these reproductions as "reproductions." Rauschenberg described the technologically created components in his prints as being as "poetic as a brushstroke." To such artists, the "products" of our society are treated

as just another kind of lithographic crayon, pencil, or paintbrush. The "products"—news clippings, advertisements, X rays, photographs, and computer printouts—are creatively recycled. In Eduardo Paolozzi's screen print (fig. 167), these readymade images shed their original purpose and identity and, it is to be hoped (if the artist is any good and has something to say), gain a new meaning for us.

The recycling of manufactured objects is not new. Groundwork was laid earlier in this century by Cubist (1907–1913) and Dada artists (1913–1923), who introduced the idea of creating art from everyday "products" and the ephemera of modern industrialism. Deliberately turning its back on traditionally accepted art materials, themes, and social values, Dada openly spurned respected artistic totems. In a symbolic act of renunciation, shocking in its time, Marcel Duchamp exhibited "readymades" (for example, a signed snow shovel; see fig. 194) as sculpture and created his now-famous (or infamous, depending on one's view) "assisted readymade" of Leonardo's *Mona Lisa* (fig. 39). Appending a moustache and goatee to one of society's most prized "objects," he openly declared art to be unfettered by the icons or ideologies of the past. The irreverence and the deliberate unorthodoxy of pioneers such as Duchamp and Johannes Baader (fig. 40) anticipated directions later pursued by modern printmakers—artists such as Jasper Johns (pl. 1), Robert Rauschenberg (fig. 38), Claes Oldenburg (fig. 41), and R. B. Kitaj (fig. 169), to name several who parlayed the recycled readymade image and everyday object into symbols that have become idiomatic to contemporary graphics, an aspect more fully discussed in chapter 7.

Many exciting contemporary images fall comfortably within the council's guidelines (fig. 42). Old master prints are fairly well documented,

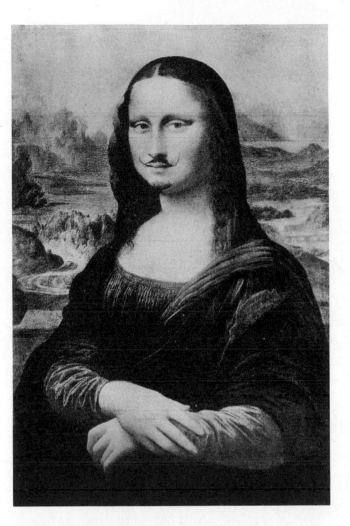

39. **Marcel Duchamp** (1887–1968). *L.H.O.O.Q.* 1919. Assisted readymade. 5¾″ x 3¾″. The March 1920 issue of *391*, a Dada magazine, published a photograph of Leonardo da Vinci's *Mona Lisa*, to which Duchamp had added an irreverent goatee and moustache. Duchamp mocked the "precious object" concept of Western art, symbolized by Leonardo's venerated masterpiece, by exposing it to ridicule as an "assisted readymade" entitled *L.H.O.O.Q.* The letters, pronounced phonetically in French (Elle a chaud au cul), loosely translate as: "She has a hot backside." Duchamp later signed an unaltered photograph of the Mona Lisa, adding the caption: "Raseé," meaning "shaved." Courtesy Private collection, Paris.

right down to known copies. Early handmade reproductions after paintings and drawings (fig. 43) are also worth collecting and are often less costly. But if your tastes put you in the position of the seventeenth-century collector attracted by the then-unconventional etchings of Rembrandt, it should be of some comfort to know that most of the "rule breakers" banned from official print exhibitions in the 1950s have already become "modern masters" in the print lexicon.

The questions raised by printmaking (unique versus more-than-one-of-a-kind originals; handmade images versus modern machine-assisted ones; signed versus unsigned impressions) are less indications of a worrisome ambiguity in the field than of a vigorous art form flexing its creative muscles.

CONTEMPORARY PRACTICES

LIMITED EDITIONS. The idea of limiting edition sizes is relatively modern. Dürer's prints were published in quantity in his lifetime as well as in posthumous editions. Rembrandt's plates also remained "active" (although often reworked so extensively that the artist's original intentions are no longer visible) until earlier in this century. In the nineteenth century, the Printseller's Association injected an element of "rarity" into the print field when they began the practice of arbitrarily retiring a stone, plate, or block before it was worn out, thereby limiting the edition. Almost all contemporary original prints are limited editions. *Edition* refers to the total number of impressions printed. A contemporary "limited edition" can vary from as few as two to five impressions, as it does in the prints of Rolf Nesch (fig. 204), to as

40. **Johannes Baader** (1876–1955). *The Author in His Home.* c. 1920. Collage of pasted photographs. 8½″ x 5¾″. Courtesy The Museum of Modern Art, New York.

41. Claes Oldenburg (1929–). *Soft Toilet #2.* 1972. Lithograph. 20″ x 14½″. Courtesy Gemini G.E.L., Los Angeles.

many as ten thousand, as it does in the case of Friedensreich Hundertwasser (fig. 181). Generally, editions run between one hundred and two hundred impressions, each signed and numbered by hand. There is also a secondary meaning of the word *edition.* Some images have been published in first, second, third, and fourth editions, as books are. Generally, the artist, like the author, had made some changes. Printing paper varies from edition to edition, and this can affect the "sparkle" of the image, so you may want to com-

pare editions where possible. First editions are usually more valuable. The edition number will be indicated on the frontispiece of the set and generally on each example. When known, this information is included in catalogues raisonnés on the artist's work. Contemporary printmakers rarely issue such editions.

SIGNING AND NUMBERING. James Abbott McNeill Whistler, along with his brother-in-law, Seymour Haden, furthered the idea of "rarity." They were two of the first artists to hand-sign their prints in pencil. In 1887, Whistler issued his first series of lithographs with a novel twist: he charged twice as much for the sets signed in pencil as he did for the same set unsigned. His signature was worth as much as the image! A long step from medieval anonymity. Later Whistler de-

42. Philip Pearlstein (1924–). *Models in Studio.* 1976. Five-color etching and aquatint. 21¾″ x 29″. Courtesy Allan Frumkin Gallery, New York /Chicago.

43. **Marcantonio Raimondi** (c. 1480–1530). *The Judgment of Paris.* 1510. Engraving after a painting by Raphael. 11½″ x 17″. Courtesy National Gallery of Art, Washington, D.C.; Gift of W. G. Russell Allen.

signed a butterfly symbol (based on the *W* of his name) and signed prints with it (fig. 44). In most modern prints, the impression number and edition size are penciled on the lower margin of the print—for example, $^{21}/_{100}$. The lower number of the fraction (100) tells you that the complete edition consists of one hundred impressions, while the upper one (21) tells you that this is the twenty-first impression in the edition. This fraction type of numbering usually appears on the lower left margin, the artist's pencil signature on the right side. Although the impressions themselves may be aesthetically equal, the difference between a signed and an unsigned print by a

major artist can be a matter of hundreds, even thousands of dollars.

There are many misconceptions about signing and numbering. One print-club mailer enticed new membership by offering a bonus of an original Picasso lithograph. A new recruit noticed that the framed Picasso she received was neither pencil-signed nor numbered. She called the club and was advised that they would issue a notice on the edition size as soon as the response to the mailing was complete. Nonsense. The size of a limited edition is set *at the time of the printing* and, in most cases, is marked in pencil by the artist on the print. The club's Picasso was probably one re-

struck (see "Re-strikes or reprints" below) from an early, uncanceled plate. It came from the original plate but in no way from the original edition. The quality of such a re-struck plate may have been far from good. In any case, the free-with-membership Picasso, one of thousands in an unlimited number, is relatively worthless.

THE "NUMBER-ONE-IS-BEST" MYTH. Many people believe that impression $\frac{1}{100}$ is better than $\frac{100}{100}$. This is not necessarily true. The artist usually signs and numbers an edition after the entire series is pulled. More likely than not, impression number $\frac{1}{100}$ was actually the last pulled and, being on top of the stack, the first numbered. In some cases, inking requires several pulls before a correct balance is struck, again militating against the number-one-is-best theory.

SIGNED IN THE STONE. Most artists sign their prints in *pencil* because under glass it would be difficult to detect a printed signature from one written in ink. The whole purpose behind signing a print is to authenticate its quality and originality for the buyer. A signature made on the stone prior to printing merely becomes part of the image and in no way indicates the artist's approval of the impression. How could it? "Signed in the stone" suggests a signature where one doesn't exist. Either the image *is* signed or it isn't. One further comment. While most contemporary prints are signed, many valuable ones are not. Ernst-Ludwig Kirchner, who printed his own prints in very small quantities—three to six examples generally—did not bother numbering or signing any of them (fig. 68). With master prints such as Kirchner's, validity can usually be traced in a catalogue raisonné of the artist's graphic work (see page 179).

ARTIST'S PROOF. A certain number of impressions above the basic edition size are set aside for the artist. These are called *artist's proofs* or *épreuve d'artist* (A.P. or E.A.). They usually number from ten to fifteen. An edition of 100 with 10 A.P.s would mean that the image existed in 110 examples. It is not common practice, but occasionally a publisher will "stretch" an edition by pulling an excessive number of artist's proofs for a seemingly small edition. Another trick for "stretching" the size of editions has been the issuance of an edition for the United States of 200 impressions and then another edition of 200 for Europe. The actual edition is really 400, but each country's version is presented as an edition of only 200. Fortunately, such breaches of ethics are few and far between.

BON À TIRER. The *bon à tirer* (which means "good to pull") is the impression selected by the artist as a sample guide for pulling the entire edition. It provides the standard of quality (color and registration) against which all other impressions are compared. Traditionally, the artist inscribes the *bon à tirer* for his master printer or publisher.

COUNTERPROOF. Except for the stencil process (page 115), all print impressions appear on the paper in reverse of the way the artist drew them on the stone, plate, or wood. The *counterproof* is a print pulled quickly from a damp impression already made from the master image. The purpose behind a counterproof is to give the artist an impression going in the same direction as his master image on the stone, plate, or wood, so that he can make corrections.

STATES. This is one of the most fascinating areas in print collecting. In the process of working out his final concept for an edition, an artist may alter the basic image, colors, inkings, backgrounds, a few lines. He takes "pulls" of these changes as he goes along. These working states offer an unusual insight into the creative circuit

44. Butterfly emblem used by James Abbott McNeill Whistler (1834–1903) as a signature on his prints.

followed. They can clarify what the artist's purpose was in selecting his final direction for the edition. A state may reveal minor or radical changes, such as the eleven states of Picasso's *Bull* (figs. 214, 215, 216, 217, 218). Such states usually exist in few copies and may even be more visually stimulating than the final edition. *Rembrandt: Experimental Etcher,* published by the New York Graphic Society, offers an intriguing survey of that master's states with the comment that "when one comes to know Rembrandt etchings in a range of impressions one sees how they grew like a living entity under Rembrandt's hand, and how he conquered the problem it presented by experimenting with many possible solutions. Then one understands as never before the process of creating a work of art" (figs. 138, 139).

HORS DE COMMERCE. This sometimes appears on a print as *H.C.* and identifies the impression as one pulled for the artist's or publisher's personal use. It is similar to the artist's proof and was originally the term used for copies reserved for critics, friends of the family, or publications. With contemporary prints, one should be cautious of the number of H.C.s, as they are occasionally used to pad an edition.

RE-STRIKES OR REPRINTS. Re-strikes are pulled from the original plate *after* the original edition has been issued, often many years after the artist's death. There are "legal" reprints (re-strikes) and "illegal" ones. Although most stones, plates, and blocks today are canceled, a publisher can legally purchase an uncanceled image. If the plate, stone, or block is not cancel-marked, the publisher can pull endless re-strikes to sell for a fraction of what the original edition would bring. The image quality is often poorer, and some plates are reworked to the point that resemblance to the original is minimal. When a re-strike is clearly labeled and priced as such, there is no harm done. Where the re-strike is passed off as an impression from the original edition, it is a fraud. One should be particularly careful to get proper credentials with prints from before the twentieth century and with artists such as Picasso, Käthe Kollwitz, Georges Braque, and Marc Chagall.

QUESTIONS PEOPLE ASK

1. *What becomes of the plate, stone, wood block, or stencil after the complete edition has been pulled?*

In modern times, it is customary to "cancel" them after the edition is pulled. To cancel a master image, the artist removes or somehow marks the design. For example, a lithographic stone can be cleaned off and used again. Sometimes an *X* is placed over the image to indicate completion of an edition, and one impression is taken of the *X*ed image before the image on the stone is "polished out." Some artists feel that metal plate and cut blocks are in themselves artworks worth preserving. In such cases, they cancel them by marking the surface—for example, by punching a hole through it at an upper corner. A number of museums collect such canceled master images. Some popular older plates and blocks were kept in circulation beyond exhaustion. Older prints are generally well documented and can be checked.

2. *What determines the size of an edition?*

In most cases an edition is limited arbitrarily by the artist and/or the publisher and is not restricted by any natural "life-span" of the plate, stone, block, or stencil. In certain mediums (such as drypoint) in which the burr on the plate is worn down with each run through the press, image quality and edition size are clearly determined by the plate's durability.

3. *What types of misrepresentations should the collector be alerted to?*

PHOTOMECHANICAL REPRODUCTIONS of prints or paintings, sometimes with forged signatures. Remove all prints from their frames: close scrutiny, preferably with a good magnifying glass, exposes reproductive screen dots in tonal areas and false plate marks hidden by the glass. When collecting modern French prints, you should check whether the artist executed the image himself or whether it falls into the category of so-called *estampes à tirage limité,* which occasionally is a masking phrase for a situation in which the artist gives a watercolor or gouache to his publisher that engravers then execute as a print and publish in a limited edition. Many of these were signed by artists, such as Braque, Picasso, and Chagall. They are not originals. They are sanctioned-by-the-artist reproductions. Major auction houses now clearly indicate that works like *Hommage à J. S. Bach* (*estampe à tirage limité*), printed in a series of three hundred signed and numbered examples, are reproductions. However, such prints still bring several hundred dollars, a high premium to pay for what amounts to an autograph.

HANDMADE COPIES. These are really hand-executed lithographs, etchings, engravings, and woodcuts made by craftsman copying the work of a well-known artist. In some instances, artists have issued such copies under their signature (such as the Chagall series published by Solier) but these works do not have the same value as an original print by the artist himself. In the case of old master prints, such as Marcantonio Raimondi's famous copies of Raphael paintings (fig. 43), the hand-executed engravings, although "copies," have become prized items to be collected in themselves. One Raimondi example, *Parnassus,* brought $1,520 at Christie's in a December 1975 auction.

FACSIMILE PRINTS are deliberately made to the exact size of an original, either by a photomechanical process or by a hand copyist. In general, using a reputable dealer is the best way to steer clear of facsimiles. With old master prints, check paper watermarks and catalogues documenting the artist's works (page 179).

POST-EDITION SIGNATURES are often forged and suddenly show up on prints that were originally published in large unsigned editions for inclusion in magazines, books, or other unlimited outlets.

NOTE: Although fraudulent practices do exist in every area of art, these infractions represent a drop in the bucket compared to the thousands of authentic fine prints purchased yearly by collectors, museums, universities, and corporations.

3

the oldest known form of printmaking: the relief process

Relief printing is possibly as old as man himself. Our prehistoric forefathers indulged in a primitive form of printmaking whenever they colored the palms of their hands with pigment and pressed them against cave walls so that the raised fleshy sections of the palm (the parts "in relief") left their impressions.

The actual technique for making woodcuts by the relief procedure was discovered by the Chinese, who also invented paper and printing. It is the oldest form of printmaking. Wood-block pictures and texts existed in China hundreds of years before the first prints appeared in fifteenth-century Europe. The earliest authenticated and dated woodcut is a scroll of the Diamond Sutra of A.D. 686 by Wang Chieh (fig. 237), discovered in the Cave of the Thousand Buddhas in eastern Turkestan. There is also evidence of a primitive form of rubbed print in China by the second century.

The principle behind relief-process printing is simple enough to anyone who has ever used an ordinary office rubber stamp. The stamp has a raised area containing words or numbers for printing. The rest of the surface is at a lower level. When the surface is inked, only the raised

45. Still life of woodcut tools.

46. **Albrecht Dürer.** *The Triumphal Arch of Emperor Maximilian I.* 1512–1515. Woodcut. 11′ x 10′. For three years, from 1512 to 1515, and without pay, Dürer supervised and contributed designs for what is probably the world's largest woodcut. Comprised of 192 individual blocks, the paper arch stands ten feet wide by eleven feet high, fully assembled. Hieronymus Andreä took two years, 1515 to 1517, to cut the designs in wood. One of a number of projects dedicated to the self-glorification of Emperor Maximilian who variously fancied himself a descendant of the Egyptian god Osiris and Caesar, the arch divides into three portal sections, depicting Maximilian's genealogy, including 108 Hapsburg coats of arms; major political events in the emperor's life; his marriage, portraits of princes and earlier rulers of the Holy Roman Empire. Dürer eventually received an annual pension of 100 florins for his labors. The paper arch was published in 1518, a year before Maximilian's death. According to Maximilian's astronomer, Johann Stabius, the paper marvel was erected in front of Maximilian "as in olden times the arcus triumphales before the Roman Emperors in the City of Rome." Courtesy the Trustees of The British Museum, London.

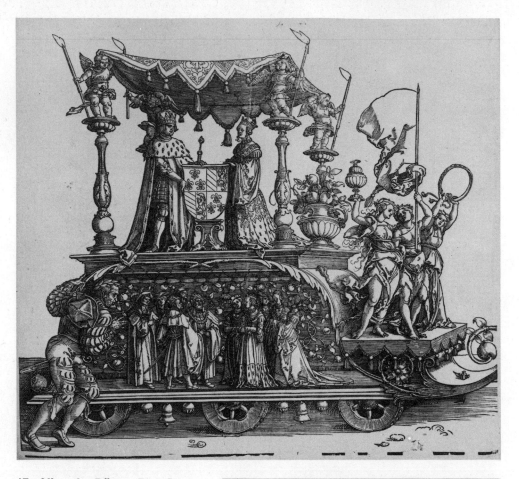

47. **Albrecht Dürer.** *The Burgundian Marriage,* wedding chariot of Maximilian and Mary, detail from *The Triumphal Procession.* 1526. Woodcut. 15″ x 16⅜″. Courtesy the Trustees of The British Museum, London.

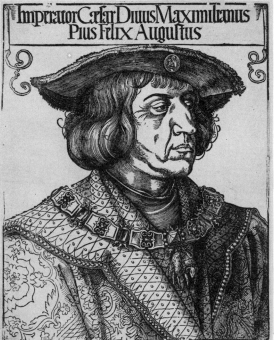

48. **Albrecht Dürer.** *Emperor Maximilian.* Woodcut made after a drawing of 1518. 16⅞″ x 12¾″. Courtesy Sotheby Parke Bernet Inc., New York.

portion picks up the color. When the stamp presses against paper, the inked portion transfers the image onto the sheet. Essentially, that is what happens when an artist makes a woodcut (figs. 46, 47, 48). The idea is to create an image on the wood that, like the letters of the rubber stamp, stands above the rest of the surface, so that it alone will print when the block is inked and pressed to paper (fig. 49, pls. 2 and 3). Most objects can be inked and printed "in relief": a pencil, a leaf, a crumpled scarf, a hanger, the raised portions of coins (fig. 57).

BASIC STEPS IN THE MAKING OF A WOODCUT

First the artist planes his wood smooth, using a plank of wood cut along the length of the tree. Cherry, maple, white pine, sycamore, redwood, or mahogany is a common choice.

49. **John Foster** (1648–1681). *Mr. Richard Mather.* c. 1670. Woodcut. 7″ x 5⅜″. Considered the oldest surviving print in America. The artist pursued printmaking in addition to his medical practice and teaching school. Foster is believed to have been Boston's first printmaker. Courtesy American Antiquarian Society, Worcester, Massachusetts.

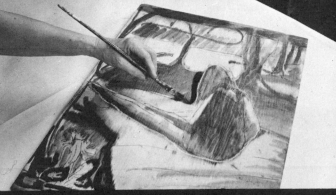

50. Drawing on the block.

THE MAKING OF A WOODCUT

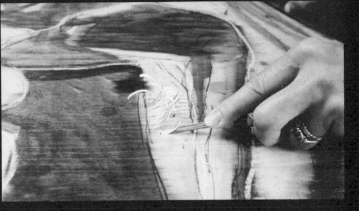

51. Cutting into wood.

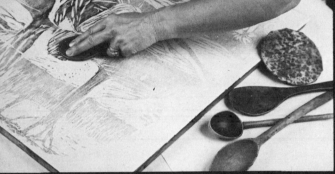

54. Rubbing the paper.

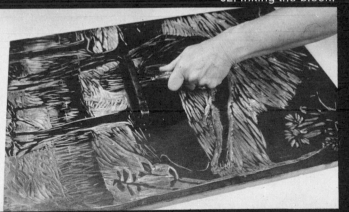

52. Inking the block.

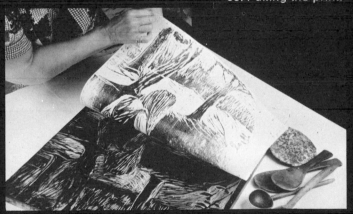

55. Pulling the print.

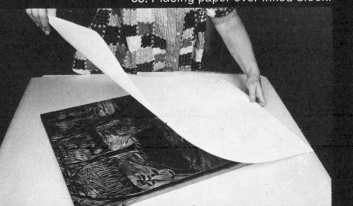

53. Placing paper over inked block.

56. The print next to the wood block.

The image is drawn on the block with a pencil or pen. *Some artists go right to work with their knives and gouges,* inventing and cutting the image as they go. Most prefer to make a rough drawing directly onto the block or paste a drawing of the design on the surface and cut through it. Just as the rubber stamp "prints" in reverse, a wood block must be planned to accommodate the mirror image that will transfer to the paper. The printmaker must think backward if the image is to print correctly forward.

The artist cuts away all those part of the wood that he does not want to print. What remains *in relief* is the image to be printed (about ⅛″ higher than the rest of the block).

A thin film of ink is rolled over the block.

Paper is placed over the block, usually a thin absorbent stock, such as rice paper.

The paper is burnished with the bowl of a wooden spoon or run through a press. This pressure transfers the inked image to the paper. Early woodcuts were rubbed with a spoonlike tool, and many contemporary artists prefer the inking control and variations that hand rubbing offers over a press.

Pulling the impression.

A woodcut, *Erica in the Garden* (1974) by Charlotte Weston, and the block from which it was printed (fig. 56).

Technical explanations of the relief process stress the fact that the raised area of the wood block carries the ink and the "positive" image. This emphasis leaves the impression that the area cut away in the block is somehow unessential in the final design. To the contrary, although this may be true of early woodcuts, the gouged-out portions that print "white" (or whatever the color of the paper) often contribute an integral design element to the modern picture. In cutting his block for *Abstract Composition* (1922),

58. **Walter Dexel** (1890–1973). *Abstract Composition.* 1922. Woodcut. 7½″ x 4½″. Courtesy Carus Gallery, New York.

57. Most objects can be inked and printed in relief.

Walter Dexel clearly considered spatial relationships in terms of an interaction between the inked areas and the white of the paper (fig. 58). An interesting aspect of this print is that the white areas "inside" the design zone appear optically to be a separate "color" from the white of the surrounding paper, although they are actually part of it—a tribute to Dexel's use of form and space. Again, white areas are not subsidiary to the black-inked image in Lyonel Feininger's woodcut *The Gate* (1920; fig. 59). Feininger sets up a dynamic dialogue between black and white elements. His cubistic fragmentation of the forms combines with this black-and-white counterpoint and a series of brisk stroke lines throughout the print to project a state of tension and explosive

energy. Exploiting the uninked portion of the block is more generally associated with the white-dominated images of wood engraving discussed further on in this chapter, but so-called negative areas should not be overlooked when one is estimating the aesthetic impact in any relief image.

As early as the sixth or seventh century A.D., the Egyptians employed the wood block for printing textile patterns. The first authenticated types of individual prints from wood were Buddhist Charms, a category not unlike the religious woodcuts sold at monasteries in the West. In both the Orient and Europe, religious themes predominated in the early stages of printmaking. The woodcut may have developed initially as a time-saving device to expedite the work of illustrating illuminated manuscripts. Monasteries were the publishing houses of their time. In these sanctuaries, copyists recorded the classics, medieval poetry, and the writings of scholars (such as Saint Thomas Aquinas) on parchment by hand. Many of the images used were "standardized" pictures recycled again and again as borders and embellishments and merely adapted to the current style. Illustrating by hand was a tedious and slow process. Printing designs from wood blocks (a procedure long known in the textile industry) probably struck someone as the logical shortcut for saving redrawing time in manuscript illustration. The production of religious pictures boomed with the introduction of speedy wood-block printing. At monasteries, convents, and shrines, woodcuts were sold by the thousands as souvenirs to religious pilgrims hazarding the precarious medieval travel routes alongside journeyman and knight. Some of the woodcuts offered the buyer insurance against attack, others protected him against plague, and still others depicted allegories on death (fig. 60) or were designed as greetings for the New Year (fig. 61). But most early religious prints were indulgences, depicting saints, images from the life of the Virgin, and Christ on the Cross. Hyatt Mayor, in his book *Prints and People*, relates the story of one legendary early Venetian woodcut. The print, known as the *Madonna of the Fire*, had been pinned to a schoolroom wall. In 1428, the school caught fire. In the midst of the conflagration, the print supposedly spun up through the flames and momentarily hung in the air as though rescued by the intercession of an invisible hand before falling safely into the crowd standing around the blazing edifice. A miracle? It appeared to be to the people of the village. Eventually, the eleven-inch woodcut was enshrined in a special

59. **Lyonel Feininger** (1871–1956). *The Gate.* 1920. Woodcut. 16″ x 17¾″. Courtesy Carus Gallery, New York.

60. *Angel Visiting the Dying Man,* Leaf 6 from *Ars Moriendi.* Cologne. c. 1475. Woodcut. 8¾″ x 6¼″. Courtesy The Metropolitan Museum of Art, New York; Harris Brisbane Dick Fund, 1923.

more humanistic and earthy interpretation of the fate shared by all men. In his famous series *The Dance of Death* in 1538, Hans Holbein's approach to the Grim Reaper is irreverent and humorous, suggesting a view of Death as the Great Equalizer. In his *Alphabet of Death,* the artist shows the Great Equalizer stripping men of all their earthly powers and illusions (fig. 3) : in the letter *D,* Death rides astride a mighty king, subjecting the ruler of men to life's ultimate rule; in *R,* the jester, who lives his life laughing at others, does not seem to find much humor in Death's having the last laugh. A horseman loses his race against Death in *U.* The only winner at the game of life,

61. Anonymous German. *The Christ Child on a Donkey.* c. 1500. New Year's greeting. Woodcut. 3¾″ x 2⅝″. Courtesy National Gallery of Art, Washington, D.C., Rosenwald Collection.

chapel, where once yearly it is uncovered and placed on public view.

With Protestantism, the flow of heavily religious church-supported prints dwindled. However much Martin Luther recognized the propaganda value of woodcuts and deployed them in spreading his views (fig. 30), the Reformation generally frowned on church art as idolatrous. This reduction in clerical patronage is reflected in the change in the way printmakers handled the theme of death. The Black Plague of 1348 had decimated huge segments of Europe's population. Survival became a daily question mark. Harsh reality combined with church attitudes to produce a tight-lipped piety toward death and dying. But with the Reformation one discerns a shift. Art pursued a

Death takes all from two gamblers in *X*. What makes Holbein's series most extraordinary is the size of these miniature masterpieces. Each is only one square inch! No larger than a postage stamp. Within this microscopic universe, the artist compressed not only a highly legible alphabet but a profound philosophical observation.

A critical turning point in the history of printmaking and Western civilization was reached with the development of the Gutenberg movable-type press in the mid-fifteenth-century. The invention made it possible to publish information inexpensively in large quantities. Soon, the information industry was pressing printed pictures into new functions. Church art might slacken, but the professions of architecture, engineering, anatomy, botany, zoology, carpentry, and art were expanding and developing with the aid of widely circulated texts elaborated with printed pictures. After financing Gutenberg's development of a movable-typeface printing system, Johann Fust, a silversmith, and his son-in-law, Peter Schöffer, booted the inventor out of the project and published the world's first dated book, the Psalter of 1457.

For some time before the Gutenberg press came along, *block books* had been popular. They were so called because picture and text were carved into a single block of wood, an inflexible master image that the printer could not reuse. One of the world's first best sellers was a block book: *Ars Moriendi* (The Art of Dying). *Ars Moriendi* (fig. 60) constituted a "how to" guide on dying in a state of grace for the population of the late Middle Ages. Illustrations depicted the dying man in confrontation with temptation: greed, despair, pride, doubt. He finally overcomes the Devil's bribes and passes on as a member in good standing. Given the high rate of death from disease and childbirth and the primitive state of medicine at the time, the imminence of death and the need for coping with it were a far more pressing issue than they are in our own time, when nutrition and science allow most of us to repress the question of mortality for decades.

Creating the first printed picturebook followed naturally from the first carved book blocks. Typeface, like the woodcut itself, is printed by a relief process. Both letters and picture reproduce from the raised portion of a master image. Wood blocks were soon teamed with typefaces to produce illustrated books. With the introduction of Gutenberg's movable-type press in the mid-fifteenth-century, the text was assembled and printed first. A blank space was left on the sheet and a picture was added later from a wood block. These same illustrations were used repeatedly, and the same woodcut image is often found illustrating books of widely diverse subject matter. Such random repetition can be found in the famous *Nuremberg Chronicle* published in 1493 with a staggering 1,809 woodcut illustrations. Using different captions, a single town view served to depict eleven different towns. Perhaps a Gothic efficiency expert realized that if he cut down the height of the wood block so that it was level with the height of the typefaces, pictures and text could be printed at one time. Whatever the origin of the idea, this conjunction of type and picture launched the modern press and its awesome power for disseminating the ideas that shape modern civilization. "Since the XV century there certainly has been no advance of comparable importance until the discovery of wireless and the development of broadcasting."[10]

Paul Gauguin and Edvard Munch inaugurated the modern woodcut. Their innovative and experimental approaches to the wood block resur-

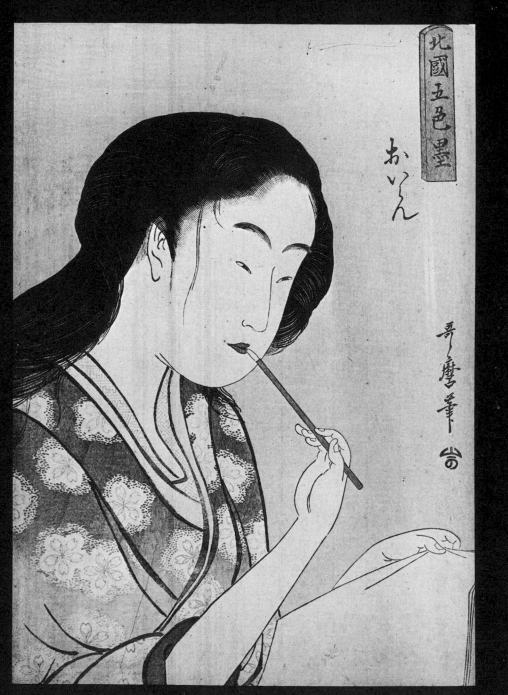

62. **Utamaro** (1753–1806). An Oiran, from the series *Hokkoku Goshikizumi* (Five Classes of Women from Yoshiwara). c. 1795. Woodcut. 14¼″ x 10″. Courtesy The Art Institute of Chicago, Clarence Buckingham Collection.

rected the medium from oblivion after centuries of commercial use as a second-class reproductive process. Their involvement with woodcuts probably stemmed from the increasing influence of Japanese woodcuts in European art (figs. 73, 74). Japanese woodcuts first came to the attention of French artists in the late 1850s, when Félix Bracquemond accidentally discovered a copy of the *Manga,* a Japanese sketchbook with woodcuts by Hokusai. Japanese aesthetics caught on in the more radical circles of French art in the 1860s and 1870s, and artists like Édouard Manet, James Abbott McNeill Whistler, Mary Cassatt, and Edgar Degas incorporated Oriental composition, themes, and colors into their work. It was through the tutorage of Bracquemond and Degas that Cassatt learned the soft-ground and aquatint techniques with which she emulated the "Japanese method" (woodcut) (fig. 62) in ten superb plates depicting the intimate, private world of woman (figs. 63, 64). In 1883, Louis Gonse published his history, *L'Art Japonais,* and that same year a major exhibition of 3,000 items of Japanese art took place at the Georges Petit Gallery. In 1887, Vincent and Theo van Gogh organized a show of Japanese prints at the café Le Tambourin in Montmartre, where many artists of the day were certainly exposed to them. Illustrated articles on Japanese art appeared in S. Bing's journal, *Le Japon Artistique,* and in 1890, the École des Beaux-Arts held its comprehensive Paris exhibition of 1,123 Japanese prints, albums, and illustrated books. These events inevitably affected printmaking, especially coming at a time of general artistic unrest and spreading rebellion against the mannerisms of the academic style. Artists of the time, in their flight from the constraints of "civilization" and "sophistication," ennobled the innocence and the primitive creativity of children, savages, and lunatics. Spurning

63. Mary Cassatt (1845–1926). *Woman Bathing.* 1891. Drypoint, soft-ground etching, and aquatint, fifth state. 14⅝₁₆″ x 10⅝₁₆″. Courtesy Sotheby Parke Bernet Inc., New York.

64. Mary Cassatt. *The Letter.* 1891. Drypoint, soft-ground etching, and aquatint, third state. 13⅝″ x 8¹⁵⁄₁₆″. Mary Cassatt made her first prints in 1879 at the age of thirty-five, two years after fleeing Philadelphia society for Paris. Eleven years later the artist, assisted by the master printer M. Leroy, produced her printmaking masterpiece, 10 aquatints on the everyday events of a woman's life. She wrote: "Sometimes we worked all day (eight hours) both as hard as we could work and only printed eight or ten proofs. . . ." The series was started soon after Cassatt attended the famous exhibition of Japanese woodcuts at the Écoles des Beaux-Arts, which included 89 prints and 16 illustrated books by Utamaro. Working with metal plates rather than with wood, the artist captured the flat, decorative stylization and composition of the Oriental woodcut. Courtesy National Gallery of Art, Washington, D.C., Rosenwald Collection.

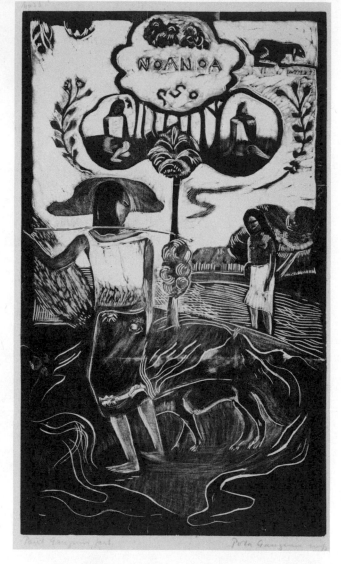

65. **Paul Gauguin** (1848–1903). *Noa Noa* (Oh, Fragrant Earth). 1893–1894. Woodcut. Title page from a suite of 10 woodcuts illustrating Gauguin's prose poem on his Tahitian journey. The themes and figures for *Noa Noa*, executed on a return trip to Europe, derive from paintings done during Gauguin's Tahitian sojourn of 1891–1893. Courtesy National Gallery of Art, Washington, D.C., Rosenwald Collection.

century academic stylization. They recognized the options presented by the wood block and the flatter, more abstract composition of Japanese prints. Breaking with traditional three-dimensional Western modeling of forms, Gauguin (fig. 65) and Munch (fig. 66) ignored realistic, illusionist space in their imagery. They rendered reality suggestively, adapting the broad, flat elementary forms of Oriental art and exploiting the rough grain of the wood itself for pattern. The final print emerged not as a sophisticated subjugation of the wood to an idea but as the end product of a spontaneous confrontation between the material and the artist.

Working with the raw wood of packing cases, Gauguin departed from the conventional chasing style of wood engravers concerned with copying works made originally in other mediums. Rather than using color to "fill in" an outline image, Gauguin conceived his pictures in the Oriental manner as an interplay between volumes and patterns, sharp contrasts of black and white, unbroken areas and textured ones, using the white line to delineate general contours rather than details. He attacked the wood, gouging out whole areas of the block with his carpenter's chisel, to create free forms that printed as broad, painterly swatches of color. This radical, flattened perspective, devoid of naturalistic modeling, is evident in *Noa Noa* (Oh, Fragrant Earth, fig. 65), the series of ten large woodcuts, based on Gauguin's South Seas sojourn, executed between 1893 and 1894. Gauguin recognized the significance of his breakthrough: "My woodcuts, which differ so strongly from everything that is being produced in prints, will prove their value one day." As a result of his experimental attitudes toward the wood block, Gauguin produced many unique impressions. Incorporating accidental cuts and slashes, deliberately blurring colors with out-of-register printing,

structure, they applauded spontaneity; condemning the artificial perfectionism of school-learned technical tricks, they praised the honesty of raw emotion, as expressed in crude styles and unedited outbursts of feeling. Like many of their avant-garde contemporaries, Gauguin and Munch were seeking creative alternatives to stiff nineteenth-

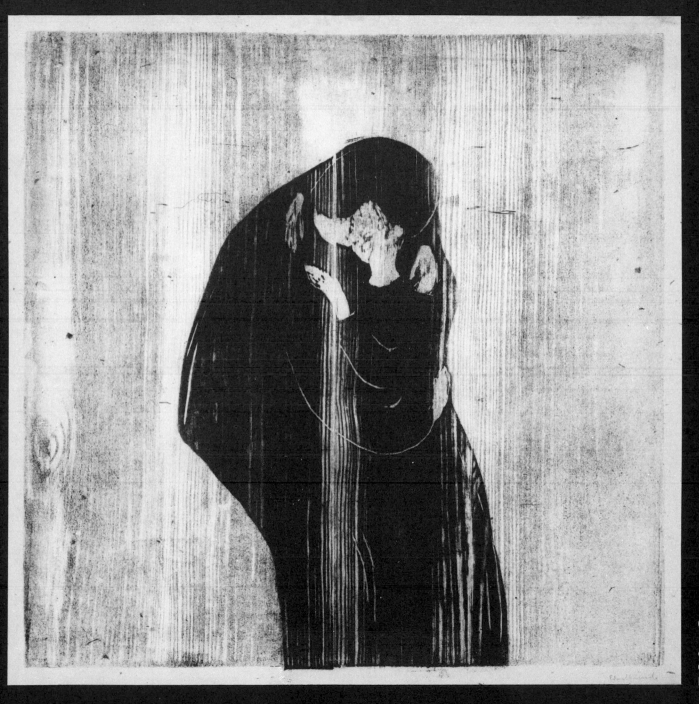

66. **Edvard Munch.** *The Kiss.* 1879. Woodcut. 18¼″ x 18¼″. Courtesy Carus Gallery, New York.

67. **Ernst-Ludwig Kirchner** (1880–1938). Cover of Die Brücke portfolio. 1912. Woodcut. 6″ x 2¾″. Die Brücke (The Bridge) 1905–1913, a group founded by Ernst-Ludwig Kirchner, Fritz Bleyl, Erich Heckel, and Karl Schmidt-Rotluff, four young architectural students at the Technical High School in Dresden, produced some of the most powerful documents in German Expressionist art. Die Brücke placed great value on graphics, considering the multiple original their best means for reaching a large public and spreading the group's antimaterialistic platform: ". . . we desire to rid ourselves of the powerful older establishment. Everybody who is willing to give uninhibited and direct expression to his creative impulses belongs to us." In 1906 Die Brücke issued the first of a series of annual portfolios for dues-paying supporters. Each portfolio contained 3 original graphics. The group's blunt, often deliberately primitive, style led one 1911 reviewer to write of their work: "They are nothing but games played with shouting colors by a group of cannibals" (see Buchheim, *The Graphic Art of German Expressionism,* p. 43). Courtesy Carus Gallery, New York.

overprinting the same image in black on an orange impression, or printing an image on thin Japanese tissue paper and superimposing it on an earlier version of the print, he developed original woodcut concepts with painterly contrasts and moods.

Edvard Munch's approach, like Gauguin's, was experimental rather than traditional, painterly rather than reproductive. Casting aside the verisimilitude of naturalism, he opted instead for the compact, flat patterns of Japanese prints. One is always aware of the participation of the wood in Munch's work. In *The Kiss* (fig. 66), a print that he executed in four different states between 1897 and 1902, the artist telegraphed the loving gesture with a single unified form: fused figures, further bonded together by the clear striations of the wood block. To avoid making a separate block for each hue in a color woodcut, Munch often im-

68. **Ernst-Ludwig Kirchner.** *Dancer.* 1909. Included in Die Brücke portfolio, 1910. Woodcut. 9⅝″ x 13⅜″. Courtesy Carus Gallery, New York.

provised a unique one-step procedure. He cut the various forms for his picture into pieces with a saw, inking some green, others red, etc., as required. He then reassembled the inked pieces of wood into a unit like a jigsaw puzzle and ran them through the press as he would a single block. In this manner, the artist not only produced multicolor images in one step but managed to keep the direction of the wood grain lines uniform, a consistency difficult to maintain when separate blocks are cut for each color.

The German Expressionist artists' association, Die Brücke (figs. 67, 68, pl. 4), placed great emphasis on graphics and produced some of this century's most important prints. The group particularly admired the blunt, direct emotional expressiveness possible with the woodcut. Erich Heckel's powerful *Self-Portrait* (1919; fig. 69) is a tour de force of explosive containment. The large areas of flat color and the self-assured and strong compositional structure sharpen and intensify our consciousness of the nervous, highstrung lines in the face. With a minimum of detail, Heckel sketched a personality at once introspective and agitated.

WOOD ENGRAVING (THE WHITE-LINE TECHNIQUE)

Wood engraving is a variation of the woodcut. Woodcuts are produced on *plank* wood (the *vertical length* of the tree). Working on the plank, the artist must create his design by cutting fairly parallel to the natural graining because extensive crossgrain cutting causes the wood to splinter. Plank wood sets certain limitations on the movement of the artist's tool and therefore on the quality of line achievable in a woodcut. Building tonal effects or subtle and intricate detailing is difficult. The woodcut line quality is therefore generally

69. **Erich Heckel** (1883–1970). *Self-Portrait*. 1919. Woodcut. 19⅜″ x 13″. Courtesy Carus Gallery, New York.

blunt, direct, "primitive." Around 1780, Thomas Bewick, a copperplate engraver, swiveled the wood around and began working on the end grain (the cross section of the wood) (fig. 70). Actually, Bewick was not the first artist to work the end grain of boxwood, but he was the first to substitute engraving tools for the woodcutter's knife. With each cut of the engraver's tool, Bewick made two closely spaced parallel grooves in the wood, producing a black line between them when they were printed. By designing a series of closely modulated parallel white lines, the artist could build up subtle areas of tone and form or delineate special details. The wood engraving is called *white-line engraving* because the printed image

70. **Thomas Bewick** (1753–1828). Wood engraving from *Water Birds.* 1804. Courtesy Sally Pleet.

is formed by the low areas on the block, the uninked grooves that appear as white on the paper. According to one author, William Ivins, the texture of Bewick's blocks was so fine that many were printed on a paper from boxes imported from China because the paper was ribless. By 1840, Bewick's white-line engraving system had become the backbone of a thriving reproduction trade in book illustration. Wood engraving continued as a popular reproductive medium until late in the nineteenth century, when photoengraving and the halftone process replaced it as a means of inexpensive copying. Leonard Baskin is one of the few contemporary artists to explore the creative possibilities of the white-line technique.

THE CHIAROSCURO WOODCUT

The process of printing color woodcuts in light (*chiaro*) and dark (*scuro*) tones of the same color flourished in the sixteenth century. Chiaroscuro prints marked the beginning of color printing in Europe. Essentially a reproductive technique, chiaroscuro was used for interpolating line and wash drawings (such as those of Raphael, Titian, and Parmigianino) into a print medium. Northern artists preferred to outline the basic forms with a black retaining line from a key block, supplementing the outline with tonal values for color. Southern chiaroscuro images were con-

structed by the layering of tone on tone of the same color, so that no one block made sense without the others. The Italian Ugo da Carpi is the artist most often associated with chiaroscuro prints (fig. 71). However, the earliest version of such prints, a depiction of the Emperor Maximilian I, traces to Germany, ten years prior to da Carpi's first dated work of 1518. By the close of the sixteenth century, the popularity of chiaroscuro color prints, and the woodcut in general, bowed to the speedier metal techniques of etching and engraving. The intaglio processes were capable of an accuracy and a detailing difficult to achieve in wood.

71. **Ugo da Carpi** (c. 1450–c. 1525). *Diogenes* (after Parmigianino. 1500s. Chiaroscuro woodcut from four blocks. 19″ x 14⅞″. Courtesy Sotheby Parke Bernet Inc., New York.

RUBBINGS

Anyone can make a rubbing, and almost any relief surface, from an incised gravestone to a Lincoln penny, can be used as the master image. Lay a piece of thin soft paper on the relief surface (for example, the head of Lincoln on a penny); then with a wax crayon or lead pencil, rub the image to transfer it to the paper. Rubbing is not considered an "official" form of printmaking. However, several modern artists have developed the technique inventively, most notably Max Ernst, who renamed the method *frottage* (fig. 72). Ernst's series of surrealist frottage prints, amplified with pencil and collage, demonstrates the richness of imagination possible in the collaboration of object, accident, and artist in the rubbing process.

Taking rubbings from church inscriptions and the designs on early gravestones is an old European tradition that is still in vogue. Long before the European custom, even before the invention of woodcuts, the Chinese were duplicating images by making rubbings from stones on which they engraved replicas of famous paintings. This early multiple form may have been a type of ancient record keeping. Sometime about 175 A.D., the Chinese engraved the *Six Confucian Classics* on a series of stone slabs that they placed at the entrance of the leading academy so that scholars would have easy access to the official texts. When techniques for using lampblack ink to take impressions from incised designs were perfected during the fourth and fifth centuries, the Chinese began striking copies of the academy texts on paper by making rubbings on the slabs so that scholars could take duplicates with them.

THE JAPANESE *UKIYO-E* PRINT

Much of the world's great art has been pro-

72. **Max Ernst** (1891–1976). *The Fugitive,* Plate 30 from *Histoire Naturelle.* 1926. Collotypes after frottage. 10¼″ x 16¾″. Courtesy The Museum of Modern Art, New York; Gift of James Thrall Soby.

duced for the aristocracy or a powerful institution such as the church. An exception to that rule is the flower of Japanese graphic art, the Edo (Tokyo) *Ukiyo-e* woodcut (figs. 73, 74). Between the seventeenth and the nineteenth centuries, Edo prints were designed for the pleasure of the man in the street. Selling for a few yen, the prints held a position tantamount to our popular poster or pinup pictures, and the Japanese valued them on a par with our Sunday comics. Few at the time would have guessed that this Oriental "pop art" would one day provide one of the catalysts to convert traditional Western art to twentieth-century modernism.

The term *ukiyo-e* derives from an early Buddhist concept: *urei-yo* ("world of grief"). The devout Buddhist believed that our stay on earth was an unhappy stopover on the way to salvation. In this context, *urei-yo* referred to everyday existence, the transitory world. In time, the deeper religious connotation faded and the worldly, here-and-now meaning remained. The

73. **Torii Kiyotada** (active 1723–1750). *Actor Dancing*. Hand-colored Tan-e woodcut. 11¼″ x 6″. This is a portrayal of the actor Ichikawa Danjuro II dancing. The costume features four Danjuro crests (stacked boxes), and the print is remarkably cubistic. The artist's name and publisher's seal appear at the right. Courtesy The Metropolitan Museum of Art; Harris Brisbane Dick Fund, 1949.

actors, prostitutes, genre subjects. In the seventeenth century, the popular Kabuki theatre form emerged, catering to the tastes of Edo's growing cities and affluent middle class, and the new *ukiyo-e* prints appeared at the same time to satisfy the common man's desire for art.

The golden age of Japanese graphic art began about 1603 and lasted until the nineteenth century. By the time the power of these woodcut images was recognized in the West, the art form was already declining in Japan. Stories vary concerning how *ukiyo-e* prints reached Western collectors. The most colorful one reports that the prints first reached Europe in the form of wrapping material for the fine porcelains shipped from the Orient, a not unlikely prospect since the woodcuts were in fact used as stuffing paper in such shipments. But even in the early 1800s, Dutch sea captains had begun to form collections of *ukiyo-e,* and the prints were popular in Paris by the 1870s. Van Gogh had a collection of Japanese woodcuts and painted a portrait of his dealer posed against a background wall covered with them. Van Gogh prized the woodcuts so highly that he would swap a canvas in order to obtain a special *ukiyo-e* for his collection.

To the nineteenth-century impressionists, the large, flat color configurations and simplified forms of the *ukiyo-e* print insinuated poetically what Western art expressed literally. This penchant for "leaving something to the imagination" left a profound impression on Van Gogh, Gauguin, Toulouse-Lautrec, Cassatt, and the avant-garde circle of their day. Carl Zigrosser captures the essence of Oriental interpretative realism with a quote: "The Japanese will draw a woman as if she were a lily, a man as if he were a tempest, a tree as if it were a writhing snake." The power of *ukiyo-e* to use suggestive symbols and shapes without any attempt at literal realism provided an important conceptual bridge to modern two-

form *ukiyo-e* contains three characters: *uki,* meaning "floating" or "transitory"; *yo,* meaning "world"; and *e,* which stands for "pictures." Hence, "pictures of the transitory world."

The *ukiyo-e* artist was the illustrator of his day, recording the transitory world, manners, and preoccupations of the merchant class: entertainment districts, fashions, pretty girls (fig. 62),

dimensional abstraction and bold color. For hundreds of years, the bulk of Western prints were reproductive, copies of ideas made in other mediums such as painting, watercolor, or drawing. A great strength of the *ukiyo-e* woodcut rested in the fact that it was originated in graphic terms and was never a reproduction of anything else. The Japanese artist's concepts were rooted in the potential of the wood block itself and found final expression from a trio of skills specifically trained in the subtleties of relief printing. The artist never cut his own blocks but worked as part of a skilled team that included master engraver (cutter) and a master printer.

The history of many Japanese *ukiyo-e* masters is obscure or nonexistent because of a peculiar Japanese custom by which the artist adopts several names over his lifetime. In his long career, the artist Hokusai (fig. 74) made over thirty thousand prints using thirty-one different pseudonyms. If legend is correct, Hokusai may also have been responsible for one of the first Happenings in art. The shogun, stopping at the Asakusa Temple, requested that Hokusai and another "people's" artist create works on the spot for his entertainment. When the presentation time arrived, Hokusai entered with a basket and, spreading a long roll of paper on the floor, he ran several blue lines along it with a brush. Then he produced a chicken from the basket. No one knew quite what to expect. Hokusai proceeded to paint the chicken's feet with vermilion ink and then turned it loose on the paper to blaze a trail of brilliant footprints. Hokusai bowed to the shogun and announced the title of his piece: *Autumn maple leaves drifting on the Tatsuta River.*

KEY PHASES IN THE DEVELOPMENT
OF UKIYO-E PRINTS:

1. SUMI-E (LAMPBLACK PRINTS). The first

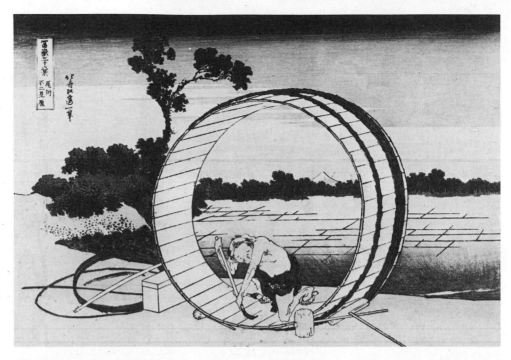

74. **Hokusai** (1760–1849). *Fujimi-ga-hara in the Province of Owari* from *Thirty-six Views of Mount Fuji.* c. 1832. Woodcut. 10″ x 14¾″. *Thirty-six Views of Mount Fuji,* considered Hokusai's masterpiece, depicts Mount Fuji from many viewpoints, sometimes close up, sometimes barely perceptible in the landscape as in this example. One author wrote that Hokusai had "an eye so sharp, and a technique so fine that he could draw two sparrows on a grain of rice." In a number of woodcuts in the set Hokusai broke with the convention of showing Fuji mantled in white by depicting the mountain as blue, black, or red, as he experienced it. Expressing his personalized "inner" reality, Hokusai anticipated an approach that would not fully develop in the West until twentieth-century Expressionism. Courtesy The Art Institute of Chicago, Clarence Buckingham Collection.

ukiyo-e prints, like the early European woodcut, were executed in black and white. A lampblack (*sumi*) was used and sometimes supplemented with color applied by hand.

2. URUSHI-E (LACQUERED PRINTS). Around 1715–1730, small quantities of lacquer or glue were mixed with the *sumi* to achieve a lustrous black. Powdered gold dust or cheap brass filings were often sprinkled over areas of the design for dramatic effects.

The technique of *gauffrage* (embossing) was introduced during this period. Thick Japanese paper, dampened and forced into the cutaway,

uninked areas of a wood block, resulted in an ink-less (white) embossed effect.

3. BENIZURI-E (FIRST COLOR PRINTS). *Beni* is a transparent red color extracted from the saf-flower. Thus red and green predominate in the *benizuri-e* woodcuts. The period began around 1741 and marks the first prints in which color was not applied by hand but by a separate block cut for each color.

4. NISHIKI-E (FIRST FULL-COLOR PRINTS). *Nishiki-e* literally means "brocade." The many rich colors of these multihued prints earned them the name: "brocade pictures." *Nishiki-e* appeared on the scene around 1764. By the nineteenth century, as many as thirty separate color blocks might be employed in a *ukiyo-e* woodcut.

THE LINOLEUM CUT (LINOCUT)

Admitting that the linoleum cut "may have certain economical and educational uses," one art critic commented, "I do not feel it possesses suf-ficient quality of its own to render it more than a weak substitute for the woodcut." He reached his conclusions before 1958, the year in which Picasso turned his fertile imagination loose on the simple, inexpensive, and surprisingly versatile medium.

Linoleum was first manufactured in 1860 from burlap covered with powdered cork, linseed oil, and resin. It is easy to cut and print in the same manner as a woodcut; namely, the design remains in relief after the artist cuts away areas he does not wish to print. Unlike wood, however, linoleum lacks a natural grain. Some artists con-sider this an asset, since the smooth, ungrained surface texture offers no resistance to their tools and allows them to cut freely in any direction. Others exploit the anonymity of the soft surface by placing objects on it (for example, a thin wire twisted into a design) and running it through a press. The form imprints into the soft linoleum and the artist can then elaborate his idea further with deliberate cutting.

Henri Matisse produced linocuts early in the century (fig. 75), but until Picasso, the linocut was stereotyped as the "amateur's print": the easy-does-it medium for grade-schoolers and hobbyists in search of homemade Christmas cards and busy-time amusements. Matisse approached the linocut primarily as a black-and-white me-dium, perhaps as little more than a process for producing his drawings in multiple. Picasso, on the other hand, attacked the linoleum block as an unexplored graphic frontier, revolutionizing the

75. **Henri Matisse** (1869–1954). *Head of a Woman.* c. 1938. Linocut. 11″ x 7⅝″. Courtesy Reiss-Cohen Gallery, New York.

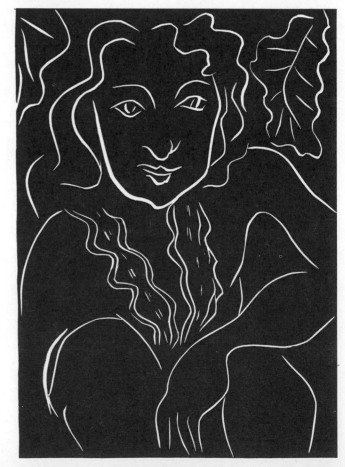

procedure, and forever putting to rest the myth that linocuts were "child's play."

Between 1958 and 1963, Picasso made over one hundred different linoleum-cut images, each in an edition of fifty, for a total of five thousand prints. To avoid the delays involved in shipping etching plates back and forth from his Paris printer, Picasso decided to try his hand at linocuts since the blocks were available in nearby Vallauris. The series began with his *Bust of a Woman After Cranach the Younger* (fig. 76). In his rendition of the painting by the sixteenth-century master, Picasso followed a traditional and tedious printing process involving a separate linoleum block for each color in the final print. This required six separate blocks. Each had to be cut, inked, trial-proofed, and run. Each color had to be registered exactly with the color printed on the sheet from an earlier block. Such arduous, slow, step-by-step procedures probably disturbed Picasso, who was known to take a print through as many as thirty states and demand overnight correction proofs from his printers. Working with separate blocks for each color has its creative drawbacks as well: the picture develops piece-meal, interrupting the normal holistic process of evolving an image. Perhaps irritated by the slow production of *Cranach,* Picasso invented a short-cut by which he could print a multicolor impression from a single linoleum block.

Traditionally, colors were built up block by block. Since a separate block exists for each color, the artist always has the option of making corrections in his design or changing colors all along the way. He is free to pull proofs at every stage of the printing and to take a final proof of all the colors in position before risking the printing of his entire edition. In Picasso's new *reduction method,* a portion of the block was destroyed (cut away) with each successive color printed. It is sometimes referred to as the *destruction method* because each

76. **Pablo Picasso** (1881–1973). *Bust of a Woman After Cranach the Younger.* 1958. Linocut. 25½″ x 21″. Courtesy Reiss-Cohen Gallery, New York.

step in Picasso's shortcut is an irrevocable one. The artist may begin with a sketch guide of his completed image. If he wants overall background color in the print, he would begin by rolling that color of ink over the *uncut* linoleum block. For an edition of fifty impressions, he inks the block fifty successive times with the background color, covers it fifty times with paper, and pulls fifty impres-

sions of the sheet with tone. The block is then wiped clean of ink and the first detail of the image is cut into it. The moment the next phase of cutting begins, the flat tonal block is destroyed and cannot be used to pull another sheet of background color. The second color is rolled onto the block when the design element has been cut, and again, all fifty impressions of this detail are inked and pulled. The block is cleaned, the next detail cut into it, inked, and printed. As the image on the paper grows, the block surface diminishes. There is no turning back once the color stage is passed. The artist commits to the size of his edition at the outset. This technique requires incredible confidence. All the linocuts produced by Picasso, with the exception of the first one, were executed by the reduction process, including his formidable and painterly edition of *Bust of a Woman with Hat* (pl. 5).

ETCHED LINOLEUM

The process is similar to metal intaglio etching. In this method, the artist does not make the line by cutting away the linoleum with a knife but by "biting" the lines into the surface with acid. The surface is first coated with an acid-resisting material (for example, warm paraffin wax). The artist draws his image into this wax with a sharp tool, exposing the linoleum wherever he draws. The surface is treated with a solution (for example, caustic soda), which eats into the exposed linoleum and incises the design lines below the surface. Depending on what portion of the block carries the image, the block can then be printed as a relief by an inking of the raised section or as an intaglio by an inking of the incised portion.

QUESTIONS PEOPLE ASK

1. *Can a wood block be corrected or changed once it has been cut?*

It is difficult but possible. It means resurfacing an entire area, planing down the area, and sandpapering and steel-wooling it, or drilling out an entire section and plugging it with new wood.

2. *How many impressions can the average wood block yield?*

This depends on several factors: (a) the hardness of the wood and how free it is from warping; (b) whether the image is composed of broad lines or delicate, intricate, and easily worn-down lines; and (c) the printer's skill.

3. *What do the seals and calligraphic notations on* ukiyo-e *woodcuts signify?*

The artist's name, the publisher, and sometimes the collector's seal or governmental marking indicating permission to print.

4. *What kinds of ink are used for the printing of a woodcut?*

Japanese *ukiyo-e* artists used watercolor inks for printing woodcuts. Many artists prefer oil-bound inks because they go on thicker and have more body.

5. *Is a collagraph the same as a collotype?*

No. Collotype is a mechanical printing process for reproduction that was used in the nineteenth century.

An enthusiastic guest at a party given by a New York collector reeled off compliment after compliment as the hostess guided her down a long corridor lined with graphics by Paul Klee, Picasso, Joan Miró (pl. 9), Willi Baumeister (fig. 78), Alexander Calder, and the like. The hostess's smile suddenly darkened when her guest innocently blurted, "What a marvelous collection of lithographs!"—revealing a basic lack of knowledge about prints. Of the twelve graphic works displayed, four were etchings, two woodcuts, two drypoints, and only four were lithographs. One frequently hears prints called lithographs as though the two terms were synonymous. They are not. Forms of printmaking (fig. 61) existed long before lithography, a technique for making prints that was invented only at the close of the eighteenth century—and then, almost by accident.

A product of *surface-method* printing, lithography is sometimes referred to as the *planographic process*. Although the artist treats the surface of the printing stone with chemicals, he does not cut into it, as he does the wood block in a woodcut, or incise the surface, as occurs in etching or engraving. The master image is drawn on, and pulled

77. Still life of lithography tools.

4

senefelder's
accident:
the
surface
process

78. **Willi Baumeister** (1889–1955). *Apoll II.* 1921. Lithograph. 15⅞″ x 10¼″. Courtesy Carus Gallery, New York.

directly from, the *flat* stone surface, hence *surface method* (figs. 79, 80).

Lithography is the only printmaking process for which we have a detailed record of discovery, written by the inventor himself. Thanks to this fascinating document, we know more about how the lithograph came onto the scene in the late 1790s than we do about the more recent emergence of silk-screen printing as a fine-art medium in the 1920s.

Lithography was one of those propitious accidents that occur at just the right juncture in history. As photography increasingly assumed the functions of reproductive prints in the nineteenth century, the dominance of copyist craftsmen in printmaking waned, thus clearing the way for a new kind of graphic expression. Lithography was waiting in the wings to fill the creative vacuum. The simple process of drawing directly on a stone enticed some of the most gifted artists of the century into trying their hand at a multiple medium—an infusion of talent that forever altered the nature of prints and printmaking (figs. 86, 92).

Lithography was invented by Aloys Senefelder (fig. 81), an enterprising but indigent Bavarian playwright. Senefelder reasoned that if he could get enough of his plays into circulation, they might catch on. Hoping to devise a cheap method for reproducing his work in quantity, Senefelder experimented with new ink combinations and home-grown printing techniques. He trained himself to write backward on various printing surfaces (so that the words would read forward when transferred to paper in the printing process). After cutting words in reverse on copper plates covered with a thick wax, he would ink them, place paper over the plate, and rub. The arduous system produced, at best, a crude printed sheet. At this point, chance interceded in

Drawing on the stone with grease crayon and tusche:
With a masterful economy of line Käthe Kollwitz exploits the grainy surface of the lithographic stone with her crayon, using the white of the paper itself to create body volumes in this moving study. Robert Motherwell's exuberant painterly effect is achieved by brushing and splattering liquid tusche onto the stone. Many variations are possible in lithography through the use of hard and soft crayons, rubbing the inked surface, brush, spatterwork, scratching with needles or sandpaper, taking impressions of objects, and special washes with benzine or turpentine.

79. **Käthe Kollwitz** (1867–1945). *Pensive Woman*. 1920. Lithograph. 21½″ x 14¾″. Courtesy Carus Gallery, New York.

80. **Robert Motherwell (**1915–). *Automatism B*. 1965–1966. Lithograph. 30¹/₁₆″ x 20¾″. Courtesy Brooke Alexander, Inc., New York.

81. Aloys Senefelder
(1771–1834). A hastily
scribbled laundry list
led Aloys Senefelder
to the invention of
lithography between
1796 and 1798. To pro-
tect his "chemical
process" against the
claims of usurpers, he
recorded his discov-
ery in a detailed ac-
counting, giving the
world its first, and
thus far only com-
plete, history of the
origin of a major print
technique. The first
lithograph made by
the "chemical proc-
ess" was not art, but
sheet music: *A Sym-
phony for Four Voices
with Accompaniment
of Different Instru-
ments.*

82. Benjamin West
(1738–1820). *He is not
here, for He is risen,*
Plate 12 from *Speci-
mens of Polyautog-
raphy.* 1807. Litho-
graph. 12⅞″ x 18⅞″.
Courtesy The Metro-
politan Museum of
Art, New York; Harris
Brisbane Dick Fund,
1931.

He is not here: for he is risen. &c.

the shape of a slab of Keilheimer stone (fig. 77),
which Senefelder had purchased to use in grind-
ing colors for his experimental inks. The porous,
toothy surface of Bavarian Keilheimer limestone
is believed to be the only stone in the world with
the particular properties required for lithography.

In 1796, Senefelder pulled the world's first
lithograph from a stone. He reports in *The In-
vention of Lithography* that his mother inter-
rupted his "backward" writing sessions one day
to say that the laundry was being called for:

> *My mother asked me to write a laundry list for her.
> The laundress was waiting, but we could find no
> paper. My own supply had been used up by pulling
> proofs. Even the writing ink was dried up. . . !
> I wrote the list hastily on the clean stone, with my
> prepared stone ink of wax soap, and lampblack,
> intending to copy it as soon as paper was supplied.*

When he was about to wash the stone clean after
copying the list over, Senefelder records:

> *The idea all at once struck me to try what would
> be the effect of such writing made thus with my
> prepared ink, if the stone were now etched with
> aqua fortis. I thought that possibly the letters
> would be left in relief and admit of being inked and
> printed like book-types or woodcuts.*

Further experiments led Senefelder, in 1798,
to the basic "chemical process" still used in mod-
ern lithography. He might never have pursued
printing from the stone beyond his initial insight
of 1796 (which was merely an adaptation of
known metal and wood techniques) had financial
difficulties not intervened: "if my circumstances
had improved, I should have returned to copper
plates." With chemical-process lithography Sene-
felder found the inexpensive technique he had
seen searching for and, with it, wrote a page of
history destined to outlive all of his plays.

The term *lithography* comes from the Greek words *lithos,* meaning "stone" and *graphein,* meaning "to draw," hence, to "draw on stone." For the first time in printmaking, any artist so inclined could make a multiple image. Senefelder's discovery liberated printmaking from the technical bottlenecks that had long deterred first-rate artists from becoming involved with the older graphic processes. The lithograph is essentially a drawing, and any artist who could draw on the stone with crayon, brush, or pen could make one. Gone was the need to master the mechanics of a technical craft; gone the difficulties of wringing a spontaneous line from resistant metals or stubborn wood, or worse, the dependence on hack copyists to translate one's images to the plate or wood block.

One of the first artists of lasting reputation to exploit Senefelder's discovery was the American Benjamin West, in 1801 (fig. 82). Théodore Géricault, before he died at the age of thirty-three, made eighty lithographs, among them his well-known *The Boxers* (1818; fig. 83). Where West's pen-and-tusche-drawn lithograph shows an affinity for the fine line and cross-hatching style associated with the older techniques of etching and engraving, the figures in Géricault's *Boxers* are modeled and shaded in a manner that more clearly reflects the lithograph's potential for achieving the graduated tonal effects of drawing. In 1916, George Bellows would compress fighters and referee into a single abstract structure of struggle (fig. 84). The shirtsleeves of the spectators in the

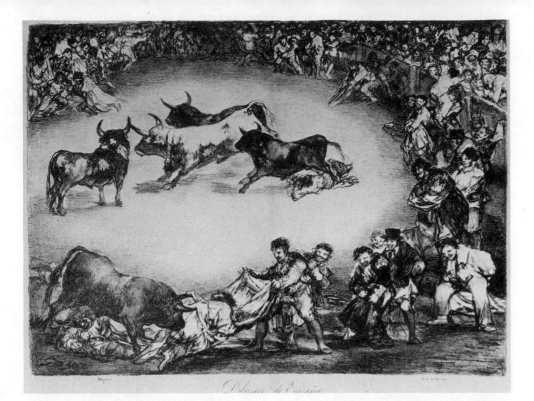

dark: exposing an essential expression, movement, or form by abstracting it from the background in a beam of light, not unlike an object discovered in a dark room with a flashlight. In *The Giant* (fig. 86), Goya covered the entire plate with aquatint and then daringly coaxed the figure out of the background darkness by scraping light areas away so that the image appears to be barely emerging (an aphorism for man emerging out of the darkness of his primitive past?). Had Goya scraped away too much, the entire impact (not to mention the plate) would have been lost. Approaching lithography, Goya brought with him the same sensitivity to tonal nuance. "He propped

foreground at ringside are highlighted and lead the eye like directional arrows toward the center of action. In spite of scattered early efforts, the creative capacities of lithography remained relatively dormant for almost a quarter of a century after its discovery. For the elite, many of whom were schooled in drawing as a matter of course, lithography became a dinner-party diversion with the hostess providing the stones for her guests to dash off mementos of their visit.

It was the aging genius Francisco Goya who finally pried open the creative door, exposing the enormous expressive potential in lithography. In 1824, the seventy-nine-year-old Spaniard, living in exile in Bordeaux, produced a series of four large lithographs on bull fighting (fig. 85). They are considered the world's first great works on the stone. Goya's earlier mastery of etching and aquatint techniques (fig. 86) taught him the power of dramatic tonal contrasts in light and

his stone on an easel like a canvas, grayed all over, then crayoned the darks and scraped out the lights," writes Hyatt Mayor. "Half blind, he used a magnifying glass but really relied, like a pianist, on the experience stored in his muscles."[11] Perhaps the artist instinctively emulated a natural process of perception: to focus clearly on any action, we must first isolate it from the blur of competing stimuli.

A fresh creative energy flowed from Goya's lithographs—vibrant, spontaneous drawing, painterly composition, and a rich sense of "color," although the images are in black and white. It seems as though he had reinvented the print, which for over a century had been languishing in the shadows of art, encumbered by mediocrity and the rote, constipated visualizations of hack engravers. Lithography remains a favorite technique for the painterly printmaker (fig. 92).

The process that Senefelder invented and Goya shaped into a painter's vernacular, Honoré Daumier and Toulouse-Lautrec would elevate to major expressive mediums in French art. So much so, that even today there is a tendency to associate nineteenth- and early twentieth-century lithography exclusively with French artists.

Honoré Daumier was only twenty years old when Goya died, yet he was already an "old hand" at lithography, having drawn lithographs since the age of eleven to supplement his family's meager income. The dire circumstances of his life literally chained Daumier to the stone. He had hoped to be remembered for his paintings, but instead history would record him as one of the greatest lithographers of his century. Daumier made four thousand lithographs over his lifetime, some running to editions of thirty-five hundred. Most of Daumier's lithographs were executed in his capacity as an artist–journalist for *La Carica-*

ture and later, *Charivari*, two liberal Parisian newspapers published by Charles Philipon. Philipon opposed the hypocrisy of the new bourgeoisie and the reactionary policies of the Bourbon king, Louis-Philippe, utilizing his presses to attack the "Citizen King" and his followers, a practice that brought Philipon (fig. 224) and Daumier (fig. 88) into conflict with the law.

Daumier stripped the human comedy down to its common denominators. His cynical, uncanny eye caught life with its pants down, exposing the follies and the vulnerabilities of deputies, lawyers, merchants, and lovers with equal bite (fig. 89). "He did with impunity things that had they been done in oil paint would have been shocking and inexcusable. The world laughed with him, the academic artists shuddered at the thought of him, and the intelligent saved and preserved his prints."

Daumier's lithographs convey an awareness of contour and movement that one might expect from a sculptor's hand, and indeed, for his first

87. **Paul Wunderlich** (1927–). *Tapir*. 1966. Lithograph. 19½" x 25⅜". Courtesy Sotheby Parke Bernet Inc., New York.

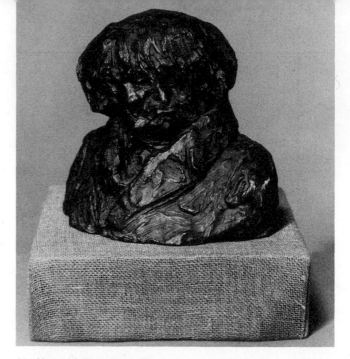

90. **Honoré Daumier.** *Docteur* (*Clément François Victor Gabriel*) *Prunelle.* 1830–1833. Bronze. H. 5″. Courtesy Smith College Museum of Art; Gift of Mr. and Mrs. Richard Harrison.

88. **Honoré Daumier** (1808–1879). *Rue Transnonain, April 15, 1834.* Lithograph. 11¼″ x 17¾″. This lithograph appeared in the newspaper *La Caricature* and caused such an uproar that the police seized the stone and destroyed all unsold impressions. The scene records the death of a family that was ruthlessly, and as it turned out, mistakenly, shot by one of King Louis-Philippe's riot squads. Daumier allows the horror of the situation to speak for itself. Courtesy National Gallery of Art, Washington, D.C., Rosenwald Collection.

89. **Honoré Daumier.** *L'Ane et les Deux Voleurs.* 1862. Lithograph. 9″ x 8″. Courtesy Sotheby Parke Bernet Inc., New York.

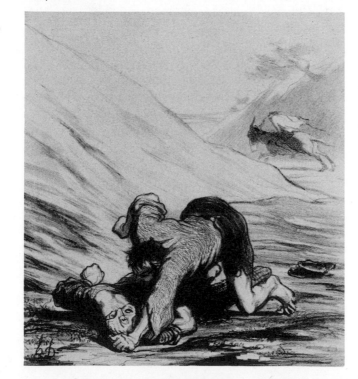

series of political portraits in *La Caricature,* he had "sketched" the subjects in clay prior to drawing them on the stone (fig. 90). Cartoonists were forbidden to draw in the Senate. Studying the deputies from the visitors' gallery, Daumier later jotted down his memories in small heads modeled from clay. The famous "deputy series" was then executed from these clay stand-ins in 1834 (fig. 91). It is difficult enough to distill personality in a few drawing lines, but to accomplish it from memory is truly an incredible achievement. Unfortunately, few of the model heads remain since the clay was reworked continually. As Daumier's eyesight failed and cruder printing processes were adapted by the newspaper, the formal modeling and shading of the figures in *Rue Transnonain* gave way to a simplified broad, bold line drawing that reveals more nakedly his flair for theatrical dramatization and the contour-conscious sculp-

64

tor's eye. For forty-five years, Paris viewed itself through the sharp magnifying glass of Daumier's stinging political and social satires. For his penetrating insight and masterful drawings Daumier received 50 francs ($10) a stone (later reduced to 40 francs), a sum that barely kept him alive from week to week.

Toulouse-Lautrec turned to lithography in 1892, when he was twenty-six years old. In the ten remaining years of his brief and tragic life, he produced 362 lithographs, including 30 exuberantly colored café and music-hall posters that al-

91. **Honoré Daumier.** *Mr. Prune.* 1833. Lithograph. 10¼″ x 7⁵/₁₆″. Courtesy Museum of Fine Arts, Boston; Bequest of William P. Babcock.

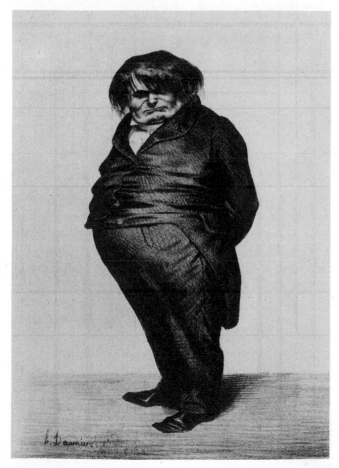

tered the landscape of Paris and jolted Europe's 1890s academic art world into a new realm of seeing. Lautrec's personal story is legend. Stunted as the result of a childhood accident, an outcast in the aristocratic world of "beautiful people" into which he was born, Count Henri Marie Raymond de Toulouse-Lautrec Monfa prowled the street cafés and music halls of Montmartre, a stray in a strange night world of prostitutes and performers. They became the heroes and heroines of the first great color works in lithography, immortalized by Toulouse-Lautrec in a cogent line, a compelling black silhouette, a telegraphic gesture (fig. 92). Like the hit tune played too often, Toulouse-Lautrec's exuberant style has lost some of its novelty. Familiarity blocks us from imagining the stunning impact these boisterously colored, flamboyant lithographs must have had on Paris in the 1890s, especially to a public weaned on the well-mannered art and follicle-to-fingernail detailing of nineteenth-century academic realism. Toulouse-Lautrec's penchant for visual abbreviation may stem from the fact that many of his prints were posters; advertisements designed to sell at a glance, enticing the casual passerby or coach rider into spending an evening's diversion at the Moulin Rouge or Le Divan Japonais (The Japanese Settee). The classic poster of the latter (fig. 93) shows Jane Avril and the music critic Édouard Dujardin at the bar listening to a headless songster, Yvette Guilbert. Avril's compelling black silhouette is topped by a hat and hair motif reminiscent of the elaborate coiffures of geishas in Japanese woodcuts. Toulouse-Lautrec, like his Impressionist friends, was captivated by the Japanese woodcuts circulating through Europe at the time. Like the *ukiyo-e* prints (discussed in chap. 3), his lithographs rely on an indication of reality rather than an explicit imitation of it. Figures spring to life in succinct sketch lines and un-

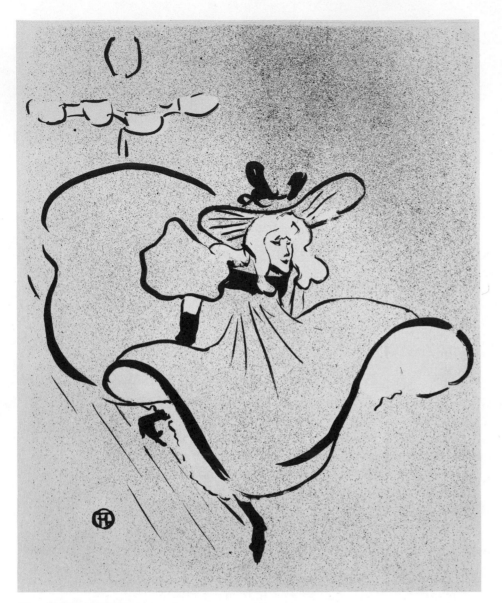

Although French artists dominated the infancy of lithography, innovation did not stop at the French border. What fascinated the Norwegian artist Edvard Munch was the inner world of emotion. In penetrating psychological lithographs, such as *The Cry* (1893; fig. 225) and *Jealousy* (1896; fig. 36), the artist exaggerated and distorted in order to intensify our experience of the emotional content. Munch's work deeply influ-

93. Henri de Toulouse-Lautrec. *Le Divan Japonais.* 1892. Lithograph poster. 31⅛" x 24". Courtesy. Sotheby Parke Bernet Inc., New York.

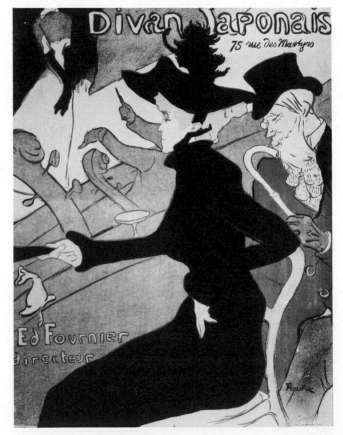

92. Henri de Toulouse-Lautrec (1864–1901). *Jane Avril.* 1893. Lithograph. 22" x 14⅞". Courtesy National Gallery of Art, Washington, D.C., Rosenwald Collection.

modeled, *flat* color forms, a design element that foreshadowed the flat, two-dimensional direction pursued by modern painting in the twentieth century. With waitresses dressed in kimonos and walls covered in cheap Oriental silks and fans, *Le Divan Japonais* provided an ideal, if ersatz, environment for Toulouse-Lautrec's talents. Around 1892, the artist began signing his lithographs with

enced a group of radical young Dresden artists calling themselves Die Brücke (The Bridge). This expressionist group, founded in 1905 and disbanded in 1913, recognized in Munch's psychological approach an alternative to stilted academic realism and an opportunity to evolve an art corresponding more honestly with man's innermost primitive drives. German Expressionist prints have been variously described as "ugly," "crude," "wild," "deformed," even "savage." In fact, theirs was an art of outrage. Rebelling against a social system that measured men in terms of wealth, power, and material possessions, the Brücke emphasized instead the other side of the coin, emotion in its rawest state, expressed in a calculatedly unsophisticated, primitive, and disturbing style that gave no quarter to bourgeois expectations of drawing-room "prettiness." "Some of the best and most significant works of the twentieth century," writes Lothar Buchheim, "will be found among the outpourings of etchings, lithographs, and woodcuts of the German Expressionists" (pl. 4).[12] Ernst-Ludwig Kirchner's lithograph of a green-faced *Woman Wearing a Hat with Feathers* (1910; pl. 6) is remarkable for the time, not only in its spontaneous and nonliteral expressionistic drawing technique, but in the artist's equally daring choice and expressionist use of colors.

In 1906, Emil Nolde (originally Emil Hansen, until he adopted the name of his birthplace, Nolde, in 1901) joined the Brücke group. Stripping natural forms down to their simplest components, Nolde applied color spontaneously, in large, consolidated areas that captured the emotional core of a gesture or a personality with a minimum of artifice, as in his lithograph *The Actress* (1913; fig. 94).

Another expressionist group, Der Blaue Reiter (The Blue Rider) (fig. 189), based in Munich between about 1910 and 1913, also sought greater artistic freedom and a social order in

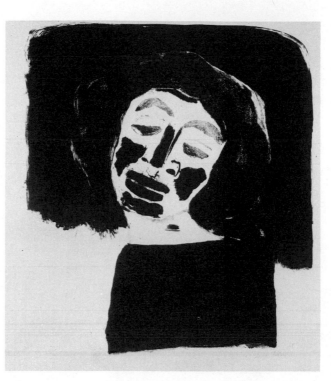

94. **Emil Nolde** (1867–1956). *The Actress.* 1913. Lithograph. 21⅝" x 18⅞". Courtesy Carus Gallery, New York.

which human values superseded material ones. In its attempt to discover universal truths, the group focused its art on the realities of man's inner world, moving even further from a traditional representation of nature than the Brücke group and ultimately opening the way to the development of nonrepresentational and abstract imagery (fig. 95).

Although prints have always been produced in America (figs. 96, 97), printmaking in general did not play as decisive a role in American art as it had in Europe, where professional graphic workshops and collaboration between master printers and artists were old traditions. As late as 1962, the painter Robert Rauschenberg, known today as one of America's most innovative printmakers, made his classic comment: "I began lithography reluctantly, thinking that the second half of the twentieth century was not a time to start writing on stones!"[13] Two determined personalities thought otherwise, and it is largely

95. **Wassily Kandinsky** (1866–1944). *Abstract Composition.* 1925. Lithograph. 13″ x 8¼″. Courtesy Carus Gallery, New York.

because of their perseverance and vision that lithography became a fulcrum of creative print innovation in the United States.

In 1957, Tatyana Grosman opened "shop" with a single lithographic press in her garage and a strong enough conviction to sell a number of important New York painters on the idea of trying their hand at the stone. Rauschenberg's comment, mentioned above, typifies the wall of prejudice that Ms. Grosman faced in getting her Universal Limited Art Editions under way. The roster of painters she eventually enticed into making lithographs with her offer of a free stone and a good cup of coffee reads like an exhibition catalogue for The Museum of Modern Art: Jasper Johns, Robert Rauschenberg, Marisol, Larry Rivers, James Rosenquist, Helen Frankenthaler, Fritz Glarner, Barnett Newman, and many others.

Three years later and two thousand miles away in California, artist June Wayne opened Tamarind Lithography Workshop under the auspices of the Ford Foundation for the purpose of

96. **Fanny Palmer** (1812–1896). *Evening* from *American Winter Scenes.* 1854. Currier & Ives lithograph. 16″ x 24″. One author refers to the ink used to print the famous nineteenth-century Currier & Ives prints, as a "witches' brew." The concoction included white wax, goose grease, beef suet, castile soap, shellac, and gas black. Currier & Ives produced over 7,000 subjects, sending artists across the nation to record events of the day. Lithographers at the home office would then transfer their drawings onto stone. These prints are valued largely for the historical record they offer of the developing nation. Fanny Palmer was the leading woman lithographer of her day and one of the few Currier & Ives' artists to execute many of her own designs on the stone. Courtesy Sotheby Parke Bernet Inc., New York.

training professional master printers and exposing the American artist and public to the medium. Many of the lithography workshops fanned out across the country today stem from Tamarind or master printers trained there.

Innovation marks contemporary American lithography much as it does contemporary life: new presses, new adaptations of industrial technology, new painting-sized prints (pl. 7), and a new peculiarly twentieth-century graphic vernacular was born from the American involvement that began to make itself felt in the late 1950s. What brought on this burst of experimentation? Why had printmaking in America remained a wallflower in the art world years after it had become a serious creative medium for Europeans? Gabor Peterdi, an outstanding print innovator (fig. 98), identified part of the reason: "Minor media do not exist, only minor artists."[14] Only when major contemporary American artists were introduced to the stone via the new workshops of Grosman and Wayne did lithography fuse with the most inventive creative energies in the land. The infusion of new blood freed printmaking from the stranglehold of competent but mundane craftsmen whose obsession with the technical aspects of printmaking had kept prints out of major-league art for years. This shift in emphasis occurred at a time when the American artist in general was at the zenith of his international influence, and an affluent, increasingly art-hungry American public could support a multiple-print market. Chapter 7 discusses some of the unusual avenues taken by contemporary printmakers. Far from being silenced, the lively dialogue with the stone begun in 1796 by an indigent Bavarian playwright continues to engage artists and collectors with fresh impact.

It is possible to read about all the technical steps involved in making a lithograph without

ever quite understanding what makes the process actually work. Much of what occurs happens *invisibly,* through chemical changes *in* the printing surface rather than changes that one can see (such as when wood is cut away in a wood block or a line is etched in a copper plate). There is one

97. **Louis Lozowick** (1892–1973). *New York*. 1923. Lithograph. 11⅝″ x 9″. Courtesy Carus Gallery, New York.

98. **Gabor Peterdi** (1915–). *The Sign of the Lobster.* 1947–1948. Engraving, soft-ground etching, and aquatint. 26″ x 20⅛″. Courtesy The Museum of Modern Art, New York; Abby Aldrich Rockefeller Fund.

especially dramatic moment in the making of a lithograph when the design appears to be completely wiped away. It almost vanishes. Or so it seems to the uninitiated observer, who is likely to cry out, "What's happening to the picture?," fearing that he is witnessing hours of an artist's work going down the drain. This vanishing act is merely one step in the preparation of the stone's surface to accept printing ink. Actually, the image originally drawn with a grease crayon, pencil, or tusche (made of fats, waxes, or animal or vegetable oils) is still in the stone. What, then, has faded? Mainly a black pigment (lampblack) added to the tusche, crayon, or pencil that allows an artist to follow what he is drawing on the stone. The grease remains in the stone but becomes *colorless* after the application of turpentine, and

we can no longer see the design it forms. You can see where this vanishing act occurs in Step 3 under "Basic Steps in the Making of a Lithograph" (figs. 102a, 102b).

Two other "invisible" factors that make a lithograph possible are:

1. *Lithography is based on the basic chemistry that grease and water won't mix.*

2. *This chemistry works because of the unusual nature of the stone,*[15] *which can be made to develop two types of sensitivity: areas that repel grease and areas that accept it.*

Both grease and water can penetrate the stone's porous surface—however, *not at the same time.* That's where the grease-and-water-won't-mix chemistry comes into play: where there is water on the stone (or plate), grease will not stick, and vice versa. In a nutshell, the idea is to use grease on the stone for the image to be printed and to keep the stone wet where you don't want anything to print.

BASIC STEPS IN THE MAKING OF A LITHOGRAPH

The artist draws his image directly onto the surface of the stone (or plate) using a black-colored grease crayon or a grease liquid called *tusche.* When paper is later placed against the inked stone, the image will print in reverse (the way a sentence reverses onto an ink blotter). The artist must anticipate this reversal when drawing on the stone.

The stone (*or plate*) *gets a chemical "bath"* (a solution of nitric acid and gum arabic) to prepare it for printing. The acid makes the surface around the image more receptive to water; the gum "fixes" the greasy image so that it won't spread under repeated inkings from the roller. (Note: The gum–acid solution is called an *etch* but

THE MAKING OF A LITHOGRAPH

99. Drawing on the stone.
100. Etching (preparing) the stone.

102a, 102b. Wash down with turpentine —vanishing image.

104a, 104b. The stone is placed on press and paper over it.

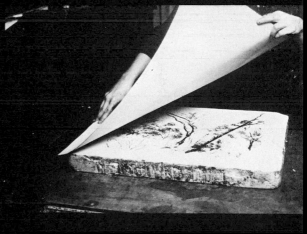

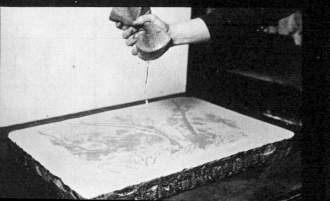

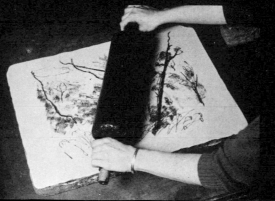

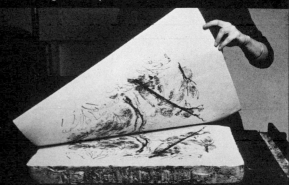

101. Sponging down the stone with water.

103. Rolling up the stone with color.

105. Pulling the impression.

106. First color printed: blue plate.

107. Second color printed: coral from the stone.

108. Third color printed: gray *The New York Times* stock listing page.

has nothing to do with the intaglio print technique also called *etching*.)

The vanishing act. The stone (plate) gets a turpentine bath that washes out the black image, leaving only a pale trace of it. Actually, the grease image is still in the stone (plate), although barely visible.

The stone (plate) is sponged down with water. The water penetrates the surface *except* for the greasy image area.

The artist now "rolls up" his color (a greasy printing ink), spreading it over the stone (plate). Because grease and water won't mix, the wet part of the stone (plate) refuses the greasy ink, but the ink clings to the greasy image area, and the design reappears as if by magic. Throughout inking, the stone (plate) must be kept wet so that the undrawn areas will continue to reject color from the roller.

The stone (plate) is placed on the press bed; paper is positioned over the image and covered with a template to hold it in place as it rolls through the press.

The stone and the paper are run through the press under high pressure, transferring the image from the stone (plate) onto the paper.

Pulling the impression: End of Summer by Jo Muller, 1976 (page 71).

109. Fourth color printed: green nest.

110. Final state proof of Diane Hunt's lithograph, *Counting as an Occupation.* 1976. 30″ x 22″.

The artist (figs. 106 - 110) draws a *separate stone* (*or plate*) *for each color* you see in the final lithograph. For example, to make the four-color lithograph on pages 72-73, the artist created three separate aluminum plates and one stone: one for the blue portion, one for the coral, and one each for the gray and the green.[16] Each color requires a separate run through the press as seen in the progressive proofs, which were pulled from the individual stones or plates shown here. If the artist were to pull an edition of one hundred impressions of this print, it would require wetting down and inking the stone hundreds of times, and at least four hundred passes through the handpress.

QUESTIONS PEOPLE ASK

1. *Is there any difference in the impression taken from a stone and the one from a zinc plate?*

The point is arguable. Many artists feel that the stone surface is more sensitive than metal and should be used whenever subtle effects are desired. As artists work in larger scale, zinc plates (which are light and easily transportable from studio to workshop) are becoming increasingly popular.

2. *What does "signed in the stone" mean?*

It implies a hand-applied signature where there isn't one. A print is either hand-signed by the artist or it isn't. What actually appears is an impression of the artist's signature rendered on the stone and "pulled" along with the rest of the image. (See page 31 on signing and numbering.)

3. *If each color is printed separately, how do they get colors to fall in the right place every time?*

This is called *color registration* and it requires great skill. If the paper is not in contact with the stone in precisely the same place for each printing, gaps or an overlapping of colors (called *off-register*) results (fig. 111).

4. *Can a stone be used more than once?*

Yes. The artist removes the image from the surface by grinding with water and abrasives, using either another stone or a levigator to abrade the surface. Cleaning the image by hand on an average stone can take hours.

5. *What is a "transfer" lithograph?*

Artists sometimes draw on a special transfer paper. The artist can then transfer the image by placing this paper face down on the stone (or plate) and running it through the press. Working directly on the stone, artists often develop this image further. Transfer paper frees the artist to draw "on location" and away from the workshop. Picasso and Whistler used this method. Once the image is transferred, the normal printing process follows.

6. *Is a "transfer print" an original?*

Yes. This was resolved in 1898 when the artists Whistler and Joseph Pennell brought a libel suit against a *Saturday Review* writer who claimed that transfer drawings were not original lithographs. He lost. The transfer technique was accepted as a legitimate original. Senefelder himself discusses using the transfer technique in his record of the study of lithography.

7. *What is the "key stone"?*

It is the stone (or plate) that carries the key image in a color print, often the black image. Other colors are worked in relation to it. In a complex lithograph, the artist must build his colors up gradually, the way a painter does, to achieve a particular result. The velvety black you see may, in fact, be several shades of blue and brown with some crimson thrown in for warmth. The order of printing colors is, therefore, extremely important for transparency, density, or tone. Key stones are also commonly used in woodcuts and chiaroscuro prints (fig. 71).

111. The commonest devices used for color registration in lithography are "pointers," wooden sticks with fine pins on the end. First, tiny holes are bored into the upper and lower center margins of the stone. Each sheet of paper is also marked at the center, top, and bottom. The pins are fitted into the holes in the paper, and then positioned into the holes in the stone for each run through the press so that successive colors deposit in the correct position.

In February 1799, at the age of fifty-three and having been stone deaf for seven years, the benign-looking gentleman (fig. 113) published a series of eighty prints in a newly popularized printmaking process called *aquatint*. Had he never produced another print, this masterpiece alone would have secured Francisco Goya's reputation as a printmaker. *Los Caprichos,* Goya's biting commentary on social decadence and injustice, was a thinly veiled attack on the corruption running rampant in the Spanish court (fig. 147). As official court painter, the artist was a firsthand witness to royal self-indulgence. Queen Maria Luisa openly rewarded her young lover, Manuel Godoy, with a series of whirlwind promotions that catapulted the young guardsman from soldier to prime minister of Spain by his twenty-fourth birthday. Goya's estimate of Godoy's competence is clearly inflammatory in the *Caprichos,* where the queen's favorite is often depicted in the form of an ass. Twenty-seven sets of *Los Caprichos* sold from the perfumery shop

112. Etching plate and inked roller.

5

biting the
image:
the intaglio
process

113. **Francisco Goya.**
Self-Portrait, Plate 1
from *Los Caprichos.*
1799. Drypoint and
burin. 5⅜″ x 4⅜″.
Courtesy Sotheby
Parke Bernet Inc.,
New York.

113. **Francisco Goya.**
Self-Portrait, Plate 1
from *Los Caprichos.*
1799. Drypoint and
burin. 5⅜″ x 4⅜″.
Courtesy Sotheby
Parke Bernet Inc.,
New York.

below Goya's apartments. The remaining 240 sets were hastily withdrawn and presented, along with all eighty aquatint plates, to the king. No doubt the purpose of this maneuver was to rescue Goya from the impending grip of the Inquisition by placing his inquisitors in the politically ticklish position of condemning artwork that had found favor with the king.

Aquatint is one of several techniques for making prints by the *intaglio process.* Engraving (fig. 114), drypoint, etching (pl. 8), mezzotint, soft-ground, lift-ground, and collagraph are others .

Intaglio comes from the Italian *intagliare,* meaning to "cut, carve, or engrave." The prefix *in* is the key to remembering how the process works. When you press your footprint *into* the hard sand at the edge of the ocean or cut a design *into* the sand with your finger, you create an *intaglio* design; the picture lies *below* the sand's surface. Should the sea spill into it, the trenches made by your finger fill with water, much as the lines etched or incised into a metal plate fill with ink in the intaglio process. The artist creates an intaglio plate for printing either by directly cutting into the metal with his tool or with the aid of chemicals, thereby forming channels below the original level of the metal plate. When the plate is

114. **Antonio Pollaiuolo** (1432–1498). *Battle of the Nudes.* Late 1460s. Engraving. 16⅜″ x 24⅛″. Pollaiuolo's fame in printmaking rests on the merits of this single engraving. Although dissection was illegal at the time, the artist may have been one of the first to inspect cadavers in order to trace the source of body motion and structure. The print is the earliest-known Italian engraving to bear the artist's full signature and is exceptionally large for a fifteenth-century engraving. Courtesy National Gallery of Art, Washington, D.C.; Gift of W. G. Russell Allen.

inked, the color goes down into these channels. For printing, the surface of the plate is wiped clean of ink (see exception under "Wiping the Plate"). To pull an intaglio print, a sheet of predampened paper is placed over the freshly inked plate. Plate and paper are pulled through the intense pressure of the press, which forces the malleable, moistened paper down into the indentations of the plate. Ink and paper make contact, and the color is transferred onto the sheet, producing the impression. Depending on the particular procedure for incising the design into the plate, the impression will be either an etching, an aquatint, a drypoint, or a hybrid of several intaglio techniques. As a print procedure, intaglio works exactly opposite to the relief process, such as woodcut, in which the image is carried by the "raised" portions of the block. Intaglio prints differ as well from the lithographic image, which is produced from the *flat* surface of the stone and feels "flat" to the touch. When you run your finger over an intaglio impression, the image often feels "raised," a textural side effect caused by the way the moistened paper is molded as the press pushes it down into the inked depressions of the plate. The texture ranges from a faint rise (discernible to only the forewarned finger) to the high, sculptural relief of inkless intaglios (fig. 151), on which the design has been bitten into the plate so deeply that the paper is shaped to a clearly dimensional quality under the pressure of the press.

Incising images into a surface comes as naturally to man as drawing images in the sand to a child on the beach. Engraved reindeer bones and elephant tusks have been found, suggesting that our caveman ancestors were already competent engravers of a sort. Engravings also embellished the bronze backs of Etruscan mirrors with elaborate scenes. Had viscous printer's ink and cheap paper existed, the idea of making prints might

well have occurred to some precocious caveman or enterprising Etruscan. But the first intaglio print in the West that has a traceable date is a copper engraving of 1446 (fig. 18). Giorgio Vasari, the famous sixteenth-century biographer of artists, credits Maso Finiguerra with the invention of engraving. Whether or not Finiguerra actually was the originator, he certainly influenced the development of the process by being one of the earliest artisans to record his *niello* designs by casting them in sulfur and then using the casts to print impressions of the design on paper for his apprentices to follow (fig. 115). *Nielli* were small plaques decorated with incised pictures. The grooves of the incised designs were filled with a black powder (*nigellum* in Latin), which became molten when heated and flowed into the lines. When the niello plaques were later polished, the black-filled patterns stood out against the glistening silver. Some feel that it is more likely that intaglio printing began several decades earlier in northern Europe (possibly with the Master of the Playing Cards), where printing, cheap papers, and the newly developed thick, viscous inks were already in use. Whatever their actual origin, woodcuts and engravings emerged around the same time in Europe. Because they could be produced more cheaply, woodcuts became prevalent —the poor man's illustration—whereas the intaglio process of engraving, which required time-consuming and delicate cutting, remained a luxury for those who could afford it. Early copper engraving plates were so costly that they were often worked on both sides.

More than any other printmaking process, intaglio methods encourage analogy to the alchemist's studio. Dotted with labels such as *Egyptian asphaltum, rosin, methyl violet dye, beeswax,* and such, the shelves of an etcher's studio suggest the conjurer's art. All but two of the intaglio techniques—engraving and drypoint

115. **Emilian (Francesco Francia?).** *Saint Sebastian.* 1470–1480. Niello print. 2⅝″ x ⅝″. Courtesy National Gallery of Art, Washington, D.C., Rosenwald Collection.

116. **Hans Sebald Beham** (1500–1550?). *Hercules Slaying the Hydra.* 1545. Engraving. 2″ x 3″. Courtesy Sotheby Parke Bernet Inc., New York.

(see page 82)—employ chemicals to create a design in the metal. Transfigurations occurring in the surface of the plate during the process and then the often strikingly different appearance one notes between the etched plate and the final visualization of the image on paper do indeed hint at sleight of hand. The visual disparity between metal plate and paper impression is particularly strong when several intaglio procedures have been combined in creating the print. Each step—be it applying an aquatint tone, biting certain lines deeper than others, or highlighting portions of the image with drypoint—amends the plate and also the image on paper, which requires a separate run through the press, procedure by procedure, until the artist conjures up his finished composition. The artist incorporating many intaglio procedures in a single image must hold his ultimate effect in mind, while keeping an eye open for happy technical "accidents" along the way.

It is not uncommon to hear people refer

117. **Martin Schongauer.** *Christ Carrying the Cross.* 1470s–1480s. Engraving. 11″ x 17″. This engraving is believed to be one of the largest Northern copperplates of its day, unusual in an age in which large sheets of paper were costly. Schongauer, son of a silversmith, is the first engraver known by name. Over 45 figures make up the surging crowd moving along the road. Although a Gothic print, the agitated, turbulent composition anticipates the dynamic spirit of Renaissance art. Courtesy Sotheby Parke Bernet Inc., New York.

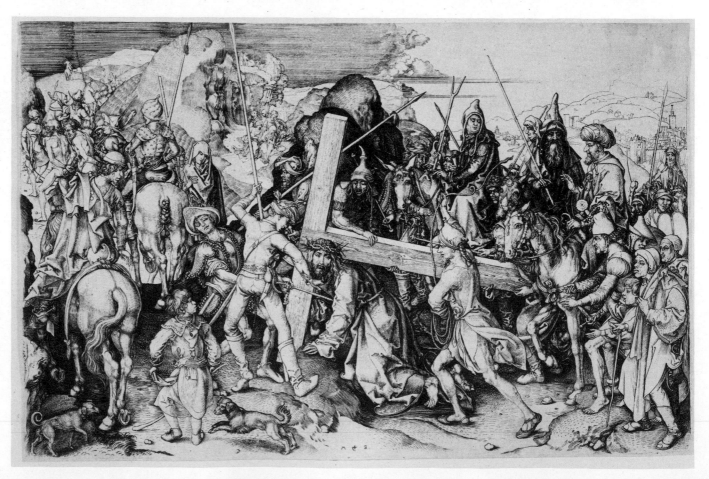

chords in a symphony, each intaglio procedure gives the artist a special visual "sound" with which to orchestrate his idea.

INTAGLIO TECHNIQUES

Design cut directly into plate without the assistance of chemicals: Engraving/Drypoint

LINE ENGRAVING

The artist cuts his line by using a *pushing* action with his tool. Resting the handle of his burin (or graver) in the socket of his hand, the artist *pushes* it through the metal, exerting considerable energy, which gives the engraved line a kinetic liveliness (figs. 114, 120). Deeply cut

118. **Martin Schongauer.** *Wild Man Holding Shield with a Greyhound.* 1480–1490. Engraving from a series of coats of arms. Diameter: 3". Images of wild men continually crop up in the art of the late Middle Ages as symbols of superhuman strength. Emblems such as this one may have been designed as family crests and the engravings used as a type of calling card. The fictitious wild men were so much a part of medieval culture that mothers supposedly told stories of the wild men's fabled "craving for the flesh of children" as a threat to make their youngsters toe the line. Courtesy National Gallery of Art, Washington, D.C., Rosenwald Collection.

119. **Christian Fossier** (1943–). *Engin.* 1969. Steel-plate engraving. 59" x 39". Courtesy RCA Collection.

loosely to all intaglio-type prints as "etchings." Although etching has been widely used since the sixteenth century, it is only one of a number of intaglio processes. The particular procedure the artist selects gives the line its characteristics and the print its specific identity as an etching, engraving, drypoint, or aquatint. Like the notes and

lines hold more ink than shallow ones and print very dark black. Varying the depth and width of his lines, the artist can create differences in light and shade (figs. 116, 117, 118, 119). As the steel tip of his burin pushes through the soft copper, it spits up a "burr" on either side (much as a plough displaces earth in cutting furrows). This burr is later removed with a scraper. To draw a curved line with a pencil, one merely swings the arm in the desired direction. When the same curve is created on an engraving, it is the plate that is twisted and turned toward the tool, which the artist works fairly parallel to his body, moving plate and tool in a contrapuntal motion that means he is often working on a design upside down or sideways. Accidental scratches are "polished out" with his burnisher, or scraping tool, also used to lighten overworked aquatint, mezzotint, and drypoint lines. A special tool with a multiline-cutting head is sometimes used to create tones of gray and black. Designed with as many as sixty-five cutting edges to the inch, the multihead cuts closely spaced parallel lines into the metal in a single stroke. The closer the lines, the more solidly black they print and the darker the shaded area appears.

A crisp, precise line distinguishes engravings such as those of Master L Cz who produced only twelve known examples, some considered masterpieces of their day (fig. 120). The style of Master L Cz, and the Satan form represented as a "conglomerate beast" compiled from an assortment of anatomical parts, clearly relates to the imaginary monsters in Martin Schongauer's *The Temptation of Saint Anthony* (fig. 11), a print famous at the time and possibly known to Master L Cz. Schongauer depicted the third-century hermit saint who suffered trials and temptations at the Devil's hand. In his biographical work on artists, Vasari claimed that Michelangelo was so enamored of Schongauer's engraving that he made a copy of it. In the print, Saint Anthony struggles against satanic forces trying to deter his ascent heavenward, a vision based on Saint Anthony's reputed belief that souls rising toward heaven are often arrested in their ascent by the Devil.

Creative rendering and artistic invention gave way to an emphasis on facile reproductive engravings with the development of a standardized style for drawing on the plate. The sixteenth-century master copyist Marcantonio Raimondi would certainly have agreed with Goethe: "God bless copper, gravers and stipple . . . so that whatever is good may be saved from oblivion by innumerable likenesses."[17] Marcantonio invented a system of engraving lines that could be taught as easily as one taught spelling or arithmetic. His standardized alphabet of lines and crosshatching patterns for translating three-dimensional forms onto the copper plate did, indeed, make "innumerable likenesses" available and created a style for reproductive engravings that dominated Europe for centuries (fig. 43). Marcantonio's assistants could take turns working on the same plate without missing a stroke or giving away the change of hands. With the sack of Rome in 1527, the large workshop dispersed and Marcantonio's assistants relocated throughout Europe, carrying their master's codified "anonymous-hand" engraving style with them.

Technically masterful, reproductive engravings are primarily the work of skilled craftsmen, not artists; emphasis rests on exact duplication of another man's ideas rather than the invention of an original and autographic iconography in the print. In *The Bite of the Print*, Frank and Dorothy Getlein summarize the standardized engraving system:

These regular lines act as a mechanical screen between the eye and the object perceived. The

120. **Master L Cz** (believed to be Lorenz Katzheimer). 1500–1515. *The Temptation of Christ*. Engraving. 8⅞" x 6½". Satan approaches Christ after He has been wearied by 40 days of fasting and meditation in the woods. The print depicts the three temptations with which Satan confronted Christ: pride, gluttony, and ambition. Pointing to the ground Satan challenges: "If you are the Son of God, command these stones to become loaves of bread." One writer suggests that the artist also subtly contrasts good and evil, for example, by placing Satan against barren rocks and Christ against a rich forest of oak. Oak is traditionally a symbol of strength, faith, and virtue. Courtesy National Gallery of Art, Washington, D.C., Rosenwald Collection.

effect is as if a fishnet were thrown over a form and the draughtsman then drew not the form but the curves of the net caused by the presence of the form. The ultimate refinement of this technique is banknote engraving. The portrait of Washington on a one-dollar bill reveals . . . the net of lines . . . thrown over the head and shoulders of the President in order to reveal their contours.[18]

Marcantonio's rote line system locked engraving into a reproductive course. In 1505, Dürer crossed over the Alps to protest Marcantonio's plagiarism of his original concepts. By the close of the sixteenth century, whole families worked in Antwerp print "factories," turning out "anonymous-hand" engravings and etchings. Until photomechanical processes took over in the nineteenth century, reproduction rather than creativity absorbed the skills of etcher and engraver.

121. **Jacques Villon** (1875–1963). *Femme au Chien Colley.* 1905. Drypoint. 20¼" x 15¼". Courtesy Sotheby Parke Bernet Inc., New York.

BROAD MANNER AND FINE MANNER. Terms used in reference to early Florentine engravings to describe the thickness and type of line used by the engraver in modeling his forms (for example, a figure's muscle structure). *Broad manner:* modeling achieved with long lines running parallel to one another in a diagonal direction. *Fine manner:* modeling achieved in lighter lines and patches of closely made cross-hatchings producing a softer tonal effect.

DRYPOINT

A variation of engraving. Distinguished by an intense, suedelike black line with a furry quality (fig. 121). The Housebook Master (fig. 21) is credited with discovering drypoint. In engraving, the engraver *pushes* his tool through the metal, gouging out his lines. In drypoint, he works with a steel- or diamond-tipped tool, held like a pencil, and *scratches* his design into the copper. As the needle scratches lines into the plate, it pushes up ridges of soft metal to either side of it. These embankments, or "burrs," hold more ink than a flat engraved line, and they print fatter—a lush, velvety black. The burr is very fragile. With each run through the press, it wears down and holds less and less ink as it flattens out. When the burr "goes," lines that originally printed a rich black appear hard and thin. Since the plate wears out easily, drypoint editions are kept small. Rembrandt used drypoint extensively in the prints he made in his forties. A master of chiaroscuro (light and dark) effects, he may have discovered in the resonant suede blacks of drypoint a graphic counterpart for the mysterious recesses from which his painted images seem to emerge. Drypoint had one clear advantage. Rembrandt, anticipating by two centuries a direct-from-nature approach advocated by the Impressionists, enjoyed the freedom and spontaneity of drawing from actual landscapes (fig. 135). With

drypoint, he could carry his plates into the countryside and record the basic scene directly onto the metal with his needle, avoiding the long time intervals and creative disruptions required by acid-biting lines for an etching. Because they permit the artist to draw directly on the metal, drypoint and engraving may appear to be simpler intaglio methods than procedures requiring acid. Actually, they are harder techniques to master. The etcher's needle moves freely in any direction through the soft wax ground with which the plate surface is covered (fig. 123). Chemicals do the actual "cutting" into the metal (fig. 125). Lines drawn directly with drypoint needle or graver's burin, on the other hand, must overcome the resistance of the metal. The tug of war between metal and man may account for the engraving line's often having the immediacy and pulsing quality of a spontaneous drawing and for acid-etched lines' having a more premeditated, controlled quality. Drypoint is widely used in conjunction with engraving and etching to accent and enrich details.

BASIC STEPS IN THE MAKING OF AN ETCHING

Edges of metal plate smoothed with files. Later these edges are burnished with a scraper so they cannot pick up ink.

Plate cleaned of all grease with whiting and ammonia mix, followed by washing in water. Plate is heat-dried, then cooled.

Acid-resisting ground (generally wax) is rolled or brushed onto entire plate. There are a variety of grounds making different effects possible. Heating on a hotplate speeds drying.

Artist draws design on plate with a sharp tool (for example, an etching needle). The tool cuts through the wax ground, exposing areas of metal. *Acid will "bite" these exposed areas but cannot erode the plate where ground protects it. Thus only the design lines are "eaten down" into the metal.*

Plate is placed in acid solution (usually Dutch mordant for copper, nitric acid for zinc). To bite some lines deeper than others the artist covers the areas he wants to keep light with a stop-out varnish to seal them from the acid's action. The plate is again placed in acid, which continues to deepen exposed lines. Each time the artist drops his plate in acid, he takes a gamble.

After lines are properly bitten, artist removes ground from plate surface by dissolving it with turpentine or alcohol. This leaves the metal shiny clean and the design incised below the original plate surface, ready to hold ink.

Moistened paper is rolled flat. Moisture makes the paper more malleable in the press so that it can be sucked down into the incised lines of the plate and pick up ink.

To ink the plate, the artist first warms it on a hotplate and forces a small amount of ink down into the incised design lines. Cheesecloth folded like a pad is used to wipe ink from the surface of the plate.

Pulling the impression. The dampened paper is placed over the inked plate on a press bed covered with a tissue layer and blankets. When the paper is run through the press pushes it down into the inked incisions. This imparts a "raised" quality to the line when the paper is pulled back up from the metal.

The impression alongside the plate from which it was pulled: Mark Lunde's *Salt Shakers,* 1974 (fig. 131).

NOTE: Because of the pressure of the press on moistened paper, the intaglio plate leaves a

THE MAKING OF AN ETCHING

122. Filing down edge of plate.

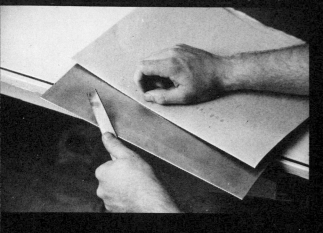

123. Grounding the plate.

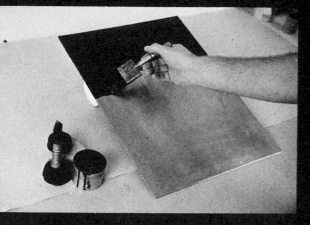

124. Drawing the image.

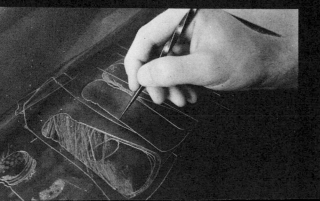

125. The acid bath.

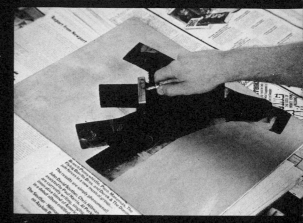

126. Moistening the paper.

127. Rolling the paper flat.

128. Inking the plate.

129. Placing paper on the press.

130. The impression being pulled from plate.

131. The impression shown with the plate from which it was pulled.

plate mark, or "cuvette," around the entire image. This is one of the ways to identify intaglio prints.

INTAGLIO PROCESSES USING ACID

LINE ETCHING

Cutting an engraving by hand is time-consuming and physically tiring. In the sixteenth century, etching was perfected to counteract both problems. The word *etching* comes from *esten,* Dutch for "to eat." The design in an etching (figs. 132, 133, 134) is *eaten out* of the metal by chemicals, instead of being cut out by sheer brute force, as it is in engraving. As a timesaving step, armorers started to paint their designs on the steel in wax and allowed acid to erode the uncovered parts of the metal. The waxed areas remained unaffected and the process of cutting lines with acid power instead of manpower suggested itself to printmakers, opening new possibilities for line variation and drawing in the metal. The ease and variegated visual possibilities of etching made it popular for centuries as an accurate reproductive medium for copying drawings, sculpture, paintings, and architecture. In addition to the line diversity possible with etching, the process allowed for "stopping out" delicate lines that the artist wanted unchanged by covering them with an acid-resisting varnish while he "bit" others still deeper and heavier. After the ground was removed from the bitten plate, the artist could highlight with drypoint and engraving directly on the metal.

The etching concept (see "Basic Steps in the Making of an Etching," page 83) is essentially the same today. The artist covers his plate with an acid-resisting material called a *ground.* Acid will erode unprotected metal but cannot pene-

132. **Pablo Picasso.** *Model and Surrealist Sculpture* from the *Suite Vollard*. 1933. Etching. 10½″ x 7½″. While working as a sculptor at Boisgeloup in the early 1930s, Picasso executed a set of 100 etchings on the themes of the artist in his studio and mythology. The series came to be known as the *"Suite Vollard,"* since Picasso gave the prints to Ambroise Vollard in payment for several canvases he had purchased from the dealer. Courtesy Sotheby Parke Bernet Inc., New York.

133. **William Blake.** (1757–1827). *Thou hast fulfilled the Judgment of the Wicked* from *Book of Job* series. 1826. Etching. 7½″ x 5⅞″. William Blake exhibited his prints only once—at the haberdashery shop of his brother James in London in 1809. The show was a disaster. Blake's style was scorned along with his equally unadorned poetry: "To see a World in a Grain of Sand/ And a Heaven in a Wild Flower,/ Hold Infinity in the palm of your hand/ And Eternity in an hour." A fellow artist, John Linnel, commissioned the aging Blake to do 20 plates (later increased to 22) based on the Book of Job. Of the total 315 impressions made from the plates only 40 had been sold seven years after the printing. Courtesy Sotheby Parke Bernet Inc., New York.

trate this ground. Working in the slightly heated ground, the artist draws his design into it with his tool as freely as if he were using a pencil. The British artist J. M. W. Turner reportedly etched with a fork that had lost all but one of its tines. Drawing in the ground is not a cutting action; it merely exposes the metal wherever the tool touches the ground. When the plate is placed in acid, these exposed areas of the metal are "bitten." The acid does the "drawing" by eating the design below the surface of the plate, forming a network of ink-holding channels. The longer the artist leaves his plate in acid, the

134. **Vincent van Gogh** (1853–1890). *Portrait of Dr. Gachet.* 1890. Etching. 7⅛″ x 6″. Van Gogh's only etching, this portrait of his doctor and friend was executed about two months before the artist's death. It was Gachet who introduced van Gogh to etching and provided him with materials. Courtesy Sotheby Parke Bernet Inc., New York.

deeper the line is bitten and the more ink it will hold. Some plates are "bitten" clear through to produce inkless sculptural impressions (fig. 151).

The unforgettable iconography and distinctive style of Albrecht Dürer's woodcuts and engravings had elevated printmaking from a simple craft to an art, yet the artist was already in his forties before he tried his hand at an etching. Although copper plates were in the ascendancy, most etchings of the time were still made on the less costly iron, a metal that acid bites unpredictably. Dürer's meticulous sensibilities probably found the crude, often uneven results offensive. After only six plates, he abandoned the medium. Etching did not come fully into its own until the seventeenth century, an age that saw the English applauding Shakespeare, Molière's acerbic comedies entertaining the French, the Pilgrims landing at Plymouth, Cardinal Richelieu founding the French Academy, and Charles I losing his head. In Antwerp between 1606 and 1669, a miller's son, Rembrandt van Rijn, created over three hundred prints that imbued etching with an originality and a power until then normally associated with painting.

Rembrandt's daring lay in an unflinchingly honest portrayal of nature as he observed it (fig. 135). Such a lack of guile must have appeared strange to a public accustomed to Baroque mannerist art: posturing god- and goddesslike figures romping through static landscapes with all the glacial vitality of a marble frieze. In two portraits of himself—first as a somewhat narcissistic, foppish young man (fig. 136), and later as a more wizened and mature man whose eyes express both sadness and resignation (fig. 137)—flattery clearly bows to truth. Rembrandt's naturalistic and introspective renderings expressed highly individualistic responses to life, more fitting perhaps in the democratic twentieth century than in an age

135. **Rembrandt van Rijn.** *The Goldweigher's Field.* 1651. Etching and drypoint. 6¾" x 12⁷/₁₆". Courtesy Sotheby Parke Bernet Inc., New York.

of absolute monarchy, when social status and art itself conformed to strict codes. The humanism of Rembrandt, like that of his contemporary Spinoza, was ahead of its time. Yet of all European cities, in Amsterdam, the cosmopolitan crossroads of seventeenth-century international trade, a man might at least risk being enterprising and independent-minded. Rembrandt's daring is particularly evident from two different states of the print *Christ Presented to the People.* All seven states of the print were executed entirely in drypoint. In the third state (fig. 138), a crowd mills below the platform on which Pilate pronounces Christ's sentence. By the seventh state (fig. 139), however, Rembrandt has removed the figures, exposing a bare platform dominated by two gaping black windows that magnetize the eye toward the central action. Cover those staring black windows, and the figures of Pilate and Christ dissolve into the anonymous band of humanity beginning at the left and arcing over

the platform to the right. A television director would quickly grasp the reason for Rembrandt's erasure of the crowd in front of the platform, as a close-up camera shot. It pulls the viewer into the action as a participant, since he is no longer watching at a safe distance but standing below the platform itself, experiencing the momentous drama as a member of the crowd.

The unwavering honesty of Rembrandt's eye influenced his hand. Ignoring the copyist's reproductive style as being divorced from life as actually observed, Rembrandt attacked his plates with the same inventiveness and spontaneous drawing that he used in his naturalistic canvases. This fresh approach opened possibilities in the etching medium that would later inspire Goya and Whistler.

In sharp contrast to Rembrandt's realistic and earthy Dutch humanism, Max Beckmann's etching (fig. 140), *The Curtain Rises* (1923),

136. **Rembrandt van Rijn.** *Self-Portrait with Saskia.* 1636. Etching. 4⅛″ x 3¾″. Courtesy Sotheby Parke Bernet Inc., New York.

137. **Rembrandt van Rijn.** *Rembrandt Drawing at the Window.* 1648. Drypoint and burin. 6½″ x 5″. Courtesy Sotheby Parke Bernet Inc., New York.

reminds one of a Halloween celebration at a madhouse. With her finger, a woman raises the curtain on a mysterious performance: a skeleton leers in the background, a crowned man half hides his eyes from a woman wearing the same bestial animal skin as the first, riding a reptile, as two candles gyrate crazily. Although tightly compacted together, the figures appear estranged, alienated from one another. Associating mankind's follies with the bizarre and grotesque antics of a carnival is an allegory dating to late medieval times. In the Baroque period, the carnival theme grew to encompass the idea that God viewed all of man's petty doings as farcical and therefore that the world was merely a cosmic stage upon which man performed. Beckmann drew on this idea of the world as theatre; however, his lashing lines strike out not at man but at the director: "My pictures are a reproach to God for all that he does wrong."[19] The curtain rises on the incongruities and absurdities of human existence and the farce is laid at the Maker's doorstep.

Between the third and seventh states of this drypoint, Rembrandt made what is considered one of the most daring deletions in all of printmaking. In the fifth state the artist eliminated the entire group assembled in front of the platform on which Christ and Pilate stand. Only the two dark openings of the prison windows and a barely perceptible "specter" image remain. Removal of the foreground figures compresses the distance between the event and the viewer. By erasing the sliver of ground that safely separated the viewer from Pilate's proclamation, Rembrandt thrusts us into a direct confrontation with his picture as witnesses to the fate of Christ.

138. **Rembrandt van Rijn.** *Christ Presented to the People.* 1655. Etching, third state. 14″ x 17⅞″. Courtesy National Gallery of Art, Washington, D.C., Rosenwald Collection.

139. **Rembrandt van Rijn.** *Christ Presented to the People.* 1655. Etching, seventh state. 14″ x 17⅞″. Courtesy Sotheby Parke Bernet Inc., New York.

140. **Max Beckmann** (1884–1950). *The Curtain Rises.* 1923. Etching. 11⅝″ x 8½″. Courtesy Carus Gallery, New York.

ditional ground. The new varnish assured artists that their plates would be exposed only as planned. The *échoppe* tool, which Callot also invented, enabled the artist to approximate engraving lines in etching. Drawing in a grounded etching plate with Callot's *échoppe*, the artist could start with a delicate line, swell and taper it with the ease of using a quill pen, and achieve gradations formerly only possible with a graver's burin. With etching more predictable, and use of the *échoppe*, the faster process of etching was soon adopted as a look-alike for time-consuming engraving. One author quotes Callot's disciple, Abraham Bosse: "The etcher's chief aim is to counterfeit engraving."[20] While always collected, Rembrandt's approach to the plate fell into relative obscurity, but Bosse's manual demonstrating etching as a shortcut form of engraving was translated into many languages. Popularized throughout Europe, it trapped the medium's creative potential in a reproductive labyrinth until the nineteenth century, when collectors began to separate the output of skilled technicians from the work of original artists. The former they called *painter–engravers,* and the latter, *painter–*

141. **Jacques Callot** (c. 1592–1635). *The Hanging Tree* from *The Miseries and Disasters of War.* 1633. Etching. 3⅛″ x 7⅛″. Courtesy National Gallery of Art, Washington, D.C., Rosenwald Collection.

Jacques Callot and Abraham Bosse

Rembrandt's genius sought greater freedom and stylistic creativity within the intaglio processes. Jacques Callot's innovations increased the medium's technical efficiency. An artist might work weeks, sometimes months, biting his design into a plate, only to have it ruined accidentally if his hard wax ground flaked off, leaving areas of the metal exposed that he had intended to protect from the acid. Such "foul biting" made etching a very unstable medium. Callot solved the problem by substituting lute-maker's varnish for the tra-

Art critic John Canady compared *Der Krieg* with Goya's masterpiece *Disasters of War:* "Goya is a spectator of atrocities, and we observe them with him and react as human beings capable of normal emotional and intellectual responses to them. But Dix is not an observer, he is a victim of insanity and butchery" (see Canaday, *Mainstreams of Modern Art*, pp. 434–435).

142. **Otto Dix** (1891–1969). *Mealtime at the Front* from *Der Krieg* (The War) portfolio. 1924. Etching and aquatint. 13⅞″ x 18¾″. Courtesy Carus Gallery, New York.

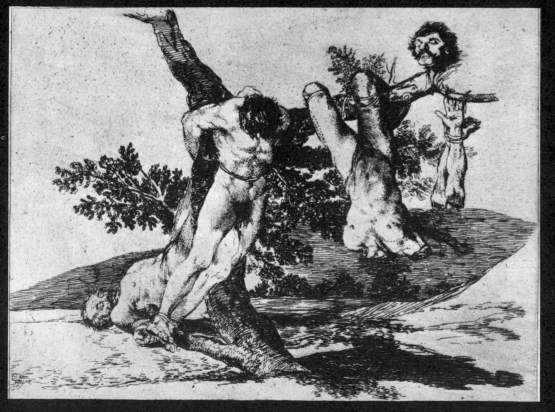

143. **Francisco Goya.** *Wonderful Heroism! Against Dead Men!,* Plate 39 from *The Disasters of War.* Etching and aquatint. 6¼″ x 8¼″. Courtesy The Metropolitan Museum of Art, New York; Rogers Fund, 1922.

etchers. Most of the great printmakers in history have, in fact, been painters: Dürer, Rembrandt, Goya, Daumier, Picasso, and so on.

Jacques Callot was an artist as well as an inventor. His set of small prints, *The Miseries and Disasters of War*, offer a strangely impersonal rendition of the horrors that confronted Callot when he returned in 1621 from Florence to Nancy, France (fig. 141). The lives of twenty-three men have been snuffed out on Callot's hanging tree, yet we sense none of the impassioned madness of Otto Dix's prints on war (fig. 142) or Goya's (fig. 143). Callot observed the death scene with the chilling impartiality of the camera.

INTAGLIO PROCESSES FOR TONAL AND SPECIAL EFFECTS:
Aquatint/Stipple Method/Soft-Ground/Lift-Ground Mezzotint/Embossed and Relief Prints

AQUATINT

As the demand for reproductions of popular paintings and watercolors grew, printmakers sought more sophisticated methods with which to imitate painterly tones, textures (pl. 9), and contrasts on the plate. Aquatint, a form of etching, developed in the seventeenth century as a process to help copyists emulate the soft, washy look of watercolors. Aquatint creates tonal areas rather than lines (fig. 144). "White specks" are often visible in these tones, as though the area had been peppered lightly. This is, broadly speaking, what does happen: a resin powder is sprinkled on the copper plate (fig. 145). The plate is then heated and the resin melts into tiny particles, which harden as they cool. The hardened "specks" form tiny protective shields wherever they settle on the plate. The plate is immune to the acid's biting action at these spots. Acid

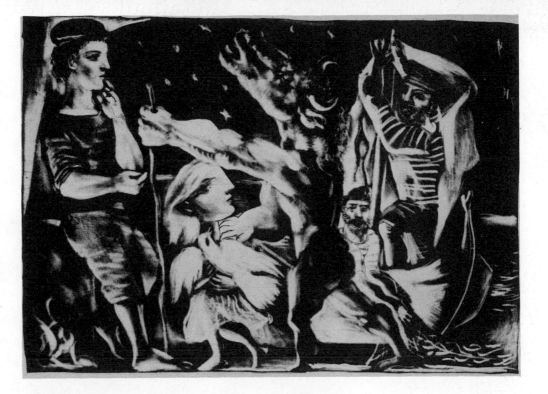

reaches only the metal *between* the particles, biting microscopic depressions that later hold ink. These depressions are so closely spaced that they print areas of overall tone on the paper. The density of the tone depends on the size of the

144. **Pablo Picasso.** *Minotaur Guided by a Young Girl in the Night.* 1934. Aquatint. 9¾" x 13½". Courtesy Sotheby Parke Bernet Inc., New York.

145. Sprinkling resin on the plate for aquatint.

146. **Max Klinger** (1857–1920). *The Plague,* Plate V from *Death II* portfolio. 1898–1910. Etching and aquatint. 19⁷⁄₁₆″ x 13³⁄₈″. Courtesy Carus Gallery, New York.

resin granules sprinkled onto the plate and how long it has remained in acid for biting. Max Klinger uses a dense black to isolate key elements in his compelling print *The Plague* (fig. 146). The action clearly pits the forces of good against evil, life against death. The black habit of the healing nun in the foreground forms a single unit with the black cross behind her (and she appears optically twice as large by its added height) as she battles to stave off the loss of still another soul.

The discovery of aquatint in 1650 is credited to Jan van de Velde of Amsterdam. Reputedly, Van de Velde's formula was forgotten until Jean Le Prince rejuvenated it in his book *Découverte procédé de graver au lavis.* Shortly after Le Prince revived aquatint in 1780, Francisco Goya used the process to produce *Los Caprichos* (fig. 147), one of the most brilliant print sets ever executed in the medium. Goya became familiar with aquatint while producing etching copies of the great Velásquez paintings in the Spanish Royal Collection, a job undertaken soon after his marriage to the daughter of the leading painter at court. While Goya, as official court painter, churned out reproductive prints and flattering paintings of the Spanish court, Goya, the genius, was taking form. As one author noted, "Had he died . . . at 46 . . . Goya would now be forgotten."[21] In mid-life, Goya began to explore the great paradox of life, that ambiguous nether land between the rational and the irrational. The subtle tonal modulations possible with aquatint perfectly suited Goya's purpose. Shadowy blacks and a moody spectrum of middle tones interplay with sudden luminous whites, exposing the human mind in its madness (fig. 86). With the restoration of Ferdinand VII to the Spanish throne in 1814 and the resurgence of the Inquisition, Goya at seventy-eight was forced to leave Spain for Bordeaux as a political exile. Of Goya's 269 plates,

147. **Francisco Goya.** *The Chinchilla Rats,* Plate 50 from *Los Caprichos.* 1799. Etching and aquatint. 8″ x 5⅞″. In this plate from his scathing satirical portfolio, *Los Caprichos,* Goya depicts the parasitic life of Spanish nobility, absorbing nourishment from society but capable of returning nothing. Arms fastened rigidly at their sides, ears deafened to reason and reality, Goya shows them spoon-fed by an ass, generally recognized as symbolizing the Spanish prime minister, Manuel Godoy. Courtesy National Gallery of Art, Washington, D.C., Rosenwald Collection.

only 130 were issued in his lifetime. Although published *posthumously* such first edition printings are not *reprints*.

STIPPLE (OR CRAYON) METHOD

Aquatint offered the printmaker a look-alike for watercolor washes. *Stipple* engraving, introduced in the eighteenth century, duplicated the appearance of a crayon or chalk drawing. The metal plate is coated with a protective ground and then pitted with a tool so that after it is bitten, it prints with the "dotty" or grainy line quality of crayon or pastel drawings.

SOFT-GROUND

Another look-alike process developed in the eighteenth century, *soft-ground* simulated the appearance of pencil drawing. The artist covered his plate with a blend of regular etching ground and suet. Unlike the conventional ground, this mixture remained *soft* and malleable even after

it dried. A thin sheet of paper was stretched over the grounded plate, and the artist drew into it. Wherever his pencil pressed the paper, it stuck to the soft ground. When the paper was removed, these "stuck" lines lifted up and exposed the metal. The plate was bitten by acid wherever the pencil drew, producing a muted soft line, less crisp and sharp than one cut with an etching needle in the regular hard ground. Many contemporary artists use the soft-ground by pressing objects and materials into it (for example, a watch part, cheesecloth, a sponge). When the object is removed from the ground, the exposed areas of metal retain the indentation of its form, producing interesting textural and surface effects in the printing. Matta (Sebastian Antonio Matta Echaurren) exploits soft-ground in his etchings to capture the playful scrawl of his pencil or ball-point pen (fig. 148).

LIFT-GROUND

One of the things that attracted many artists to the lithograph was the fact that the image could be drawn onto the stone as easily as one drew on a sheet of paper. The resulting prints had the autographic spontaneity of direct crayon or brushwork. *Lift-ground* offers the etcher a similar hand-to-plate directness in an intaglio process. Using a water-soluble sugar solution, he draws directly onto the raw plate as if the solution were paint. When the sugar-solution drawing dries, a thin liquid hard-ground is spread over the plate. After the coating dries, the plate is soaked in warm water. The water activates the sugar drawing and it begins to dissolve and swell. It lifts up through the ground (hence, *lift-ground*), exposing the metal wherever the picture had been painted. When these drawn areas are completely exposed, the plate is placed in acid and the drawing permanently bitten into the

148. **Matta (Sebastian Antonio Matta Echaurren,** 1912–). *The Bus from Scènes Familières.* 1962. Soft-ground etching. 19¾" x 25⅝". Courtesy The Museum of Modern Art, New York; Inter-American Fund.

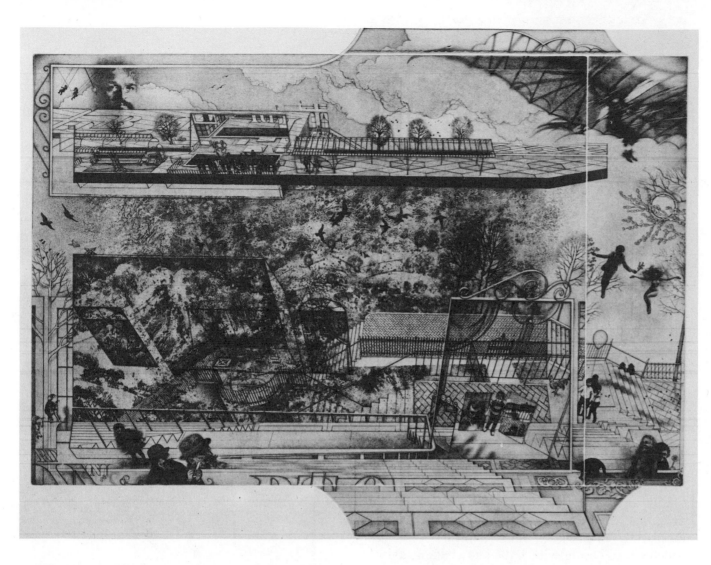

149. **Peter Milton** (1930–). *A Sky-Blue Life*. 1976. Etching. 25½″ x 32½″. Courtesy Impressions Workshop Inc., Boston.

metal. Peter Milton (fig. 149) uses sugar-lift extensively. Milton's prints get their surreal undertone from a deceptive verisimilitude: incongruities and visual enigmas presented within what, at first glance, appears to be a photographically accurate situation. The artist's through-the-looking-glass blend of past and present, known and unknown, remembered and imagined happenings, achieves its effect of photographic realism without any mechanical photographic aids. Milton uses photographs to draw from but develops his prints through a sequence of complex handworked steps: sugar-lift, etching, aquatint, and engraving—sometimes spending months on the drawing aspect alone.

In the seventeenth century, an experimental form of sugar-lift was used by Hercules Seghers. Rembrandt owned several Seghers prints. Contemporaries and innovators, both men died penniless with Seghers's originality as a printmaker unrecognized for years.

MEZZOTINT

Mezzotint or halftone (*mezzo* meaning

150. **Valentine Green** (1739–1813). *George Washington,* after a painting by John Trumbull. 1781. Mezzotint. 24¹⁵/₁₆″ x 15¹⁵/₁₆″. Courtesy The Metropolitan Museum of Art, New York; Bequest of Charles Allen Munn, 1924.

this point, the "pocks" would hold enough ink to print solid black, which is why the French call mezzotint the *manière noire* (the black manner). In 1657, Prince Rupert, von Siegen's pupil and also a soldier, improved the method by employing a "rocker" that pitted the plate more evenly. Rocking the metal takes hours because it must be done in all directions. If the plate prints solid black, how does the artist create an image from it? He polishes out areas of the pitting with a scraper or by burnishing. These areas print in varying grades of gray to white, depending on how much of the pitting he smooths down.

151. **Omar Rayo** (1928–). *Scissors* from *Souvenirs.* 1966. Inkless intaglio. 11½″ x 7½″. Courtesy Ann Kendall Richards, Inc., New York.

"half"; *tint* meaning "tone") is a variation on drypoint. Developed in the seventeenth century, mezzotint introduced into printmaking that epoch's fascination with light and shadow, a concern that expressed itself in Rembrandt's later paintings. Invented by a soldier, Ludwig von Siegen, mezzotint allows the printmaker to develop his forms through patterns of tone rather than by line alone, in painterly shading gradations ranging from solid pitch blacks through glistening pure whites. Von Siegen discovered that he could pit the entire surface of the plate by rolling it with a "roulette" tool, an instrument with tiny spikes on its end. The closely spaced "pocks" created by the roulette became tiny ink holders. If the plate were inked and printed at

In spite of the sheer physical exertion and time involved, a number of contemporary artists use the process. The technique is sometimes called, the *English manner* because in the eighteenth century mezzotint was used extensively in England to reproduce prints of portrait paintings in black and white (fig. 150).

Yozo Hamaguchi and Mario Avati are modern printmakers who, like Wolfgang Gäfgen (pl. 10), specialize in mezzotint.

EMBOSSED AND RELIEF PRINTS

The contemporary trend toward obliterating traditional distinctions between art mediums has resulted in painted sculptures and canvases shaped like sculpture. The embossed or "sculptured" intaglio print (fig. 151), which breaks the stereotype of paper as flat (and in some cases achieves considerable dimensionality), reflects much the same tendency, although embossed seal prints already existed in the fifteenth century (fig. 152). The basic technique also appeared in the *gauffrage* blind stamping used in eighteenth-century Japanese woodcuts, as well as in images stamped on heavy paper (called *stereotypes* and *glyptographies*) during the Art Nouveau epoch in France. The contemporary inkless embossed effect is generally achieved by pressing a moistened sheet of thick paper over a deeply bitten, uninked intaglio plate. Under the heavy pressure on the press, the paper is pulled deep into the design lines. When it is removed from the metal, the paper retains the form created as it was forced down into incisions in the plate. A spacer or filler should be used when one is framing such prints to prevent the glass from touching the relief work and to allow the play of shadows that enriches the sense of dimensionality. The concept of a "raised" print was further developed by Rolf

Nesch (fig. 204) (discussed in chap. 7, page 141) and also by S. W. Hayter in the 1930s.

COLLAGRAPH OR COLLAGE PRINT

The "plate" in this case is actually an assemblage or collage of various materials attached (for example, glued) to a cardboard, metal, or Masonite backing. Materials can range from string to a coin, a cardboard shape, or even a piece of etched plate. Joined together on the backing, the combination of elements offers enormous textural and visual variety. The collagraph can be printed as an intaglio plate or as a combined intaglio and relief plate.

152. *Patron Saints of Ratisbon: Saint Denis, Saint Emmeram, and Saint Wolfgang.* German, 1460–1470. Seal print from woodcut. Courtesy The Metropolitan Museum of Art, New York; Gift of J. Pierpont Morgan, 1917.

153. **James Abbott McNeill Whistler.** *The Traghetto,* No. 2 from *First Venice Set.* 1880. Etching. 9⅜″ x 12″. Whistler dated his prints only intermittently in the 1860s and abandoned the practice by 1870. Courtesy Sotheby Parke Bernet Inc., New York.

WIPING THE PLATE

Just as it takes more than a good voice to "put across" a song (style, phrasing, and personality, for example), it takes more than a good drawing to create an exciting intaglio print. The tools, the type of ground, the acid-biting skill, the paper used—all contribute to the final effect. An artist can also be inventive in the way he inks and wipes his plates: the drier the plate surface,

the more brilliant the contrasts between paper and the printed ink lines in the actual impression. Normally, to achieve this crispness, the artist left ink only in the lines incised below the plate surface and the surface itself was wiped clean. However, Rembrandt, ever the iconoclast, preferred to leave a film of ink here and there, wiping the plates so expressively that many impressions are valued as one-of-a-kind examples. The sharp

white of a face, where the plate tone was wiped clean, gleams against shadowy areas that Rembrandt achieved by hand-rubbing ink on his plates to create painterly contrasts. Later, James Abbott McNeill Whistler exploited the same painterly effects of surface inking (fig. 153) and wiping while working in a hotel room on his famous first *Venice Set* of etchings. Whistler, possibly finding the facilities (a tabletop) unconducive to careful acid-biting of the overall plate area, focused his drawings at the center of the metal. To pull the "unfinished"-looking image together, he unified it with a soft overall background tone by leaving a light film on the surface of his plates when he wiped the ink off to ready the metal for printing.

INTAGLIO COLOR PRINTING

Well into the twentieth century, most intaglio prints were made in tedious black and white. However, color had been used in etching and engraving in Holland by the late seventeenth century. The French called this early form of color printing *à la poupée; poupée* is the French word for the cloth or ball of paper with which colors are rubbed into different lines of the plate. In this way several colors were applied to a single plate. By the eighteenth century, the modern custom of using a separate plate for each color in the final impression had been introduced. Separate plates distinguished one color from another with a crispness impossible to obtain by use of a *poupée,* but it also introduced the problem of color registration. First, one color is printed on all the sheets. When this dries, the same sheet must be rerun through the press for the next color. Intaglio prints are made on damp paper, which stretches when wet and contracts when dry. Retaining exact paper size for each new application of color so that the color falls in exact registration with

the one before it is a tricky business. Some artists cut their plates into sections with a jigsaw, ink and wipe each piece separately, then reposition the inked pieces to facilitate one-step printing.

Stanley William Hayter resurrected the term *intaglio* and generated a new experimental attitude toward a medium that had come to seem prosaic and musty. Color became a major factor in prints with the development of color lithography at the turn of the century, calling attention to the decorative and painterly possibilities in the graphic medium. A chemist and geologist before turning to printmaking in 1926, Hayter brought his scientific orientation to the Paris studio he opened in 1933. Atelier 17 was soon a hotbed of experimentation. Most importantly, Hayter developed ingenious methods for applying several colors to a single plate that bypassed registration problems. Knowing that one could produce lines of varying depth in a plate simply by exposing the metal in acid for different lengths of time, Hayter exploited the dissimilarities of printing

154. **Stanley William Hayter** (1901–). *Undersea.* Engraving. Courtesy Sotheby Parke Bernet Inc., New York.

inks as well. By using inks of varying density, he could roll several colors onto a single plate without one's muddying into another, since their different viscosities kept the inks isolated. The softness or hardness of the ink rollers presented additional options: Hayter used a soft roller to press ink down into the most deeply bitten lines and harder rollers to skim along the surface-level lines in the plate. Hayter's images (fig. 154) are rooted in a Surrealist belief in automatism, allowing pencil, paintbrush, or etching tool to move without conscious guidance by the artist. He would begin a composition without a structured design, permitting the burin and his subconscious to interplay and develop the initial form. Later, Hayter searched out the idea in these "accidental" patterns and elaborated on it.

155. **Edgar Degas.** *Ludovic Halévy et Madame Cardinal.* c. 1880. Monotype. 8¼″ x 6¼″. Courtesy Sotheby Parke Bernet Inc., New York.

MONOTYPE: EXCEPTION TO THE RULE

There is nothing to stop an artist from pulling only one impression from his master image, but the term *print* usually connotes a picture that exists in more than one example. The monotype is the only printmaking procedure that normally produces only a single impression from the master image (fig. 155). To make a monotype, the artist paints his picture on a nonabsorbent surface such as glass, in either paint or printing inks. He places paper over the painted image and applies pressure by hand or through a press. The master image is "destroyed" by this single printing, making additional sharp impressions unlikely (which is why the process is called *mono,* which means one). The artist may, of course, pull a second, less defined, impression and rework it with pastel or paint as Degas often did.

Generally, the invention of the monotype is credited to the Italian painter and etcher Giovanni Benedetto Castiglione, born in 1616. Monotype remained a relatively obscure medium for two hundred years until Degas's friend the Vicomte Ludovic-Napoléan Lepic developed his method of *eau forte mobile,* which had the effect of making every impression in an edition unique. Lepic varied the density of ink on his printing plates in a manner that altered the weather, the season, or the mood of the landscapes he etched. Rembrandt and Whistler had also modulated ink-

ings of their plates to create tonal variations in individual impressions, but it was Degas who actually pioneered many of the innovative techniques we associate with modern monotypes: finger-painting the master image, applying textures to the paint, rubbing, and working spontaneously without a preplanned concept. Degas exhibited his monotypes, many augmented with pastel, in the Third Impressionist Exhibition of 1877. Between 1874 and 1893, he made approximately four hundred examples in the medium. The monotype may have fascinated Degas because of the tentative, almost "fleeting" painterly image it produces, an image that teeters on the edge of realization like a half-remembered event. Pulled without the intercession of cutting tools, acids, or mechanical devices, the monotype lies somewhere between a print and painting. The entry blanks of many print exhibitions continue to exclude the medium.

QUESTIONS PEOPLE ASK

1. *Can the artist "erase" areas he doesn't want after they have been bitten into the plate with acid?*

Yes. He does this with a scraper tool and then burnishes the surface to a smooth polish with engraver's charcoal mixed in water. Scratches are also removed this way. Once smoothed, the area can then be reworked.

2. *Why are copper plates more popular for intaglio printing?*

Zinc yields fewer good impressions, particularly with drypoints, in which impressions become faint very quickly. By *steel-facing* a copper plate, the artist can extend its life. Steel facing, introduced in the mid-1800s, is a process for electroplating a thin layer of iron over the copper to make it more durable. According to William M.

Ivins, Jr., the artist Seymour Haden regularly steel-faced his plates, permitting him to print successive editions from some of them for as long as thirty years.

3. *How does the artist bite different types of lines and textures to achieve variations in his image?*

By using "stop-out" procedures. Stop-out varnishes protect areas that the artist wants to remain unchanged from further etching in the acid. With these areas covered, the artist can proceed to bite other areas.

4. *When someone calls an intaglio print a "good impression," what does he mean?*

Intaglio plates wear down under repeated pressure from the printing press. They get thinner. Lightly bitten lines become even shallower, holding less and less ink until, eventually, they disappear and don't print at all. Since these lines often carry the subtleties and details that enrich the overall impression, the image loses some of its original character and becomes "flat." To realize the enormous aesthetic loss that can occur, one should compare an early, fresh impression with one taken from a worn plate. If you live near a museum or a university collection that contains old master prints, it may be possible to arrange to examine the same image in an early and a late impression.

5. *Why is it that more early engravings have survived than early woodcuts?*

Single-sheet woodcuts of the fifteenth century were the calendars of their day and were treated just as casually as we treat ours. They were tacked to the wall or pasted up with wax. If the elements didn't destroy them, they were eventually discarded. Engravings, since they were more costly, were kept safely in books or boxes, and therefore more of them have survived.

COMPARATIVE INTAGLIO LINE CHART

156. Example of engraving.

158. Example of etching.

160. Example of mezzotint.

162. Example of soft-ground.

157. Example of drypoint.

159. Example of aquatint.

161. Example of sugar-lift.

163. Example of inkless intaglio.

INTAGLIO PRINTS AT A GLANCE

TYPE OF PRINT	HOW IT LOOKS	HOW IT'S MADE
ENGRAVING	(*fig. 156*)	Lines cut into plate by hand with steel burin or graver. No acid used. Metal displaced in cutting smoothed with scraper. Makes crisp, meticulous line.
DRYPOINT	(*fig. 157*)	Line scratched into plate with diamond needle held like pencil. No acid used. Tool throws up "burr" on either side of line as it cuts. Ink fills lines and sides of burr, producing a "furry" thick line when printed.
ETCHING	(*fig. 158*)	Plate covered with "ground" that resists acid. Image drawn into ground with sharp tool, which exposes metal. Exposed areas (the drawing) bitten in acid. Acid "eats" image lines below original plate surface. These incisions hold ink.
AQUATINT	(*fig. 159*)	Technique for creating tonal areas. Surface of plate sprinkled with powdery resin. Acid bites into metal wherever it is unprotected by resin particles. These closely spaced indentations hold ink and print as tones.
MEZZOTINT	(*fig. 160*)	Surface of plate pocked with tiny, closely spaced indentations made by roulette. These hold ink and print as solid black. Plate is scraped or burnished smooth to achieve white and highlight areas, from which forms take shape.
SUGAR-LIFT	(*fig. 161*)	Image painted directly onto plate with water-soluble sugar solution. Plate grounded and placed in water. Water causes sugar solution to dissolve and swell, lifting up ground over it. Exposed area is bitten in acid and drawing "eaten" below surface of metal.
SOFT-GROUND	(*fig. 162*)	Mixture of regular etching ground and suet that remains malleable. Artist places thin paper over the soft-ground plate and draws (or presses an object) into it. When paper is removed, the pressed areas lift up, exposing the metal, which is then bitten in the standard manner.
INKLESS (EMBOSSED) INTAGLIO	(*fig. 163*)	Plate grounded and deeply bitten as in etching but run through press without inking. Dampened paper sucked into uninked indentations. Image appears embossed when paper is pulled off plate.

6

"sieve" printing: the stencil process

With the introduction of nonobjective subject matter and abstraction in art in the first decades of the twentieth century, artists were freed from the restriction of making only "likenesses." They began to investigate the vocabulary of art in its purest terms: line, form, color, and composition. Uncamouflaged and undiluted by representational connotations, these elements could now be explored independently. The *color* red, rather than the red *dress,* engaged the viewer's attentions. This was a dramatic departure. For centuries, images had been viewed merely as simulations of the real world, as surrogates, rather than as autonomous objects with distinct features of their own, like a chair or a hat. By subjugating the distractions and visual seductiveness of representational subject matter, abstraction isolated for public scrutiny the basic ingredients underlying all good artwork, whatever its outer style.

164. Silk screens

165. **Saul Steinberg** (1914–). *The Matisse Post Card* from *Six Drawing Tables* portfolio. 1970. Lithograph. 22″ x 30″. Courtesy Impressions Workshop, Inc., Boston.

Wassily Kandinsky, the artist most often identified with the introduction of abstraction, recognized that the same fundamental principles applied in art, whether abstract or representational. But Kandinsky was well aware that in a bad realistic picture there is always the consolation of reproduced reality, whereas in a bad abstraction one faces the utter despair of a purely decorative experience, or the blunt absence of spiritual value, unsoftened by things we can recognize. The widespread popularity of silk-screen prints since the 1960s arose from a number of factors, not the least of which is connected with

the exploration of the pure language of art that began earlier in this century. In particular, screen printing is a medium unusually well suited to the investigation of color and our perception of it (pls. 11, 14, 15).

Screen printing is a *neutral* process, the Lon Chaney of the graphic artist. Unlike most other print mediums, screen printing does not leave any characteristic markings of the process on the image, such as the grain of the wood in a woodcut, the bite of the acid in an etching, or the grease crayon of a lithograph (figs. 79, 165). The visible signs of the "craft," and the artist's dex-

166. **Richard Lindner** (1901–). *Room for Rent.* 1970. Screen print. 41" x 29".

two groups of contemporary artists in particular: those working with color problems and those concerned with the cultural implications of mass-media-made images for society's values and perception of reality.

The silk screen first earned its respectability as a major print medium through association with the impersonal style and brightly heraldic-type images of artist Robert Indiana (pl. 12) and the color explorations of Auguste Herbin (pl. 13), Josef Albers (pl. 14), and Richard Anuszkiewicz (pl. 15). These works, loosely categorized under the heading of *hard-edge art*, rely heavily on color as a crucial component. Artists such as Herbin, Albers, and Anuszkiewicz sought a pure, uncontaminated confrontation between viewer and color experience. Even in their paintings, such artists strove to eliminate their personal "handwriting," preferring the anonymous style of flat color, devoid of cosmetic distractions such as brushstrokes, textures, or idiosyncratic drawing styles. Screen printing suited their needs ideally. The viewer could be presented with a direct optical color sensation devoid of stylistic intrusions by artist or print medium.

"Color is the message," said Richard Anuszkiewicz:

> *Shape and form are dependent on what I am trying to say with color. Silkscreen is the medium that gives the greatest deposit of pigment on the surface of the paper. I usually butt warm colors against cool colors: red against green, yellow against purple. You need opacity when colors touch like that because you have to overlap them a little to protect yourself against white gaps that are caused in the printing when the paper shrinks or stretches. To overlap you need opacity, so that one color doesn't come through. Lithography, on the other hand, is a very transparent process and you could work with the elements of transparency in that medium.*[22]

terity in the "mechanics" of manipulating it, are completely subservient to the personal style of the artist using the process, and are capable of impersonating stylistic modes as autographic as that of Richard Lindner (fig. 166), which clearly discloses the distinct and highly recognizable drawing style of the artist, or more impersonal and anonymous approaches in which the artist's personal gesture becomes secondary, even undetectable. The medium's anonymity and ability to assume many faces often distress traditionally oriented printmakers.

For many years curators would not admit such prints into official exhibitions. But the screen print's lack of characteristic markings enticed

167. **Eduardo Paolozzi** (1924–). *The Silken World of Michelangelo* from *Moonstrips Empire News* portfolio. 1967. Silk screen. 15″ x 10″. Courtesy Editions Alecto, London.

168. **Eduardo Paolozzi.** *Tortured Life* from *As Is When* portfolio. 1965. Silk screen. 32″ x 22″. Courtesy Editions Alecto, London.

169. **R. B. Kitaj** (1932–). *The Good Old Days* from *The Struggle in the West* portfolio. 1969. Screen print and collage. Courtesy Marlborough Fine Arts, Ltd., New York.

Colorists found the neutral characteristics of screen printing an aesthetic bonus. The Pop artists, whose imagery perhaps more than any other dominated the coming of age of silk screen in the 1960s, found the medium compatible for other reasons.

Screen printing had an extensive history of commercial application, and to a great extent, this commercial association had given the medium a black eye with serious printmakers. Between 1900 and the 1930s, the silk screen was widely used as an inexpensive reproductive procedure for churning out pedestrian items such as posters, highway signs, decals, pennants, box labels, and the like. The subject matter of Pop art drew from precisely the same sources: the mass-produced products and repetitive, impersonal imagery of a consumer- and media-oriented culture.

The artist–commentators of Pop art extricated, transformed, and recapitulated into the art lexicon the daily experiences shaping popular culture and values. What had the meticulous, "hand-crafted-ness" traditionally revered by printmakers to do with the impersonal, machine-made icons of pop culture: the spate of news photos, television images, movies, labels, advertisements, assembly-line carbon-copy clothes, and products that saturated modern life? Artists chronicling mass culture, such as Richard Hamilton (pl. 16), Eduardo Paolozzi (figs. 167, 168) and R. B. Kitaj (fig. 169), naturally responded to a graphic process capable of paraphrasing the detachment and the commercial tenor of contemporary experience.

Photographic techniques had been incorporated into commercial screen printing since 1916, but its conversion to artistic ends occurred only in the 1960s, when Robert Rauschenberg introduced silk-screened images into his painted canvases. He used the printed-on photographic picture element as a brushless form of painting, but even though the color in which it was printed acted as a formal painterly element in the composition, the character of the printed image added a distinctly twentieth-century "media" element to the picture (fig. 38). The transposition of such already-existing images from newspapers, television, history books, film, and the like was adapted to prints, and it remains one of the more innovative contributions of Pop art to the iconography and techniques of modern graphics.

Ultimately a technique is only a tool, screen printing no more and no less than a pencil. But however well the artist's hand drawing of anything may resemble the original subject, the act of drawing itself imparts a wholly new and reconstructed character to the original source material. The neutrality of screen printing, on the other hand, allowed Pop artists to "borrow," intact and unaltered, not only the mass-produced images of

170. **Richard Hamilton** (1922–). *My Marilyn.* 1965. Screen print. 20⅜" x 24⅞". Courtesy The Museum of Modern Art, New York; Joseph G. Mayer Foundation Fund.

popular culture but the actual visual identity of mass-printed materials themselves.

Andy Warhol's *Jackie* (fig. 37) is based on a widely circulated photograph of Jacqueline Kennedy at the time of President John Kennedy's assassination. For those living at the time the media reported the event, the picture has become a telegraphic symbol of *tragedy*—but tragedy once-removed, experienced by millions of people indirectly through such photographs and, basically, more of an "image" experience than an actual one. Richard Hamilton's *My Marilyn* (fig. 170) is similarly powered less by our knowledge of Marilyn Monroe the person than by Monroe the actress and cultural symbol: a love goddess. Hamilton's print is an image of an image and, like a large proportion of modern man's experience, is more symbolic than direct.

A number of contemporary printmakers have specifically zeroed their attention in on the reproduction systems that spew out society's mass imagery (for example, television and films). The conventional relationship between artist and medium is reversed in such explorations. The artist relinquishes total control over his image-making tools in favor of what might be called an exploration–collaboration. His purpose is no longer the traditional one—the expression of his own ideas —but is rather to permit the mass-media reproductive process itself to play a part in defining and shaping his artwork. Richard Hamilton based his screen print *I'm Dreaming of a White Christmas* (pl. 16) on a 35mm film frame from the movie *White Christmas*. Using technical procedures such as separation drawings, conversion to halftone, and step-method exposure photography, the artist altered the original film frame. Only one or two elements from the original film remain intact (for example, the window on the left), yet we continue to experience the picture as a reproductive image—rather than as an artist-made one.

"No other graphic artist, with the exception of Eduardo Paolozzi, has so completely identified printmaking with other forms of reproduction," states an exhibition catalogue of the artist's works. "Some of Hamilton's prints look so much like their prototypes that one is forced to make an effort to detect the artist's role."

Hamilton pursued his investigations of the reproductive picture in *People* (fig. 171). The image derives from a detail in a photographic postcard of an English beach. A segment of the picture was enlarged and then altered by the artist with four separate screen printings as well as collaged and hand-painted sections. Hamilton explained in the exhibition catalogue:

> *This is one of a series of explorations into the breaking point in legibility of a photographic image degraded by enlargement. . . . It was a search for this moment of loss that became the true subject of the series. . . . When viewed from a distance [the print] appears thoroughly informative in a photographic sense. . . . Closely, the*

171. **Richard Hamilton.** *People.* 1968. Photograph with additions in screen print, collage, gouache, and lettrascreen. 15¼″ x 23¼″. Courtesy Petersburg Press Ltd., London.

172. **Henri Matisse**
(1869–1954). *Icarus*,
Plate 8 from *Jazz*, pub-
lished by Tériade for
Éditions *Verve*, Paris.
1947. Pochoir (screen
print). Sheet size:
16⅝″ x 25⅝″; image
size: 16¼″ x 10¾″.
Courtesy Sotheby
Parke Bernet Inc.,
New York.

*image disintegrates into an assemblage of discrete
surface qualities which seem totally unrelated to
the information at photographic level. . . . In
other words it becomes progressively abstract.*[23]

Hamilton's preoccupation with mass-media im-
agery goes further than a twentieth-century ob-
session with technology. If media images are
indeed a major vehicle through which people to-
day "experience" life, then exploration of this
media-made reality—how it can be controlled, dis-
torted, and manipulated—is as artistically per-
tinent as the earlier Impressionist disclosures of
how color and light shape man's direct perceptions
of reality.

Although it has been called the most "paint-
erly" of the print processes because of the thick,
opaque deposit of paint it drops on the paper's
surface, screen printing did not win acceptance
in artistic circles easily, nor was it the first time
that printmakers had turned their backs on a
medium. Lithography faced the ire of British
aquatinters, who sought to prevent the Bavarian
limestones needed to make lithographs from en-
tering England by demanding the imposition of
heavy government import duties. Like the detrac-
tors of silk screen, they considered lithography a
second-rate medium compared with engraving and
aquatint.

The term *serigraph*, a synonym for *silk
screen*, was coined during the 1930s (reportedly
by Carl Zigrosser), when artists working under
government-supported WPA programs began to
explore the medium seriously. It was hoped that
the term *serigraph* would separate the commercial
applications of the process called *silk screen* from
that process as used in fine art. Since synthetic
meshes have generally replaced silk fabrics, the
term *serigraphy* (*seri*/"silk," *graph*/"drawing")
is already an anachronism. However, popular
misrepresentations to the contrary, the terms
serigraph, *silk screen*, and *screen print* are inter-
changeable names for prints made by the *stencil
method*.

The stencil method is the least technically
complex of the printmaking processes, requiring
simple equipment and comparatively less me-
chanical know-how. The youngest of the print
mediums to be adopted by artists, the stencil
method is also one of the oldest techniques known
to man. Our ancestors left a record of themselves
in the form of stencil method when they spread
their fingers against cave walls and outlined the
hand form in vegetable colors. Decorative stencils
have long been used to imprint designs on fabrics

112

and to embellish furniture and wallpapers. Many early playing cards, printed first as black-and-white woodcut images, were later colored with the help of stencils to speed up a process that could be time-consuming by hand.

The basic premise underlying the stencil method is the same one that makes a simple school alphabet-lettering stencil work: the shape (the letter *A*, for example) that you wish to print appears as a cutout form in the paper stencil. The area around the cutout *A* is solid, so that no color can pass through. When a crayon or paint is applied over the *A* opening, the color drops through to the paper below, duplicating the shape of the *A*. Because of the way in which the color drops through the openings in the stencil material, the Germans called the process *sieve printing*.

Henri Matisse's exuberant series of prints for the book *Jazz* (fig. 172) were produced by a very simple open-stencil method like the school stencil process. When Matisse became bedridden in the early 1940s, he had great difficulty in manipulating a paintbrush. Instead he worked with large cutout forms shaped from sheets of paper that he painted in brilliant colors. The *Jazz* images are derived from these designs. Stencils were created from the shapes of Matisse's cutouts, and the same luminous paints used to cover the original sheets of paper were brushed through the openings in the stencil. The French call this method *pochoir* printing.

Modern screen printing is far more involved. Its precise origins are vague, but many believe that the technique traces back to an ancient Japanese and Chinese stencil system used for printing particularly delicate designs. If the *A* shape on our school stencil had been made of skinny, spidery openings, holding the form in position while coloring over it would have presented a problem. To stabilize such fine linear details, or an element

intended to float "free" in a final design, the Orientals devised a special support system, which is probably the prototype for our stencil process. They held the fragile design details in their paper stencils in position by constructing a network of silk threads to brace the forms or by using fine human hairs glued between double sheets of thin stencil paper. This armature of threads or hair was sometimes formed into a fine grid pattern. When the design was printed onto silk, the grid became invisible and lost in the weave of the silk itself. The idea of using silk rather than paper as the stencil material may have been suggested by the way in which the supporting grid fused with the silk texture.

Screen printing can be used to apply an image to almost any material: paper, glass, wood, fabric, metal, cardboard, and so on. One may draw directly onto the silk (called the *screen*), or one may print or transfer a collage or a photographic image onto it. The basic components of the screen print are the stencil, the screen, and the squeegee.

THE SCREEN. This is a piece of silk or synthetic mesh tautly stretched on a wooden frame.

THE STENCIL. The stencil is a material made up of positive and negative areas and carries the design elements. The positive areas are open and allow color to pass through onto the paper. The image is carried by these open parts of the stencil. Negative areas "block" the paint from reaching the paper.

There are a number of ways to create the negative and positive areas. One is to apply a filler substance (for example, lacquer, glue, or shellac) directly to the silk. This seals the parts of it that the artist does not want color to pass through. The areas left unsealed are the design. The same effect is also achieved by sheets of precut acetate film adhered to the silk. The openings are cut into the acetate beforehand, and then the acetate is

fused onto the silk. Acetate is preferred when the design requires meticulous geometric precision, as in the example by R. Rand (pl. 11).

THE SQUEEGEE. This is the tool used for screen printing (fig. 179). The squeegee has a rubber or plastic blade. Harder or softer consistencies of rubber create different deposits of paint. The heavier the pressure on the squeegee, the thinner the deposit of paint on the paper.

BASIC STEPS IN THE MAKING OF A SCREEN PRINT

The serigraph, *Conjugation on Orange* (pl. 11) by R. Rand (1974), was made with a hand-cut acetate film (figs. 174-180).

Cutting the stencil. The artist places her template (model) for the design under the transparent acetate film and cuts out the shapes she wishes to print. Generally a separate stencil is made for each color in the final print. The knife cuts through the upper layer of the stencil material but *not* through the vinyl backing to which the acetate is laminated.

The area to be printed is "opened" when the cutout is peeled away from backing.

The acetate stencil is adhered to the underside of the silk screen with adhering liquid. The stencil "melts" into and fuses with the silk. Adhering fluid is applied to small areas at a time and is dried quickly with a rag. Too much liquid would dissolve the stencil material rather than fuse it.

The vinyl backing behind the stencil is peeled away. The portion of the film stencil carrying the design remains adhered to the silk.

Paper is positioned under the screen.

Paint is pulled across the screen with a squeegee. Color drops through the open areas in the stencil and drops onto the paper.

First color in place. The procedure is re-

peated for each color in the completed print (pl. 11).

HOW THE STENCIL IS MADE

An artist may follow one of two approaches in creating the stencil that will print his image. He may create the design directly on the screen itself, or he may use an indirect technique, in which the design is first created on another material and later adhered to the screen. Both of these approaches can be combined in a single print.

DIRECT METHODS FOR MAKING A STENCIL

1. *Simple block-out (or stop-out):* A sub-

173. Screen with acetate stencils.

174. Cutting the stencil.

175. Opening the image areas in the stencil.

178. Stencil in position for printing.

176. Adhering stencil to the screen.

179. Application of color with a squee-gee

177. Peeling the protective acetate off the stencil.

180. First color in position.

stance such as glue or water is painted directly onto the mesh screen. The areas that the artist does *not* want to print—where he wishes to block out the paint from getting through—are covered. Areas left unblocked, carry the image and allow paint through.

2. *Glue washout and lacquer:* The artist paints his design onto the silk with glue. When the glue dries, he coats the *entire* screen with an opaque lacquer filler. After the lacquer dries, water is applied to the underside of the silk screen. As the artist rubs the silk with water, the glue on the screen (the painted design) softens. This causes the lacquer over it to break. Both the glue layer and the lacquer over the glue pull away, leaving the design areas originally painted with glue open. The remaining portion of the screen is undisturbed and still lacquer-sealed.

3. *Tusche washout* (*glue/tusche method*): This method is based on the natural antagonism of a substance that dissolves in water and one that is impervious to water but will dissolve in turpentine. The latter, a waxy substance (liquid wax, lithographer's crayon, liquid tusche, asphaltum varnish), is used to draw the image directly onto the screen. Then the water-soluble substance (for example, glue) is coated over the *entire* screen. This coating is unaffected by turpentine. The artist washes out the waxy areas (the design) with turpentine, which opens these areas on the screen so that the paint can flow through. The remaining sections remain blocked out with the glue sealer. One advantage of this technique is that the freedom and spontaneity of the artist's original drawing line remains intact and visible (see fig. 79).

4. *Maskoid and water-soluble filler:* This is a system similar to tusche washout (above), except that this is a commercially sold synthetic latex that is immune to water and alcohol when dry. The artist draws his design onto the screen with the Maskoid, then coats the *entire* screen with glue and allows it to dry. The art Maskoid

area (the design) is then erased with a piece of natural rubber, leaving openings for paint to flow through. The glue remains everywhere else as a block-out.

INDIRECT STENCIL-MAKING METHODS

1. *Paper stencil:* Shapes the artist wants to print are cut out in an overall sheet of paper, which becomes the stencil and is then adhered to the screen frame. The images can be torn in the paper, rather than cut, to create soft edges. In the Orient, a method of acid drawing is used to make a stencil. The artist draws with an acid ink that eats through the paper, creating open areas. This stencil is then attached to the silk for printing. Paper stencils lose their sharpness quickly and are not good for large editions.

2. *Cut-lacquer film stencils* (see "Basic Steps in the Making of a Screen Print," page 114).

3. *Photographic stencil:* There are a number of ways to make a photographic stencil. What is worth remembering is the principle that makes them all work: a gelatin that hardens when exposed to light. Generally an indirect stencil-making approach is followed in the making of photostencils. The artist places a photographic "positive" (for example, a snapshot or a drawing) over a piece of light-sensitive gelatin film affixed to a transparent mylar backing. The emulsion side of the "positive" faces the emulsion side of mylar film. The duo are exposed to light, which passes through the *non*opaque portions of the photograph, causing the gelatin film under those areas to harden. Since the light cannot pass through the opaque areas of the photograph or drawing, the gelatin under these areas remains soft and washes away in water or solute when the film is later developed. Wherever the gelatin washes away, the area will be open. When the transparent mylar backing is removed and the stencil is adhered to the screen, paint will pass

through these openings. What was opaque in the photograph or drawing—say, an eye or lips—is now an open area on the film stencil. Everything else is solid block-out. Photographic stencils can be used alone or in combination with other stencil-making methods.

TRANSPARENCY AND OPAQUENESS

Anyone who thinks screen printing is simply a matter of printing one color next to or over another once the stencils are ready should have a long talk with Richard Anuszkiewicz, whose portfolio *Sequential* (pl. 15) required twenty-one color proofings. Perhaps the most crucial step in achieving a superb multicolor screen print is the choice of the *sequence* in which colors are to be printed. The artist must anticipate and juggle optical surprises resulting from the fact that some colors are transparent and others opaque. Printing a blue circle over a yellow field of color, for example, is not as simple as it sounds. If the yellow is an opaque color and the blue a transparent one, the circle will appear not blue but as a mix of the yellow and the blue, namely, as green. To solve the problem, the artist would have to cut his yellow stencil with an opening so that the blue circle could be dropped in at a later printing. Dropping in the blue in an edition of prints raises the problem of registering the circle exactly inside the opening on each impression. Color sequence not only affects registration and how stencils are cut but also color and form crispness in the viewer's eye. In most screen prints, the juncture at which different colors appear to touch actually involves a slight overlapping of colors. Opaque colors are usually planned as the top color so that they do not peek through and disturb the eye or muddy what should be a clear tone.

Color effects are influenced by ink opacity, by transparency, and by the quality of the paper or material surface on which the artist is printing. How a surface absorbs or reflects light can increase, diminish, or alter our perception of a color. There is no color without light. To understand this, imagine a platinum blond in bright sunlight, then inside a room with barely any light, then in total darkness.

The screen-printing artist has perhaps the widest assortment of inks available in all printmaking (fig. 181). He can achieve opaque effects, mat or glossy finishes (pl. 17), fluorescent or metallic colors. In their book *The Complete Printmaker*, John Ross and Clare Romano divide the inks into two major types: (A) Those that dry by evaporation or oxidation and (B) those that dry by polymerization and by penetration.

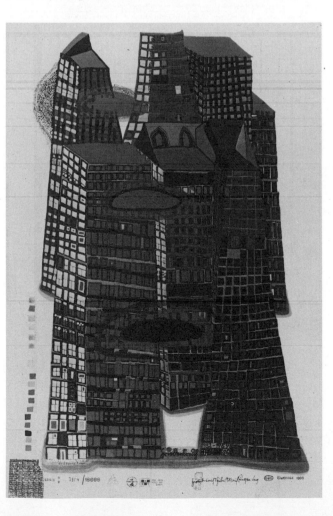

181. **Friedensreich Hundertwasser** (1928–). *Good Morning City, Bleeding Town.* 1970. Embossed serigraph. 30⅛″ x 19½″. An edition of 10,000 prints was made, with 200 variations; 2,000 of them with metal imprinting and phosphor inks. The artist includes formulas for the color variations in the edition in the chart at the lower left of the impression. A total of 18 colors were used. Calling attention to the collaboration between modern technology and the artist, Hundertwasser includes the trademarks of all the participating companies involved in the print's production; a practice similar to the notations one sees on Japanese woodcuts to specify publisher, artist, cutter, and collector. Courtesy Carus Gallery, New York.

117

A TYPE

Evaporation: The solvents carrying the color pigment evaporate during the drying process, leaving a film of color pigment on the paper. Most artists opt for some type of poster-paint color that dries this way. Such paints take from fifteen minutes to an hour to dry, depending on the paper and the atmosphere.

Oxidation: A slower drying process because it occurs in two steps. The solvents evaporate during drying. Then chemicals in the pigment oxidize (much as a metal pipe rusts from exposure to air), leaving the dried color. Enamel inks require from six to twenty-four hours' drying time. An interesting effect is that the shiny "wet" quality of paint is retained by enamel colors even after drying.

B TYPE

Penetration: These inks are designed to dry by absorption into the printed surface. Extremely fast-drying inks are favored for commercial screen printing on wallpapers, fabrics, and signs.

Polymerization: Most effective on glass, tile, plastics, and metals. Rarely used by artists. A formulation of ink from epoxy, resins, and sometimes a catalyst, which is usually heat dried.

QUESTIONS PEOPLE ASK

1. *How does an artist create a look of different textures, such as wood, on a screen print?*

There are a number of ways. One is photographically. More commonly the artist places a piece of textured wood under the mesh screen and rolls over it with a glue mixture. The glue adheres to the screen wherever the texture of the wood is raised. A regular stop-out procedure (see page 114) can then be followed. The glue can also be applied directly to the textured surface (even to a piece of crumpled netting) with a roller. A piece of paper is then placed over the glue-covered textured material, and the design is transferred to it, creating an "offset" of the design. The design is then rubbed onto the silk screen from the offset paper. Some artists prefer to use a greasy lithographic crayon to transfer textures directly onto the silk, by placing the object under the screen and crayoning over it as one might do in taking a rubbing of a coin.

2. *How is the master image canceled in screen printing so that no further impressions can be pulled from it?*

The design is "washed-out" with a solvent, which removes the stencil forms (the design) and leaves the mesh entirely open for the application of a new image.

3. *What types of paint does an artist use in screen printing?*

Many kinds, ranging from enamels, vinyl inks, and acrylics to regular artist's oils, poster colors, fluorescent inks and toners (concentrated inks) that create transparent effects.

4. *Can tonal and shading effects be achieved in screen printing, or is the process only for solid, flat, hard-edge designs?*

Screen printing can achieve many subtle effects, including tonal quality. One way tonal effects can be achieved is to apply glue block-out to a *dampened* silk screen. The moisture dilutes the glue, creating tiny pinholes in the stencil. These pinholes in the block-out allow small amounts of paint to seep through. The paint falls onto the paper in small dots, forming what appears as a shaded area. Because the medium does not impose any characteristic markings of its own, screen prints are capable of giving the artist a variety of quite different effects, from soft to hard.

When the caterpillar asks Alice in Wonderland, "Who are you?," a perplexed Alice replies, "I hardly know, Sir, just at present—at least I know what I was when I got up this morning but I think I must have changed several times since then." A similar dilemma confronts the collector of contemporary prints. No sooner does he feel secure in his ability to distinguish an etching from a lithograph, aquatint from sugar-lift, and the many hybridizations thereof, than he encounters an unorthodox example like Claes Oldenburg's *Tea Bag* (fig. 182), a giant vacuum-formed plastic teabag filled with twenty cups of kapok, or the photographic permutations of Richard Hamilton (pl. 16), or the *Cardbird* inventions of Robert Rauschenberg (fig. 183).

Modern technology, freely borrowed from industry and the science laboratory, is no stranger in today's printmaking workshop. In fact, the exploration of technology, from the commercial offset press and photography to vacuum forming and computers, is one of the identifying marks associated with the *contemporary* print. But prints that are merely a result of clever craftsmanship—whether hand-executed or technologically assisted—are not enough to explain the widespread popularity of "unorthodox" contemporary print images. "What interests me," Jasper Johns has said, "is the technical innovation possible in printmaking."[24] More than any other art medium, printmaking emulates modern industry in its emphasis on experimentation and invention. Today's graphic artist has access to a wide range of tools, machinery, and processes, a "creative technology" that he exploits with the enthusiasm of an inventor. Indeed, the print can be called the art world's most relevant counterpart to the twentieth century, echoing not only the technological concerns of our age, but also the prevalence of duplicated imagery in our culture.

The pictures of contemporary society characteristically appear in multiple form: replicated

7

the uncertain image

182. **Claes Oldenburg** (1924–). *Tea Bag.* 1966. Serigraph printed on felt, Plexiglas, and plastic with cord. 39⁵/₁₆″ x 26¹/₁₆″. In his book *Printmaking Today*, Jules Heller quotes the artist's reasons for selecting a teabag as a subject. ". . . I often drop the bags I use when drinking tea, and the effect is that of a 'print' . . . I always try to establish a corresponding effect outside art for what I do in art." Courtesy Ruth O'Hara.

over and over again on television screens, in films, on billboards, on the front pages of hundreds of newspapers. More than the single painting or drawing, the print parallels the images, objects, processes, and premises from which twentieth-century life-styles emanate and by which our culture will one day be characterized. This innate capacity for speaking a twentieth-century visual dialect enabled graphics to escape the confines of the drawing-room print cabinet and exert a powerful impact on contemporary art. It also created problems for the collector.

As "spokesmen" for their age, many contemporary prints, intentionally or accidentally,

lead us into a perplexing terrain in which artistic and societal considerations overlap. This correlation produces iconography that is both baffling and strange to our eyes: the uncertain images of a century marked by uncertainties. Confronted with images that don't "make sense" along expected lines, we often feel duped and disappointed. In our irritation, we demand a clear-cut definition of the artist's purpose, a finite explanation of what is, and what isn't, art. In short, we find ourselves grappling with two of the most aggravating questions in all of modern art.

The influx of major contemporary painters such as Jasper Johns and Robert Rauschenberg into printmaking in the late 1950s and early 1960s altered the grammar of the medium. The emphasis shifted from a preoccupation with the "how" of making traditional prints to concerns that lay at the core of the aesthetic issues then being explored in the mainstream of art: Abstract Expressionism, Pop art, Minimal art, Op art, and color-field painting. An innovative and antitraditionalist spirit spread through the art community generally, and this spirit infected not only the types of techniques used for making prints but, more importantly, the imagery as well. The new breed of painter–printmakers entering the field were undaunted by hard-and-fast ideas concerning what a print should or should not be. Either they were unaware of the medium's five hundred years of tradition, or they were so committed to experimentation that they had few compunctions about employing unconventional, even commercial, processes to translate their images into graphic terms. The image was the message, craft or technology merely its servant. Therefore, one must look beyond the fact that Oldenburg's *Tea Bag* was vacuum-formed and also ask: Why the teabag? Eduardo Paolozzi's use of computer-selected color variations

for his prints is a fascinating adaptation of technology, but why his images of Mickey Mouse (fig. 167)? One can appreciate James Rosenquist's use of the commercial offset press, but what is the meaning of the staircase in his lithograph *Off the Continental Divide* (pl. 7)? One can hardly imagine Toulouse-Lautrec making a print about a flashlight (fig. 201), yet that is the subject of major works by Jasper Johns. Clearly, discussion of the breakthroughs in the craft or methodology of the new wave of printmakers does not of itself put the collector in touch with the true impact of such deviations in the field. More edifying is an exploration of the attitudes underpinning and energizing large sectors of contemporary imagery and technique. Many of these attitudes took root in and trace their potency to earlier decades in this century when art first began to respond to the technological and commercial fallout of modern society. At a rate unprecedented in history, life changed. New realities and life-styles rolled off the assembly lines and out of the scientific laboratories faster than they could be absorbed. As though hurrying to find a footing in this radically altering social framework, art itself went through a series of cataclysmic visual upheavals: Expressionism, Fauvism, Futurism, Cubism, Suprematicism, Dada, Constructivism, and Surrealism. One after another, the new artistic insights shattered traditional patterns of seeing. Entrenched concepts of reality, and the artist's role in depicting it, crumbled. As in society itself, artistic certainties that had prevailed for centuries gave way to confusion: questions arose where the answers had once seemed self-evident.

A full discussion of the massive upheaval in thinking that occurred in the first decades of this century is beyond the scope of this book. However, some of our most powerful and puzzling contemporary prints become more intelligible viewed against the backdrop of aesthetic issues ignited earlier in this century, many of which are still in the throes of resolution. One offers art-historical connections hesitantly, aware that, at best, they are subjective and controversial and represent only one possible route to understanding. Ultimately, a work of art must be appreciated without "captions" and didactic explanation. However, this is not always as simple a matter with contemporary imagery as many people would have us think. Keeping this in mind, the reader will, I hope, follow James Thurber's admonition: "I show any and all thoughts to their seats whether they have tickets or not. They can be under-age and without parents, or they can show up without a stitch on: I let them in and show them the best seats in my mind."[25]

For centuries the basic imagery of art was

183. **Robert Rauschenberg.** *Cardbird IV.* 1970–1971. Collage print. 26″ x 28″. *Cardbird* elements include corrugated cardboard, reinforced sealing tape, hand-screened and photo-offset printing, and rubber stamping. Each piece was coated with clear matte acrylic polymer. Courtesy Gemini G.E.L., Los Angeles.

relatively simple to grasp. Art served the spectator as a surrogate for the visible world, *the world that man could see and touch:* a landscape, a bowl of fruit, people. Stylistic innovations might have generated controversy, but whether an artist depicted his subject matter mythologically, anecdotally, or naturalistically, his intent was essentially to mirror a likeness of the three-dimensional "real" world on his two-dimensional surface. The discovery of the rules of perspective in the Renaissance opened new possibilities for creating the necessary illusions of depth and space, further permitting the spectator to imagine that he was peeking through the window of the picture frame at an actual slice of life. In our own time, the film producer relies on much the same extension of our imagination to involve us in events occurring on the screen. We know it is only a movie, yet for the time we spend in the theatre, we respond as though witnessing a "real-life" situation. The movie illusion, also a surrogate for life, can often move us to genuine tears or wholehearted laughter through its deft representations of *commonly shared* realities. For hundreds of years, the "model" for Western art had been just such replications of the commonly shared, visible, physical world.

Anyone who takes a life-drawing class soon discovers that it is possible to create a surprising number of totally different images from a single pose of the model simply by sketching from various points in the room. The frontal sketch showing the model's face is no less accurate a reporting of the pose than a view from the rear, in which the face vanishes below the curve of the shoulder. Each shift in the sketcher's point of view changes his perspective and redefines the "reality" he observes and shares with us in his picture. Conceivably, then, one could line up the drawings of twenty students working from the same pose and discover, quite apart from stylistic varia-

tions, twenty factually different views of "reality," each of which would be valid.

For hundreds of years the "model" for Western art had been the world men could clearly see and touch: physical, visible reality. With French Impressionism, art began to move around the room to study new aspects of that "reality." The Impressionists investigated the effect of light on how people actually perceived color. It soon became apparent that the visible world was not as simple as it appeared on the surface. The green leaf admired from a park bench turned out, on closer scrutiny, not to be green at all but spots of blue and yellow that our eyes blended into green.

184. **Louis Marcoussis** (1883–1941). *Head of a Woman.* 1912. Drypoint. 11¼" x 8⅝". Courtesy Sotheby Parke Bernet Inc., New York.

Plate 1. **Jasper Johns** (1930–). *Figure 7* from *Color Numeral Series*. 1969. Lithograph. 38″ x 31″. Johns used an iron-on transfer reproduction of the *Mona Lisa* purchased with bubble-gum wrappers and 25¢. He transferred the image to the stone with a hot iron. Courtesy Gemini G.E.L., Los Angeles.

Plate 3. **Carol Summers** (1925 –). *Fonte Limon*. 1967. Woodcut. 33½″ x 24¾″. Summers's woodcuts are atypical examples of what the woodcut "looks like." The artist's special technique for applying ink submerges the character of the wood grain. The artist cuts out his shapes in plywood. A separate plywood piece is made for each color in the final print. Summers then places his thin Japanese paper over the *uninked* shapes and applies his ink *onto* the paper, diluting and spreading the color beyond the borders of the cut wood form so that the outline of the design appears softly diffused. To achieve color opaqueness, the artist prints a solid white on the rear of the paper, which blocks the ink from seeping through. Courtesy RCA Collection.

Plate 4. **Erich Heckel** (1883 – 1970). *Fraenzi Reclining*. 1910. Woodcut. 8⅞″ x 15⅞″. Courtesy Carus Gallery, New York.

Plate 5. **Pablo Picasso** (1881–1973). *Bust of a Woman with Hat.* 1962. Linocut. 25½″ x 21″. In 1958, at the age of seventy-seven, Picasso embarked on a new graphic medium, the linocut. Impatient with the laborious and creatively fragmenting process of making a separate block for each color, Picasso invented the reduction method of cutting and printing in which a multicolor linoleum print could be made from a single block. Courtesy Reiss-Cohen Gallery, New York.

Plate 6. **Ernst-Ludwig Kirchner.** *Woman Wearing a Hat with Feathers.* 1910. Lithograph. 17½″ x 15″. Ernst-Ludwig Kirchner made over 2,100 prints, a body of work unmatched by any other twentieth-century artist, with the exception of Picasso. Kirchner's achievement is even more remarkable because the artist printed virtually all of his 673 etchings, 990 woodcuts, and 442 lithographs himself, often signing and annotating examples (for example, ''worked over'') but never numbering any. Although powerful statements in their own terms, the artist came to consider his prints a prelude to painting: ''I am now designing paintings in graphic form… I find it increasingly necessary to express my ideas first in engravings or litho, so that they develop before I start to paint…'' Courtesy Staatliche Graphische Sammlung, Munich.

Plate 7. **James Rosenquist** (1933–). *Off the Continental Divide.* 1973–1974. Hand-drawn offset lithograph. 42″ x 78″. James Rosenquist created his mural-sized print, *Off the Continental Divide,* on a commercial hand-fed offset press. Unlike the standard art lithography press, offset permits the artist to view results immediately, thereby facilitating revisions. Normally, plates for the commercial press are made photographically, but Rosenquist's are all hand-drawn. Over a period of almost a year and a half the artist drew 46 separate plates, of which 29 were used in the final printing of the edition of 43. In an interview (*Newsday,* May 19, 1974) Rosenquist explained that "The whole print is about the idea of source and about myself... When I started out, I could have gone to California and become a cattle rancher. I thought, 'No, I'll go East and go to school.' In the West are stairs for going, for hiding under, black 'like a child's fear,' a car, a wrinkled rainbow. East are a book and nails [for art?]." Three Chinese ideograms (barely visible in this reproduction) in the black area—a circle, triangle, and square—represent the idea of the "universe." Courtesy Universal Limited Art Editions, Islip, New York.

Plate 8. **Friedrich Meckseper** (1936–). *Still Life with Spring* from *Reconnaissance du Cuivre*. 1975. Etching. 10¾″ x 14¾″. Courtesy Fitch-Febvrel Gallery, New York.

Plate 9. **Joan Miró** (1893–). *Equinox*. 1968. Etching and aquatint. 41-1/16″ x 29″. In *Equinox* Miró produced one of the extraordinary works in intaglio printing. The print achieves its stunning painterly impact both through its large size for an intaglio and its unique technique. Difficult to reproduce here are the deep, dimensional impasto areas (mainly the blacks) that Miró created by painting directly on the plate with a synthetic resin and carborundum mixture. The resin hardened, building up thick relief forms on the metal. When inked and printed, these built-up areas impressed themselves into the paper, producing a high impasto effect similar to that achieved by a painter when he layers thick wads of color on his canvas. All around these dense textural forms Miró's gay and bright calligraphy flits about in transparent aquatint washes and appears to be floating in limbo. A design that continues off the edges of the paper, Miró's image explodes into space, further amplifying its power and size. Courtesy Sotheby Parke Bernet Inc., New York.

Plate 10. **Wolfgang Gäfgen** (1936–). *Pyramide.*

Plate 11. **R. Rand** (1937–). *Conjugation on Orange.* 1974. Serigraph. 32″ x 42″. Courtesy

Plate 12. **Robert Indiana** (1928–). *Triangle* from *Indiana: Polygons.* 1975. Screen print. 31″ x 28″. Courtesy Galerie Denise René, New York.

Plate 13. **Auguste Herbin** (1882–1960). *Été.* 1961. Serigraph. 25½″ x 19⅝″. Courtesy Galerie Denise René, New York.

Plate 14. **Josef Albers** (1888–1976). *LXXIIIA* from *Birthday Pair*. 1973. Silk screen. 18″ x 18″. Courtesy Galerie Denise René, New York.

Plate 15. **Richard Anuszkiewicz** (1930–). *Sequential*. Plate 5. 1972. Serigraph. 28″ x 22″. Courtesy the artist.

Plate 18. **Richard Hamilton** (1922–). *I'm Dreaming of a White Christmas*. 1967. Screen print
22⅛″ x 33⅞″. The camera ranks as one of the commonplace gadgets of modern life, and mos
people are familiar with photographs and the picture negatives that accompany them. Yet how
many of us ever seriously consider studying the image on a negative? This interim step
usually passed over indifferently, contains one of the more astonishing image inventions o
our time: a visual interpretation created outside of the photographer's intent and control *by the
film process itself*. It is such process-induced imagery that concern prints such as Hamilton's
I'm Dreaming of a White Christmas. The artist restricts himself to creating a picture by manip
ulating the visual possibilities existing within the film processes themselves. Courtesy The
Museum of Modern Art, New York: Celeste and Armand Bartos Foundation Fund.

Plate 17. **Clayton Pond** (1941–). *Ionhian Involute Upwardcani* from *Capital Ideas*. 1974. Serigraph. 37″ x 29″. Courtesy Sanmore Editions, New York.

Plate 18. **Robert Rauschenberg** (1925–). *Link* from *Pages and Fuses*. 1974. Handmade paper, dye, screen print on tissue. 25″ x 20″. Courtesy Gemini G.E.L., Los Angeles.

Plate 19. **Alexander Archipenko** (1887–1964).
Figure from *Thirteen Drawings on Stone* portfolio.
1921. Lithograph. 17″ x 9″. Courtesy Carus Gallery,
New York.

Plate 20. **Roy Lichtenstein** (1923–). *Bull II* from a set of 6 prints. 1973. Lithograph, linocut. 27″ x 35″. Courtesy Gemini G.E.L., Los Angeles.

Plate 21. **Roy Lichtenstein.** *Bull III.* 1973. Lithograph, silk screen, linocut. 27″ x 35″. Courtesy Gemini G.E.L., Los Angeles.

Plate 23. **Roy Lichtenstein.** *Bull VI.* 1973.
Lithograph, silk screen, linocut. 27″ x 35″.
Courtesy Gemini G.E.L., Los Angeles.

Plate 22. **Roy Lichtenstein.** *Bull IV.* 1973.
Lithograph, silk screen, linocut. 27″ x 35″.
Courtesy Gemini G.E.L., Los Angeles.

Plate 24. **El Lissitsky** (1880–1941). *Globetrotter in Time,* Plate 5 from *Victory over the Sun.* 1923. Suite of 10 lithographs. 21″ x 17⅞″. The lithographs represent the figurines for the 1912 opera by A. Kruchenykh. Courtesy The Museum of Modern Art, New York.

If green was not green, then other traditional assumptions about the true nature of "reality," and equally traditional methods of reporting it, might also be open to reevaluation. Art continued to move around the room. Out of these changing points of view came a series of startling artistic breakthroughs, such as Expressionism, Cubism, and so forth. Step by step, art amplified its observations concerning the nature of what was "real." Although our eyes may see only one aspect of an object at any one time, in fact all its other sides exist simultaneously. To express this simultaneity, the Cubists fragmented objects in a way that suggested more than one viewpoint in a single composition. Breaking up conventional representations of a form, such as a guitar or a face (fig. 184), had further repercussions: it destroyed the object's commonly recognized form and forced the viewer to consider the artist's image not as a "likeness" for something else but in artistic terms as forms, colors, lines, and composition (pl. 19). The Fauves and the Expressionists probed the emotional content of reality, communicating through the psychic power of color and distortion (pl. 6). The Futurists sought to replicate the feverish dynamism of modern existence and machines on the inert picture plane (fig. 185). Yet all these investigations still revolved essentially around the same *model* of reality, representational sources, the things man could see and touch. Art would not fully break free of such tradition until it found a completely new orientation. The nineteenth-century German poet Heinrich Heine predicted the direction art would inevitably pursue: "In artistic matters . . . I believe that the artist cannot find all his forms in nature, but that the most remarkable are revealed to him in his soul."[26] By the end of the nineteenth century, Symbolist artists (fig. 227), although still using representational subjects, had already begun to probe man's inner conscious-

ness. Exploration of reality was shifting to what the artist *experienced inside himself* rather than what he *saw*. The attempt to record psychological truths and the whole drama of inner consciousness is one of the keystones of modern art.

In 1911, the first edition of Wassily Kandinsky's famous treatise, *Concerning the Spiritual in Art,* appeared, paving the way for the acceptance of abstraction. Other artists of the period (Frank Kupka, Mikhail Larionov, and Kasimir Malevich, to name a few) were, like Kandinsky, experimenting with nonrepresentational forms of expression. *Concerning the Spiritual in Art* provided a convincing rationale for their nontraditional experiments. Kandinsky argued that the artist's "inner necessity" to work in one style or another, rather than any outwardly imposed academic standards or public preferences for representational art, should determine the form that subject matter took in a work of art. This new *freedom of expression* represented a radical departure, which can be best appreci-

185. **Umberto Boccioni** (1882–1916). *Forward Motion*. Executed c. 1913, published in *Fourth Bauhaus Portfolio*, 1922. Lithograph. 11½″ x 15″. Courtesy Carus Gallery, New York.

186. An engraving after **Gustave Moreau** (1826–1898). *A la Mémoire de Théodore Chassériau.* Late nineteenth century. 12¼″ x 8″. Courtesy The Metropolitan Museum of Art; The Elisha Whittelsey Fund, 1966.

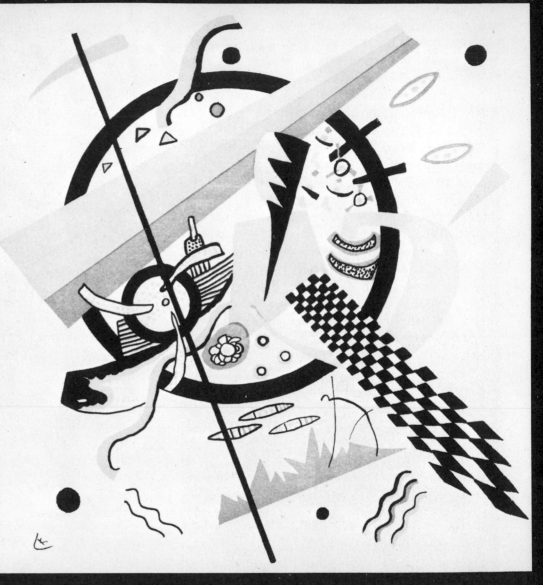

187. **Wassily Kandinsky.** *Kleine Welten IV.* 1922. Lithograph. 13⅜″ x 11⅜″. Courtesy Carus Gallery, New York.

188. **Wassily Kandinsky.** *Der Spiegel.* 1907. Linocut. 12½″ x 6⅛″. Courtesy Sotheby Parke Bernet Inc., New York.

ated by a comparison of Gustave Moreau's proper academic engraving (fig. 186) with Kandinsky's abstract lithograph *Kleine Welten IV* (fig. 187), and the latter with Kandinsky's own earlier linocut of 1907 (fig. 188).

189. **Wassily Kandinsky.** *The Blue Rider* (Der Blaue Reiter). 1912. Woodcut: cover of *The Blue Rider Almanac.* 11⅛" x 8¼". This is a major document in European art literature. In 1930 Kandinsky himself explained the origin of the almanac's unusual title: "We invented the name 'Der Blaue Reiter' while sitting at a coffee table in the garden in Sindelsdorf; we both loved blue. Marc liked horses, I riders. And after that Maria Marc's fabulous coffee tasted even better."

A year after the publication of *Concerning the Spiritual in Art,* Kandinsky was the inspiration behind another landmark manifesto of modern art, *Der Blaue Reiter* (The Blue Rider). The almanac, coedited by Kandinsky and Franz Marc, expounded the avant-garde theories of their day. The cover, a woodcut by Kandinsky (fig. 189), also called *Blaue Reiter,* shows the galloping blue horseman who came to symbolize the rallying cry of a new generation of artists: *Alles ist erlaubt* or "Everything is permitted."

Freedom of expression—*expressionism*—turned each artwork into a private code through which the artist communicated in a one-to-one dialogue with his viewer. The model from which the artist now worked existed in his mind and was

no longer a tangible reality experienced in common by everyone. A good deal of the rhetoric surrounding modern art seems actually to be an attempt to reestablish a commonly shared visual reference point—the model—from which viewers can then share in and judge the artist's portrayal of inner reality. The expression of personal visions (to which there is no commonly held key) resulted in a proliferation of subjective styles and has made this century's images immensely varied and thus frustratingly difficult to evaluate.

The artist has emerged as his own man. But his own man for what purpose? He had come a long way from the anonymity of a medieval craftsman or the Renaissance genius protected by his prince. On the other hand, his new freedom meant that he could no longer depend on the erudite patronage and commissioned assignments of either a church or an aristocracy to guide him. In their stead rose a new bourgeoisie with its clamor for decorative pictures. In the main, these new benefactors preferred pleasing traditional motifs. By the nineteenth century, many artists found themselves trapped in a network of visual conventions, producing art that was academically masterful but spiritually barren.

By the early twentieth century, the constraints on artistic creativity reflected a general cultural bankruptcy which many artists sensed in the fraudulent social values they saw surfacing all around them. The Expressionists and Kandinsky sought refuge from their disillusion with a defunct outer world by turning inward. The embittered World War I generation of artists of 1914 and 1918, brutalized by their direct experiences with the irrationality and cruelty of war,

190. **George Grosz** (1891–1959). Plate 5 from *Im Schatten.* 1921. Lithograph. 14¾″ x 10⅝″. Courtesy Carus Gallery, New York.

slid even more deeply into alienation from established culture and accepted values. What had the academician's manicured representations of man and nature to do with the raw insanity of the world as it had burst into their lives? And what had such pretty pictures to say about sixteen-hour workdays, war, hunger, and child labor? Even the Expressionists' attempts at redeeming mankind through an art of "spiritual" renewal could not furnish a reality with which they could identify themselves. It was the paradox of modern existence to which this disenchanted group of artists turned its attention: the cynical, Kafka-esque, and irrational aspects of existence that boiled to the surface as twentieth-century reality. Calling their art *Dada*,[27] they set out to awaken society with a sharp slap in the face. George Grosz (fig. 190) described Dada as "the organized use of insanity to express contempt for a bankrupt world,"[28] and Max Ernst (fig. 191) shouted "Let there be fashion, down with art." Disillusioned, artist Hans Arp wrote that man was like "a tiny button on a senseless machine."[29]

Marcel Duchamp, the quintessential Dadaist, placed an insolent moustache and goatee on a reproduction of Leonardo da Vinci's famous *Mona Lisa* (fig. 39). No cultural institution was too sacrosanct to escape Dada's scorn. One audience was herded into a famous 1920 exhibition, "Dada-Vorfrühling" ("Dada Early Spring"), by way of a public lavatory to be met by a young girl, dressed in white as though for her first communion, who began reciting obscene verses. Art with a capital *A* was committing suicide, refusing to pander to the dictates and tastes of those whose values it found corrupt and philistine. The Blaue Reiter's liberating cry: "Everything is permitted," took on a cynical, antiart coloration with Kurt Schwitters's (fig. 192, 193) Dada declaration, "Anything the artist spits is art."[30]

In its efforts to break the grip of traditional thinking, and in particular, to topple the pretentious attitudes of "high art," Dada appropriated processes (impromptu, random, accidental occurrences), materials (common everyday objects), and tactics (irrational and provocative) never before considered the province of serious art. The group's antiart antics gained respectability, and in time their negativism established positive traditions that expanded the acceptable parameters for creative expression.

What has all this to do with collecting contemporary prints?

It has to do with understanding them. Many

191. **Max Ernst** (1891–1976). *Fiat modes, pereat ars* (Let there be fashion, down with art). Plate 1. c. 1919. Lithograph. 17⅛" x 12". Courtesy The Museum of Modern Art, New York.

192. Kurt Schwitters (1887–1948). Cover design for an anthology of the artist's poems published in 1919. Lithograph. 8¾″ x 5¾″. Courtesy Carus Gallery, New York.

Schwitters gained notoriety with a nonsensical Dada love poem "Anna Blume." A portion of the poem translated by the artist reads:

> Blue is the color of your yellow hair,
> Red is the whirl of your green wheels,
> Thou simple maiden in everyday dress,
> Thou simple green animal,
> I love thine!
> Thou thee thee thine, I thine, thou mine, we?

Dada glorified the irrational, unpredictable, and absurd, in part to counteract what the movement saw as a society increasingly propelled by the rationality and nonhumanistic logic of industry and science.

193. Kurt Schwitters. Untitled lithograph from the publication *Die Kathedrale,* 1920. 8⅞″ x 5¾″. Courtesy Carus Gallery, New York.

of the images and techniques used in modern printmaking would have been inconceivable without the changes in attitude that took place during the first decades of this century. These new visual vocabularies developed so quickly one upon the other that they still remain undecipherable and alien to many people. There are those who literally find it impossible to see, let alone form judgments, within twentieth-century visual contexts. Such confusion is understandable when one realizes how short a public assimilation period these new ideas have had. The Egyptian style of art lasted for thousands of years, the Gothic for several hundred. A twentieth-century art movement such as Cubism was at its zenith for only a few years, as was Dada, which flourished roughly from approximately 1913 to 1923.

Today's prints reflect the influence of many earlier modern movements. But it is particularly the legacy of Dada that may prove most enlightening for the collector. André Breton wrote that Dada was less an art movement than "a state of mind." As such, it has left an indelible stamp on the printmaking of recent times, even on many prints in which the artist's stylistic execution is associated with other schools.

Dada was the first movement to prick the pomposity of art by laughing at it and consistently to validate common everyday objects as grist for the artistic mill: shovels, bicycle wheels, advertisements, news clippings, photographs, matchbook covers—life and everything of which it was composed. One can only surmise the indignation and shock Marcel Duchamp stirred up in 1918 when he submitted a common store-bought shovel to a sculpture exhibition under the title: *In Advance of the Broken Arm* (fig. 194). An appalled public considered Dada's antics creative heresy, to which Duchamp responded by dubbing himself an "unfrocked" artist. "I wanted to put

painting [art] once again at the service of the mind,"[31] he declared, insisting firmly on an intellectual rather than a purely retinal, sensual basis. Decades after the initial shock, many museumgoers would still find it a good deal easier to accept the impeccable and conventional draftsmanship of Gustave Moreau (fig. 186) than a snow shovel on a pedestal or, for that matter, Rauschenberg's *Cardbird IV* (fig. 183), of which the artist said, "a desire built up in me to work in a material of waste and softness . . . with its only message a collection of lines imprinted like a friendly joke."[32] Such notions run headlong into conventional concepts about what is and what is not appropriate material or subject matter for art.

What cultural canons did the Dadas find so stifling that they opted for heresy, and why base their art on the shock tactics of revolutionaries? Dada's was an insurrection against *all* sacred cows. In particular, they ridiculed the dicta constraining art, official codes that transformed art into a ritual act performed according to preset formulas. To standardize art, they insisted, was to kill it. The creative process, like life itself, should be open-ended, unprogrammed, unpredictable.

All the earlier "isms" had rattled the applecart, but Dada toppled it completely. The issues it raised concerning the nature and the purpose of art remain virulent and controversial to this day. More than the haunting refrain implied by the labeling of contemporary artists such as Rauschenberg as Neo-Dadaists, the Dada "state of mind" represents a continuous undercurrent in modern art.

When contemporary printmaker Friedensreich Hundertwasser publishes his prints in a massive edition of ten thousand impressions (fig. 181), art acquires the accessibility of a common

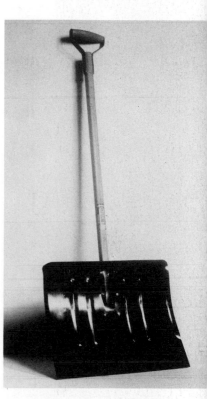

194. **Marcel Duchamp.** *In Advance of the Broken Arm.* Reconstruction, 1945. Wood and metal "readymade." H. 47¾". Courtesy Yale University Art Gallery; Gift of Collection Société Anonyme.

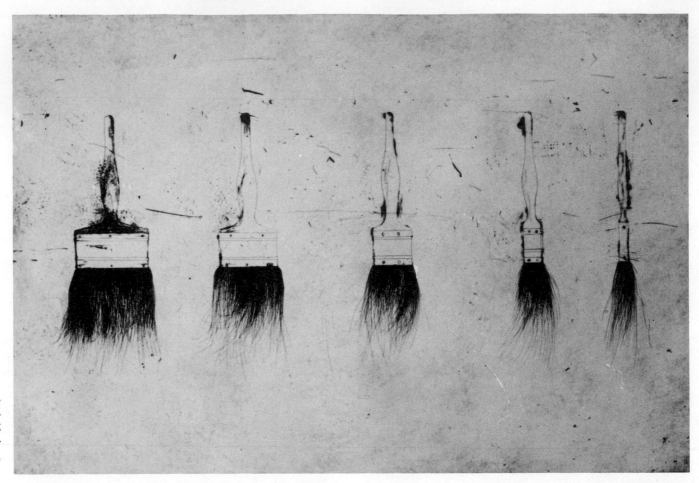

195. **Jim Dine** (1935–). *Five Paintbrushes*. 1972. Etching. 23¾″ x 35¼″. Courtesy Petersburg Press Ltd., New York.

everyday object and moves into the province of popular culture. It is a restatement of the original Dada challenge to our stereotype of the work of art as something costly, inaccessible—a museum piece. Andy Warhol grapples with other entrenched assumptions. Warhol selects mundane subjects for his imagery, but more pointedly, he hand-signs a photograph but only rubber-stamps his signature on the back of an original print. Warhol's action continues the dialogue begun when Dada artist Kurt Schwitters was asked: "What is art?" and he replied: "What isn't?"

Questioning the nature and purpose of art is a relatively modern phenomenon.

Art was not always a luxury item, nor were works of art always associated with precious museum objects or even decoration. The bulls, deer, and game animals that our prehistoric ancestors painted and incised on the walls of their caves more than likely had specific magical functions as a part of rituals in which the artist's renderings were meant to ensure a bountiful hunt and, thereby, survival. Art has played the role of teacher as well. The depiction of biblical events in medieval churches may appear to be adornments to us, but to a public that could not read, such visual storytelling imparted the religious information and moral training around which

much of their world revolved. In time, art lost its functional connection with man's daily existence and came more and more to be created as a status "object" for those who could afford it. As less of its subject matter and form derived from the realities of life, art acquired an aura of superfluousness. Divorced from life, it existed for its beauty alone ("art for art's sake"), and eventually even the scope of this beauty narrowed to fit "official" prescriptions.

Official codes of art developed gradually. Prior to the nineteenth century, the artist and the patron who supported him by commissioning his works had a far different relationship from today's collector and artist. By and large, they shared a broad consensus regarding aesthetic standards and what constituted appropriate subject matter (for example, religious themes, portraits, historical and genre themes, still life). One artist's particular execution might be more brilliant than another's, but the views of patron and artist substantially overlapped. This close-knit rapport was disrupted when the mechanism of patronage and its associated master–apprentice teaching apparatus broke down. Academies of art soon appeared to fill the gap. The academic structure had several ramifications. Schools found it practical to codify the techniques of the great masters of the past into principles that could be passed on to students in an orderly curriculum of learning. In time, and through repetition, the fresh inspirations of a Raphael or a Leonardo rigidified into "official" recipes: the "shoulds" and "should nots" in art. Students learned "correct" drawing by copying plaster casts of classical statues, "correct" colors for landscapes, tricks for making "correct" clouds, and even the "correct" subjects for their attention. The increasing dominance of an officially sanctioned "idea of art" trapped young artists in

a vicious circle: sales depended on the public's seeing their work, but most exhibitions of the time were held at the very academies that were perpetuating artistic clichés—and their own institutions—by exposing the public only to those works that conformed to academic rules.

What of the artists who rebelled? Groups such as the Impressionists eventually laid the foundations of modern art. In time their posture of avant-gardism became the prototype of the twentieth-century artist, who has since evolved into something of an accredited social "outcast," unofficially charged with regularly renovating our concepts. Each of the post-Impressionist movements can be classified as rebellions against official art, but the *act* of rebellion itself was intrinsic to the Dada creative process. Often cast as the lunatic fringe of art because of the anti-logic basic to all Dada-inspired works, the movement was actually amazingly international, with Dada enclaves springing up in every major art center from around 1913 on—Moscow, Zurich, Berlin, Munich, Paris, New York. Dada crossed national boundaries, and more vitally, though less widely acknowledged, it crossed artistic boundaries. Artists generally identified with structured, formalist works were simultaneously producing in the Dada idiom. The participation of artists such as László Moholy-Nagy, Hannah Höch, and Theo Van Doesburg suggests that Dada's really crucial function was to serve as a polemic forum —an experimental oasis in which art could permissibly be kept in continual ferment and renewal.

One might call Jim Dine's etching of ordinary household paintbrushes (fig. 212) a "portrait" of tools. The artist imparts to each brush an individuality and character that grants it a unique personality. His manipulation of subtle

196. **Marcel Duchamp.**
Self-Portrait. 1959.
Serigraph. 25½″ x
19⅝″. Courtesy
Sotheby Parke Bernet
Inc., New York.

ing machines as casually as he constructs human forms from computer dots (upper section of *Moonstrips*). Paolozzi's prints were prepared with the same montage of "readymade" materials used for his earlier *As Is When* series (fig. 168) of 1965. In *Moonstrips,* however, magazine photographs and texts and pictures from technical manuals, paperbacks, and periodicals were collaged, where in the earlier series, printing screens were developed from collages of weaving diagrams, engineering patterns, photographs, and the like. *Moonstrips* confronts the viewer with a barrage of imagery and data compiled from the printed minutiae of daily life. The material is presented, undigested and undifferentiated, exposing Paolozzi's viewer to the same indiscriminate onslaught of commercial media he faces all around him. A solarized photograph of the head of Michelangelo's *David,* one of the world's great artistic masterpieces, shares equal focus with Disney's Mickey Mouse, perhaps the best-known symbol of popular culture. Mickey Mouse demythifies *David* in much the same way that Duchamp's addition of a goatee reduced *La Gioconda* from untouchable masterpiece to public domain.

Computers, Mickey Mouse, flashlights, paintbrushes—how have such things come to share museum space with the *Mona Lisa?* If contemporary printmakers tend toward the provocative, their underlying aim resides with Dada: to keep the spectator off balance.

Duchamp's Dada serigraph (fig. 196) typifies the tactic. It is a random white form against a black background, possibly inspired by the shape of an accidentally torn scrap of paper. But this visual reading of the print would be hasty. If one reverses focus from the dominant white form and concentrates instead on the black area, a forehead, nose, and chin jut into the white zone and

personal notations in the handling of etched lines and plate tone (lost in a reproduction photograph) combines with an acute sensitivity for details to embue objects no less mundane than Duchamp's shovel with an impact one generally associates with portraits of people. Likewise Jasper Johns's still life of the common flashlight (fig. 201, discussed further on) is hardly a conventional topic for the investigation of form, line, and composition. In his *Moonstrips Empire News* (1967; fig. 167), Paolozzi explores the paradox of modern society: the infantilism and Mickey Mouse values of popular culture existing alongside sophisticated computer technology capable of sending men to the moon. Whether intentionally or not, Paolozzi reflects a Dadaistic sense of the absurdities of modern life and culture, humaniz-

a silhouette becomes visible. The "torn edge" of white actually forms a profile of the artist. In a sense, the eye jumps to an erroneous conclusion in making its initial assumption. Because of a memory of previously experienced, similar-looking forms (that is, torn pieces of paper), we slide into such visual habits or "traditions of seeing" without question. The immediate feeling of certainty and familiarity accompanying such assumptions cuts short any considerations of alternate possibilities.

Duchamp's print is not only an amusing lesson in perception, it points out the vulnerability of becoming overly complacent about things that one believes to be irrefutably true. Just as Duchamp's placement of an ordinary shovel in a museum context blurred its identity and forced the spectator to consider this utilitarian object in new terms—that is, as a form—his print also shocks us out of rote seeing. The aim is to provoke. One rarely considers the effect that programmed thinking patterns can have on everyday behavior. But if we believe, as most people do, that a tabletop is "supposed to be" a flat surface, a series of actions follows without reflection. We never again critically "observe" tabletops, and they become one of those items that are "seen but not looked at." Faced suddenly with a table surface designed as a convex mound, we would be thrown out of a rote response and into either confusion or facing the new possibilities presented in terms of dishes, knives, forks, glassware, and even seating.

Josef Albers also devotes his artistic energy to heightening the viewer's awareness of the pitfalls of perception. Best known for his series *Homage to the Square* (pl. 14), Albers's lifelong concern with the deceptive dialectic between reality and illusion (what we *think* we see and what is *actually* there) is perhaps most clearly evident

in his series of *Structural Constellations*, of which *Embossed Linear Construction 2-A* is an example (fig. 197). At first glance, the two geometric configurations appear identical. Both share the same polygonal outer contour and key internal lines. The image, controlled and mathematically precise, was made by a system of programmed tape engraving. An engineer–programmer translated Albers's original drawing to a digital tape, and the tape then guided an automatic engraving mill in cutting the plates to replicate Albers's original drawing exactly. Plates and tape were later destroyed. The "twin" structures appear logical and mutually predictable. But the surface similarities of the two "look-alikes" seduce us into overlooking the *differences* in their internal line construction. Even the calculated purity of the artist's white-on-white embossed image offers no distracting element such as color. If we are misled into believing that both forms are identical, Albers makes clear that it is by our own preconceptions, a process equally deceiving in life itself.

197. **Josef Albers** (1888–1976). *Embossed Linear Construction 2-A.* 1969. Engraving. 20$\frac{1}{16}$″ x 26$\frac{3}{32}$″. Courtesy Gemini G.E.L., Los Angeles.

USE THE FACT THAT

The above object (Everything in the above object)
The above painting ()
The above game (Games)
The above structure (The structure of the structure)
The above diagram (Diagram)

IS ISOMORPHIC
TO ANYTHING

(Chair, Landscape, Airplane, Hand, Cake, etc.)

To surround degree by degrees

198. **Shusaku Arakawa** (1936–). *The Degrees of Meaning* from *Reality and Paradoxes*. 1972. Lithograph and screen print. 30¹/₁₆" x 22⅜". Courtesy Ronald Feldman Fine Arts, New York.

Albers's concerns link his work with that of Shusaku Arakawa, whose explorations in *The Degrees of Meaning* (fig. 198) are more openly baffling. In spite of the artist's apparent attempts to provide the viewer with clarity through explicit verbal and visual information in the image, we remain puzzled. The "meaning" of a pictorial gesture such as the joker or the perfectly legible sentences below the image remain ambiguous no matter how often we search them. Arakawa's prints do not aim at clarification, at resolving the viewer's tension by offering apparent "meanings." On the contrary, they leave us "hanging in the air," frustrated that the "information" the artist appears to be providing refuses to integrate or "make sense" in any conventional way. "What is he trying to say?," we ask, and in the process begin sorting out likely options. It is in the process of exploring the possibilities of meaning that we experience Arakawa's intentions: to expose the infinite range of meanings that actually exist in any communication. Toward this end, the artist offers verbal data that we can clearly read but not decipher, visual symbols that we can clearly perceive but not decode. Confronting us with the uncertainty at the core of things about which we are certain, Arakawa asks, "What does language mean? What do our signs signify? How do we make sense out of anything in our lives, if the meanings of basic things are so arbitrary and fragile?"

Jud Fine's screen print *3.3.3/2.2/1.* (fig. 199) questions standard assumptions by sending the eye on a wild-goose chase. The artist permits our own beliefs to entrap us and thereby exposes their vincibility. The carefully inscribed text and the arrows and meticulously lettered notations, like those in Arakawa's prints, appear to give information, yet on closer inspection they make "no sense." Relying on accepted precision sym-

134

bols—such as an equilateral triangle, mathematical arrows, and markings, and words themselves—the artist sets in motion a whole series of commonly held preconceptions concerning the nature of logic and order, namely, that its symbols will lead to rational conclusions. Instead, he deploys the very same symbols irrationally. The abrupt elimination of design from the lower portion of the triangle calls the viewer's attention to the "nakedness" of the bare paper surface, and the bit of design allowed to dribble over into this blankness suggests that all symbols—including Fine's print—are only illusions. Like those of Arakawa, Johns, and Albers, Fine's print poses issues beyond art: If the trusted symbols of geometry and the normally intelligible codes of language can become meaningless, what of other rational assumptions that we take for granted and in whose inviolability we place so much blind faith?

One is confronted by no such ambiguity or uncertainty in a Dürer engraving or a Toulouse-Lautrec lithograph. The artist's intentions are clear and visually satisfying. What, then, is accomplished by keeping the viewer off balance, by provoking rather than pleasing him? Provocation, as the Dadaists were the first to realize, is an effective consciousness-raising tool. The well-known Fifth Avenue jeweler Tiffany's has used the same device in window displays to catch the eye of preoccupied New Yorkers for years. Draping thousands of dollars worth of diamonds over, around, and under a dozen ordinary supermarket eggs is an unorthodox sight likely to warrant a second glance. Tiffany's, no less than Duchamp or Arakawa, breaks with expected visual conventions (in Tiffany's case, diamonds on velvet). The spectator must consider a whole new set of relationships. The result is that he stops and critically observes the diamonds, an appraisal he

might not have made if his eye had not been "irritated" by a provocative, unfamiliar sight.

When I asked Jasper Johns why he chose such banal objects—flashlight (fig. 200), ale cans, numbers, light bulbs, etc.—as his subject matter, he replied,

What interested me was this: at a certain point I realized that certain things that were around me were things that I did not look at, but recognized. And recognized without looking at. So you recognize a flag is a flag, and it's very rare that you actually look at the surface of it to see what it is. This aspect of things interested me and I began to work with it, to see how I could look at things that I was accustomed to looking at, but not seeing—how to look at something that you think of only as having a "usefulness" as though it were useless and a formal element in space.[33]

Johns often explores the same item, even

199. **Jud Fine** (1944–). 3.3.3/2.2/1. 1975. Screen print. 22″ x 28½″. Courtesy Ronald Feldman Fine Arts, New York.

using the same composition, in different mediums and dimensions (figs. 200, 201). Apart from demonstrating the artist's uncanny facility for exploiting and exhausting the graphic range of various techniques, this replay process tends to make the viewer acutely aware of the infinite possibilities for perceiving any object, if options are kept open. Each investigation of the object in a new medium alters its character. No sooner do we relax with one way of "seeing" flashlights, than Johns springs another and another on us. The selection of common objects, about which people hold fairly fixed visual stereotypes, makes Johns's mutations even more dramatic and provocative.

1st Etchings (figs. 201, 202), a series of six variations on themes recurrent in Johns's work (light bulb, ale cans, flashlight, paintbrushes, flag, and numbers), presents each subject in a dual format: a small halftone picture of the object and a line etching of it. The etched portion of *Flashlight* (fig. 201) is an almost belligerently casual notation and nonchalant "sketch" of the form. The casualness and clearly "drawn" quality of the rendering has the effect of exaggerating the "solidness" of the flashlight in the halftone (a picture of Johns's sculpture of a flashlight). When they are seen together, the counterpoint sharpens our awareness of the familiar flashlight in two new identities. What has happened to the *real* flashlight, our everyday stereotype of it? Or are all these identities equally real? We rarely "look" at the contours or surface of a flashlight, because such items are categorized as useful objects, not aesthetic ones. Johns continually challenges, as did Dada, such aesthetic limitations. In the same series, the cans in *Ale Cans* (fig. 202) appear to be a picture of the actual objects. But appearances, as Johns continually demonstrates, should not be trusted. The seeming "reality" of the cans is actually another picture of Johns's

sculpture of ale cans. On the same sheet, Johns avoids using shading to round the forms of the etched cans in a way that would approximate their appearance in real life. Nor does his use of shading create an illusion of space or depth as it might. The hatching lines, on the contrary, spill over the edges of the cans, emphasizing that these are not objects but drawn images on paper.

200. **Jasper Johns** (1930–). *Flashlight I* from *1st Etchings,* second state. 1967–1969. Etching over photoengraving. 19¼″ x 25¾″. Courtesy Sotheby Parke Bernet Inc., New York.

To the right, a casual *X* doodle that one might make on paper further stresses the two-dimensional nature of the image. At every turn, Johns refutes the comfortable view of the etched cans as merely representations of objects we have seen before, insisting through his execution and presentation that we relinquish preconceptions and continually rediscover the ale cans. "Seeing"

201. **Jasper Johns.** *Flashlight* from *1st Etchings,* first state. 1967–1968. 22½″ x 17¾″. Courtesy Universal Limited Art Editions, West Islip, New York.

202. **Jasper Johns.** *Ale Cans* from *1st Etchings,* first state. 1967–1968. 26″ x 20″. Courtesy Universal Limited Art Editions, West Islip, New York.

is never a passive exercise.

Why not create images that are more readily understandable, more conventionally pleasing? What *is* the relationship between art and life? The Dada's question persists.

Dada's rebellion against aesthetic constraints, Arakawa's insistence on the infinite possibilities of meaning in any symbol, and the active "seeing" process instigated by Johns's works are artistic concerns with powerful implications for twentieth-century man. The contemporary artist in this context emerges as neither a shaman of the caves nor as a religious teacher nor as the maker of vapid decorations. He has become instead something of an intuitive explorer, using his art to pioneer processes of

thinking that man may need to survive in a wholly new type of existence.

Such connections between art and life may be less farfetched than they at first sound. In *Culture and Commitment*, Margaret Mead discusses the astonishing rapidity of change in modern society, concluding that customs and traditions have become virtually impotent. No adult group or institution can keep its knowledge current enough to pass on to the young with any certainty that the information will be useful to them. As this pace of cultural change accelerates, youth leans less and less on the past as a source of its behavioral and thought patterns. Instead, values and actions are improvised within one's own lifetime. Judgments are made without recourse to precedent or preconception. "The yet unborn, whose characteristics are 'unknown,'" writes Mead, "becomes the symbol of the *uncertainties at the core of modern culture*" (italics mine).

Dada was perhaps the first art movement ever to identify completely with this peculiarly twentieth-century phenomenon of uncertainty. But the loss of cultural anchors was not restricted to aesthetics. About the same time that aversion to the status quo and all types of "fixed" thinking surfaced in art, a general collapse of long-held certainties was occurring in other fields. Einstein's theories had recently toppled seemingly unassailable laws of physics, while Freud's had embued the irrational and unpredictable in man with respectability, unleashing the unconscious to rival the rationality and logic by which men had forged their control over nature.

In light of such cultural developments, the Dada position remains surprisingly pertinent today. Perhaps the theme of uncertainty has become modern man's new *model* of reality and the uncertain image its hallmark.

Most contemporary printmakers would deny that their art has such a specific message or intent. Yet one wonders whether an artist living in an age more complacent in its certainties than ours would have described the function of art in quite the same terms as Jasper Johns:

Part of the activity of art is one of exercise, and an activity that keeps faculties lively, whatever the discipline touches on: the mind, the ear, whatever. And one hopes that by sharpening of such things and by an attempt to see the possibilities that are offered . . . that the senses we use in dealing with our lives will be kept in a state of readiness to deal with whatever may happen.[34]

The uncertain, the unpredictable, chance, accident, even chaos entered the artist's repertoire with Dada. Although artists throughout history have turned accidents to the service of their craft, happenstance became virtually synonymous with the Dadaist "creative process." The now-famous story of Dadaist Hans Arp is a classic example. Arp became frustrated while working on an abstract drawing. The image kept falling short of the conception in his mind, until finally, in a fit of pique he ripped the drawing up. To Arp's surprise, the scraps fell to the floor in an accidental pattern that achieved precisely the quality he had been unable to capture through conscious effort. Discovering a creative resource in seemingly "meaningless" acts (for example, the random pattern of Arp's torn drawing), Dada offered unmodified noises, objects, and events as art on the premise that chance shaped form. At one social pole stood the logic of technology, the rational precision of the modern assembly line, the controlled conclusions of businessman and scientist, the predictable "recipes" of establishment art. At the other extreme stood the nonsense poetry (fig. 192), unstructured theatrical performances, and irreverent art forms (fig. 194) of Dada, pro-

claiming the inherent disorder and absurdity of both life and art. This irrational element maintains its hold on contemporary artists. "I consider myself successful," said Robert Rauschenberg, "only when I do something that resembles the lack of order I sense."

Rauschenberg's lithograph, titled, interestingly enough, *Accident* (fig. 203), can be cited as the beginning of major American influence in the graphic arts. In 1963, the print won the Grand Prize at Ljubljana, Yugoslavia, and First Prize, the following year, at the Venice Biennale.

Prior to 1963, American entries had been heavily representative of artists whose prints demonstrated virtuosity in the mechanics of printmaking. With Rauschenberg's *Accident,* imagery from the mainstream of American art found a voice in international graphics. The diagonal white gash slicing the print lengthwise was caused by an accidental crack in the lithographic stone on which the artist was working. "While at another period," Riva Castleman remarks in her book on contemporary prints, "the stone for a lithograph would have been discarded once it had begun to break and the image transferred to a healthier surface, Rauschenberg chose to document the progressive deterioration . . . by including the image of the loose fragments in his composition."[35] Incorporating such unplanned accidents in the creative process—a legacy from Dada—places art and artist firmly outside the tyranny of preconception. The original conception makes room for accident. Unpredictable, experimental, and innovative, contemporary prints and art in general echo the quixotic nature of modern existence itself. Years before Mead or Alvin Toffler identified uncertainty and change as hallmarks of a new life-style, Dada poet Richard Huelsenbeck wrote, "To sit in a chair for a single moment is to risk one's life."[36]

Few of us expect to sit still for very long,

given the nature of contemporary existence. In the span of twenty-four hours, the average person may be confronted with many events of equal impact: he could conceivably fly to another city on business, witness the eruption of a volcano in Portugal and a labor strike in London on television, attend an art opening, and dine with friends. It is impossible to focus all these events into a *single* mental image. However, a composite image, composed of key fragments of each event, produces a mental collage of the day's happenings. Such "constructed" or collage images mirror the simultaneity and complexity of events with which modern man copes daily. Artists such as

203. **Robert Rauschenberg.** *Accident.* 1963. Lithograph. 38½" x 27¼". Courtesy The Museum of Modern Art, New York; Gift of Celeste and Armand P. Bartos Foundation.

204. **Rolf Nesch** (1898–). *Oriental King.* 1954. Metal print. 23⅜″ x 17¾″. Courtesy Carus Gallery, New York.

R. B. Kitaj (fig. 169), Rauschenberg (fig. 38), and Eduardo Paolozzi (fig. 167) often opt for the collage motif over more traditional and static single-focus formats. As our eye hops from item to item in the artist's image, the information rushes at us from all directions. Pictorially, the disjointedness and fragmentary collage format simulates, in microcosm, the tension and continual flux of modern media.

The term *collage* derives from the French, *papiers collés* ("pasted papers"), a technique invented by the Cubists Picasso and Braque, who pasted scraps of unrelated materials (for example, wallpaper, newsprint, and oilcloth) into their paintings. The Cubists used these items largely in lieu of paint, as graphic devices for color or textural forms. The constructed or collage images of contemporary printmakers, however, are more akin to the photocollage techniques employed somewhat later by the Dada artists (fig. 40), who did not destroy the identity of the items they used but often selected an already "manufactured" item (for example, a news clipping or a photograph) specifically for its known connotation. Likewise, Kitaj selects materials for their telegraphic "message," such as the wallpaper appearing in *The Good Old Days* (fig. 169), which was typical of the wartime period the image portrays. If the wallpaper or photographs alter in character at all, it is through the added connotations they gain from the art context. The original photographs for Richard Hamilton's *My Marilyn* (fig. 170) were taken by George Barris and published in the English magazine *Town* after the actress's suicide. The x slashes were made by Marilyn herself to indicate the photographs on the proof sheet that she did not wish developed. Hamilton in some cases blocked out areas *not* to print, added painterly colors and partly solarized images (printed

in negative or reverse). The artist deliberately left the image itself and Marilyn's hand markings unaltered. Hamilton's selective visual collage develops a poignant comment on life and death based on our prior knowledge of the snapshot subject. Monroe, the object of widespread adulation and love, canceled her own life by suicide, an act of self-negation symbolized in the cancellation slashes on the snapshots. Hamilton's negative and positive exposures of the images could also suggest the thin line between life and death for a woman who often felt loved more as a celluloid image than as a real person.

Why are so many contemporary printmakers drawn to the use of prefabricated images—photographs, news clippings, advertisements, film? Perhaps today's artist feels pressured into making his point hurriedly, before it is outdated, and so avoids the tediously executed, traditionally drawn image. Andy Warhol's work suggests even more pertinent possibilities. Warhol often selects a popular photograph of his subject, one that has almost universal recall and journalistic associations such as *Jackie* (fig. 37). Through worldwide exposure in newspapers, magazines, and television, the picture is indelibly linked with tragedy and the death of President John F. Kennedy. Such images carry the immediacy of a newsreel and the documentary shock of life itself, especially in a culture in which people increasingly experience reality through the one-step-removed images of the media. By preempting the journalistic energy of such media images, the artist faithfully emulates modern reality in a way that his hand drawings could not.

The metal prints invented by the Norwegian artist Rolf Nesch (fig. 204) relate more comfortably to the Cubist use of collage. Although the general public is not familiar with his name, Nesch is one of the outstanding innovators in

contemporary printmaking. Starting with a studio accident, in which a hole appeared in a metal plate that he had exposed in acid for an overly long period, Nesch began to develop plates that could produce sculptural or embossed images. Nesch created metal collage plates—soldering onto them copper forms, wire nettings, and shapes of mica, wood, cork, and rope. He produced rich dimensional impressions that were neither sculptures nor traditional paper prints. As his techniques became more sophisticated and sure, Nesch simply colored the pieces of his metal collages and laid them in position loosely on the plate, shifting colors and positions with each printing. The artist seldom makes more than four or five impressions, each different from the other and in their way closer to a unique monotype than to an editioned print.

Once one becomes familiar with Nesch's metal prints, he can recognize them at a glance. The same is not true of the works of many contemporary artists: "Whenever I work successfully, I feel I become invisible in the art. The condition I strive for is productive anonymity."[37] In discussing his remarkable series *Pages and Fuses* (pl. 18, fig. 205), Robert Rauschenberg expresses

205. **Robert Rauschenberg.** *Page 1* from *Pages and Fuses.* 1974. Handmade paper, laminated rag. 23″ x 28″. Courtesy Gemini G.E.L., Los Angeles.

206. **Colin Self** (1941–). *Prelude to 1,000 Temporary Objects of Our Time.* 1971. Etching. 81¾″ x 63¾″. Courtesy Editions Alecto, London.

an idea deeply rooted in Dada tradition. Although it is questionable whether any really strong artist can totally eliminate the idiosyncratic clues that identify his work, diminishing their autographic presence is the goal of many. The impersonal execution of Josef Albers's *Linear Constructions* discussed earlier forces the viewer to respond to the image on its own terms, not on the basis of its clearly being "an Albers." Beneath this trend toward "productive anonymity," one detects the faint voice of Dada's Duchamp: "In French there is an old expression, *la patte,* meaning the artist's touch, his personal style, his 'paw.' I wanted to get away from *la patte.*"[38] Anonymity stresses the creative "process" over the creative personality, eliminating the middleman between artwork and viewer. Explaining his *1,000 Temporary Objects of Our Time* (fig. 206) series, contemporary artist Colin Self said, "I make pictures without direct hand work or physical contact with the paper, trying to eliminate calligraphic gesture completely, which I increasingly saw as stopping the viewer from seeing what is to be seen."[39]

In developing his *Pages and Fuses* (1973), Rauschenberg sought to explore the paper in terms of form and color: how color and form altered the character of paper, and how the basic nature of paper left its imprint on color and form. Rauschenberg undertook the project at Moulin à Papier Richard de Bas in Ambert, France, a mill that had been making paper since the fourteenth century. He said, "I had no pre-conceived ideas. . . . There were just two basic areas I wanted to experiment with. One was the form being the "print" [fig. 205] and the other idea . . . was painting with paper"[40] (pl. 18). The artist's autographic drawing "style" (fig. 38) submerged itself in the paper-making process throughout the project, which apart from the artist's signature and the project's inventiveness bears no indicative

"Rauschenberg" gestures. *Pages* shapes were achieved by the free pouring of pulp into tin molds that had been designed to Rauschenberg's specifications. Rags, cord, twine, and the like were added improvisationally. For the *Fuses,* sheets of Japanese tissue were screen-printed with magazine images selected by the artist. These tissues were then laminated to the wet sheets of paper as they were being made. Light-fast pigments especially devised for paper making supplied color. When the editions were completed, "workers . . . wearing heavy wooden shoes" trampled the paper molds.

Creative collaboration between master craftsman and artist is a tradition as old as printmaking itself. But collaboration between the artist and his viewer in the creative process is a newer development and one closely aligned with the Dada attempt to narrow the gap between art and life. The lithographs of John Cage's *Mushroom Book* (fig. 207) appear to be hodgepodge scribbles (more decipherable texts appear in an accompanying sheet in the portfolio). Cage deliberately chose accidental word groupings suggested to him by the *I Ching* (Book of Changes) as the basis for the order in which he superimposed his word blocks. Such random placement, Cage explained, would permit the viewer "to hunt for a particular text in a given lithograph, just as he might hunt for a particular mushroom in a forest." Art and life. Art *as* a living experience. Setting aside questions of personal preference or "prettiness" for the moment, one can recognize that there is a fundamental difference in the demands placed on a spectator by prints such as Cage's and those of a Reginald Marsh (fig. 6). One needn't "hunt through" the latter. The image gratifies at a glance. Isn't this the purpose of art? "Is it?" ask artists like Cage, who prefer to shift our attention from the *products* of creativity (the artwork

207. **John Cage** (1912–). *Mushroom Book,* Plate VII. 1972. Lithograph. 30″ x 22½″. Courtesy The Museum of Modern Art, New York.

itself) to the *processes* of creativity, from adulation of art as an *object* to an awareness of art as a living *experience.* And, for that matter, of experience as a creative process. The products (artworks) generated out of such Dadaist impulses are sometimes less enticing than the routes followed by the artist in making them or the creative involvement of the viewer in bringing the artist's idea to life.

The artist Dieter Rot incorporates a fresh piece of banana in one of his prints. Day by day the fruit decays, mutating from its familiar yellowish tone and texture to a furry green-white mold to a petrified-bark brown, until the original

fruit is completely transfigured and unrecognizable. If we can jettison preconceptions about the "ugliness" of decay and the "inappropriateness" of banana as an art material, it is possible to observe a process that alters colors and form in a way that may be as creatively intriguing as the shifts in cloud formation that have long been appreciated on an aesthetic level. Prints such as Dieter Rot's and Cage's raise as many questions as they answer. Dieter Rot isolates a natural process of change that becomes "creative" as the viewer watches it unfold. To what extent *should* the spectator's participation influence the creative act? In the April 1920 Dada exhibition mentioned earlier, at which the young girl recited obscene verses, Max Ernst displayed a wooden sculpture to which he had attached an ax and a note, inviting viewers to assist in destroying the piece. By encouraging people to manhandle his sculpture, Ernst was challenging his audience to fly in the face of their reverence toward art. Similarly, Dieter Rot calls attention to our common stereotypes about art.

Traditionally, works of art supplied the viewer with extensive visual data—for example, a naturalistic rendering of a landscape, so that his response and enjoyment was a direct by-product of the act of looking. The viewer's mind was not engaged in the same way that a less explicit, more symbolic or abstract contemporary image would tax his imagination. In the latter case, the work of art presumes that the spectator will not be a passive observer but, rather, an active collaborator in completing the picture. The activation of viewer participation in the creative cycle can probably be dated to the influx of Japanese woodcuts into Europe in the late nineteenth century.[41] Japanese artists had developed a flat, simplified style for depicting reality (figs. 62, 73, 74). Their more abstracted pictorial approach did not attempt to re-create three-dimensional objects but merely to suggest them. The viewer was expected to "fill in" details and bring something of his own imagination and experience to the situation. These semiabstractions greatly impressed Western avant-garde artists, who were at the time rebelling against the literalness of academic styles. The Impressionists' practice of presenting color in a way that mixed optically in the viewer's eye rather than on the canvas was another innovation that activated the spectator's role in completing the work of art.

The prints discussed thus far involve the viewer in discovering for himself how deceptive his perceptions can be. Today a new type of multiple "print" is emerging that blurs the line between real and unreal, certainty and uncertainty, even further. This medium is called video tape. Although outside the scope of this book, video-tape editions are a development with which collectors interested in contemporary graphics should become familiar. Editions are both limited and unlimited and are gaining popularity as "collectibles" with the availability of inexpensive home-viewing equipment.

The video-tape camera records events instantaneously on tape, permitting the action to be replayed later. On replay, the image appears no less "live" or instantaneous than when it first occurred, though it now represents only an illusion, like a painting. In this sense, video tape offers an ideal apparatus for exploring new aspects of reality and how we perceive it. When one thinks of the disorientation experienced when we watch a live newscast on television, only to discover that the broadcast has been taped days earlier, the potential of video-tape art to record the paradoxical nature of modern reality becomes apparent. As an art form, the medium is still struggling to find its way. Artists like Taka Imura

have exploited the medium's ability to expand our perception. In an unlimited-edition tape, *Project Yourself* (1974), Imura taped people indulging unwittingly in autoerotic (but nonsensual) behavior normally frowned on in our society, namely, looking at themselves. Imura positioned cameras so that people entering an exhibition confronted images of themselves on the TV screen. Some were embarrassed, others stared dumbly, still others "acted." All these performances were made permanent on the video tape. Later in the exhibit, the unwitting actors were accosted by replays of themselves. Perhaps for the first time in their lives these people were placed in the position of seeing themselves as others see them, or as though they were viewing a painting of themselves. Imura, in effect, turned the spectators at his exhibition into his creative material, and their renewed perceptions of themselves became the creative act. Whatever the ultimate artistic application of such electronic print media, these initial efforts in video tape mark still another step in the exploration of nontraditional art forms and aspects of reality opened by the Dada "state of mind."

Is "Everything the artist spits" art? Or did Dada anarchy merely unlatch a Pandora's box on which we can no longer shut the lid? Where do you draw the line on what is and what isn't art? Should there be a line at all? Are many artists today charlatans and fakers, or are they the standard-bearers of art as provocateur? Are their images put-ons, empty exercises, as some insist, or concepts that push perception in new directions?

The types of prints discussed in this chapter are part and parcel of these perhaps unresolvable issues of modern art. When we seek what Kenneth Clark calls the "Beethoven element"—the heroic meaning—in contemporary prints, they often disappoint. Perhaps one must approach them as Francis Picabia's wife recommended that people approach the disconnected word images in her husband's Dada poems, as "a succession of very simple images that one must 'look at' as, on a trip, one looks at the scenery fly past, without searching for an innuendo or an interpretation."[42] Each collector must draw his own conclusions whether or not a particular print holds meaning in terms he can respect, keeping in mind that the power of many contemporary images rests less with a concern for pleasing the eye than with provoking it.

In order to isolate a number of key points, it was necessary to exclude a discussion of prints that fall more comfortably within orthodox definitions of "beauty" and "art." This exclusion in no way implies that these prints are less contemporary or collectible. The house of art has many windows. The important thing is not through which window the collector chooses to look, but the fact that he takes the time to look at all.

8

"my
six-year-old
could
do that."

The title of chapter 1 reads, "I Like What I *Know*." However, many people, unconsciously, transpose the words and read them as the more common phrase, "I know what I *like*." It is this quirk of human perception—the tendency to look for what we *expect* to see—that inhibits many people from enjoying abstract or nonrepresentational forms of art. Much of contemporary graphic imagery explores such inconsistencies between *looking* and *seeing*. Although the problem can be touched on only briefly in a book of this kind, the question of perception is pertinent enough to warrant discussion. The output of contemporary artists constitutes one of the richest supplies of prints for a neophyte collector and one of the best areas for buying top quality at relatively reasonable prices.

Of the two heads pictured in the lithographs by Theo Wujcik (fig. 208) and Walter Wahlstedt (fig. 209), which one is realistic and which abstract? Actually they are *both* abstractions. It is merely a matter of degree. Any depiction of a three-dimensional object on a two-dimensional paper surface is automatically an abstraction of it. A face is made of flesh, blood, and bone, not lines and shadows. Why, then, does the Wujcik lithograph strike us as more "lifelike"? Because the artist employs a system of visual abbreviations to which we have become habituated almost without realizing that the learning process was taking place. In daily life, we rely on many such common culturally accepted abstractions: maps, photographs, musical notations, mathematical formulas, and, of course, numbers and words. The effectiveness of such codes rests largely on their total integration into the culture and their feeling as being inborn to us as our mother tongue. Yet just as the abstraction *w-i-n-d-o-w* conveys nothing to a person unfamiliar with the English alphabet, many basic visual codes taken for granted for

208. **Theo Wujcik** (1936–). *Robert Rauschenberg.* 1977. Etching (working proof). 30¾″ x 41¼″. Courtesy Brooke Alexander, Inc., New York.

209. **Walter Wahlstedt** (1898–1970). *Fiorenza.* 1921. Lithograph with gilt paint and watercolor. 15¾″ x 12½″. Courtesy Carus Gallery, New York.

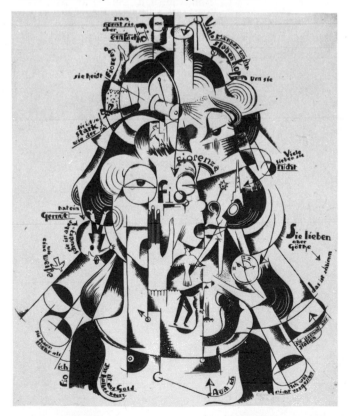

hundreds of years in Western art would probably strike an ancient Egyptian as ridiculous (fig. 210). People who consistently brush aside images they find perplexing in modern art with a condescending "My six-year-old could do that" in many ways share the same point of view with the ancient Egyptian.

DO WE REALLY SEE WHAT WE THINK WE DO?

Much of the time we actually see what we *expect* to see and not necessarily what is there. These are just a few examples that demonstrate the often-unrecognized influence of indoctrinated visual conventions on our powers of perception. When these conventions are ignored or made ambiguous, the viewer often becomes confused and unable to identify—to make sense out of—the visual patterns. The more art deviates from familiar seeing codes (for example, Cubism, Surrealism, and abstractions in general), the more the viewer is forced to see without relying on clear, established prototypes for guidance. This may be part of the reason that so much explanatory rhetoric has become almost a prerequisite to understanding developments in contemporary art, why one cannot always appreciate the image by merely looking at it.

Figure 210: Early Egyptian Versus Western Ideas on Perspective

Rudolf Arnheim's incisive study, *Art and Visual Perception,* offers these two schematic representations of a square pond surrounded by trees of the same size. Figure 210A is executed in Western cameralike perspective—from a single fixed viewing point—whereas figure 210B is made according to Egyptian principles (and the style often seen in children's drawings). Arnheim

PERCEPTION DIAGRAMS

210. Western eye view versus ancient Egyptian. Copyright © 1954, 1974, by The Regents of The University of California.

points out that the Egyptian, with good cause, might say that A does not realistically show the pond's shape since it is an "irregular quadrilateral rather than a square." In "real life," the trees are of equal height and meet the ground at right angles, yet A shows them obliquely in some instances and "in the water" in others, and they are hardly evenly spaced around the pond. Western eyes would find B equally inadequate, admitting a relationship to the view of the pond from the air but insisting that the artist had depicted not standing trees but trees lying flat on the ground.

211. Diagram of "circle."

Figure 211: What Shape Is This?

True, the form *resembles* our conventional image of a circle, but in fact it is two *broken* arced lines. The eye's tendency to seek resemblances and make such "looks like" associations helps us to accept a two-dimensional drawn image for its real-life source and unsettles us in Josef Albers's *Linear Construction* (fig. 197) when the image does not resolve itself in the "expected" way.

212. Diagram of ground-field inversion.

Figure 212: Is This an Image of Two Profiles or a Goblet?

What constitutes background and what constitutes foreground (the image) in this famous example of perceptual ambiguity? The same paradox of seeing is used in Marcel Duchamp's deceptive self-portrait (fig. 196).

Figure 213: How Tall Is the Woman Walking Furthest Away from Us?

Normally, in Western size–distance perspective formulas she would be the smaller of the three figures. Since the woman in this well-known psychological pictogram appears to be larger than the others, we automatically assume that he *is* much bigger. Actually the three figures are pre-

213. Diagram of receding figure.

214. **Pablo Picasso.** *The Bull*. 1946. Lithograph, eleventh state. 11½″ x 16½″. Courtesy Carus Gallery, New York.

cisely the same size and only our expectations alter the fact.

But what does all this mean for the print collector? Don't close your options too soon. Seeing is not necessarily the instinctive and natural process one might assume. Images that initially seem incomprehensible ("Is that art?") could become fascinating areas for collecting once the visual language is better understood.

One might assume by the simplicity of the lithograph *The Bull* (fig. 214) that, like a child, the artist did not know how to draw very well, which most people understand to mean that he did not know how to depict a bull realistically. But quite the contrary is true. The dramatic metamorphosis by which Picasso arrived at the image is a fascinating demonstration of how a seemingly "childlike" abstract creation may be anything but the effortless accident it seems to suggest. Picasso explored ten alternatives before settling on this particular version of the bull for his printed edition. The lithograph represents the eleventh reworking of the concept over a period of almost two months.

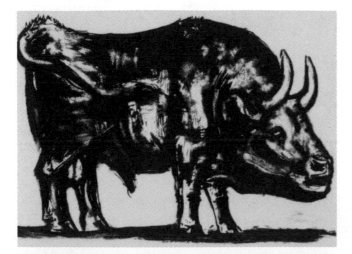

215. **Pablo Picasso.** *The Bull.* 1946. Lithograph, second state. 11½″ x 16½″. Courtesy Ruth O'Hara.

Jean Celestin, who worked at the Mourlot printing workshop in Paris, where Picasso made the series, tells us that when the artist began (state 2 fig. 215) the bull was

> *a superb, well-rounded bull. I thought myself that that was that. . . . A second state and a third state, still well-rounded followed. . . . But the bull was no longer the same. It began to . . . lose weight [fig. 216]. Picasso was carving away slices of his bull. . . . [figs. 217, 218]. He would say, "we ought to give this bit to the butcher. . . ." In the end, the bull's head was like that of an ant [fig. 214] . . . at the last proof there remained only a few lines. . . . I still remembered the first bull and I said to myself: what I don't understand is that he has ended up where really he should have started! But he, Picasso, was seeking his own bull. . . . And when you look at that line you cannot imagine how much work it had involved.*[43]

In reducing the bull's ferocious mass, symbolic potency, to an almost whimsical outline, Picasso arrived at a rarely seen humorous interpretation of the creature. Focusing on the animal's mindless phallic power, he pitted its great bulk against a pinpoint head. Far from exhausting the creative possibilities inherent in the bull's form and con-

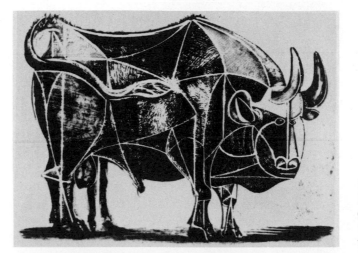

216. **Pablo Picasso.** *The Bull.* 1946. Lithograph, fourth state. 11½″ x 16½″. Courtesy Ruth O'Hara.

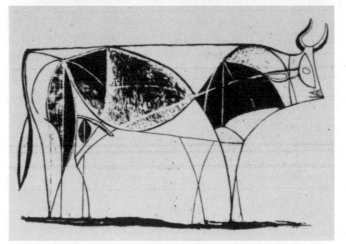

217. **Pablo Picasso.** *The Bull.* 1946. Lithograph, eighth state. 11½″ x 16½″. Courtesy Carus Gallery, New York.

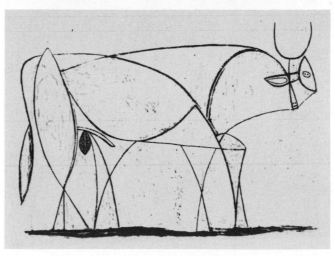

218. **Pablo Picasso.** *The Bull.* 1946. Lithograph, ninth state. 11½″ x 16½″. Courtesy Carus Gallery, New York.

149

notation, Picasso's series clearly incited still another imaginative exploration, that of Roy Lichtenstein (pls. 20, 21, 22, 23).

The facile statement—"My six-year-old could do that"—camouflages a skill many grown-ups would do well to retrieve. The six-year-old pedals his tricycle or steers the phantom wheel on his cardboard-box automobile with equal conviction, moving between the worlds of reality and imagination as easily as a fish negotiates currents. Perhaps everyday necessity overtrains adults to use their eyes purposefully, strictly in functional and utilitarian ways, until, in a sense, we develop a kind of blindness to anything that doesn't "make sense" in practical terms. The secretary who retypes a letter until it falls "right" on the com-

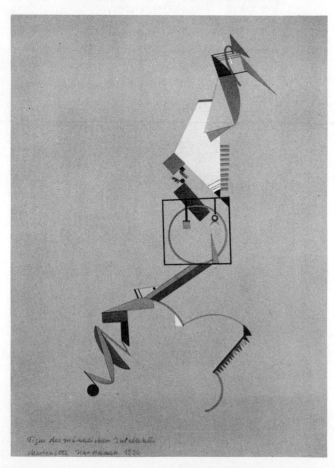

219. **Lothar Schreyer** (1886–1966). *Figure of the Masculine Intellect.* 1920. Lithograph. 15½″ x 11½″. Design for a puppet made while Schreyer was head of the Bauhaus theatre workshop. Courtesy Carus Gallery, New York.

pany stationery may scoff at geometric-type prints such as those by Lothar Schreyer (fig. 219) or El Lissitsky (pl. 24) without realizing that in a rudimentary way, she also grapples with universal laws of balance, composition, and forms in space. The child's willingness to see inventively gives him the power to transform the same colorless cardboard box into a sleek spaceship or an eight-cylinder car, to leap past the prison of everyday reality into a creative universe in which anything is possible. Indeed, the charm in children's drawings rests not alone in their technical naïveté but in the innocent eye with which the child records what he sees, uncensored, unfiltered, and unprogrammed by prevailing visual conventions. What, then, differentiates the child's ingenuous abstractions from the artist's? The child stumbles on his concept, while the artist achieves it consciously through skill and control and for a deliberate purpose.

When an adult retrieves his childhood gift for accepting different levels of reality—shifting from the concrete to the purely imagined realms with equanimity—he expands the latitude of aesthetic experiences open to him. Just such a startling insight has been credited with the birth of abstract art. Although a number of artists were exploring the possibilities simultaneously, Wassily Kandinsky is widely acknowledged to be the "father of abstraction." Kandinsky returned to his Murnau studio one afternoon after a long day working out of doors. Upon entering the studio, Kandinsky tells how he was taken by surprise at the sight of an "indescribably beautiful painting." In this strange canvas, he discerned no representational image, only "forms and colors." After some moments, Kandinsky recognized that the beautiful "abstraction" in the dusk lighting was actually one of his own paintings turned on its side. The next day he attempted to reproduce the nonrepre-

see that artists can achieve unsettling effects simply by hoodwinking the eye. The images of both Giovanni Battista Piranesi (fig. 220) and M. C. Escher (fig. 221) appear calm and rational at first glance. But they are anything but that. Both artists have deliberately rubbed accepted visual stereotypes the wrong way, jarring our expectations so that without really knowing why, we are left with feelings of disorientation and uneasiness. First in 1745, at the age of twenty-five and on commission, Piranesi etched his sixteen prints for *Imaginary Prisons,* and again, sixteen years later, he published a second edition. Unlike so many of

221. M. C. Escher. *Relativity.* 1953. Lithograph. 11″ x 11⅜″. Courtesy The Museum of Modern Art, New York.

220. Giovanni Battista Piranesi (1720–1778). *Sixteen Imaginary Prisons,* Plate III. 1761. Etching. 21⅜″ x 16¼″. An undercurrent of despair and terror permeates Piranesi's famous series of prison interiors. Courtesy Sotheby Parke Bernet Inc., New York.

sentational image that had so moved him: "I knew then precisely that objects were harming my painting."[44]

Seeing his canvas turned sideways, Kandinsky did not recognize his own work. It did not look the way it was "supposed to"; therefore, he was momentarily unable to "see" it. What we *expect* to see so often conditions what we actually

the other great graphic artists (Dürer, Rembrandt, Goya, Daumier), Piranesi was never a painter, and his genius comes to us largely through printmaking. What embues Piranesi's prison interiors with their forbidding, Kafkaesque mood? Heavy ropes and pulleys snake through many of Piranesi's prison images, dramatizing the massive space of the interiors and conveying a sense of dread. And, indeed, the ropes and pulleys had a sinister origin in Piranesi's time. A basket with a prisoner crammed inside was sometimes attached to one of the ropes and hoisted to the ceiling. The rope would then be suddenly let loose, causing the basket to plummet several hundred feet and then snap to a stop in midair with such violent force that most of the prisoner's bones were broken. But the sinister atmosphere created by Piranesi's images relies on far more deliberate

222. **Albrecht Dürer.** *Melancholia I.* 1514. Engraving. 9½″ x 7½″. Courtesy Sotheby Parke Bernet Inc., New York.

devices. In addition to their dramatic perspectives and lighting, close inspection reveals that Piranesi's architecture is not quite as perfect as it appears: wood structures often lead nowhere and serve no other function than to trap the eye in labyrinths in which it circles hopelessly for an exit, not unlike the hero of Kafka's *Trial*. The stairwells in M. C. Escher's lithograph *Relativity* appear, like Piranesi's *Prisons,* to be orderly and logically constructed. It is this very impeccable clarity and logic that catches us offguard and whirls us topsy-turvy into confrontation with the irrational. Look closely at the two figures on the upper-level staircase. They seem to move in the same direction, but actually Escher has depicted one person going up and the other going down the same staircase.

> It is impossible for the inhabitants of different worlds to walk or sit or stand on the same floor, because they have different conceptions of what is horizontal and what is vertical. Yet they may well share the use of the same staircase. . . . Contact between them is out of the question, because they live in different worlds and therefore can have no knowledge of each other's existence.[45]

Escher, a mathematician, architect, and photographer, ignores the normal Western art convention of presenting a scene from a single observation point. Using an unorthodox approach to perspective, he tricks our expectations, showing the scene *simultaneously* from below, above, and frontally, and as a result we can't find a visual foothold. Although Escher works in a more representational idiom, one is reminded of the same baffling explicitness in Arakawa's prints (fig. 198), dotted with readable words that lead frustratingly nowhere and everywhere at once.

Art speaks in many voices. But not always in

the same language. Where does this leave the spectator? Often scratching his chin and puzzling over what it's all about. More so, if the artist's particular vernacular departs radically from commonly identifiable visual symbols. Without question, art should be *experienced* and not worked out like a crossword puzzle, but just as comprehension of the sentence

presupposes some acquaintance with notations used in Gregg shorthand, visual shorthands are not always self-explanatory. As critic John Russell pointed out in another context, such conclusions often correspond to the judgments of a deaf man on music or a eunuch on sex.

Even in instances in which we can derive a prima facie delight in the image because the artist's language relies on easily recognizable forms, we miss a good deal that might enrich our enjoyment of the imagery by having only a partial understanding of the artist's personal code. For centuries, people have been fascinated by the iconography of Dürer's famous engraving, *Melancholia I* (fig. 222), which means "black bile" in Greek and possibly derives from a fifteenth-century theory that attempted to classify the "melancholy man of genius" into one category who shows brilliance (white-bile melancholy), and another brooding type who exhibits mania (black-bile melancholy). Dürer himself noted that the keys in his picture meant power and the purse, wealth. In *The Complete Engravings, Etchings and Drypoints of Albrecht Dürer,* Walter Strauss also tells us that "the woman's wreath is braided from two watery plants, watercress and water ranunculus, which reputedly served as a remedy for body dryness caused by melancholy. The magic square [numbers] is a Jovian device used to counteract the negative influences of Saturn." To re-

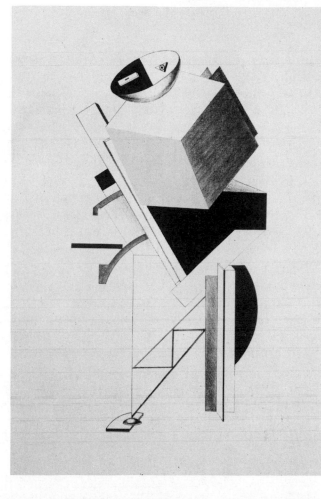

223. **El Lissitsky** (1890–1941). *Sentinel,* Plate 3 from *Victory over the Sun.* 1923. Suite of 10 lithographs. 21″ x 17⅞″. The lithographs represent the figurines for the 1912 opera *Victory over the Sun* by A. Kruchenykh. Courtesy Carus Gallery, New York.

ject or belittle what we do not immediately comprehend in art is easy.

In a stunning series of ten lithographs representing mechanical figurines for A. Kruchenykh's opera *Victory over the Sun,* El Lissitsky envisions his "actors" more as mechanisms than men (fig. 223). Lissitsky observed that "The sun as the expression of the world's age-old energy is torn down from the sky by man; the power of his technical supremacy creates for itself a new source of energy." Precise and unsentimental, the machinelike figures are formulated in terms of geometric harmonies, a symmetric beauty associated with the structures of architecture and

technology rather than those of nature. "The text of the opera," wrote the artist

> *obliges me to preserve something of the human anatomy in my figurines [pl. 24]. The colors in various areas of the design are to be understood as material equivalents. That is: those parts of the figurines done in red, yellow or black do not indicate that they should be executed in these colors, but rather that they are to be made of corresponding materials—for example—shining copper, dull iron.*

A major print document, *Victory over the Sun* is one of the rare expressions of Russian Constructivism in graphics. Are these mere shapes and forms? Or, as the title of the opera implies, are they a provocative articulation of a generation's optimistic belief in man-made technological prowess as the means of man-made growth? Rationalizing nonrepresentational imagery with such verbal explanations appears to answer the literal-minded question, "But what does it mean?" Although such explanations often permit people to accept the abstractions they find hard to "see," ultimately this is an exercise in *thinking* art rather than *seeing* it. What of the colors, shapes, and forms themselves? Since they are not literal representations of anything, are they merely random accumulations, perhaps no more than decorative whims on the part of the artist?

In the case of Lissitsky's *Globetrotter in Time,* we discover that the entire geometric construction (pl. 24) pivots almost tentatively at a single point on the large black disk. Note that the point of contact does not fall at the center axis of the circle but favors the left side of the composition. If we were to cut the disk top to bottom at this contact point, it would produce a segment exactly the balance complement in size and shape of the partial sphere at the top of the design.

Cover the upper of the two winglike shapes, again segments of a circle, and the composition collapses to the left. The overall visual structure of Lissitsky's image is held in subtle balance by many correspondences of this nature that one perceives as a "wholeness," a design to which we can add nothing or from which we can subtract nothing without destroying some intrinsic equilibrium. But balance is only part of a *dynamic* equilibrium that infuses *Globetrotter* with energy as an image. From its tenuous perch on the large black disk, the construction seems about to lift off into flight. Not only is the disk a resting point for the design, but its compelling, dense *"blackness"* leads the eye to the two smaller *black* intersected circles at the left, and they, in turn, propel us on to the *black* profilelike rectangle at the top of the image. From thence, we are moved down again through the fine *black* line work (which resembles the wing struts of early planes) and back again to the *blackness* of the large disk. Color further activates the dynamic element of Lissitsky's *Globetrotter in Time,* a title that in itself implies movement. Warm red, as in the diagonal bar of *Globetrotter,* tends to move toward the viewer, subordinating cooler colors in the design, which, by contrast, appear to be receding. Such color interactions and overlapping of shapes create not only a sense of depth but a sense of movement in space as well, energizing a seemingly flat, static geometrical construction. The idea that colors have motion is not as preposterous as it may sound. Astronomers measure the shift in the color of a star to determine the speed with which it is moving toward or away from us. This analysis only touches on the intricate sensibilities and judgments that go into creating a major abstract image, no matter how simple it appears. Just as many literal images never rise above mediocre representations, abstract compositions may remain decorative exer-

154

cises. But individual elements become as crucial to making masterful abstractions "work" as the choice of a particular red hue, the drawing and placement of a hand, or the emotional focus in the more literal compositions of Goya or Rembrandt.

An interesting sidelight on the opera *Victory over the Sun,* produced in 1913 (and in itself an avant-garde landmark of modern ideas), was the unorthodox lighting effects designed by another pioneer of abstraction and a dominant influence on Lissitsky, Kasimir Malevich (fig. 235). Radical for its time, the lighting treated the stage as though it were a pictorial space and presaged Lissitsky's later print cycle:

> *The figures themselves were cut into shape with the knives of the searchlights and robbed alternatively of their arms, legs, or head, since for Malevich they were only geometrical bodies subject not merely to dissection into their component parts but also to complete extinction within the picture space. The only reality was the abstract form that absorbed the whole luciferian haste of the world.*[46]

As early as 1909, Kandinsky wrote his *Yellow Sound,* a clearly abstract stage composition featuring five yellow giants, described as forms with indistinct features. At one point, a single yellow giant, lit against total blackness, grew to the full height of the stage, transforming into a huge cross. Music, form, lighting, and sound were used nonnaturalistically throughout, explained by Kandinsky as an effort to touch the inner experiences of the audiences. Kandinsky's experimental composition may have provided the stimulus for Malevich's 1913 "painting" with stage lighting.

The familiar shapes of the human physiognomy may remain within a commonly understood visual vocabulary, but if the artist takes liberties

through distortion and exaggeration, he may devise, at the very least, a new dialect with which to express reality. With a sinister eye for nuance, Charles Philipon drew his biting satires of *Poires,* depicting Louis-Philippe as the "pear king." Conveniently for the political satirist, *Poire,* which appeared in *Le Charivari* in 1834, resulted in the paper's being fined, offering Philipon still another opportunity to retaliate by printing his four-section *Poires* (fig. 224), which progressively distorts

224. **Charles Philipon** (1800–1862). *Les Poires*. Lithograph, *Le Charivari,* January 17, 1834. Courtesy The Metropolitan Museum of Art, New York; Gift of Arthur Sachs, 1923.

225. **Edvard Munch.** *The Cry*. 1895. Lithograph. 14″ x 10″. Courtesy National Gallery of Art, Washington, D.C., Rosenwald Collection.

the king's features. The four famous caricatures raised an interesting issue for the government censors: at what point does distortion become libelous? Daumier worked on Philipon's paper, and both artists depicted the king in his pear configuration at one time or another.

Intent on the emotional rather than the political truth, an artist can use distortion and exaggeration to render man's deepest anguish with devastating impact. In Edvard Munch's lithograph *The Cry* (fig. 225), the central figure's entire face sucks inward in the shape of a harrowing scream. Nervous lines gyrate throughout the print, setting up a frantic pulse, as though the scream itself were rippling through the paper. The boardwalk railing slices the composition at a sharp angle, ending abruptly—a knifelike visual cut that echoes the stabbing pain one senses in the screaming form. Munch makes it almost possible for us to hear the cry with our eyes.

The language of art is never complete. Its peculiar regenerative powers and vitality derive from the never-ending imagination of artists who, like children, continuously rediscover the cardboard box. Following suit, the open-minded collector learns the measure of his own capacity for creative growth, as did one who admitted that "Most of the things hanging on the walls here today that are postwar, five years ago neither my wife nor I would have wanted to own." More than four hundred years earlier, in 1506, Albrecht Dürer, on a second visit to Italy, reported similar sentiments to his friend Pirkheimer: "The works which pleased me eleven years ago no longer appeal to me. If I had not seen it for myself, I would not have believed anyone who told me such a thing."[48]

Thousands of prints change hands at auction houses yearly. If you become a print collector, the chances are better than average that one day you will want to use this marketplace yourself to buy or sell. But a mystique has grown up around auctions that makes many newcomers shy away. The media, in particular, tend to dramatize the "show" and obscure the "business" aspects of major international auctions, further nourishing the feeling that they are not for the average collector. As the vortex of international trading in prints, the auction block represents the place where worldwide markets for an artist's work are established or evaporate in an afternoon and where recordbreaking prices and new areas for collecting are most likely to emerge.

Even if you never buy or sell a single print at auction, however, there's hardly a better way to keep current with print trends and prices than following such sales. That kind of information comes in handy both as a guide on what to buy and as a protection when you sell. To give a dramatic instance: say you bought one of the etchings from Picasso's *Suite Vollard* (fig. 132) in the early 1940s, when impressions could be had for $50 each. In 1973, you were offered $300 for the print, a 500 percent return. If you kept current on prices you would have turned the offer down, knowing that the set of one hundred prints of the *Suite Vollard* sold for a quarter of a million dollars that year.

Sotheby Parke Bernet's print auction of May 14, 1974, included a number of fine examples of Rembrandt's etching *Adoration of the Shepherds with the Lamp* (fig. 226). The following two entries appear in the catalogue. The descriptions are almost identical. *Almost but not quite.* The difference is worth $5,500. Which Rembrandt would you bid on? Which would you assume to be the more valuable?

9

lot #89

226. **Rembrandt van Rijn.** *Adoration of the Shepherds with the Lamp.* c. 1654. Etching, first state. 4⅛" x 5". Courtesy Sotheby Parke Bernet Inc., New York.

lot 88: The Adoration of the Shepherds; with the Lamp.
(B., Holl. 45; H. 273; BB 54-1), etching, a very good clear impression of the first state of two, on lightly tanned paper, with 2 to 4 mm margins, in good condition.

lot 89: The Adoration of the Shepherds; with the Lamp.
(B., Holl. 45; H. 273; BB 54-1), etching, a very good, bright impression of the second state of two (Nowell-Usticke's second state of three, early, before the wear in the dark shading above the cows), printed with slight retroussage at right to enhance the lighting effects, with small margins, in good condition.

Careful reading reveals that lot 88 is the rarer *first state* of the work, executed in the art-

ist's lifetime. It brought $7,500 at the auction against lot 89, also a fine impression but of a later second state, which was knocked down at $2,000.

In a Swiss auction of the same year, two portfolios by the German Symbolist Max Klinger went on the block. In the price estimates issued by the auction house prior to the sale, one portfolio, *Intermezzi,* was estimated to bring $900; the other, *The Glove* (fig. 227), was estimated for $750. Which would you consider the smarter buy? The estimates reversed themselves dramatically in the actual sale, at which *The Glove* sold for $4,900 (plus commission)—over six times the estimate— and the *Intermezzi* reached only $1,000 (plus commissions). This surprised no one familiar with Klinger's work, since *The Glove* is the artist's most famous cycle of prints.

Obviously, uneducated instinct has about as much place at the modern print auction as an eight-cylinder engine in ancient Mycenae.

Impulse may carry you through on occasion, but more likely it will "carry you away" and your hard-earned cash with it. Buying intelligently calls for informed instincts, with an emphasis on the *informed.* Even professional art dealers do their homework or find themselves in the position of taking unnecessary gambles. One dealer, interested in purchasing a newly published lithograph by Alexander Calder, did not bother to attend the preauction exhibition on the assumption that Calder's bold images would be easy enough to evaluate from her second-row seat in the auction room. But when the Calder lot number was called out, she got a rude surprise. In place of the usual framed image, the attendants placed on the display pedestal a large gray cardboard tube. Apparently the print had never been framed by its owner and had been sent directly to auction still in its original tube. Had the dealer done her homework and attended the exhibit, she could have asked to have the lithograph removed from its

227. **Max Klinger.** *Abduction,* Plate 9 from *The Glove.* 1880–1881. Etching and aquatint. 17½″ x 24⅞″. Courtesy Carus Gallery, New York.

tube for inspection. Instead she bid blind, unaware of the quality of the image or even the condition of the print.

Are auctions the best place to scoop up "bargains"? The famous art dealer Duveen was fond of saying that paying a top price for a masterpiece *was* a "bargain." Certainly, good buys abound at auction, but an alert collector or dealer often unearths a far more spectacular bargain by sharp-eyed gallery shopping. One collector acquired a fine impression of Picasso's *Femme au Fauteuil* (fig. 228) for $9,500, which she would have had to pay $28,000 for at an auction held later in the same year. Be realistic. Keep in mind that today's large auctions are international "happenings" that bring together competitive and knowledgeable collectors and dealers from all over the globe. Prices for important and well-known images will generally fall within an internationally expected price range, except in instances in which a market readjustment is occurring on that work or the artist's entire oeuvre (for example, prices tend to go through a leveling-out period following a major sale of an artist's work), or an international economic realignment is in process (see pages 177–178).

The following questions and answers offer a rudimentary introduction to auction practices. The information was compiled in a series of interviews with Marc Rosen of New York's Sotheby Parke Bernet print department, Nicholas Stogdon of Christie, Manson & Woods International, and several New York print dealers and collectors. For purposes of clarity, the section is divided into four categories: "The Mechanics of Buying and Selling"; "Reserves, Estimates, and Guarantees"; "Factors Affecting Value"; and "Catalogues Raisonnés." The chapter concludes with a brief list of basic reference sources, to which the collector can turn for information, and the addresses of major print-auction houses.

THE MECHANICS OF BUYING AND SELLING

Can you determine the value of a print before consigning it for sale at auction?

Major auction houses are continually scouting for salable prints and prospective clients. On this basis, they usually offer preliminary estimates on what a print *might* be expected to bring at sale. Either bring your print directly to the auction gallery (be sure to make an appointment in advance), or if you live at a distance, send a letter and a photograph, if available, with as much information as possible (artist, title, size of image, condition, signed or unsigned, year, medium, edition size, etc.). You can also check auction catalogues to ascertain whether the print has sold

228. Pablo Picasso.
Femme au Fauteuil
(Woman in an Armchair). 1948. Lithograph, final state.
27³/₁₆″ x 20⅛″. Courtesy The Museum of
Modern Art, New York; Curt Valentin Bequest.

recently and at what price. Quality and condition should be comparable, of course.

Is there a charge for appraisals?

Generally there are two types of appraisal services available. At Sotheby Parke Bernet (SPB), for example, there is no charge for *informal* estimates. These are either verbal or written tentative opinions of an item's worth. Informal appraisals tend to be on the conservative side to assure that the consignor wil receive well within the estimated range at the actual sale. *Formal* appraisals, made for insurance purposes, are another matter. These currently carry a charge of 1½ percent for appraised values up to $50,000 (1 percent for anything above that; but charges can change. Check with the auction house for the current rates). Formal appraisals provide the most optimistic view of the item's market value. They are drawn up in multiple copies and notarized for future legal uses. The SPB formal appraisal is one of the few recognized by the Internal Revenue Service and is often used by people intending to donate items to institutions for tax deductions. SPB will take court action if necessary to defend its appraisals, a significant difference between its informal opinion and its formal one. Christie's Appraisals, Inc., also stands behind its appraisals and charges 1 percent of the appraised value or a negotiated fee. Anyone with valuable prints or an extensive collection should select an appraiser whose judgment is universally acceptable to the IRS. The Art Dealers Association of America (ADAA) offers appraisals that are also recognized by the IRS. The association, a nonprofit organization, is national in membership and based in New York City. ADAA offers an appraisal service for donations to museums and charities. Written appraisals from ADAA represent a consensus of three opinions from members recognized as specialists in the particular artist or school. Fees for the service are set on a sliding scale.

People trying to determine the possible auction value of a print sometimes contact a gallery to ask, "How much is it worth?" That is tantamount to having a stomach pain and expecting the doctor to know without examination if it is an ulcer or simply the aftermath of last night's dinner. Since a written appraisal can involve a

day or more of research, the dealer should be sent a photograph with a precise description and offered a 1 percent fee if a serious appraisal is needed. If you are a regular client, the gallery may do the appraisal as a courtesy.

When is it wiser to sell a print privately or through a dealer rather than at auction?

Auctions are unpredictable, although *reserves* (see page 165) offer the seller some protection against a print's selling below its value. Whether one sells through a dealer or at auction, a gamble is always involved. In the spring of 1973, Toulouse-Lautrec's print *Le Jockey* was sold by the Knoedler Gallery for $8,000. A comparable impression of the famous 1899 lithograph brought $40,000 at Sotheby Parke Bernet in February 1974. Keep in mind too that many prints are not "auction material." They either have been issued too recently to have established an international market value or were made by artists who have not yet been revived as "collectible" or by artists with no buyer demand. Sale at auction is most effective when an artist's work has wide acceptance and an established international price level that attracts strong buying interest.

How do you consign a print for sale at auction?

First, ascertain by phone or mail whether the auction house will consider the print for sale and whether, in their expert's opinion, it has good potential at auction. Then either bring the print to the premises or send it. Large, framed prints must usually be sent crated or via special art truckers. A receipt is immediately issued when the property arrives, and if you decide to sell based on a confirmation of the estimate, a contract is sent. Terms of sale can vary, especially on an expensive item or collection, and should be discussed with the auction house at the time of consignment. Property should reach the gallery at least three months prior to the sale. Exceptions are possible, but you then run the risk of missing the auction of your choice and listing in the sales catalogue, which usually goes to the printer two months prior to a sale.

Can a print be withdrawn once it has been placed?

Generally there is no charge for withdrawal of an item until cataloguing for the sale is completed and the catalogue prepared or until a signed contract has been received. Once the contract is received, or the catalogue has been published, property cannot be withdrawn without the auction gallery's agreement. At this point, there is usually a charge for withdrawal. If you are placing an item for sale on a tentative basis, in fairness the auction house should be informed that your decision is still pending.

What is the standard commission charged for the sale of prints?

Commission arrangements vary slightly from one auction house to the next, and it is best to check with each individually. A listing of major auction galleries and their addresses appears at the end of this chapter. At the present time Sotheby Parke Bernet (New York) charges 12½ percent for a single item over $15,000, 15 percent for an item over $5,000 and up to $15,000, 20 percent for a single item over $1,000 and up to $5,000, and 25 percent for a single lot up to $1,000. That means that on a print sold for $750, the seller would be charged a commission of $187.50. On a print that sold for $3,500, the commission would come to $700, a smaller slice of the total amount. More valuable prints give the seller a proportionately higher return. In this sense, the commission acts as a natural screening device, attracting high-quality prints as well as covering the gal-

lery's expenses in handling an item. Christie's takes a straight 10 percent from the buyer *and* 10 percent from the seller. German, Swiss, English, and Austrian auctions take commissions from both seller *and* buyer (except when an item does not go above the seller's reserve). Apart from some fluctuations and dealer discounts, the commission is 15 percent from the buyer and 15 percent from the seller. Austria's state-run Dorotheum auction takes 20 percent from both. If you get an auction price or estimate from Europe that is $1,000, for example, you must remember to *tack on 15 percent or 20 percent* in calculating costs. This is especially important in determining your bid on the basis of a presale estimate if you are working within a budget.

Do commissions arrangements ever vary?

Yes. Special commission rates can be negotiated at any time depending on the nature of the prints and the overall quality and value of a consignment. It might be more appropriate, for example, to use a single flat commission rate of 12½ percent for a property that included many items, if only a handful of the prints fell into the 25 percent bracket and the bulk of them into the 12½ percent category.

Is it possible to bid on prints if you cannot attend the auction in person?

Yes. Such bids are called *order bids.* Major auction houses maintain a bids office that handles orders from clients unable to attend a sale in person. These bids may be sent by mail or telephoned in and *confirmed by mail.* Written bids may also be left with gallery personnel on the exhibition floor. In addition, both Christie's and SPB maintain a customer-advisory service to help answer questions for persons unfamiliar with auction procedures in general.

Won't the auctioneer take advantage of the bidder's absence to push the price of an item to the maximum on the order bid?

An order bid represents the *top* price the buyer is willing to pay for a lot. In this sense, all order bids are maximum bids. The auction house will try to obtain the item for you at any price *up to* the amount stated. This does not mean that you cannot purchase a print for less than the maximum set by your bid. It is entirely possible for a person to set a maximum of $10,000 and buy the print for only $5,750. Competition from the sales floor and other order bids all come into play. If the highest bid received from any other person were only $5,500, and the auctioneer was advancing bidding in $250 increments, you would obtain the print for $5,750, even though your order bid set a maximum of $10,000. To guarantee fair execution of your bids, deal with reputable auction houses. Some people prefer to pay a local agent 10 percent of the purchase price to bid for them in person. The agent will also inspect the print for you at the preauction exhibit and advise on its quality and condition.

Who gets the print when two absentee bidders set identical order bids and audience competition does not reach that price?

If two persons bid $2,000 on the same lot, the earliest bid received at the auction house will be the successful bidder in the sale, assuming audience bidding does not exceed that level. Frequently clients who are in the habit of bidding by mail may give the auction house a margin of discretion in bidding. Generally, when people place a limit on their bid at $2,000, they are really thinking in round rather than precise terms. The lot is worth "in the vicinity of" $2,000 to them. When an order bidder indicates that the auction house use its discretion in the execution of his bid, the house will sometimes exceed his indicated maximum to obtain the item and override a price tie.

If a person cannot attend the auction, is it possible to place an "alternative" bid?

Yes. An *alternative bid* means that, if the first-choice item on the person's list is successfully purchased, the gallery is instructed not to execute the second bid. If the first item is lost, they will proceed with bidding on the second.

What are the pitfalls of absentee bidding? Who is responsible if the auctioneer forgets to execute a bid or executes it incorrectly?

In a sale of approximately eight hundred items such as the SPB auction of May 1973, there were over three thousand order bids involved. The margin of error due to incorrect transcription into the auctioneer's sale catalogue or misreading or overlooking a bid is probably less than one-tenth of a percent. However, auction houses do not accept formal responsibility for executing order bids because of the legal quagmire that might ensue. It is virtually impossible to pin down the precise time of arrival of order bids. Order bids sent by mail frequently arrive only on the morning of the sale, leaving inadequate time for entry into the sale record. Orders telegrammed often arrive hours after an item has been knocked down. However, if a person sends an order bid for lot 140 and the auctioneer incorrectly bids on lot 141, it is the house's error and the bidder is not responsible. Some margin of error exists whether one attends in person and is distracted, or appoints an agent, or submits an order bid.

Are all order bids entered into the auctioneer's sale catalogue for the sale?

No. If five mail or phone bids are received on an item, the lowest three haven't a chance and are usually not even recorded.

Is it possible to place a last-minute bid by telephone?

Bids received five minutes before the sale over the telephone are risky, and most galleries insist on written confirmation. Send your bid early enough to allow it to be carefully transcribed into the sale catalogue.

Under what circumstances might an auctioneer reject a bid?

A bid would be rejected when a buyer may be known to have a poor credit standing or may not appear to be competent (for example, intoxicated) or authorized to bid on the item.

Who determines the dollar interval between bids?

The auctioneer. The dollar increments between bids on an item set the pace of the sale. The auctioneer is responsible for not wasting the time of serious bidders. On a work bringing multiple thousands of dollars, the auctioneer, for example, would be unlikely to accept incremental advances of $10 in the bidding.

Who pays for insurance, cartage, pictures for the catalogue, and so on when an item is consigned for auction?

Generally, the consignor, although Christie's picks up the tab on catalogue photographs. Depending on how eager the auction house is for the property, there is a degree of flexibility.

Is it true that auction houses will buy items for resale?

Under certain circumstances, yes. Such outright purchase or "minimum-price guarantee" on a lot is controversial and provoked art critic John Canaday to complain on the art page of the Sunday edition of *The New York Times:* "the auctioneer is no longer a consignee working for a commission but a dealer buying and selling in the market." When the auctioneer bids from the book under such circumstances, Canaday argues, he is "bidding against the public for his own gain." Marc

Rosen of the Sotheby Parke Bernet print department sees the "guarantee bid" differently. The few items bought outright are designated as owned by the gallery in the sale catalogue. The auction house does frequently "guarantee" a property to be sold. This is a commitment on the auction gallery's part to pay the seller a certain sum based on the gallery's estimate of what an item will bring at sale. A *G* appears next to each lot number on which such a minimum price guarantee has been made. For example, if a print is predicted to bring between $8,000 and $10,000, SPB may guarantee the owner proceeds of $6,000 prior to sale. SPB would be obliged to buy the item at that price if no bid at the sale went higher. There is always a risk that this will occur. One must ask whether this type of guarantee compromises the auctioneer's dispassionate role as intermediary between buyer and seller? Some, like Canaday, feel that it definitely does. However, Marc Rosen disagrees:

> *Consumer protection is usually thought of only as a matter of protecting the "buyer" of goods, such as the buyer of a refrigerator at a store, or the buyer of a print at auction. What is often forgotten is that in the context of a public auction, the seller is also a consumer in the larger sense of the word, and it is in the public interest to maintain a reliable avenue through which the consumer can obtain the best possible price for the works of art he wants to sell.*[49]

The guarantee, for Mr. Rosen, is a form of consumer protection for the auction house's clients. Without such guarantees, he feels that many fine artworks would never reach the public auction block. The executor of an estate with the fiduciary responsibility for securing a basic amount of money for the estate may feel that he cannot risk the vagaries of a public auction. The auction house may estimate an art estate to be worth $500,000, yet the executor may be compelled to sell it for $200,000 cash rather than risk sale at auction. The guarantee arrangement offers a means of assuring him a reasonable minimum amount for the property, as well as the chance for higher returns.

Is there a special commission arrangement on property that the auction gallery guarantees?

The gallery charges a premium on the amount it "guarantees" to the seller but reverts back to normal commission on the average. The premium above the normal commission is 7½ percent at SPB. An item guaranteed for $10,000 that brought $18,000 at sale would cost the owner his regular commission (12½ percent), plus the premium on the first $10,000 (the amount guaranteed).

RESERVES, ESTIMATES, AND GUARANTEES

What is an estimate?

Prior to a sale, many auction houses issue an *estimated price list* indicating their assessment of what each item is expected to bring. These estimated prices are educated opinions, *not* promises. Prints frequently bring much more than their estimate and occasionally fall far short of it. The estimates are guides for prospective buyers based on past sales records and a feel for present market conditions. If a print has not been sold in recent years, the estimate is a "guesstimate" based on the prices commanded by comparable works. Rarity, condition, and fads for particular schools and artists can affect estimated prices. Different impressions of the same print can carry different estimates if one lot is in better condition than the other or a different state of the print.

How accurate are print estimates when compared to actual selling prices at auction?

People occasionally fling around presale auction estimates as though they represented an unequivocal "going price" for a particular print. Dealers offering the print quote high auction estimates to underline the bargain their client is getting; on the other hand, the client points to a conservative presale auction estimate to suggest that the dealer is scalping him. It is a mistake to take auction estimates too literally. What they provide is a *range* within which the print will most probably sell. An estimate of $800–$1,000 does not suggest that the print won't sell for $750–$1,200 but rather that, in the opinion of the person who prepared the sale catalogue, it is unlikely to go as low as $500 or reach $2,000. Order bidders often make the mistake of placing their mail bids smack in the middle of the estimated range and lose. Use the estimate as a guide and then make up your own mind on what the print is worth to you. Some auction houses, such as Germany's Hauswedell, tend to be conservative; others set estimates fairly close to actual selling prices, as is the case with SPB. Still others, like Munich's Karl und Farber, tilt toward the high side.

How can a buyer who places his bids by mail best use the estimates issued by auctions?

For one thing, don't be bound by rote "formulas," such as always making a bid that's 10 percent over—or below—the estimated figure. Consider the estimate and other prices at which the print has sold in the past, if you know them (many collectors build a library of price exhibition catalogues for this purpose), and then calculate how much you would be *willing* to pay to own the print. The top price for a print that you feel is underpriced, or momentarily out of fashion, can become a low price as the artist's work increases in value.

What is a reserve price?

It is the price below which an item *may not* be sold at auction by mutual and confidential agreement between the consignor and the auction house. The reserve protects the seller against an unusually low price.

Do all prints carry a reserve?

One can assume that all lots carry a protective reserve, although in America, items of small value often carry none. European auctions usually place a reserve on almost everything. Reserves comfort nervous consignors who want a cushion against the proverbial rainy day on which only a handful of bidders show up. In these days of internationally attended auctions, this threat is more fiction than fact. Nonetheless one can understand the position of a widow planning to retire to Florida on the proceeds of items auctioned from her husband's collection. She fears that everything estimated to sell at $1,000 will slip through her fingers at only $100. Occasionally prints of substantial value go on the block without any reserve. In 1974, SPB sold an important collection of nearly one hundred Whistler prints with a famous provenance, and the question of reserves never came up. The demand for these works was so strong, a reserve seemed superfluous.

What happens if bidding on a print does not reach the reserve set by its owner?

The lot is "bought in" by the owner, who pays the auction house a handling fee. SPB charges 5 percent on the price at which bidding on the item stopped. If the lot stopped at $3,000, the owner would pay $150 to retrieve his print. However, auction houses can elect to waive this handling fee and often do.

Is it possible for someone to use the reserve system to stimulate a false market for a print, simply by setting a high reserve and buying the work in himself?

At the actual sale, the auctioneer does not reveal which items have been "bought in," and one can presumably leave the sale thinking that an item brought a high price when, in fact, it never even sold. However, major auction houses publish a price list following their sales. The above question would be properly taken only if the item that was "bought in" by its owner were to be listed on the postsale price list as "sold." Generally auction houses omit such items from their post-sale listings altogether, so that there is no doubt as to which lots have actually changed hands. Consignors should be cautious about setting overly ambitious reserves on their prints. This pushes the presale estimate upward and jeopardizes the prospect of selling altogether.

Do auctions guarantee the authenticity of the items they sell?

Most reputable auction houses offer some type of guarantee or warranty. In the fall of 1973, SPB instituted a formal guarantee of authenticity; anything offered and sold as a Miró, a Picasso, a Klee, and so on, is guaranteed to be the work of that artist. Christie's offers a similar warranty. Neither signatures nor the descriptive material in the catalogue is covered. The legal ramifications of covering such data, which can sometimes become so controversial as to be a matter of opinion between experts, make this type of guarantee unwieldy.

If a catalogue neglects to mention some small defect, such as a discoloration of the paper or a tear, can the buyer return the print and get his money back?

Descriptions in auction catalogues are just that: descriptions not documentations. There may be practical limitations to their completeness, and they only call the prospective buyer's attention to significant defects. Don't rely on the catalogue to do your work for you. Inspect the print you want

to buy before the auction. For example, the description "foxing predominantly in the margins" can be misleading. The word *predominantly* signals that the foxing extends into the image itself. One collector found herself enticed into bidding on a lot by the low offers being made for a well-known print. Thinking herself the owner of a "bargain," she sadly discovered that the "right side slight tear" mentioned in the catalogue went three quarters of the way into the image area! The print was not returnable because the auction catalogue offers descriptive data only as an aid. If a signature appears on the print but is not mentioned in the catalogue description, assume that the signature is highly questionable. The catalogue phrasing "bearing a pencil signature," rather than "signed," indicates that there is doubt concerning the authenticity of the pencil signature. *Signed* followed by a question mark also indicates doubt. The flat term *signed* in the description states that a print has been individually signed by the artist.

Although not under obligation to do so, a major auction will usually accept a return if it feels that a serious error of description was made. The burden of inspection rests with the buyer because otherwise the auction house would be open to a Pandora's box of complaints: everything from fingerprints to excuses invented in order to mask a change of mind or an unexpected dent in the buyer's pocketbook.

What do the letters and numerical markings after the title indicate?

The (B., Holl. 45; H. 273; BB 54-1) designated in the sale catalogue for lot 88, the Rembrandt example at the opening of this chapter, refers to abbreviations for authors of standard reference books on the artist's graphics (for example, *Holl.* refers to Hollstein). The numbers refer to pages and illustrations in the reference

book that correspond to the print on auction. By checking such catalogue references (catalogues raisonnés), the collector can garner valuable information on the particular impression, the size of the total edition, how many states, if any, exist, the paper used, the publisher, the printer, and so on and decide intelligently on the print's value for him.

Is the auction's guarantee of authenticity applicable if the print is sold to a new owner?

No. Only the original purchaser has legal recourse.

When a print is placed for auction in a frame, is it unframed so that its condition and proper conservation can be ascertained, or is the buyer bidding on the item "as is"?

In the case of a group of items of minor importance, frames may not be opened. However, almost all major prints received framed are checked out of the frame. According to Marc Rosen of SPB, "If we say 'in good condition' in the catalogue one can presume an inspection has taken place." If there is no comment on the print's condition but merely the indication that the piece is framed, one should make no assumptions about its condition. If you wish to inspect a print out of its frame, special arrangements can be made for you to do so prior to auction.

FACTORS AFFECTING VALUE

What gives an original print its value?

In market terms, several considerations determine the value of a print.

1. What is the international reputation of the artist?

2. What is the quality of the image? (Is it from an important period or is it a minor work in the artist's total output? Is it a clearly printed early state, or only a less sensitive late impression of an old master?)

3. Has the artist used the medium in any especially innovative way? One thinks here of Miró's extraordinary aquatints for the Fondation Maeght (pl. 9) or Picasso's innovative linocuts (pl. 5.).

4. How rare is the print? (An important print from a small edition, or a proof impression, or an old master print that is practically in pristine condition are rarities.)

5. The condition of the print—stains, tears, discolorations, etc.—can greatly diminish value in modern prints since one expects to find them in pristine condition. (A tear in a contemporary print, in which surface perfection may be essential to the aesthetics, might affect value far more than in a Rembrandt, where few impressions are available in perfect condition.)

6. How popular is the particular school of art at the moment? Demand affects price.

How is the "market" for a particular print or artist established?

Pinpointing the "market" for a particular artist or print can be as reliable as locking a breeze in a closet. Stability or instability in prices depends on several assessable factors and on others as unpredictable as the flurry of frantic and indiscriminate buying that often occurs immediately after a major artist's death, momentarily causing artificial and unrealistic surges in the prices of his works. Such inflated prices later drop back and appear to alter his "market" again. In recent years, the market for good prints by major artists has moved dramatically upward. Rather than merely duplicating the price at which a particular print last sold, an auction house estimate (or sale) might reflect some public reaction to events since that estimate (or sale), such as a change in the overall economy or art market. A readjustment

of "market" levels for an artist's work also can occur when a major collection of his works goes on the block at a single sale. A major exhibition and prices set by galleries for the print also influence its "market" potential.

Does a signature affect the value of a print?

Signatures are only sometimes a factor (see pages 173–174). Old master prints and many important nineteenth- and even twentieth-century works are not signed, for example, Toulouse-Lautrec's lithograph *Femme au Tub* from the *Elles* series, which sold for $20,000 at SPB in February 1974, or *Le Jockey*, which brought $40,000 at the same sale.

Do museum shows, retrospective exhibitions, and books on the artist affect the price of his prints?

Very frequently they do not, or they cause

229. **Pablo Picasso.** *Frugal Repast.* 1904. Aquatint. 18⅜″ x 14¾″. Courtesy Sotheby Parke Bernet Inc., New York.

only short-lived upswings. Ultimately the "market" will find its long-term level from the number of buyers willing to pay a certain price for the artist's works over a sustained period of time. The publication of a catalogue raisonné (see page 179) can add a certain measure of confidence and security to the market for an artist's work.

An investment survey by Frank Pick, for Barron's, termed "etchings" the best investment of 1973 (up to 400 percent in one year, better than stocks, bonds, gold, and postage stamps). How realistic is this type of statement and market comparison?

Many of these investment-type prophecies have self-fulfilling aspects. The people who write them and the people who quote them convince one another and go out and make happen what they predicted would happen. To this extent, the prophecies contain an element of truth. But art-market prices generally do not go up at any regular chartable pace. Stock-market curves are great generalizations and simplifications of what is actually going on in the price history of any given stock issue, and this type of generalization is even more deceptive when applied to the art market. Prints usually go up in fits and starts rather than anything resembling a logical curve.

Is the unelaborated statement that an impression of Picasso's Frugal Repast *sold at auction for $154,000 in 1973 the same thing as saying that General Motors stock sold at $43 a share on a particular day?*

The *Frugal Repast* (fig. 229) print sold at the Kornfeld auction in Switzerland was an unusual print. It came from the collection of Georges Bloch, the man who wrote the catalogue raisonné on Picasso's graphics, and it is one of the impressions pulled before the *Frugal Repast* plate had been steel-faced and the 1912 edition of 250

pulled. The fact that prints exist in multiples, as do stock certificates, encourages the analogy to stocks and the quotation of print prices in terms of stock prices. Stocks are "symbolic" of something else and are little in themselves but pieces of paper. They have no intrinsic value and merely represent a degree of ownership in a corporation. Quoting auction print prices in the context of the stock market goes on the erroneous assumption that all impressions, like stock certificates, are identical in quality and condition. This is simply not the case. Quality and condition are crucial. This is particularly true with old master prints, where it is unusual to find an edition of consistent quality. Dürer published large editions and achieved international fame through his widely distributed woodcuts and engravings. On the other hand, Rembrandt rarely printed an entire edition at one time, but pulled impressions from the plate over a period of time. Many of his plates remained in circulation after his death, and editions continued to be pulled as late as 1906, when the so-called *Recueil de Rembrandt* edition of seventy-eight plates was issued by Alvin Beaumont to celebrate the artist's tercentenary. In the May 1974 auction mentioned at the opening of this chapter, at which Rembrandt's *Adoration of the Shepherds* sold in a lifetime first-state version for $7,500 and in another for only $2,000, a third impression from a well-printed posthumous edition was also sold for only $720, one tenth of the price reached by the impressions from Rembrandt's own hand. Many factors can affect value: Toulouse-Lautrec poster prices fluctuate greatly with the condition of the paper (which was tantamount to our newspaper quality and is the reason that Lautrec posters are often backed with other material) and also the freshness of the colors. Examples of the same poster can sell for $7,000 or $2,000, depending on condition.

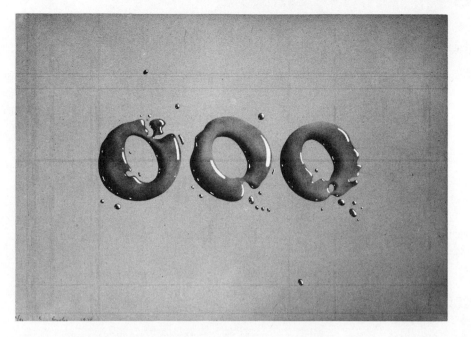

Should a person have any minimum amount of money set aside prior to embarking on a print collection?

Enough to buy his first print. High-price-tag items and gilt-edged auction audiences capture the headlines and create the mystique that one needs a hefty bankbook in order to buy on the block. But you really don't. Of the forty-four Dürer prints sold at Sotheby Parke Bernet on May 14, 1974, twenty-five went for bids under $1,000. Auction sales-commission structures tend to encourage the consignment of higher-priced lots rather than the under-$100 variety, but a large proportion of the material sold falls well within the $250–$750 range. In June 25, 1974, a small Manet etching and aquatint of 1882 sold, together with an etching by Corot, for only $475. Two silk screens by contemporary artist Ed Ruscha (fig. 230) sold for only $150 at the same sale. At the auction at which Toulouse-Lautrec's *Le Jockey* was knocked down at $40,000, a number of Picasso and Miró prints brought in about $1,000 each. One collector built a fascinating collection of "offbeat" prints by well-known masters

230. **Ed Ruscha** (1937–). *OOO*. 1970. Lithograph. 20″ x 28″. Courtesy Brooke Alexander, Inc., New York.

231. **Auguste Rodin** (1840–1917). *Le Printemps.* Drypoint published by *Gazette des Beaux-Arts* in 1883. Prints by major artists not generally known for their graphics are often quite reasonable. This Rodin drypoint, a favorite at auction, has sold anywhere from $150 to $450 in recent years. Courtesy Sotheby Parke Bernet Inc., New York.

on a relatively small budget by concentrating on artists known for their work in other mediums but not as printmakers (fig. 231). Generally, they have made only relatively few graphics, and these rare examples sell fairly inexpensively.

Is it customary for an auction house to advise collectors on what to buy? Where can a new collector get intelligent guidance?

An auction house is primarily a sales mechanism and will not act as a formal adviser in the compiling of a collection. It is not the role of the auction to "predict" market trends or to influence the course of people's investment or collecting preferences. To do so would place the auction house in the position of fostering the develop-

ment of one market to the detriment of another, in which it is also involved as a selling agent. An auction house, within the practical limits of available time, may advise on the basic principles and questions that the collector should keep in mind.

What is the potential for an inexperienced collector as an "investment" buyer?

It requires years of experience and exposure to the print market to develop the kind of informational backlog and educated "eye" necessary to buy strictly for investment purposes without professional advice.

The mercurial fortunes of great artists are legend, and the history of printmaking is punctuated by them. In the sixteenth century, Albrecht Dürer (fig. 24), who invented the modern watercolor and probably etching as well, was unquestionably the greatest engraver of his age (fig. 25). A century later, Rembrandt, who was the greatest etcher of his age, and perhaps of any other, was one of Dürer's staunchest admirers. Not only did he own Dürer's *Life of the Virgin* and woodcuts of the *Passion,* but Dürer's book on proportion appears as item 273 on the inventory taken at the time of Rembrandt's own bankruptcy. By the eighteenth century, at the famous Mariette sale of 1775, however, Dürer's prints changed hands inconspicuously bunched in with a catchall assortment of graphics by what were then deemed minor artists. Not until 1910, 135 years later, did the German print master regain his rightful place. On the other hand, examples of Picasso's famous etching, *Frugal Repast* (fig. 229), fetched $100 at auction in New York in 1936; $275 in 1946; $3,356 in 1964; $10,080 in 1970. As noted earlier, one impression of *Frugal Repast,* made prior to reenforcement of the plate by steel-facing (explained on page 214) for a larger edition, brought an astronomical $154,000 in 1974.

El Lissitsky's portfolio *Victory over the Sun* (pl. 24) was estimated at DM 2,500 at the Ketterer auction house (Stuttgart Kunst Kabinett) in 1960, which at that time was the equivalent of about $550 for all ten lithographs. Individual examples from the set sold for from $40 to $50 each. In 1973, the portfolio brought $48,000 (including commission) at auction, a single plate in the set fetching $9,000 at Hauswedell.

In the span of a single year, prices for Toulouse-Lautrec's La Clownesse Assise *(fig. 232) spiraled from $16,000 in a November 1972 sale at Sotheby Parke Bernet to $25,000 at auction on May 11, 1973, only to be topped by the equivalent of $48,000 a month later at the Kornfeld und Klipstein sale in Switzerland. What factors trigger "runs" on certain prints?*

La Clownesse is one of a series of ten monogrammed (but not signed) lithographs (plus frontispiece and cover) on the subject of life in the brothel. Toulouse-Lautrec's publisher was unable to sell out all of the edition of one hundred, printed under the title *Elles*, in 1896. In 1966, the entire *Elles* series sold for £8,000 at Sotheby's, England, then the equivalent of about $22,400. A curious "reverse rarity" factor often comes into play at auction. Familiarity breeds interest. Prints that come up again and again become old friends and appeal to a broader spectrum of buyers. Increasing demand leads to decreasing availability and pushes prices up. It is one of the anomalies of collecting and probably explains why modern master prints sell for relatively higher prices than old master prints, which have less auction exposure because so few examples of an impression have survived. Until the famous Charrell sale held at Sotheby's in 1966, Toulouse-Lautrec's prices had risen slowly. Eight years later, after the market shot up several times and auction audiences had been exposed to the *Elles* series a

number of times, it sold at Sotheby Parke Bernet, in February 1974, for an aggregate total of $118,000, over five times the price it commanded eight years earlier.

Why might a print or work of a particular artist suddenly plummet below expected prices?

There might be a significant change in taste or a downturn in the overall economic climate. A particular work may have brought a fluke price that was not a genuine reflection of its market value in the first place, or the works presented at a sale may not appeal to a particular auction audience, as was the case with the presentation of contemporary American graphics at Germany's Ketterer auction in 1974, where many works that would have sold well in America did not even reach their estimates.

In 1973, a Jasper Johns print that brought

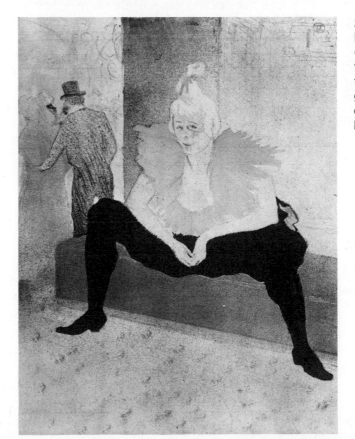

232. **Henri de Toulouse-Lautrec.** *La Clownesse Assise* from the *Elles* portfolio. 1896. Lithograph. Courtesy Sotheby Parke Bernet Inc., New York.

a very high price in Los Angeles was estimated far lower when the same print came up for sale in New York. The print did in fact fetch a good deal less in the East. Instances of irrationally high or low prices dot the history of auction sales. A lithograph by James Abbott McNeill Whistler that brought $1,350 in 1919 at the sale of the famous Walter Jessup Collection reached only $450 in a 1971 Sotheby Parke Bernet sale. After soaring to peak prices in the 1920s, Whistler prints (fig. 153) slid downward and remained in a slump until the 1950s. Prices began to climb back in the mid-1960s. By May 1971, 114 Whistlers sold at Sotheby Parke Bernet and estimated to bring $90,000 brought $110,000.

Is there any way to anticipate trends in the print field?

Given the increasing worldwide demand for works of art, one might safely assume that important works by major artists will continue to rise in price. But one must exclude items that are merely voguish and concentrate on artists and works whose place in history is already established. There are a great many artists whose works remain inexpensive in spite of the fact that they have achieved solid recognition in art history. Such undercollected artists, and periods of art, remain dormant for stretches of time before their prices start climbing. It would be wise to study the work of such people as avenues for investment. For example, prints by American artists of the 1920s and 1930s have only recently begun to rise in price, and many, such as Howard Norton Cook (fig. 233), Armin Landeck, and Rockwell Kent, can be purchased for under $250 at this writing. The same holds true for genre prints of the seventeenth and eighteenth centuries, lesser French masters of the eighteenth century, and reproductive-type prints (for example, an engraving after a painting by Rubens).

233. **Howard Norton Cook** (1901–). *Skyscraper*. 1929. Woodcut. 17⅞" x 8⁹⁄₁₆". Courtesy Carus Gallery, New York.

If you have never heard of an artist whose work you are considering, how can you find out if he has any established reputation in the art world?

One guide would be to check a standard art reference that lists data on many internationally recognized artists. While not all-inclusive, the books and catalogues raisonnés listed at the close of this chapter provide important documentation and information. Looking through a catalogue raisonné of an artist's work, if one exists, is time well spent. It is probably the quickest way to develop a "feel" for the overall work and initial judgments as to which examples are particularly outstanding and worth owning.

Wide fluctuations in price for a particular print may merely reflect the different quality of the impressions. In the May 10, 1973, auction at Sotheby Parke Bernet, an early impression of Rembrandt's Agony in the Garden *(fig. 2) sold for $70,000. At the same sale, another impression sold for only $3,600. Both prints come from the same plate. What accounts for the $66,400 gap?*

Rembrandt's custom of hand-wiping the ink on his plates to create painterly highlights and contrasts individuated each impression and made it practically a monotype. The print sold for $70,000 was one of the finest impressions of the image ever to come up for sale. It was as unique in its way as a Rembrandt drawing. In fact, the price was almost in line with what one might have paid for a Rembrandt drawing at the time of the sale. The impression, unlike the $3,600 print, was made in the artist's lifetime and is one of the earliest and finest ever printed. Its rich aesthetic quality, tone, and texture made the other impression appear to be a ghost by comparison.

Given equally fine impressions of a print, what effect would the following conditions have on the print's value: cut margins, foxing, a tear, discoloration of the paper?

Cut margins on a relatively common contemporary print might affect its price substantially, whereas cut margins on a nineteenth-century French print that is not normally found in pristine condition might be far less significant, and of no concern with old master prints, which very often have no margins at all, especially the early etchings and engravings. The brown specks found on prints called *foxing* (see page 189) can be a factor depending on how serious the condition is and how easily it can be removed. Foxing on a black-and-white print can generally be cleaned without harm to the image. Foxing on a colored print presents serious problems because cleaning can impair the color. Attitudes toward "laundering" prints differ. Some museums prefer not to tamper with the print and simply arrest the foxing by deacidifying the print to prevent the disease from spreading. *Tears* affect value drastically if the image is impaired aesthetically. Tears in the margin fall into the same category as cut margins. A missing piece of margin in a contemporary print that is customarily found in perfect condition would be discouraging for buyers, but a tear in the margin of an old master print—sometimes even within the image—may not affect the price at all if the print's aesthetic impact is not marred.

If a print has been restored, is it less valuable than an unrestored print?

Yes. But it is a question of degree. It would depend on the success of the restoration and also on how common it may be to find a perfect example of that print in the first place.

Does it ever make sense to choose an impression in fair condition over one in perfect condition. What about so-called proofs?

A collector of old master prints might prefer a slightly damaged but magnificent impression of an important subject over a later, weaker printing in pristine condition. Then there is the category of "proofs" (artists proofs, work proofs, trial proofs), which are made in very few examples before the edition itself was pulled. These rare "proof prints" can bring more than impressions from the regular edition when they are artistically preferable. The situation on proofs is somewhat different in the case of contemporary prints, where a substantial number of impressions designated as artist's proofs are in no way different from the regular numbered edition except for the inscription *A.P.* or *E.A.* (artist's proof). There is no reason for such examples to be costlier, since only a working proof or a trial proof that reveals something of the artist's creative process is of special interest and value above and beyond the regular edition.

How important is the artist's signature on a print? Does it significantly affect the value of the work?

If someone offers you a hand-signed Rembrandt etching, you know it's worthless. Rembrandt did not sign his prints. Prints prior to and well into the nineteenth century were rarely signed, and many of the master prints from earlier in this century were also unsigned. The presence of a signature does not affect the aesthetic merit of the image itself, and one is, after all, collecting art not autographs. An artist's signature is most important on prints where the normal edition is known to be signed and is expected to be found signed. But within a single edition, Pierre Bonnard and Édouard Vuillard sometimes signed and sometimes neglected to sign impressions; occasionally they numbered the impressions and just as often omitted the numbering. In such cases, signature and numbering do not very substantially affect price. Édouard Manet prints are generally unsigned. One unsigned lithograph, *The Execution of Emperor Maximilian* (1867; fig. 234), sold for over $11,000 in 1974. A working proof of an etching from

234. **Édouard Manet** (1832–1883). *The Execution of Emperor Maximilian.* 1867. Lithograph. 13⅛″ x 17″. Courtesy Gallery L'Ancien S.A., Zurich.

Goya's *Los Caprichos,* bearing no indication of the artist's name or signature, brought $20,000 at the same sale. The absence of a signature alone would not deter an experienced collector from purchasing a major print. Usually he will first check with a catalogue raisonné or a curator knowledgeable in the field to determine how many prints were known and how many signed and unsigned versions exist. In some cases, preference for signed impressions affects the price measurably. Picasso's *Suite Vollard* (fig. 132), published in an edition of three hundred examples (plus several proofs), generally commands at least twice as much for signed as for unsigned impressions. There is no qualitative difference among the images. Picasso simply never completed the task of signing all the impressions from the edition. However, many Picasso buyers are inexperienced collectors who place great stock in signatures. It has been drummed into them

that a print isn't valuable unless signed and numbered. Occasionally this obsession with autographs leads naïve or inexperienced buyers into purchasing graphics that are not authentic Picasso prints but are from a series of reproductions after his watercolors or oils that Picasso authorized with his signature. These authorized reproductions were frequently issued in editions of three hundred (see comments on page 35).

How can the collector be certain that an unsigned print is an original?

This is generally a technical question that can be checked in a catalogue raisonné that describes all known examples of an impression or, if none exists, substantiated with a gallery or museum curator specializing in the area. Excellent prints have been left unsigned by the artist and later "signed" with an authorized *estate stamp.* The lack of a signature often lowers the prices but not the artistic merit of such examples (prints by John Sloan and George Bellows, for example) and offers good collecting opportunities. The best protection is to educate oneself in a chosen field of collecting and to buy from knowledgeable and ethical sources.

How does the size of an edition affect value?

It is a mistake to assume that a rare print is automatically more valuable than one from a larger edition. The size of the edition is a secondary consideration. What establishes price on a print is whether the image itself is a strong example of the artist's work. Many of Picasso's prints from small editions sell for far less than important images from the *Suite Vollard,* an edition of three hundred, or a print such as his *Frugal Repast,* which exists in two hundred and fifty impressions on Van Gelder paper (twenty-seven or twenty-nine on Japan) in addition to examples made before the steel-facing of the plate. More sig-

nificant than the size of an edition may be the *state* of a particular print. Rembrandt's portrait of his friend Jan Six, of which only three first-state examples are known to exist, was valued by the expert Nowell-Usticke at $100,000 in 1974, whereas the same print in a relatively common second-state version was valued at only $1,000 (*ARTnews,* March 1974, p. 62).

Many early prints, Dürer's for example, were published in large editions, yet the catalogue cites particular impressions as "rare." What does rare refer to in such cases?

The term *rare* in the context of old masters usually refers to what has been preserved rather than the original size of the edition.

Is rarity necessarily an asset?

Rarity in any medium appeals to relatively sophisticated buyers, a smaller number of people. On the other hand, the attractive, more common print (less rare) is a comfortable and noncontroversial purchase. People inexperienced or unknowledgeable in prints are more secure about investing in items that consistently come up at auction. Rare items are speculative in the sense that the demand for them is limited to the few collectors sufficiently knowledgeable in the area to compete for their ownership. At a time when the name Malevich barely turned a head in print circles, one collector quietly went about acquiring the complete graphic works of the Russian avant-garde artist and founder of Suprematism (fig. 235). His choice was informed rather than impulsive. Kasimir Malevich was one of the outstanding innovators in twentieth-century art. In his classic 1936 study of the development of abstract art, *Cubism and Abstract Art*, the first director of The Museum of Modern Art, Alfred H. Barr, Jr., credits Malevich with being the "first artist to establish a system of absolutely pure

geometrical abstract composition," adding that the Suprematist–Non-Objective movement that Malevich founded was by far "the most important development in Russian abstract painting."[50]

If someone collects old master prints, should he buy what is available even if the condition

235. **Kasimir Malevich** (1878–1935). Front and back cover designs for N. Punin's book *First Cycle of Lectures*. 1920. Created for teachers of drawing. Lithograph. 8⅜" x 5⅝". Due to the greater exposure of his work in Western art centers of the time, Wassily Kandinsky (fig. 187) is generally acknowledged as the father of abstract art. But research increasingly reveals that many artists of the period were struggling toward a new visual vocabulary that would free them from the constraints and traditions of 400 years of representational art. One of the first to break with convention, the Russian, Kasimir Malevich, completely cast aside all references to recognizable subject matter. It was a radical act. Malevich recognized it as such: "In the year 1913 in my desperate struggle to free art from the ballast of the objective world I fled to the form of the square and exhibited a picture which was nothing more or less than a black square upon a white background." Malevich's early introduction of purely geometrical pictorial elements positions his work as a prototype of modern nonrepresentational art. The front and back covers for Punin's book, shown here, are Malevich's only color lithographs and the only graphic work exemplifying the nonrepresentational Suprematist style that Malevich introduced in the famous "0.10" exhibition of 1915. Courtesy Carus Gallery, New York.

isn't the best, or should he hold out in the hope of obtaining a better impression?

There is no "right" answer on this. It can sometimes be shortsighted to put off buying an available print in this category. Another may never come up. If the print is aesthetically satisfying in spite of its condition, one might risk it. If a better example comes up, chances are the earlier one can be sold at a sufficient price to help pay for the new acquisition.

Is there a "right" time to buy and a "right" time to sell?

Everyone enjoys snaring prints at rock-bottom prices, "before anybody else was on to the artist," or selling a print at the top of the market. But hindsight, rather than foresight, often identifies what the "right" time actually was. In 1967–1968, Sotheby Parke Bernet auctioned off, in a two-part sale, the fine Nowell-Usticke collection of Rembrandt etchings. As the prices climbed to astronomical heights, one could feel the auction room fill with the gasps of experienced collectors and dealers. Yet by the time Sotheby's offered the Lord Downe Rembrandt collection in London in 1970 and then in a second part, in 1972, the Nowell-Usticke prices had been completely eclipsed, and many professionals were regretting their reluctance to pay what had seemed wild prices in 1967–1968.

The provenance (ownership history) of an artwork affects the value of paintings, drawings, and sculpture. What role does provenance play in the value of a print?

Provenance plays a role only when the previous ownership has a special significance: If the owner was a friend of the artist and received the print directly from him, as with Picasso's *Frugal Repast* (fig. 229), owned by Georges Bloch, author of the catalogue raisonné on Picasso, or if

there was some historic connection between collector and artist, as in the case of the *Portrait of Dr. Gachet* (fig. 134), that brought $15,635 at a 1970 Kornfeld and Klipstein auction because the example had been inscribed by Paul Gachet, van Gogh's mentor and friend, and bore three of the Gachet family's collector's stamps on its verso. Provenance also enhances the value of a print when an owner has assembled a collection of particular fame and quality. This was the case with Nowell–Usticke's Rembrandts, which caused a total reevaluation of Rembrandt prices following the record-breaking 1967 sale of the collection at Sotheby Parke Bernet.

Can one trace collector's stamps? Would one want to?

It was once customary to place a small stamp on the back of a print to designate the owner (occasionally egotistic collectors stamped *directly* into the image area). With old master prints, there is a chic attached to having prints that passed through the hands of notable collectors. One can often trace a Rembrandt provenance straight back to the artist's own lifetime. There is a standard reference book by Fritz Lugt, *Les Marques de Collections*, that is a compilation of collector's marks and brief sketches of the collectors and items included in sales of their holdings. The collector's stamp provides a secondary, fun aspect to collecting. Some people collect collector's stamps rather than prints. Such provenance information can be helpful corroboration of one's judgments and interesting historically, but it should not be used as an end in itself.

Are people attracted to print collecting because the so-called blue-chip artists are always available and traded frequently?

When a Picasso painting is sold, it may vanish from the market forever and at a price that

puts it well out of reach of the average collector. Not so with prints. Because the image exists in more than one example, the possibility of owning an original work by a major talent is a realistic one for many people. Collectors who couldn't dream of acquiring an oil by the artist can share, via an original print, the same excitement that owning a Picasso painting may give David Rockefeller. The availability and liquidity of prints by important artists is certainly a factor in swelling the ranks of print collectors.

In an interview for The Print Collector's Newsletter (*March–April 1974*), *Paul J. Schupf, a print collector and partner in a stock-brokerage firm, claimed that the price gap between certain "key" prints and the rest of the print field results from a "two-tier" market comparable to that of blue-chip stocks and ordinary stocks: "you have a small number of safe prints by internationally accepted artists on the top tier and all the rest below." Is there a two-tier market with vastly overpriced key prints, or is the print market more fluid than that?*

Rather than alter the size of the bed, King Procrustes preferred to cut his guests down to size so that they would fit it. To accommodate Mr. Schupf's two-tier Procrustean bed we have to reshape basic art-market realities just as drastically. Unlike stocks, art values are strongly influenced by aesthetic judgments and emotional factors unrelated to any dollar considerations. The pitfalls of print–stock analogies were discussed earlier. Such comparisons may comfort those who consider art a type of commodity or a surrogate stock investment, but they imply a price stability and predictability that is misleading. Any superficial relation between the Dow-Jones listing of top securities and a so-called list of blue-chip prints falls apart when one realizes that every print offered for sale must stand or fall on its individual condition and quality, not as part of an edition with a single set market value as of that moment. The influx into the auction scene of money-loose, inexperienced buyers also plays havoc with print prices. Such investment-oriented buyers are often unknowledgeable and, in their efforts to "play it safe," put their money into well-known names. The rush to buy "names" produces price flurries that have little real substance over a long period of time. When this surplus discretionary capital drops out of the art market, prices readjust. If a genuine two-tier factor operates in prints at all, it is possibly in the difference between sophisticated quality-minded collector–buyers and the unsophisticated "name"-struck investment-oriented buyers.

Can a collector sell a good print whenever he wants to?

Prints by artists of international reputation are generally liquid, but it is usually not simply a matter of a quick telephone call. *Prints are not cash.* If you place the bulk of your funds in prints, don't assume that you can pull the money out overnight for an emergency. Assuming that the work was purchased at a reasonable price and appeals to a broad spectrum of buyers, one can generally find an appropriate auction outlet, gallery, or private collector for liquidating it. To obtain the best possible price, the collector should allow himself a period of at least three to four months, and preferably half a year, to consummate an advantageous sale. With prints in high demand, an almost instantaneous sale can often be consummated. However, this may not be the best way to obtain *top* price for the piece. It takes time to negotiate an advantageous sale.

Does the general economic climate affect the print market?

Yes. If the dollar is devalued 40 percent, the value of an internationally traded item such as a

print that was worth $1,000 would change to $1,400 (in addition to any natural price rise for the item). Collectors and dealers have found themselves obligated to pay thousands of dollars more than anticipated for prints when their overseas bills come due with prices adjusted to reflect devaluation. Prices are affected on both sides of the Atlantic. Often economic turmoil lures more people into the art market, which seems to weather financial storms with a relative calm not exhibited in commercial areas. The prints most severely hit in times of stress are often those that had been the object of reckless speculation by investment-type buyers in the first place. Picasso's *347 Suite* (fig. 236), which was published piecemeal, became a "hot item." As soon as they were released, prints from the series were feverishly bought by people with little knowledge of factors that create sound long-range market appreciation in prints. As a complete set, as a *total* statement, the *347* is a remarkable and valuable work, but individual prints within the series selling separately reached prices disproportionate to their quality in Picasso's overall graphic output. They were bought on the strength of the artist's name rather than because of any understanding or feel for their place in art history. When the economic crunch hit, the inexperienced investment buyers were shaken out of the market, and the less effective images from the series became vulnerable to drastic declines. As a complete work, the set continues to command impressive prices.

236. **Pablo Picasso.** *L. 17* from *347 Suite.* 1968. Etching. 14¾" x 10¾". Courtesy Sotheby Parke Bernet Inc., New York.

What is the best reason for collecting prints: investment or enjoyment?

Everyone hopes that the prints he buys will appreciate in value. But buying art strictly for its investment potential without serious attention to where the artist fits in art history and to the work's inherent value often results in owning the worst examples by the "best names." Art syndicates heavy on capital but thin on aesthetic expertise and judgment have missed the boat on just this point. Not all great artists are great printmakers. Nor is every print by a great printmaker a great print! Direct exposure to many prints, serious involvement in the literature of the field, and questioning dealers and curators build up a reserve of data on which to make wise decisions. As one becomes more confident in his or her taste and judgment, the neophyte buyer evolves into the seasoned collector.

Is the assumption that one-of-a-kind art (that is, paintings, sculpture, drawings) is automatically a better value and investment than prints actually the case?

Would the fact that one was a print and the other an oil painting convince you to turn down a first-state Rembrandt etching in favor of a canvas by an unknown local artist? Value is a matter not of the medium but of the quality. Mentioned earlier was the impression of Picasso's *Frugal Repast*, which brought $154,000 at a 1973 auction, a figure few gouaches, drawings, and paintings could command at the time. Many prints sell for thousands of dollars whereas watercolors or paintings of lesser quality do not.

Is there such a thing as a safe print investment?

Buying the work of artists whose reputations in art history are already established makes the safest investment (and often carries the highest price tags). Buying the work of a little-known or less-well-established artist is an investment in your own instincts and enjoyment. Among the many works purchased by the famous collector John Quinn at the Armory show of 1913 was a woodcut for which he paid $6.00. The artist, hardly a name at the time, was Paul Gauguin.

What course of action should a beginning collector on a limited budget follow?

Begin with your wallet closed and your eyes and mind open. First, look around. Define where your natural inclinations lie. A person rarely buys intelligently in an area for which he has little empathy. An enthusiast of bold and colorful contemporary art would probably have difficulty responding to the tight, thumbnail images of Hans Sebald Beham (fig. 116). Find a period of art you like and concentrate on it. A sophisticating process occurs naturally as people learn more about prints and develop a historical perspective in a particular period. Good works at reasonable prices are still available in most categories. Developing the instincts for finding the best your budget can buy is part of the fun of becoming a collector.

CATALOGUES RAISONNÉS

Where does one research and document prints and artists?

The following listing is incomplete. It is offered only as a starting point. Many important reference books and catalogues raisonnés are written in German and French and some in English. An art librarian or museum print department can assist with translations, and the brief language guide (page 182) gives basic terminology. After a while, you will acquire enough familiarity with the key vocabulary to extract vital data on your own.

What are catalogues raisonnés?

One of the best sources of information you can use. These catalogues give the title of each of the artist's prints up to the time of the catalogue; the date of the print's publication (if known); the technique; the number of impressions in the complete edition (if known); the size of image area and overall sheet; the number of states and any pertinent data known about them; the paper(s) used; and whether or not the print was signed in pencil, pen, crayon (and where the signature appears), or whether an estate stamp or monogram was used. If the edition is known to be canceled (that is, the master plate effaced or marked), this is also generally indicated. Reproductions of the artist's official signatures, estate stamps, and/or monograms are also included, permitting verification of signatures with those on the prints you contemplate buying (see Appendix, page 207).

Not all artists have a catalogue raisonné. Few such references exist on the graphics of contemporary artists, for example, since their output is still in process. Check gallery and exhibition catalogues, and write to museum print rooms or dealers specializing in the artist for information in such cases.

SELECTED LIST OF REFERENCES

Subject	Reference
Bauhaus	HANS M. WINGLER. *Graphic Work from the Bauhaus.* Trans. by Gerald Onn. Greenwich, Conn.: New York Graphic Society, 1969. *50 Jahre Bauhaus*, Exhibition catalogue. Württembergischer Kunstverein. Stuttgart, 1968.
Max Beckmann	KLAUS GALLWITZ. *Max Beckmann: Die Druckgraphik.* Ausstellungskatalog. Karlsruhe, 1962.
Pierre Bonnard	CLAUDE ROGER-MARX. *Bonnard Lithographe.* Monte Carlo, 1962.
Georges Braque	FERNAND MOURLOT. *Braque Lithographe.* Monte Carlo, 1963.
	WERNER HOFMANN. *Braque: His Graphic Work.* New York: Harry N. Abrams, 1961.
Mary Cassatt	ADELYN D. BREESKIN. *A Catalogue Raisonné, The Graphic Work of Mary Cassatt.* New York: H. Bittner and Company, 1948.
Marc Chagall	FERNAND MOURLOT. *Chagall Lithographe,* 4 vols. Monte Carlo, 1963, 1974.
	EBERHARD W. KORNFELD. *Verzeichnis der Kupferstiche, Radierungen und Holzschnitte (Engravings and Woodcuts) von Marc Chagall. Werke: 1922–1966.* Bern: Kornfeld and Klipstein, 1970.
Jim Dine	GALERIE MIKRO. *The Complete Graphics of James Dine.* Berlin, 1970.
Albrecht Dürer	KARL-ADOLF KNAPPE, ed. *Dürer, The Complete Engravings, Etchings and Woodcuts.* New York: Harry N. Abrams, 1965.
	JOSEPH MEDER. *Dürer Katalog; ein Handbuch über Albrecht Dürers Stiche, Radierungen, Holzschnitte, deren Zustände, Ausgaben und Wasserzeichen.* Vienna: Gilhofer & Ranschburg, 1932.
Dutch and Flemish etchings, engravings, woodcuts	F. W. H. HOLLSTEIN. *Dutch and Flemish Etchings, Engravings and Woodcuts* (c. 1450–1700), 19 vols. Amsterdam: M. Hertzberger, 1949–1976.
James Ensor	ALBERT CROQUEZ. *L'Oeuvre Gravé de James Ensor.* Genf-Brussels, 1947.
	AUG. TAEVERNIER. *James Ensor, Illustrated Catalogue of His Engravings, Their Critical Description and Inventory of Plates.* Ghent, 1973.
Max Ernst	CHARLES GEORG and ELISABETH ROSSIER. *Max Ernst, Oeuvre Gravé.* Tours and Paris: Musée d'Art et d'Histoire, 1970.
	HELMUT R. LEPPIEN, ed. *Max Ernst: Das Graphische Werk.* Houston: Menil Foundation; Köln: M. Dumont Schauberg, 1975.
Lyonel Feininger	L. E. PRASSE. *Lyonel Feininger: A Definitive Catalogue of His Graphic Work.* The Cleveland Museum of Art, 1972.
German engravings, etchings, woodcuts	F. W. H. HOLLSTEIN. *German Engravings, Etchings, Woodcuts* (ca. 1400–1700). Amsterdam: M. Hertzberger, 1954–
Francisco Goya	LÖYS DELTEIL. *Le Peintre–Graveur Illustré,* vols. 14–15. Paris, 1922.
	TOMÁS HARRIS. *Goya: Engravings and Lithographs,* 2 vols. Oxford: Bruno Cassierer, 1964.

Erich Heckel	ANNEMARIE and WOLF-DIETER DUBE. *Erich Heckel: Das Graphische Werk,* 2 vols. Munich, 1967.
David Hockney	WIBKE VON BONIN and MARK GLAXEBROOK. *David Hockney: Druckgraphik, Werkverzeichnis,* in *David Hockney.* Ausstellungskatalog. Hanover: Kestner-Gesellschaft, 1970.
William Hogarth	RONALD PAULSON, comp. *Hogarth's Graphic Works,* 2 vols. New Haven and London: Yale University Press, 1970.
Jasper Johns	RICHARD FIELD. *Jasper Johns Prints 1960–1970.* Exhibition catalogue. Philadelphia Museum of Art, 1970.
Wassily Kandinsky	HANS KONRAD ROETHEL. *Kandinsky: Das Graphische Werk.* Köln: M. Dumont, Schauberg, 1970.
Ernst-Ludwig Kirchner	A. and W.-D. DUBE, *E. L. Kirchner, Das Graphische Werk.* Munich: Prestel-Verlag, 1967.
Paul Klee	E. W. KORNFELD. *Verzeichnis des Graphischen Werkes von Paul Klee.* Bern, 1963.
Käthe Kollwitz	AUGUST KLIPSTEIN. *Käthe Kollwitz; Verzeichnis des Graphischen Werkes.* Bern, 1955.
Kasimir Malevich	DONALD KARSHAN. *Malevich, The Graphic Work: 1913–1930. A Print Catalogue Raisonné.* Jerusalem: The Israel Museum, 1975.
Marino Marini	L. F. TONINELLI. *Le Lithographe di Marino Marini.* Milan, 1966.
Reginald Marsh	NORMAN SASOWSKY. *The Prints of Reginald Marsh.* New York: Clarkson N. Potter, Inc., 1976.
Henri Matisse	KATALOG PULLY. *Henri Matisse: Gravures et lithographies de 1900–1929.* Exposition Annuelle de gravures et dessins, Pully, 1970.
	WILLIAM S. LIEBERMAN. *Matisse: Fifty Years of His Graphic Art.* New York: George Braziller. 1956.
Henry Moore	GÉRALD CRAMER, ALISTAIR GRANT, and DAVID MITCHINSON. *Henry Moore: Das Graphische Werk, 1931–1972.* Geneva, 1973.
Edvard Munch	GUSTAV SCHIEFLER. *Verzeichnis des Graphischen Werk Edvard Munch,* 2 vols. (1906 and 1906–1926). Berlin: Euphorion Verlag, 1906, 1927. Reprint. Olso: J. W. Cappelens Forlag, 1974.
Emil Nolde	GUSTAV SCHIEFLER–CHRISTEL MOSEL. *Emil Nolde: Das Graphische Werk,* 2 vols. Köln, 1966/67.
Pablo Picasso	GEORGES BLOCH. *Picasso: Catalogue de l'Oeuvre Gravé et Lithographie 1904–1967,* 3 vols. Bern: Kornfeld and Klipstein, 1968, 66–69, Bern, 1971.
	GEORGES BLOCH. *Picasso: 347,* 2 vols. New York: Random House/Maecenas Press, 1970.
Rembrandt van Rijn	A. HIND. *A Catalogue of Rembrandt's Etchings Chronologically Arranged and Completely Illustrated,* 2 vols. London: Methuen and Co. Ltd., 1923.
Georges Rouault	KORNFELD AND KLIPSTEIN. *Auktionskatalog* (Auktion 120). Bern, 1966.
Jacques Villon	JACQUELINE AUBERTY et CHARLES PERUSSAUX. *Jacques Villon, Catalogue de Son Oeuvre Gravé.* Paris: Paul Prouté et ses Fils, 1950.

James Abbott
McNeill Whistler

EDWARD G. KENNEDY. *The Etched Work of Whistler.* The Grolier Club of the City of New York, 1910.

BIOGRAPHICAL AND GENERAL REFERENCE SOURCES

ADAM BARTSCH. *Le Peintre Graveur,* 2d ed. Würzburg, 1920.

E. BENEZIT. *Dictionnaire des Peintres, Sculpteurs, Dessinateurs et Graveurs.* 10 vols. France: Librarie Grund, 1948, 1976.

LÖYS DELTEIL. *Le Peintre-Graveur Illustré, XIX et XX siècles.* 32 vols. Paris, 1906. Republished, New York: Da Capo Press, 1968.

ULRICH THIEME, and FELIX BECKER. *Allgemeines Lexikon der Bildenden Künstler.* Leipzig: W. Engelmann, 1907–1950.

HANS VOLLMER. *Allgemeines Lexikon der Bildenden Künstler des XX Jahrhunderts.* Leipzig: E. A. Seemann Verlag, 1953, 1962.

Encyclopedia of World Art, New York, Toronto, and London: McGraw-Hill Book Co., 1959.

Watermarks

CHARLES MOÏSE BRIQUET. *Les Filigranes, Dictionnaire Historique des Marques du Papier des leur apparition vers 1282 jusqu'en 1600,* 4 vols. New York: Hacker Art Books, 1966.

Collector's Marks

F. LUGT. *Les Marques de Collections de Dessins et d'Estampes.* Amsterdam, 1921; Supplement, The Hague, 1956.

QUICK GUIDE TO BASIC CATALOGUE RAISONNÉ VOCABULARY

ENGLISH	FRENCH	GERMAN
color linocut	*gravure sur linoléum en couleurs*	*Farblinolschnitt*
color woodcut	*bois en coleurs*	*Farbholzschnitt*
drypoint	*gravure à la pointe sèche*	*Kaltnadelradierung*
edition	*tirage* or *édition*	*Auflage*
engraving	*gravure*	*Kupferstich*
etching	*eau forte*	*Radierung*
lithograph	*lithographie*	*Lithographie*
margin	*marge*	*Papierrand*
print	*tirage* or *impression*	*Abdruck* or *Druck*
proof	*épreuve*	*Probedruck*
re-strike	*réimpression*	*Neudruck*
serigraphy	*sérigraphie*	*Serigraphie*
signed	*signé*	*Signiert*
silk screen	*impression à trame de soie*	*Siebdruck*
state	*état*	*Zustand*
stencil	*pochoir*	*Schablone*
wood block	*planche*	*Holzstock*
woodcut	*gravure sur bois*	*Holzschnitt*
wood engraving	*gravure sur bois debout*	*Holzstich*

MAJOR PRINT-AUCTION HOUSES

Christie, Manson & Woods Ltd.
8 King Street
St. James
London, SW1
England

Christie, Manson & Woods International Inc.
502 Park Avenue
New York, New York 10022

Dorotheum
Dorotheergasse 11
A-1011 Vienna
Austria

Galerie Wolfgang Ketterer
Prinzregentenstrasse 60
8 München 80
West Germany

Martin Gordon, Inc.
1000 Park Avenue
New York, New York 10028

Hauswedell und Nolte
Poeseldorfer Weg 1
2 Hamburg 13
West Germany

Drouot Rive Gauche
7, Quai Anatole-France
75007 Paris
France

Karl und Faber
Amiraplatz 3
8000 München 2
West Germany

Kornfeld und Klipstein
Laupenstrasse 49
3008 Bern
Switzerland

Sotheby
34-35 New Bond Street
London, W1A, 2AA
England

Sotheby Parke Bernet Inc.
980 Madison Avenue
New York, New York 10021

Sotheby Parke Bernet
7660 Beverly Boulevard
Los Angeles, California 90036

P.B. 84 (branch of Sotheby Parke Bernet)
171 East 84th Street
New York, New York 10021
(frequently includes lower-priced prints)

NOTE: Print-auction houses issue catalogues for each sale; they are often profusely illustrated and accompanied by estimated prices. Serious collectors should subscribe to and follow at least one auction house's catalogues annually.

10

the paper wasp

There exists a most extraordinary four-winged insect, *Polistes,* more casually known as the *paper wasp.* Millions of years before the idea occurred to man, this ingenious and enterprising little creature was manufacturing paper out of wood pulp. The paper wasp's home, which many architects consider a masterpiece of design, is constructed entirely out of paper that the wasp makes himself. He begins by chewing up bits of dry wood for pulp and later excretes a pasty substance that serves for a binder. It took centuries of experimentation and finally a drastic shortage of rags (the basic material in early papers) before humankind managed to copy *Polistes* and manufacture its own inexpensive papers from wood pulp.

Paper is one of those ordinary everyday "miracles" that one tends to accept as having always been there, like the sun and the moon. But paper is a surprisingly young development in the Western world, and it is anything but ordinary. Next to the wheel and the printing press, few inventions have influenced civilization so profoundly until the coming of radio and television in this century. For the print collector, paper has special meaning. "The beauty and longevity of an original print," begins one Tamarind Lithography Workshop brochure, "depends greatly on the paper that supports it." Just as theatre lighting can dramatically alter the character and intent of a playwright's scene, a printmaker's papers are selected for their power to "set the stage" for his image. There was a time when prints were not hung on the wall or viewed behind glass. They were stored in print cabinets and taken out for intimate viewing or the entertainment of a few close friends. Unfortunately we rarely get to hold the "naked" print in hand these days and have little chance to experience fully the subtle individual complexions papers bring to an image. Rembrandt experimented with a wide variety of papers

—oatmeal, Indian, vellum, gampi—exploiting the flesh-warm tones of one for his nudes, the coolness and absorbency of others for his landscapes.

The ingredients used over the years for making paper read like a sorcerer's shopping list: rags, wasps' nests, moss, cabbage stalks, marshmallow, Indian-corn husks, pine cones, potatoes, beans, tulips, horse chestnuts. Papyrus was a favorite Egyptian writing surface as early as the third millennium B.C., but it left much to be desired: papyrus was brittle, geographically limited in supply, not very durable, and could be used on one side only. When paper came onto the scene, confusion occurred because the name given to the new pulp-made writing "paper" derived from the Latin word *papyrus*. Papyrus, although commonly thought to be an early form of paper, was not. Paper and papyrus are made by two different processes. Paper is manufactured from a *liquefied* pulp; papyrus was produced by the *lamination* of strips of pith (inner bark from the sedge plants that grew profusely along the Nile).

Long before it reached twelfth-century Europe, paper was already known in the Orient, where it had been invented a thousand years earlier (fig. 237). Whereas the originators of fire and the wheel remain history's secrets, we can identify the name and address of the inventor of paper: a Chinese eunuch, Ts'ai Lun, in the court of Ho Ti (A.D. 89–150). As one writer suggests, diversions for a eunuch at court were few and far between, so there was plenty of free time to turn his thoughts to household problems. One of these involved what to do about salvaging scraps of silk that piled up day after day as excess material was snipped from scrolls made for the emperor. Ts'ai Lun hit upon so simple and ingenious a system for recycling the silk scraps that his idea remains at the core of papermaking to this day. The strips were soaked in water and hand-beaten into a pulp.

This pulp was then spread evenly over a bamboo screen so that excess water would drain off through the openings between the bamboo strips. When the remaining pulp was sun-dried, the material solidified into *paper*. Much to the credit of Ts'ai Lun's imagination, he contrived a bamboo mold for papermaking that in spite of all its modern ramifications remains essentially unchanged after eighteen centuries. In its journey westward, the Oriental custom of creating pulp by hand-beating fibers was replaced by the use of water-power and the windmills of Europe.

THE ROUTE TRAVELED BY PAPER FROM CHINA TO THE WEST

A.D. 105	Paper invented in China.
A.D. 610	Paper introduced in Japan.
A.D. 751	Paper made in Samarkand (now Soviet Uzbekistan); process reportedly learned from Chinese prisoners of war.
A.D. 793	Paper introduced in Baghdad.
A.D. 900	Paper made in Egypt.
A.D. 1100	Papermaking reaches Morocco.
A.D. 1151	First paper-stamping mill opens in Xativa, Spain.
A.D. 1276	First mill, Fabriano, opens in Italy.
A.D. 1322	First use of paper in Holland.
A.D. 1348	First paper mill in France.
A.D. 1390	First mill established in Nuremberg, Germany.
A.D. 1450–1455	Introduction of Gutenberg movable-type press.
A.D. 1657	First paper mill in Hertfordshire, England.
A.D. 1690	First paper mill in Germantown, Pennsylvania, United States.

The earliest known European document on paper, dated 1102, is a deed written in Arabic and Greek under Roger I, the Norman conqueror of Sicily. However, the first widespread acceptance

奉請除災金剛　奉請辟毒金剛　奉請黄随求金剛　奉請婆婆訶

凡欲讀經先念淨口業真言通

補唎　補唎　摩訶補唎　補補唎　補唎

237. Diamond Sutra. A.D. 868. Woodcut. World's oldest-known printed page. 9¾" x 11½"; length of scroll: 17½". Courtesy the Trustees of The British Museum, London.

of paper in Europe did not occur until the fifteenth century, a fact that prompts several questions. Why did paper take a thousand years in reaching Europe? And, once it arrived in the twelfth century, why did it loll around for another two hundred years before coming into general usage? Paper existed and the method for woodblock printing, which had been around as far back as Coptic textiles, also existed. Why then were no prints produced in the twelfth century?

Perhaps it was a case of technology in advance of its time: the invention of the propeller before the discovery of the principles of aerodynamics. Paper and "printed" pictures waited in the wings until medieval Europe found a job for them. The delay in putting paper to work seems baffling within the context of an invention-saturated twentieth-century world. But one must adjust his sights backward to the insular feudal society of the time, eking a living off reluctant

land. Under feudalism, men and animals were tied to the land and very few people could move about. Few of any class could read. Serfdom had not yet bowed to citizenry. Only a handful of cosmopolitan urban centers existed. No newspapers. No international monetary system. Trade was conducted largely by barter, and travel was undertaken with great trepidation. An early use for woodcuts was, in fact, as a warning against marauding highwaymen and the perils of leaving one's enclave (fig. 34). In such a precarious existence, books, writing paper, and "pictures for the wall" were hardly priorities.

The trappings of modern society begin to surface in the thirteenth century: international banking, cities, guilds, craftsmen, middle-class tradesmen, and more extensive travel. The Crusades, begun in 795, under Pope Urban II, had opened commerce with the Orient. To service the trade routes, free cities sprang up in Europe and with them, an increasingly prosperous middle class unanchored to the land. The apparatus of modern culture took time to pry loose from the insular structures of manor life, and the Great Plague of 1348, which wiped out a third to a half of Europe's population, deterred progress even further. But by the fifteenth century, a turning point had been reached. The Renaissance unleashed a new individualism and enterprise, and even as monks continued to copy Aristotle and Plato on parchment and vellum by hand, vehicles for change appeared in the north: the invention of Gutenberg's movable-type press around 1450–1455, the availability of inexpensive paper, and a viscous printing ink. For the first time, it would be possible for people to communicate and exchange their ideas and discoveries with hundreds of others miles away. The information explosion generated pressure for more and more printed material, and the first prints appear largely in conjunction with texts and religious teaching.

In the Orient, the silk fibers Ts'ai Lun used to make paper pulp had been replaced with cheaper fibers from the gampi, kozo, and matsimuto plants. Lacking these plants, Europe substituted cotton and linen rags as the basic ingredients for pulp. The rags were soaked and rolled into giant balls. These were set aside for as long as two months to ferment. When fungi appeared on the balls, they were considered ready for "beating to a pulp." Many of the prints made between the sixteenth century and the early nineteenth century, when rag was still used extensively in paper, suffer from foxing (brown spots, fig. 238), which some experts attribute to the fermenting process used in early paper manufacture.

Few substances have proved more of a boon to modern progress than paper, but medieval Europe greeted the new material suspiciously. Paper was mistrusted on two counts: it was considered the invention of foreigners, and reluctance also arose from the fact that many of the rags used in papermaking were from the clothing of those who had died in the series of plagues that swept across the Continent throughout this period. However, by the mid-fifteenth-century, when Gutenberg's press could put it to good use, paper had gained general acceptance. Eventually acceptance became so widespread that it led to a shortage of rags. Laws were passed in both Europe and America to preserve the raw materials needed for paper pulp. One regulation in England actually forbid the burial of anyone in clothing "usable for the making of paper."

French scientist René Antoine Ferchault de Réaumur (1683–1757) hit on an alternative for pulp by studying the spinnings of the paper wasp. De Réaumur surmised from observing the insect that wood could be used as a substitute for rags. It was plentiful the world over, and unlike vellum or parchment, wood pulp was also inexpensive. Matthias Koops, a Dutchman living in London,

also recognized the potential in wood pulp and began producing it in quantity. In 1880, Koops published a *Historical Account of Substances Which Have Been Used to Describe Events and Convey Ideas from the Earliest Date to the Invention of Paper*. Apart from its incisive recognition that being in the paper business was really being in the business of "communication," Koops's publication was unusual in another respect: the publication was printed on paper made from straw and had an appendix printed on paper made entirely from wood pulp.

Inexpensive and readily available, wood-pulp paper quickly replaced rag-content paper for most practical uses. Unfortunately this change represented a problem for artists. Wood-pulp papers

238. Example of foxing: **George Fuller** (1822–1884). *Portrait of a Lady.* 12⅛" x 8⅞". Courtesy Museum of Fine Arts, Boston, M. and M. Karolik Collection.

tend to yellow and grow brittle with age, making them unsuitable for artwork. Printmakers still prefer expensive handmade rag or vegetable-fiber papers. The manufacturing process of wood-pulp papers presents a further problem for artists. Wood pulp is naturally tan, and strong chemical bleaches and sulfites must be used to obtain any white paper. Such papers retain traces of the chemicals, and these vestigial acids can stain and burn other materials. For this reason, placing a wood-pulp-content backing board or matting next to artwork can be dangerous.

MAKING HANDMADE PAPER

The mold is the essential papermaking tool, just as it was when Ts'ai Lun first thought of the idea. There are two basic types of paper mold: a *laid construction* and a *wove construction*. The mold itself is simply a rectangular wooden frame, across which is stretched either brass wires (laid construction) or a fine wire cloth (wove construction). When pulp is poured into the mold, the excess water drains out through the wire-screen openings (or through the cloth openings), leaving only a thin layer of liquefied fibers.

Step 1: The mold is dipped into a vat containing pulp (a mixture of macerated fiber and water).

Step 2: The mold is lifted out of the vat and given the "vatman's shake," a rapid motion that spreads the fibrous mix evenly over the screen.

Step 3: The wet sheet, still in place on the mold, passes to the next operation, where it is removed and "couched" on a piece of felt. Another piece of felt covers it. Such sandwiches are made for each new sheet added to the pile.

Step 4: "Sweating" with pressure removes large quantities of water. When the paper finishes sweating, it is dried.

Step 5: Damp sheets are hung on cords in spurs of four or five, which separate out as the paper dries.

PRESSING AND SIZING

Pressing and sizing give paper its final surface look and feel. The more pressure exerted on the paper, the harder its surface.

Sizing determines the paper's absorbency and its receptivity as a writing and printing surface. Blotting paper, for example, is unsized. Orientals use starch and gypsum as a size. In the West, we apply a thin layer of glue or gelatin made from the hides or hoofs and bones of animals. Sizing is important to the printmaker because absorbency affects how his paper responds to various inks and, in the intaglio process, how long the paper must be moistened to print his image to the color density he desires.

GLAZING

Once paper has been dried, pressed, and sized, it needs a finish. This process is called *glazing*. The papers used in Dürer's day were burnished or *finished* by hand: they were rubbed with a smooth stone. Later finishes were achieved by the passing of the paper through revolving rollers.

Paper is beautiful. But it is also fragile and plagued by a number of environmental dangers that the collector would do well to bear in mind if he prizes his prints.

HUMIDITY. Extreme humidity and poor ventilation may merely cause discomfort for people, but they threaten the health of a print. When the humidity rises above 70 percent, it can cause mold growth. This is a chemical action of mold on the iron salts in most papers. Mold feeds on sizing and the paper fibers, eventually weakening the entire

fish have been known to eat their way through a print. Roaches are drawn to any glues containing sugar.

HEAT. No matter how good a print looks over a working fireplace, don't hang it there. Heat speeds the deterioration of paper. Radiators and air ducts also present a heat problem.

AIR POLLUTION. People living in the city aren't the only ones suffering from air pollution. Prints in urban areas suffer the effects also. Sulfur dioxide, which is present in smog and therefore part of modern city life, causes discoloration, brittleness, and eventually a breakdown of paper fibers. It is one of the most serious threats to art on paper. Sulfur dioxide is absorbed by the paper and changes into sulfuric acid. The acid resides in the paper and often causes brown stains when a frame has not been properly sealed. Correct framing with 100 percent rag mats and backing offsets some of the pollution problem (see chap. 11).

HANDLING PAPER. Paper looks solid, yet as we've seen, it was made by the fusion of many tiny individual fibers, which can crack or break if handled improperly. One should always lift prints with both hands, placing a hand under either side of the paper. When shipping prints, take the time to wrap them carefully. If the prints become "bent" in shipping, the fibers may be broken irreparably. First, wrap the print in tissue. Tape the tissue closed. Then sandwich the print between four pieces of heavy corrugated-cardboard sheets, slightly larger than the print. It's a good idea to tape the tissue-covered print down to one of the corrugated boards. Tape the boards together into a rigid container. It's also a good idea to check the overall shipping size permitted by the U.S. Postal Service. Large shipments can be made by United Parcel Service or air freight (and occasionally cost less this way).

sheet. Air conditioning, dehumidifying machines, airtight storage cases, and silica gel (a dehumidifying agent) help. A humidity of 50 percent is ideal. Avoid hanging prints near outside walls in brick or stone houses or in damp basements or cellars. Mold also attacks prints left in the seeming safety of summer houses left closed and unventilated for the winter.

What does mold look like? It often appears as rusty spots called *foxing* (fig. 238). Small dishes of thymol crystals placed in print-storage cabinets help prevent such mold. Once a print has been "cured" of mold, don't hang it back in the same spot where the original trouble began. It can start up all over again.

LIGHTING. Victorian watercolors of the nineteenth century were sometimes displayed in frames covered with small curtains that rolled up like window shades for viewing of the picture. The idea of protecting a work of art from overexposure to light is a sound one. Light fades artworks on paper. A print should never be hung directly in sunlight. The ultraviolet rays of the sun and unfiltered fluorescent lighting are particularly harmful. Traditionally prints were stored in cabinets or albums and viewed only occasionally in private or with friends. As objects of display today, they are vulnerable to light damage. The best thing next to learning to see in the dark is to light your prints with no more illumination than you need to read a book—around 150 watts—and to rotate hanging arrangements so that no one piece gets the same exposure continuously.

INSECTS. Cockroaches and silverfish are a threat to prints. Both inhabit warm, lightless, and damp places, moving rapidly in the dark so that they often inflict a good deal of harm before they are discovered. In an effort to get at the glue sizing and flour pastes used for mounting, silver-

QUESTIONS PEOPLE ASK

1. *Is rice paper really made from rice?*

No. So-called rice paper is actually not a paper at all. The thin white material commonly associated with Oriental papermaking and sometimes used as a synonym for all Oriental papers is made from the *pith* of a plant grown in Formosa and not by a pulp process, as is paper. Another misleading term is *woven paper*. There is really no such thing. *Wove* has no connection with weaving. The terms *laid paper* or *wove paper* merely describe the type of screen used to make the paper in the mold.

2. *Why does paper yellow?*

The yellowing of a paper depends on the amount of acidity (pH) in its fibers (7 pH is neutral, 0 pH is highly acid). Papers with less than 4.5 pH lose strength and disintegrate.

3. *How is a deckle edge made?*

The papermaking mold that gets dipped into the liquefied pulp is made up of two parts: the mold frame and a removable wooden frame that locks into it, called the *deckle*. The size of a sheet of paper is set by the size of the deckle. *Deckle edge* refers to the "hairy" irregular edges on a sheet of handmade paper. These irregular endings occur when pulp runs out under the deckle frame. Deckle edges were once considered distasteful and were cut off. Today we consider them a sign of quality.

4. *Don't many people ship prints rolled in a tube rather than flat between cardboard?*

Yes, especially large prints. Use an inner and outer tube method for packing. Place your print down on a piece of tissue that extends beyond the print, then cover the image area with tissue and roll tissues and print around a tube (not too wide and slightly longer than the print itself). Tuck the overhanging tissue in at either end of the tube. Wrap this unit in another outer layer of paper and seal with tape. Select a sturdy outer tube, slightly taller than the print, but one that does not permit too much room for jostling. Ball up some tissue and place it in the bottom of the outer tube. Slip the print in and then put another ball of tissue between the print and the cover of the tube. This prevents movement in any direction. Secure the lid, label, insure, and ship.

Fine art outlives its owners. In this sense, the collector is only the custodian of a work of art and bears a caretaker's responsibility for preserving its beauty. But few people realize that a print may hang handsomely on a wall for years while shoddy materials inside the frame are destroying its value. Trusting framing to an incompetent framer is likely to have the same outcome as placing one's health in the hands of a witch doctor, namely, an unfortunate one. One young man learned this rather unhappily several years after he invested $375 in a Lyonel Feininger woodcut.

Finding himself in economic difficulty, the young man put the print up for sale. As Feininger prints had risen in value since his purchase, he anticipated getting his original investment back, plus cash to spare. Instead he was offered less than he had originally paid for the print. What had occurred in the intervening years between the time the print was purchased and the time the collector tried to sell it? Improper framing.

Knowledgeable dealers, collectors, and auction houses open the frame and inspect the condition of a print before giving an estimate on its value or offering to buy it. In the case of the young man's Feininger woodcut, inspection revealed that the original margins of the print had been trimmed down to accommodate the frame size, and someone had glued the print to the backing board, presumably as a way of keeping it "flat." If such framing infractions do not strike you as criminal, they should. More fine prints are destroyed, damaged, and devalued by such tactics than by any other cause.

Unfortunately, professional framers as well as many dealers and artists focus on the frame as decoration and still ignore its purpose as a means of conservation.

One of the most insidious "enemies" inside a frame is the cardboard backing used by many

11

framing: there's more to it than meets the eye

framers because it is less costly than 100 percent rag-board backing. These inferior boards contain a wood-pulp core that, in time, disintegrates and "burns" any art with which it is in contact. Acids from such wood-pulp boards can also "infect" the artwork, causing foxing (brown spots), brittleness, and disintegration.

Many people put more effort into investigating the relative merits of one television set over another than into finding a competent framer. Yet it makes no sense at all to invest in beautiful works of art only to become an accomplice to their destruction. The Tamarind Lithography Workshop, concerned with this problem, issued a helpful pamphlet with *Questions to Ask Your Framer and Answers You Should Get* (Tamarind Lithography Workshop, Inc., 112 North Tamarind Avenue, Los Angeles, California 90038). There are three major areas of concern:

1. Using the correct mat board.
2. Using healthy hinging materials and techniques.
3. Sealing the frame properly.

MATTING AND BACKING

Are the matting and backboard 100-percent rag?

A mat consists of two sections: the backboard and the front window board. A work of art should always be backed and matted with acid-free boards. Specifically ask your framer to use four-ply 100-percent rag board, sometimes called *museum board*. A caution on this: be certain that the board is rag *through and through*. Some framers use a thrifty version with a rag layer on top of wood-pulp board. When the mat opening is cut, it exposes the harmful wood-pulp core, which exudes chemicals that can damage the print. Four-ply board is preferable, although two-ply is lighter and acceptable for storage purposes.

Some collectors prefer colored mats or, for traditional prints, mats that are decorated in a pattern typical of the period. Since rag board does not take color effectively, you can apply the color to a regular board as long as it is then backed up with 100 percent rag, so that only the rag touches the print.

Does the framer know correct hinging materials and methods? Is he using them?

Many tapes stain artwork almost immediately. When one client objected to the use of Scotch tape in attaching his print to a backboard, the framer reassured him that any staining from the tape would be "covered by the mat anyway." Obviously he wasn't familiar with Sotheby Parke Bernet's concise guide on *Framing and Preservation of Works of Art on Paper:* "Use of self-adhering tapes such as 'scotch' or masking varieties, which stain almost immediately, must be avoided at all costs. Even if . . . hidden by the mat or frame, staining will diminish the value of many works of art." Also harmful are animal glues and rubber cement. Old-fashioned library paste or any vegetable-based paste can be used safely. The best tape, and the one suggested by many museums, is a Japanese mulberry-paper tape. One commercially made gummed glassine is also acceptable; it is listed in the sources at the end of the chapter.

HINGING

STANDARD HINGE

The artwork is hinged to the backing board with two pieces of rectangular mulberry paper tape folded lengthwise so that one half attaches to the backing and one half to the art (see fig. 239). The art is hinged at the top only, and the lower portion of the print hangs free on the backboard.

to protect the artwork from dust, insects, and dirt. The first should be either 100-percent rag board or rag-surface board, and finally, the last, the outer backing, should be a material with body to it: corrugated cardboard, Masonite, or stiff pasteboard. Never place a wood backing directly against the print. Resins from the wood will stain the print.

If your framer responds to your questioning with the attitude that you are making "too much" of the whole thing, gather up your prints and find another framer. Your local museum or a good print gallery should be able to supply the name of someone competent. A source list is also included at the close of this chapter to help in the location of materials mentioned in the event that you can not find them locally.

RESTORING A DAMAGED PRINT

One of the most persistent and irksome problems with prints often turns up after framing, when a print develops "waves." Such buckling is particularly prevalent in areas where the climate seasonally swings from one extreme to another. Why do prints develop "waves"? Because paper is an organic material. It goes through changing "moods," reacting to environmental shifts in heat, light, and humidity—shifts in the atmosphere—by expanding and contracting. This expansion and contraction appears to us as "waves" in the paper. Faced with a "moody" print and the complaint, "Can't you make it lie flat?," framers and even artists have devised a number of solutions that amount to torturing the paper into submission. Worse, the solutions obliterate the paper's natural reflexes and, in a sense, "kill" it.

To obtain "flatness," prints are sometimes dry-mounted. This process involves fusing the artwork to a backboard under heat and pressure.

Artwork is never glued directly to the backboard.

ENVELOPE HINGE

Four triangular envelope corners are constructed from mulberry tape or rag paper and affixed to the backing board so that the four edges of the artwork can be easily slipped into them (see fig. 239). The corners are covered by the front window mat. Envelope hinging avoids the use of any type of adhesive on the print itself. An alternative to the standard and envelope-type hinges is the T-hinge (see fig. 240).

"FLOATING" THE PRINT

With many contemporary works, the traditional window matting is inhibiting to the design. In this case, the print is "floated" on the 100-percent rag backing only and hinged only at the top.

Note: Mats are not purely decorative. They create a "no-contact zone" between the glass and the print. Without this space, moisture and condensation can occur on the glass and make the print susceptible to mold growth and staining. If you eliminate the window mat for aesthetic reasons and "float" the print, ask your framer to insert a *fillet*, which will create the necessary space between the artwork and the glass.

CLEAR PLASTIC FLANGES

This is a variation on the idea of the clear plastic hinge. The flange is a long strip that can be cut to size and fixed to a backboard. The tab is adhesive on one side and has a channel that slips over the print edges at top and bottom, permitting the art to be easily removed.

Did the framer seal up the frame properly?

Once the print is hinged, matted, and placed in its frame, *two* additional backings are needed

239. Diagram of proper hinging techniques.

240. Diagram of "T" hinge.

* Used for all four corners of the print. The paper slips into the "envelope" in the same way that triangular corners were once used to hold photographs in place in an album.

Some people also freeze prints into position by gluing all the sides to a backing to prevent movement. Prints are sometimes even "stretched" over wood frames to ensure their immobility. Each of these "solutions" stifles a natural *breathing* process and destroys the original quality of the paper. Many people act as if the paper were incidental to the image it carries. But paper is far more than a "carrier" in printmaking. Most artists select their papers for specific effects: tone, texture, how it takes the ink. By mounting, stretching, or gluing the paper rigidly, you distort its basic personality and tamper with the original visual balance of the entire print. Apart from destroying the artist's intentions, flattening a print by force can cause a breakdown of the paper fibers by inhibiting natural expansion and contraction. "Such 'embalmed' prints have lost an essential quality, a fact that is frequently reflected in their reduced market value,"[51] according to Christa Gaehde in her essay on the care of prints for the Print Council.

What should you do if a framed print develops "waves"? Leave it alone. When the weather changes, the print will probably straighten itself out. If the print begins to rub against the glass, have it reframed.

Proper framing conserves your prints. Once damage is done, a good restorer is needed. Tears in the paper can be mended, stained margins cleaned, impaled prints freed from their mountings. *But restoration is not a do-it-yourself undertaking.* Knowing the right way to handle a particular restoration problem is a matter of experience and instinct more than rote formula. One home remedy backfired when a collector successfully removed some foxing on the margins of a print with talcum powder. The spots bleached out, but the chemicals in the talcum eventually burned the entire margin. Restoration is an art in itself. One should never trust the job of restoration to a framer or someone selected merely on the basis of an advertisement in an art journal. Get some solid references. Art students sometimes make pin money by doing "restoration" work, but many are far from qualified. The American Institute for the Conservation of Historic and Artistic Works (1 East 78th Street, New York, New York 10021) lists such "paper" restorers in their annual directory. The best way to find a competent restorer is to contact the print department of a major museum or auction house and ask if they will suggest a few names to you. Prices vary with the problem and the restorer. Cleaning badly stained margins can cost as much as $100. In the case of rare or fine prints, this is well worth the investment. Be sure to discuss maximum price and how long the job will take.

CHOOSING THE CORRECT FRAME

". . . the Italians say that a beautiful frame . . . acts as a pimp for the painting." According to Henry Heydenryk's fascinating study of framing,[52] this observation graced the pages of the 1699 edition of the *Dictionnaire des Beaux Arts*. What is the connection between the enjoyment of a work of art and the frame it lives in? In the same way that ill-fitting clothes detract from a person's physical attributes and appropriate attire enhances them, proper framing increases our perception of a piece of art. Therefore, quite apart from its conservation functions, a frame's "looks" should be carefully considered.

Prior to 1786, the print collector would have had no such worry. Clear glass came into general usage around that time and made the framing of prints feasible. Before then, prints were simply tacked to the wall, much as our modern-day calendars are, or pasted up with wax and left hanging until they disintegrated and were thrown

away. Although some collectors mounted their prints in books, many fine works of art were lost as victims of the environment. The development of proper framing solved the problems of exposure but raised others. Good framing requires creative judgments that can be as subtle as an artist's decision to play a dot of cadmium yellow against a field of cobalt blue. A mat that is too narrow and inhibiting can actually shrink the image optically and diminish its aesthetic impact. An overly ornate frame on a delicate print can wash it out rather than underscore its sensitivity. When one begins to recognize framing for the creative process it really is, it is not so surprising to find that people who normally know precisely what they want thumb their way through a wall of frame samples with a good deal of frustration.

What is a frame?

Decoratively speaking, a frame is a way to define space; it telegraphs boundaries to our eyes. Some frames signal the eye to "halt," making so sharp a distinction between the artwork and the surrounding wall space that we are forced to see the image as though it were an island within the total setting. Other frames (particularly many of today's so-called nonframe frames) provide little more than a casual interruption between artwork and surrounding setting. In this case, the eye tends to experience the art as part of the total environmental space rather than as a separate element in it. The "environmental frame" is much like the choir singer, whom we perceive as part of a total unit. The "island frame" is the soloist, who rivets our attention by wearing a gown that stands out against the choir. It helps to decide which of these visual goals you have in mind for a particular space or artwork.

Attitudes on framing range from "the best frame is no frame at all" to that of Napoleon, whose obsession with codification extended even to the paintings in the Louvre, every one of which the emperor had reset into Empire frames, without the slightest regard for whether or not the style clashed with the art. Louvre curators are busily rectifying the infraction to this day.

How do you select the correct frame?

Discernment in framing, like taste in any other area, results more from education than instinct. Preferences develop through exposure, conscious and conscientious observation of gallery and museum framing, and the ordinary learning that proceeds from trial and error. There are no absolute rules in framing as far as style is concerned. But there are basic considerations worth keeping in mind.

The artwork itself holds a clue.

What type of print are you framing? An intimate seventeenth-century Rembrandt etching? A bold, dynamic Picasso linoleum cut? A contemporary color work by Josef Albers? A fragile fine-line work by Charles Sheeler (fig. 245)? Many people associate ornate framing with being "expensive" or "museum-piece." Although framing a nineteenth-century print true to its period has its charms, traditional stereotypes in framing can be quite out of the place with works from other periods. One must remember that each frame style developed within a specific historical and environmental set that may no longer be valid in the contemporary living context. Prior to electricity, for example, the ornate gold-leaf frames generally associated with expensive art served a very practical purpose. In the dim, often dark castle hallway, sometimes all that made a work of art visible was the candlelight bouncing off the gold-leaf frame. The dignity and impressiveness of some frames may still be appropriate for older prints and certain "painterly" examples, but generally a good rule of thumb in framing graphic work is to keep

the frame basic and simple. If the frame catches your eye before the art, the piece is probably over-framed.

The movement toward less elaborate framing gained momentum with the Impressionists. Like many of our contemporary artists, the Impressionists found the obvious and ornate frames of the nineteenth century an intrusion on their work, competition for the eye. One artist, Georges Seurat, went so far as to continue his paintings right out onto the frame itself in an effort to release the image into surrounding space and to eliminate the artificial boundary created by elaborate frames.

The artist's effort to soften the division between image, space, and spectator gained further momentum with abstract art. The visual thrust of most abstractions draws the eye outward into the environment. The image presses right to the edge of the canvas or paper and is sometimes truncated to imply that it continues out into the surrounding space, which with the help of our eye, it does, in a sense. This outward thrust in modern art eventually encouraged the development of a minimal boundary frame: the nonframe frame. Many contemporary prints look best "floated" without matting in such simple, thin, steel containing-edges or in clear Plexiglas boxes. Occasionally a print-maker tries to control the visual relationship between his image and the surrounding space by providing a built-in mat—a margin deliberately left on the print around the image. These margins are often an integral part of the work and should be respected when you frame it.

What size matting should you use?

When a regular mat is called for, it is best to keep the window *opening* slightly larger than the image area (usually about ⅛″ all around and slightly deeper at the bottom if the print is signed). Experiment with size. Many people find

size difficult to visualize from the mat samples in frame shops. It sometimes helps to test mat-size possibilities yourself with plain white typing paper cut in varying widths before bringing the print in for framing. You will soon learn that the mat can fool the eye: to increase the size and importance of a relatively small print, for example, you can "jewel-case" it in a large matting, taking care not to overwhelm the art. A mat that reflects the proportions of the print usually does it the most justice, although dramatic effects can sometimes be achieved if you deliberately exaggerate the vertical or horizontal aspect of a particular piece.

What do you do when the design goes all the way to the edge of the paper where a regular mat would cover it? Float the print on a backboard and cut the window of the cover mat ⅛″ or ¼″ larger than the print, leaving all its edges exposed within the window. Or, use no mat at all.

In general, plain white or off-white mats show off a print to best advantage. Colored mats tend to attract attention to themselves rather than the artwork. Colored mats also present a conservation problem discussed later in this chapter. As your collection grows, you may want to revise hangings. The use of standard-sized mats (the outer overall size) makes storage and frame swapping easier. It also saves money on framing if you stick with one of the "in-stock" frames sizes: 30″ × 40″; 22″ × 28″; 16″ × 22″; 14″ × 20″.

It's a good idea in matting to check for an "echo" effect. The width of your mat and the width of the frame strip should not be too close. This sets off a visual "echo" and dulls the overall effect. Watch out for the width of lines within the image as well. The width of the mat or frame can accidentally reiterate some vertical or horizontal movement in an image and actually compete with the composition.

How original is your hanging?

If a beautiful frame acts as a "pimp" for the picture, a beautiful hanging prepares our eye for the seduction. Living with a print collection, whether large or small, can be an exciting visual experience or no "experience" at all, depending on how willing you are to experiment with space. Many people tend to balance everything. The objects and spaces in a room should relate to one another, but balance need not be synonymous with boredom. Unexpected arrangements, while balanced to the eye, can create a sense of drama because they are not predictable or overly symmetrical.

Understanding the deadening effect of too much symmetry, the Japanese practiced a delicate aesthetic balance in their tearooms, taking care never to place an incense burner directly in the center of the pedestal of honor, where it would divide the space into equal, and therefore symmetrically dull, halves. A rectangular kettle dictated that the water pitcher should be round. To the Oriental, a room that was too pat missed being perfect. How does one arrive at such a happy unbalance? A good deal of juggling and some unusual juxtapositions can be accomplished before the first nail goes into the wall. Lay your prints out on the floor, using the actual positions you plan, in front of the wall intended for them. This gives some idea of how the various images and frames "feel" together. It also allows you to try out unconventional arrangements without ruining the plaster.

While some people concentrate on a "period" of art, which makes hanging a collection a good deal simpler, two Queen Anne chairs and a Chippendale desk are no excuse for avoiding a Rauschenberg or a Warhol anymore than a sleek Eames chair should deny you the pleasure of owning a fifteenth-century Dürer woodcut. The contrast between contemporary and traditional is often refreshing and stimulating. A well-selected collection can cross centuries by exposing compatibilities that go deeper than surface style.

STORAGE OF PRINTS

The traditional Japanese tearoom remains undecorated—empty to Western eyes—except for a single work of art placed on the *tokonoma* (place of honor). The artwork is changed as the mood, guest, or season suggests. Behind this seeming austerity lies the conviction that to perceive beauty one must concentrate. Whether you prefer your art uncluttered, tearoom style, or your collection has simply outgrown available wall space, you require a way to store your collection without damage to the prints. The worst danger is dust. Architectural cabinets or dust-sealed drawers will do. Always separate the individual prints with sheets of acid-free lining paper or matting to prevent abrasion (0.005 cellulose acetate for *short-term* storage is also acceptable). This separation is especially important with silk screens, where the inks lie on the paper surface and scratch easily. Solander boxes are also available for storage of prints not displayed on the wall. They have a flap-down front-end panel for easy viewing and removal. The boxes hold from seventeen to twenty matted prints. Invented by an eighteenth-century Swedish botanist, Daniel Solander, the boxes come in standard sizes or can be custom-ordered.

QUESTIONS PEOPLE ASK

1. *Do silk- or linen-covered mats harm the artwork?*

Natural silk- or linen-covered mats and backings are safe as long as the boards they cover are

100-percent rag. An extra piece of rag paper should be positioned between the glued area of the linen on the reverse side of the window (top) mat to buffer it from the artwork. Burlap contains active chemicals that affect paper and should be avoided as a mat covering.

2. *Are Plexiglas frames safe?*

Plexiglas UF-1 filters out ultraviolet rays and is recommended by most sources. Plexiglas has a number of advantages: it is unbreakable; it is lightweight and can handle today's large-scale prints without requiring the expenditure for heavier frames that a corresponding area of glass would necessitate; the no-frame Plexiglas look often complements the modern print. The drawbacks are: Plexiglas is electrostatic and attracts dust (there is now an antistatic spray available); Plexiglas can cause charcoal or pastel to lift off the paper and stick to the frame, which makes it unsuitable for those mediums. It also scratches easily.

3. *Why is it necessary to hinge a print to the backboard? Wouldn't the window mat keep it in place?*

Paper expands and contracts. If the print isn't hinged to the backing, it will slip. One reason for hinging only one side (usually the upper) to the backing is to allow the paper room to expand with changes of climate.

4. *Why is it wrong to trim the margins of a print to accommodate the frame size?*

Defacing original artwork, for whatever reason, is always wrong and will usually decrease its value. If you absolutely must change the size of a print, it is less damaging, *although not recommended,* to fold the margins back.

5. *Is nonglare glass effective?*

To be effective, nonglare glass must be placed directly against the artwork, which, as has been explained, can damage the print should moisture condensation occur. Therefore the use of nonglare glass is not a good idea.

SOURCES FOR MATERIALS

It is hoped that the following list of materials will be helpful to the reader. The author cannot, however, make any guarantee as to their quality or assume responsibility for their use.

ALL-RAG MAT BOARD
(*acid-free museum board*)

Dennison Manufacturing Company
Coated Paper Division
300 Howard Street
Framingham, Massachusetts 01701

Charles T. Bainbridge's Sons
20 Cumberland Street
Brooklyn, New York 11205

GUMMED LINEN TAPE
(*Holland tape*)

Dennison Manufacturing Company
Coated Paper Division
300 Howard Street
Framingham, Massachusetts 01701

Gane Brothers and Lane, Inc.
135 West Lake Street
Chicago, Illinois 60607

Gaylord Brothers, Inc.
P.O. Box 61
Liverpool, New York

GUMMED TRANSPARENT HINGING TAPES
(*acid-free glassine, cellulose acetate,*
Japanese papers for covering prints)

Talas
104 Fifth Avenue
New York, New York 10011

SOLANDER BOXES

Spink and Gaborc, Inc.
32 West 18th Street
New York, New York 10003

The Mosette Company
28 East 22nd Street
New York, New York 10010

ACID-FREE FOLDERS, STORAGE BOXES

The Hollinger Corporation
3810 Four Mile Run Drive
Arlington, Virginia 22206

PLEXIGLAS

Rohm and Haas Company
Plastics Department
Independence Mall West
Philadelphia, Pennsylvania 19105
(Also supplies filters for fluorescent lights)

CELLULOSE ACETATE SHEETS
*Write to the following address for technical
information and names of local suppliers:*

Eastman Chemical Products, Inc.
Plastics Division
480 Cochituate Road
Framingham, Massachusetts 01702

12

doing your "homework"

In *The Tastemakers* (1954), Russell Lynes poses the question: "Just what is the matter with American taste, if anything is the matter with it?" "I believe a great deal is the matter with it," Lynes replies, "and the first thing that is the matter is that too many people worry about it."

Taste is a subjective term with so many interpretations that one is tempted to brush the entire issue aside as irresolvable. But the issue of taste really masks a genuine concern keenly felt by new collectors. Namely, the fear of making inappropriate decisions, both aesthetically and financially. No collector worth mentioning has completely avoided such pitfalls. Indeed, the courage to risk one's own judgments all along the way is precisely what shapes collections with a strong personal imprint. But the leap from novice to knowledgeable collector is not a function of time alone. More than anything else, it's a matter of doing your homework. Don't be put off by the term. Curators, dealers, and collectors use it all the time, and the process goes hand in hand with building a satisfying and successful collection:

Begin by establishing a solid framework of information. Weak prints can sell themselves to the unschooled eye that hasn't learned to winnow the wheat from the chaff (for example, technically inferior uses of a medium; takeoffs on imagery and styles established by well-known artists). Before plunging into any overzealous collecting, read several survey-type books on prints and printmaking. These ground you in the basic visual and technical history of the field, and if nothing else, knowing standard terminology helps you in asking the right questions. Most print collectors eventually build up a personal library of books on the subject and keep them on tap for quick reference.

Educate your eye to quality. Looking is as much a part of print collecting as buying and, in

many ways, is even more essential to building inner confidence in your judgments. Commonly, a new collector finds an artist he likes and plunges headlong into a purchase, regretting his haste a little while later when he discovers a far more appealing print by the same artist that he would have preferred to own. There is no substitute for seeing as many works by an artist you like as possible before deciding to collect his work or a particular print by him. Apart from galleries and museum shows, the presale exhibitions held by major auction houses, if you live near one, can be an education in itself, whether or not you intend to buy. In the seventeenth and eighteenth centuries, when formal museums as we know them did not exist, auctions served as crossroads for transmitting new ideas. No doubt Rembrandt, who never traveled to Italy, gleaned many of his insights into the Italian High Renaissance style by way of the paintings and prints he viewed or purchased at the famous Amsterdam auctions. With an artist of international reputation, you may also study his entire body of work in a catalogue raisonné, if one exists, or in selected examples in a local museum or university print room. But be sure to write or call ahead for an appointment.

Explore your budget options before you buy. What prints are realistically within your means without a sacrifice of quality? If you are thinking of assembling a group of prints for under $1,000, there is no sense in setting your cap for a first-state Rembrandt impression executed during the artist's lifetime. It might make more sense to look into less-sought-after seventeenth-century printmakers such as Adriaen van Ostade or to shift entirely to a period where it is still possible to acquire major prints—a contemporary such as Jim Dine (fig. 241), for example, whose sensitive exploitation of the etching technique is often rem-

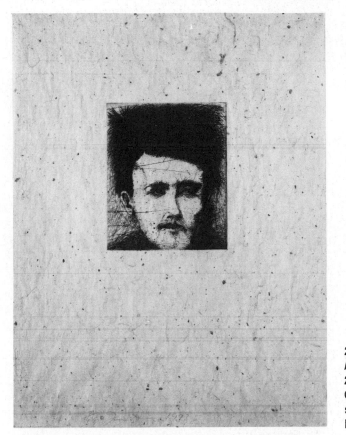

241. **Jim Dine.** *Rimbaud*. 1973. Etching. 20¹¹/₁₆″ x 15⁷/₁₆″. Courtesy The Museum of Modern Art, New York.

iniscent of Rembrandt's intensely personal, introspective drawing quality (figs. 136, 137). Popular imagery (fig. 242), informational-type prints, and *ex libris* and book illustrations provide another out-of-the-mainstream area for collecting, with good examples still available for limited budgets. Make an armchair survey of auction and gallery catalogues, most of which are profusely illustrated and are accompanied by price lists. Consider it your equivalent of a cram course in the print market. You will find a listing of major auction houses in chapter 9 and a partial listing of print galleries offering catalogues in most issues of *The Print Collector's Newsletter*.

But what if you opt for the adventure of collecting undiscovered artists, the possible Picassos of tomorrow? All the more reason to give yourself

a solid grounding in and knowledge of the important prints of past and present. Such an overview stands you in good stead when it comes to singling out the most original and gifted works by newcomers and will also help you to avoid art fads or the trap of a merely decorative, Picasso-over-the-sofa-type collection.

Structure your collection around a primary area of interest. Specializing in a particular artist or period builds expertise. Each area has its own market characteristics, print sources, reference texts, and history. The more you know, the better you buy, and the more unified and striking a collection you are likely to build. You can always branch out later on. With the soaring prices on major prints and their diminishing availability, attempting to build a survey-type collection covering five hundred years of printmaking is an undertaking even museums shy away from these days.

Develop good working relationships with reputable dealers in your field of interest. Collectors acquire prints through four basic sources: dealers, auctions, print publishers, and the artist himself. Some contemporary artists publish their own prints, but generally they create an edition for a publisher for a fixed fee. The publisher owns

and distributes the edition to dealers at a wholesale price (generally anywhere from 20 percent to 50 percent off retail price), and the dealer sells the prints to the public. One can sometimes buy directly from the artist's stock of artist's proofs, but most reputable publishers prefer not to undersell their dealers or to deal with retail trade.

The advantages of working regularly through a dealer are not always apparent to the new collector, who often places price above all other considerations. Dealers see more than one example of an image or a particular artist's work, and their judgments on quality can be invaluable in helping the collector to avoid mistakes. With early prints, even examples produced earlier in this century, quality can vary widely from impression to impression in inking, color, and condition and, as a result, in overall aesthetic impact. A knowledgeable dealer can recognize this. He is also better equipped to ferret out fakes and is most likely to hear about and pass along good buys to his steady clients. Established clients are also permitted to take prints out "on approval" for several days and live with them before making a final purchase decision. Occasionally dealers will invite reliable clients to join them in purchasing a collection of prints, which provides the client with a chance to own choice examples at favorable prices.

Learn to view prints within their historical context. Artists do not create in a historical vacuum, so why should you collect in one? Major works of art often reflect their times or anticipate them. Placing a print within the mentality, events, and aesthetic limitations of the era in which it was created adds a special dimension to one's overall pleasure and perception of it. John Sloan's *Turning Out the Light* (fig. 243), Wassily Kandinsky's *Klein Welten IV* (fig. 187), Kasimir Malevich's *The Prayer* (fig. 244), and Charles Sheeler's *Barn* (fig. 245), for one reason or another, represented

styles or concepts controversial in their time, however tame these prints may appear to us today. In the case of contemporary printmakers, where the artist is often a painter or a sculptor as well, the graphic works are intricately linked in style and iconography to work in other mediums. Although each print should stand as a satisfying statement in itself, familiarity with the artist's overall effort and the relevance of his work to the issues under exploration in contemporary art as

243. **John Sloan** (1871–1951). *Turning Out the Light* from the *New York City Life* series. 1905. Etching. 5" x 7". In 1906 the American Watercolor Society invited Sloan to exhibit his *New York City Life* series. Four of the etchings, including this one, were excluded from the show as being too vulgar for public display. To modern eyes such subjects hardly appear "radical" or "vulgar." But viewed in the climate of the early 1900s the print shocked staid Victorian sensibility by depicting life-in-the-raw. Such realistic subject matter was deemed heretical by the powerful art academies of the time, where classical, allegorical, and historical themes were still thought the only proper concern of art. As one of the New York Realists (later dubbed the Ashcan School), Sloan's antiestablishment stance makes him one of the first American artists to adopt the avant-garde posture that was to become a hallmark of art in the twentieth century. Courtesy Sotheby Parke Bernet Inc., New York.

244. **Kasimir Malevich.** *The Prayer.* 1913. Illustration for *Explodity,* a publication by A. Kruchenykh: Lithograph. 6¼" x 4½". Malevich's Cubo-Futuristic lithograph of a kneeling peasant woman with hands clasped to her forehead was one of two prints the artist contributed to *Explodity,* a vanguard Russian Futurist booklet of 1913. Written in Zaúm, a transrational language devoid of logical meaning, the booklet abounds in pure sounds, absurdities and nonsense. Its deliberately antitraditionalist text and iconoclastic format (pages were uneven, stapled together, and text was rubber-stamped) ridiculed the decorative and ornate formality of deluxe books produced at the time. Courtesy Carus Gallery, New York.

a whole gives some indication of his potency as an artist and reveals whether his graphics are merely a rehash of paintings or unique expressions of his concepts.

Trading up. What if you outgrow the prints that you own, or want to trade up for better quality, or shift to a new artist or period? One of the strongest arguments for buying the best examples of an artist's work that you can afford, apart from the great satisfaction in owning such images, is that these prints have the best chance of appreciation. They also offer the greatest opportunity for resale should you have a change of heart or simply want to sell.

245. **Charles Sheeler** (1885–1956). *The Barn.* 1918. Lithograph. 8¼″ x 18½″. Courtesy Sotheby Parke Bernet Inc., New York.

There are four basic outlets for selling prints. You can sell to another collector, either a private individual or an institution such as a museum. You can sell to a dealer specializing in the artist or school, or at auction, or by advertising in a newspaper art section or in a professional journal. The last three outlets are more appropriate for prints by artists with established reputations and resale value, and least effective for work by unknowns. There is also another option. Making an "exchange" with another collector or with a dealer. If you have established a good relationship with a gallery, and the print you own has market value, it is sometimes possible to swap your print for another one, and simply pay any price difference. But let's assume you decide to sell the print. What can you realistically expect?

We have already discussed selling at auction. Advertising can be costly, and unless the artist has widespread appeal, your investment and time may not produce the result you want. If you sell through a dealer, there are two ways to go about it: Either you can offer the print *on consignment,* by leaving the print with the dealer for sale for a specified period of time, or you can sell the print to him outright and receive immediate payment. If the dealer is willing to buy outright, don't make the common mistake of assuming that a print worth $500 on the market will bring $500 from the dealer. His profit lies in the spread between the price he pays for a print and what he can sell it for. Normally you can expect to receive 50 percent of market value. Selling outright is the simplest and quickest way, but obviously not always

advisable or possible. You stand to make more money selling on consignment. The dealer usually asks only 10 to 15 percent on a consignment sale. But it takes longer. When you leave the print, be sure to ask for a written receipt. This agreement-receipt should *include all vital information:* your name and address, the dealer's name and address, and complete data about the print (title, artist, medium, dimensions, year, framing, condition). Also include the *terms of your consignment,* covering the period of time that the work is consigned to the dealer for sale, the percentage you agree to pay him if he sells it, how it is insured (that is, by the gallery), and any price adjustment if the dealer should sell the print to a museum that normally expects a 10 percent discount. Also specify when you expect to receive payment once the sale has been consummated, such as in thirty days or fifteen days. While the print is on consignment, do *not* offer it yourself. This is unfair to the dealer, and you may accidentally offer it to the same parties and "burn" (overexpose) the print on the market, thereby killing all possibilities of sale.

Keep current on the field. It needn't become a full-time occupation, but in addition to your boning up occasionally on gallery and auction sales catalogues, several informative periodicals will help to keep you abreast of trends and market developments:

1. *The Print Collector's Newsletter* should become standard reading. The *Newsletter* offers articles on various aspects and periods of print-making and discussions on the works of artists from all periods. Listings of selected print sources, current print exhibitions, and new books and periodicals as well as a selective synopsis of the most recent prices brought by prints at auction are included.

2. *ARTnews* publishes special print issues twice yearly, and *The Art Newsletter* (biweekly), a division of *ARTnews,* proffered as an "insider's" report on the art market, includes data on prints.

3. *Print Review,* a biannual publication, is issued by Pratt Graphics Center and Kennedy Galleries, Inc. (contact: Pratt Graphics Center, 831 Broadway, New York, New York 10003). The *Review* covers a broad range of artists, periods, and topics, including museum news and many illustrations.

4. *International Auction Records,* by E. Mayer, Editions Publisol (approximately $52), offers a more extensive listing but is not as current as *The Print Collector's Newsletter.*

5. *Buy–Sell Newsletter,* a quarterly, is issued by the Art Appraisal and Information Service, Art References Gallery, Inc. (89 Park Street, Montclair, New Jersey 07042), includes a buy–sell exchange and an appraisal facility.

6. *Art Investment Report,* a biweekly (120 Wall Street, New York, New York 10005), occasionally discusses print auctions.

appendix:

sample page from a catalogue raisonné

This sample page from a catalogue raisonné (Tomás Harris, *Goya Engravings and Lithographs,* 2 vols. Oxford: Bruno Cassierer, 1964) chronicles all known and pertinent details pertaining to Plate No. 48 from Goya's *Los Caprichos* series. Although format varies from catalogue to catalogue, the time spent in studying such references is invaluable. One need only glance at figure 16 (page 11) before, and then after, reading the data below to experience some of the sense of enrichment possible. Such spadework, time-consuming as it may seem, provides confidence and insights that cannot help but lead to more intelligent buying and collecting decisions.

83. SOPLONES.
Tale-bearers—Blasts of wind.

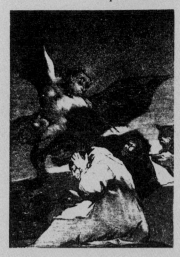

L. and H. 48; B. 68; V.L. 694; M. II.48; D. 85.

205 × 150 mm.

Etching and burnished aquatint.

I. *WORKING PROOFS*

Before letters or number.

1. No proof is known before aquatint.

2. With aquatint.
 *Formerly Madrid Gerona** (ex-Pidal). With pencil retouches. Listed in Delteil's 'Additions et Modifications'.

II. *TRIAL PROOFS*

With letters and number.

None known with distinguishing characteristics.
See 'Proofs and Editions', p. 62.

III. *EDITION IMPRESSIONS*

1. FIRST EDITION

The plate in good condition.

Fine grain aquatint, in one tone; contrasts brilliantly with the highlights on the foreground figure and in the sky on the right.
Burnishing is used extensively to create a wide range of halftones on the winged demon, in the sky, on the dress of the foreground figure and on the four heads behind him.

2–3. SECOND AND THIRD EDITIONS

The plate in fair condition.

Aquatint begins to wear; the highlights lose their brilliance.
Burnishing weakens, particularly on the foreground figure.

4–12. FOURTH TO TWELFTH EDITIONS

The plate in poor condition.

Aquatint wears to an uneven grey stain.
Burnishing is almost entirely lost except for very slight traces, e.g. a light area on the demon's shoulders.
Etching prints very well throughout.
The plate is bevelled in the fourth edition.
False biting in the lower margin wears out by the fifth edition.

Goya's commentary: The tale-bearing witches are the most irritating in all witchcraft and the least intelligent in that art; if they really knew something they wouldn't blast it about.

A drawing in red crayon is in the *Prado, No. 68.*

The copperplate is in the *Calcografía.* *Ill. I, 117.*

notes

CHAPTER 1

1. *The Print Collector's Newsletter*, 1, no. 4 (1970).

2. Quoted from a taped interview with Donald Marron, January 2, 1975.

3. Quoted from a taped interview with Donald Karshan, September 13, 1975.

4. *Ibid.*

CHAPTER 2

5. Carl Zigrosser and Christa M. Gaehde, *A Guide to the Collecting and Care of Original Prints* (New York: Crown Publishers, 1965).

6. Quoted in Donald Karshan, "American Printmaking, 1670–1968," *Art in America* (July–August 1968), p. 25.

7. Peter Peregrinus, *Epistola de Magnete*, 1269; quoted in Geoffrey Grigson and Charles Harvard Gibbs-Smith, eds., *Things, A Volume of Objects Devised by Man's Genius Which Are the Measure of His Civilization* (New York: Hawthorn Books, n.d.), p. 239.

8. Quoted in Ursula Meyer, "Protestant Broadsheets," *The Print Collector's Newsletter*, 5, no. 3 (July–August 1974), p. 61.

9. Gabor Peterdi, *Great Prints of the World* (New York: The Macmillan Company, 1969).

CHAPTER 3

10. Carl Zigrosser, *The Book of Fine Prints* (New York: Crown Publishers, 1937), p. 34.

CHAPTER 4

11. Hyatt Mayor, *Prints and People* (New York: The Metropolitan Museum of Art, New York Graphic Society, 1971), text accompanying ill. 630.

12. Lothar Günther Buchheim, *The Graphic Art of German Expressionism* (Seldafing: Buchheim Verlag, 1960).

13. *ARTnews*, special print issue (January 1972), p. 59.

14. Peterdi, *Great Prints of the World*, p. 3.

15. Special zinc plates can be used in place of the stone.

16. To create the plates for the blue mountain image, *The New York Times* stock page, and the green nest in proofs 1, 3, and 4, a photographic technique was used. A negative was made from a photograph of the mountain, from the newspaper page, and also of the nest from an old glass slide. A special emulsion was applied to the standard lithographic plate to photosensitize it. The negative was then placed on top of the sensitized plate and both were exposed to light on a vacuum-arc table. This exposure burns through the open areas in the negative, producing an image on the sensitized plate. The artist develops the plate in a special lacquer developer, after which the plate is desensitized with a gum etch and printed by the regular lithography technique (pages 70–73).

CHAPTER 5

17. Buchheim, *The Graphic Art of German Expressionism*, p. 8.

18. Frank and Dorothy Getlein, *The Bite of the Print* (New York: Bramhall House, 1963).

19. Friedhelm W. Fischer, *Max Beckmann*, trans. P. S. Falla (New York: Phaidon Press, 1973), p. 25.

20. Mayor, *Prints and People*, text accompanying ill. 461.

21. *Ibid.*, text accompanying ill. 624.

CHAPTER 6

22. Quoted from a taped interview with Richard Anuszkiewicz, June 25, 1975.

23. *The Prints of Richard Hamilton*, exhibition catalogue prepared by Richard S. Field. Davison Art Center, Wesleyan University, Middletown, Connecticut, 1973, p. 37.

CHAPTER 7

24. Jasper Johns, quoted in Diane Kelder, "Tradition and Craftsmanship in Modern Prints," *ARTnews* (January 1972), p. 59.

25. Quoted in Walter Sorell, *The Duality of Vision: Genius and Versatility in the Arts* (Indianapolis and New York: Bobbs-Merrill, n.d.), p. 318.

26. *Ibid.*, p. 274.

27. There are conflicting stories concerning the origins of the name *Dada*. In a declaration personifying the group's irrational and mocking style, Hans Arp stated, "I hereby declare that [Tristan] Tzara invented the word Dada on 6th (*sic*) February 1916, at 6 p.m. I was there with my 12 children when Tzara first uttered the word. . . . it happened in the Café de la Terrasse in Zurich, and I was wearing a brioche in my left nostril." Quoted in Manuel L. Grossman, *Dada: Paradox, Mystification, and Ambiguity in European Literature* (New York: Pegasus Publishing, 1971), p. xv.

Italian and Russian Futurists had already laid the groundwork for Dada's assault on hidebound traditions in art, literature, music, theatre, and society itself, employing the "shock" tactics, provocative declarations, and irrationality later to become integral parts of Dada. Filippo Tommaso Marinetti, the father of Italian Futurism, published his first revolutionary manifesto, "Le futurisme," in 1909. In 1912 a major Futurist exhibition toured Europe popularizing the group's antitraditionalist doctrines. The Futurists set out to destroy society's "old molds" in order to find fresh structures that were more in keeping with modern life. Dada's scorn of tradition went deeper: a total repudiation of permanent structures and fixed values of any kind.

28. George Grosz, "The Saddest Man in the World," *The New Yorker* (December 4, 1943), p. 40.

29. Robert Motherwell, ed., *The Dada Painters and Poets: An Anthology* (New York: Wittenborn, 1967).

30. Quoted in Kenneth Coutts-Smith, *Dada* (New York: E. P. Dutton, 1970), p. 23.

31. Quoted in Calvin Tomkins, *The Bride and the Bachelors* (New York: The Viking Press, 1968), p. 13.

32. Quoted from *Cardbirds* brochure, 1971, pp. 2–3. Copyright © 1971 by Gemini G. E. L.

33. Quoted from a taped interview with Jasper Johns, July 31, 1974.

34. *Ibid.*

35. Riva Castleman, *Contemporary Prints* (New York: The Viking Press, 1973), p. 22.

36. Coutts-Smith, *Dada*, p. 82.

37. Quoted in Joseph E. Young, "Pages and Fuses: An Extended View of Robert Rauschenberg," *The Print Collector's Newsletter* (May–June 1974), p. 26.

38. Tomkins, *The Bride*, p. 24.

39. Editions Alecto brochure for *1,000 Temporary Images of Our Time* (1971).

40. Young, "Pages and Fuses," p. 27.

41. The extent of this influence can be surmised from the increasing attention devoted to Japanese art between the time of Commodore Perry's opening of trade with Japan in 1853 and Toulouse-Lautrec's Oriental-style lithograph *Le Divan Japonais* (fig. 98) of 1892. For example: the first organized showing of Japanese art in Europe at the London International Exhibition (1862); the Paris Universal Exposition of one hundred Japanese prints (1867); the exposition of art from the Orient at the Palais de l'Industrie (1873); the Paris Universal Exposition in which the Japanese show was reviewed by Edmond Duranty for the *Gazette des Beaux-Arts* (December 1878); the same year (1878) the *Gazette* published *Le Japon à Paris*, the first major article on the influence of Japanese art on French artists. In 1882, the pamphlet *L'Art Japonais* traced the history of the Japanese woodcut, and in 1883, Louis Gonse issued his systematic study of Oriental art, the first in Europe. That year, 3,000 items of Japanese art were shown at the Georges Petit Galleries. Vincent van Gogh and his brother, Theo, organized a show of woodcuts at the café Le Tambourin in 1887, and three years later, the École des Beaux-Arts exhibition listed 1,153 Japanese items in its exhibition catalogue.

42. Quoted in Grossman, *Dada: Paradox, Mystification, and Ambiguity in European Literature*, p. 131.

CHAPTER 8

43. Fernand Mourlot, *Picasso Lithographs, 1919–1969*, trans. Jean Didry (Boston: Boston Book and Art Publisher, 1970), introd.

44. Wassily Kandinsky, "Reminiscences," in Robert L. Herbert, ed., *Modern Artists on Art: Ten Unabridged Essays* (Englewood Cliffs, N.J.: Prentice-Hall, 1964), p. 32.

45. M. C. Escher, *The Graphic Work of M. C. Escher*, trans. John Brigham (New York: Ballantine Books, 1971), p. 15.

46. Henning Rischbieter, ed., *Art and the Stage in the Twentieth Century: Painters and Sculptors Work for the Theater* (Greenwich, Conn.: New York Graphic Society, 1970), p. 137.

47. Interview with Marron (see n. 2).

48. Walter L. Strauss, ed., *The Complete Engravings, Etchings and Drypoints of Albrecht Dürer* (New York: Dover Publications, 1972), p. viii.

CHAPTER 9

49. Quoted from a taped interview with Marc Rosen, June 24, 1975.

50. Alfred H. Barr, Jr., *Cubism and Abstract Art* (1936; reprint ed., New York: Arno Press, 1974), p. 122.

CHAPTER 11

51. Zigrosser and Gaehde, *A Guide to the Collecting and Care of Original Prints*.

52. Henry Heydenryk, *The Art and History of Frames: An Inquiry into the Enhancement of Paintings* (New York: James H. Heineman, 1963).

aqua fortis: Latin words for "nitric acid." In intaglio, the acid used to etch the plate.

aquatint: Intaglio technique for creating tones and textures in a metal etching plate. The plate is sprinkled with powdered resin, then heated so that the resin melts and clings to the plate creating a porous, overall ground (see page 93). Aquatint is rarely used by itself but in combination with other intaglio methods.

artist's proof (A.P.): Impressions for the personal use of the artist, outside the regular edition and designated as such.

bite: The action of corrosive agents or acids on the metal plates used in intaglio processes.

blockbook: An early form of book in which the illustrations and type for a book page were hand-cut together into a wood block before metal-cast letters and movable type were used.

bon à tirer (or RTP): French term meaning "good to print." The *bon à tirer* impression acts as the guide for the rest of the edition. *RTP* stands for "right to print."

cancellation proof: Proof made from a defaced stone, plate, block, or screen indicating that no further prints can be made from the original master image.

cellocut: A technique in which a design surface or texture is built up with liquid plastics on a backing (for example, wood, cardboard, or plastic). The artist can cut into and alter the surface, printing it either by an intaglio or a relief method.

chiaroscuro woodcut: The first color woodcuts printed in Europe, involving a key block, usually printed in a dark color to define details and outlines, and other wood blocks representing tonal areas in the final composition. An early sixteenth-century contribution to printmaking.

chine collé: A procedure for obtaining color in an etching through the use of colored-paper collage. Colored papers are cut (or torn) into various shapes and glued to the printing paper. The pressure of the press adheres the glued paper to its backing paper. The intaglio plate runs through on the collaged color paper and the two, together, make up the *chine collé* image.

glossary

chop mark: An inkless, embossed stamp indicating the publisher or artist.

collagraph: The printing plate is an assemblage of various materials glued together on a firm backing (for example, Masonite, cardboard, or metal). The built-up surface can be printed in relief or intaglio and produces interesting textural effects. *Collagraph* traces to the French word *coller,* "to glue," and the English word *graphic,* "written" or "drawn."

counterproof: The artist places a fresh piece of paper over a print while the ink is still wet and pulls another impression (in reverse) from the print itself. This slightly fainter image allows the artist to work out corrections and alterations on the drawing, because the image appears in the same direction (that is, backward) as it appears on the plate.

dotted print: See *manière criblée.*

drypoint: Intaglio method. The design is scratched into the metal plate (copper, steel, zinc, etc.) with a steel or diamond needle. A metal burr is raised by the point's cutting into the plate. This burr holds ink and, when printed, results in a soft, velvety line rather than a crisp, engraved line.

embossed print (*gauffrage,* inkless intaglio): The plate is not inked. Dampened paper is pressed deeply into the depressed areas of a plate or wood block, producing a three-dimensional, sculptural image.

engraving: The artist makes his design by cutting directly into the metal plate with a graver or burin, a lozenge-shaped steel rod. The deeper the artist cuts, the wider his line will be.

etching (*eau forte*): The design is "eaten" out of the metal by acids (see page 83). Most artists re-etch their plates many times to control the character of the lines and tone. By covering completed areas with a stop-out varnish, the artist can continue to etch other portions of his plate.

feathering: Removing the bubbles created on a zinc or copper plate by the action of nitric acid.

foul bite: Accidental error in the etching of an area.

frottage: A print image is produced by rubbing rather than printed in a press.

ground: Acid-resistant material applied to plates in the etching process.

gum: Contraction of "gum-arabic" solution, used in lithography to coat the stone or plate.

gum etch: A mixture of gum-arabic solution and nitric acid used for desensitizing (called *etching*) the stone or plate in lithography.

hors de commerce (H.C.): Similar to the artist's proofs. These impressions are pulled outside the regular edition for the personal use of the publisher. Normally only five or six impressions.

incunabula: The cradle period or infancy of an artist's work or an art form.

intaglio print: Design prints from incised areas of the plate that have been cut, scratched, or etched below the surface to hold ink for printing.

intaglio relief: Made by the inking of the surface rather than the incised lines of an intaglio plate.

key block or plate: The guide block or plate used to register other plates (or blocks) for color printing.

levigator: A cast-iron or aluminum circular tool used to grain lithographic stones.

lift-ground (sugar-lift): The artist draws directly on a metal plate with a viscous liquid (for example, India ink or poster paint mixed with sugar syrup). When the drawing dries, the plate is covered with a liquid hard-ground. When the plate is later placed in warm water, the design dissolves and lifts up through the ground, exposing the plate for acid biting.

light-sensitive plate: Plates used for photolithography or photointaglio which are treated so that the image may be transferred to the plate photographically. Coating may also be transferred to an ordinary plate to photosensitize it.

linocut (linoleum cut): The artist cuts his design into linoleum with a knife or gouge, removing the areas he does not wish to print. The remaining raised relief surface is inked and produces the design.

lithography (planographic or surface process): The image is drawn directly on the surface of the stone or the zinc plate with a greasy tusche ink

or litho crayon, hence the name *surface* process. Tones are created by soft crayons or dry-brush "washes," much as they are in drawing. The tusche and the grease crayon permit the artist to scratch in textures with sandpaper, needles, and the like.

maculature: Intaglio technique whereby a second proof is pulled without reinking, to remove excess ink on the plate.

manière criblée (dotted print): The white-line metal-cut technique appearing about the time of wood-cuts. The term comes from the French *crible*, meaning "sieve." *Manière criblée* prints have tonal effects resulting from the groups of dots punched into the plate, reminiscent of the design of a sieve.

mezzotint (*manière noire*): An intaglio technique. The metal-plate surface is pitted all over with a tool called a *rocker*. As in drypoint, the raised burrs hold the ink, producing on the plate an overall dark, velvety impression. Scraping and burnishing the pitting produce modulations of tone. Mezzotint was popular for the reproduction of paintings.

monotype (monoprint): Generally a single impression. A unique print, pulled from an inked plate (or surface) such as glass.

mordant: Any one of the acid solutions used to incise an intaglio plate.

offset print: An indirect commercial process of printing the image whereby the design is transferred from one roller (or plate) to another, then printed on the paper.

open bite: Plate without any ground used. The artist draws on the plate with an acid-resisting material (for example, varnish) and places it in acid, which bites the metal wherever it is not protected by the acid-resist.

photointaglio: The image is transferred by photomechanical methods onto a light-sensitive plate. The plate is then etched in the usual manner.

photolithography: The image is transferred to a light-sensitive plate by photomechanical means (see page 209).

platemark: The impression made by the edges of the plate on intaglio prints.

pochoir: A type of stencil printing popularized in France (see page 113).

poupée: A process developed in France whereby various color areas are individually inked and wiped on the same plate with a folded tarlatan *poupée*, making it unnecessary to use a separate plate for each color. Also called *à la poupée*.

progressive proofs: A series of color proofs, each of which shows the consecutive applications of color to the print from color A to A and B, then A, B, and C, and so forth.

registration: The placement of the paper for printing so that each color applied falls in the correct relationship to the first one. When the colors overlap correctly, the print is "in register." When they do not, the print is considered "out of register" or "off register."

relief: The design area stands out "in relief." The rest of the plate or wood block is cut away so that it will not print when the surface is inked.

repoussage: Sometimes the plate has been overscraped and the surface is too low to print well. To get the plate back to its original level, the artist forces the metal from the back of the plate with a hammer. Also a system used whereby paper shims are glued to weak areas of the plate (backside) and run through a press to push that section back into position.

re-strikes (reprints): Produced *after* the original edition was issued but from the original plate. Re-strikes are made in unlimited numbers, often years after the artist's death, when the plates are too worn to produce fine impressions.

retroussage: Produces a richer printed effect. The artist gently lifts ink from the incised portions of his plate but wipes the rest of the plate surface clean for printing.

screen: In screen printing, the term refers to silk or any fabric covering the printing frame.

serigraph (screen print): An image produced by the stencil process, which is based on a simple concept: open areas allow paint to pass through, and areas blocked by the stencil material screen out the paint.

soft-ground: An acid-resistant coating that remains in a semihard state, permitting the artist to press various textures and forms into it (for example, nails or gauze). The texture is etched into the plate by the same method as hard-ground etching.

state: An impression, pulled by the artist outside the edition, in which the image has been altered. Sometimes "trial proofs" or "work proofs" are pulled by the artist in the process of developing his final edition.

steel facing: A thin coating of iron (chrome or nickel) deposited on the surface of the copper plate by an electrolysis technique discovered in England in 1800. The physicist Michael Faraday improved the method in 1832. Steel facing imparts a uniform hardness to the plate surface so that many more impressions can be pulled. Impressions are "cooler" because of the thin layer of protective steel, which retards deterioration. The facing can be removed, imperfections in the plate corrected, and the plate again steel-faced.

stencil: Any material that blocks the passage of paint through a screen.

stipple print: A halftone effect created by the engraving or etching of small dots onto a plate so that they read as tonal areas when printed.

stop out: In screen printing, a substance that stops ink or paint from penetrating the screen. In intaglio printing, a substance applied to the plate to stop the acid from biting.

tusche: Grease in liquid or stick form used in lithographic drawings. Also used in serigraphy.

woodcut: The oldest of the print methods. Known in the East by the eighth century and in the West by the fifteenth century (see page 38). The design sits in relief after the rest of the surface has been cut away. Wood is cut on the plank and generally worked parallel to the grain.

wood engraving: A variant of the woodcut. Rather than cut the wood along the plank, the artist cuts it on the end grain (crossgrain), eliminating the restrictions of grains and allowing work in all directions. The image emerges in white lines and textures (see page 49).

working proof: A trial proof on which the artist has indicated additions and corrections.

xylography (white-line engraving): Applies to early woodcuts and in some cases to any print made with wood. An archaic, rarely used term.

COMMON ABBREVIATIONS FOUND ON OLD ENGRAVINGS AND PRINTS

Del. (Delineavit):	Drawn by the designer.	Pinx. (Pinxit):	Painted it.
Exc. (Excudit):	Published it.	Sculp. (Sculpsit):	Engraved it.
Imp. (Impressit):	Printed it.	f. or fec. (Fecit):	Made it.
Inv. (Invenit):	Designed it.		

ARNHEIM, RUDOLF. *Art and Visual Perception, A Psychology of the Creative Eye.* Berkeley and Los Angeles: University of California Press, 1971.

ARTnews (Special Prints Issue). New York: March 1974.

BROWN, MILTON W. *American Painting from the Armory Show to the Depression.* Princeton: Princeton University Press, 1970.

BUCHHEIM, LOTHAR GÜNTHER. *The Graphic Art of German Expressionism.* Seldafing: Buchheim Verlag, 1960.

CANADAY, JOHN. *Mainstreams of Modern Art.* New York: Simon & Schuster, 1959.

CASTLEMAN, RIVA. *Contemporary Prints.* New York: The Viking Press, 1973.

————. *Modern Art in Prints.* New York: The Museum of Modern Art, 1973.

CHIEFFO, CLIFFORD T. *Silk-Screen as a Fine Art, A Handbook of Contemporary Silk-Screen Printing.* New York, Amsterdam and London: Reinhold Publishing Corporation, 1967.

COUTTS-SMITH, KENNETH. *Dada.* Great Britain: Studio Vista Limited; New York: E.P. Dutton, 1970.

DANIELS, HARVEY. *Printmaking.* New York: A Studio Book, The Viking Press, 1971.

FIELD, RICHARD S. *Jasper Johns Prints 1960–1970.* Philadelphia Museum of Art Exhibition, April 15–June 14, 1970. Catalogue.

FIORE, QUENTIN. *Paper.* Originally appeared as article in *Industrial Design* (November 1958, Whitney Publications). Reproduced in pamphlet form (Tamarind Lithography Workshop, Los Angeles).

GETLEIN, FRANK, and GETLEIN, DOROTHY. *The Bite of the Print.* New York: Bramhall House, 1963.

GILMORE, PAT. *Modern Prints.* New York: Dutton Vista Pictureback, 1970.

GOMBRICH, E. H. *Art and Illusion, A Study in the Psychology of Pictorial Representation.* (The A. W. Mellon Lectures in Fine Arts, 1956, Bollingen Series XXXV, 5.) Princeton: Princeton University Press, 1960.

GROSSMAN, MANUEL L. *Dada: Paradox, Mystification, and Ambiguity in European Literature.* New York: Pegasus Publishing, 1971.

HAFTMANN, WERNER. *Painting in the Twentieth Century.* New York: Praeger Publishers, 1965.

HELLER, JULES. *Printmaking Today.* 2d ed. New York: Holt, Rinehart & Winston, 1972.

selected bibliography

HIND, ARTHUR M. *An Introduction to a History of Woodcut.* vols. 1 and 2. New York: Dover Publications, 1963.

How to Care for Works of Art on Paper. Boston: Museum of Fine Arts, 1971.

IVINS, WILLIAM M., JR. *How Prints Look.* Boston: Beacon Press, 1943.

————. *Notes on Prints.* Cambridge: M.I.T. Press, 1969. (First published by The Metropolitan Museum of Art, 1930.)

————. *Prints and Visual Communication.* Cambridge: M.I.T. Press, 1953.

KARSHAN, DONALD H. *Picasso Linocuts 1958–1963.* New York: Tudor Publishing Company, 1968.

KLEIN, H. ARTHUR. *Graphic Worlds of Peter Bruegel the Elder.* New York: Dover Publications, 1963.

KLINGENDER, F. D. *Goya in the Democratic Tradition.* New York: Schocken Books, 1968.

KURTH, WILLI, DR., ed. *The Complete Woodcuts of Albrecht Dürer.* New York: Dover Publications, 1963.

LEVENSON, JAY A. *Prints of the Italian Renaissance, A Handbook of the Exhibition.* Washington, D.C.: National Gallery of Art, 1973.

Master Prints of Japan, Ukiyo-e Hanga. Text by Harold P. Stern. New York: Harry N. Abrams, 1969.

MAYOR, A. HYATT. *Prints, Metropolitan Museum of Art Guide to the Collection.* New York: The Metropolitan Museum of Art, 1964.

————. *Prints and People.* New York: The Metropolitan Museum of Art, New York Graphic Society, 1971.

MEAD, MARGARET. *Culture and Commitment. (A Study of the Generation Gap).* New York: The American Museum of Natural History, Natural History Press/Doubleday, 1970.

Metropolitan Museum of Art Bulletin. New York: The Metropolitan Museum of Art, May 1961.

MOTHERWELL, ROBERT. *The Dada Painters and Poets.* New York: Wittenborn, 1951; 2d ed., 1967.

MOURLOT, FERNAND. *Picasso Lithographs 1919–1969.* Translated by Jean Didry. France: Andre Sauret, Éditions Du Livre; Boston: Boston Book and Art Publisher, 1970.

NARAZAKI, MUNESHIGE. *Masterworks of Ukiyo-e, "Hokusai."* English translation by John Bester. Tokyo: Kodansha International, 1968.

NESCH, ROLF. *The Graphic Art of Rolf Nesch.* Detroit: The Detroit Institute of Arts, March 1969. Catalogue.

PETERDI, GABOR. *Great Prints of the World.* New York: The Macmillan Company, 1969.

————. *Printmaking (Methods Old and New).* New York: The Macmillan Company, 1967.

Prints (A Handbook to Accompany the Exhibition). Storrs, Conn.: Museum of Art, The University of Connecticut, 1972.

Rembrandt: Experimental Etcher. Boston: Museum of Fine Arts, 1969. Catalogue.

ROSS, JOHN, and ROMANO, CLARE. *The Complete Printmaker.* New York: The Free Press, 1972; London: Collier-Macmillan, 1972.

RUSSELL, FRANCIS, and THE EDITORS OF TIME-LIFE BOOKS. *The World of Dürer 1471–1528.* New York: Time-Life Books, 1967.

SALAMON, FERDINANDO. *The History of Prints and Printmaking, from Dürer to Picasso, A Guide to Collecting.* New York: American Heritage Press, McGraw-Hill Book Co., 1972.

SENEFELDER, ALOYS. *A Complete Course of Lithography.* New York: Da Capo Press, 1968.

SHESTUCK, ALAN. *Fifteenth Century Engravings of Northern Europe.* Washington, D.C.: National Gallery of Art. Catalogue.

STRAUSS, WALTER L., ed. *The Complete Engravings, Etchings and Drypoints of Albrecht Dürer.* New York: Dover Publications, 1972.

TOMKINS, CALVIN. *The Bride and the Bachelors (Five Masters of the Avant-Garde).* New York: The Viking Press, 1965.

VASARI, GIORGIO. *The Lives of the Artists.* Translated by George Bull. Baltimore: Penguin Books, 1965. Reprinted 1972.

VERKAUF, WILLY. *Dada, Monograph of a Movement.* New York: St. Martin's Press; London: Academy Editions, 1975.

WECHSLER, HERMAN F. *Great Prints and Printmakers.* The Netherlands: Harry N. Abrams, 1967.

ZIGROSSER, CARL. *The Book of Fine Prints (An Anthology of Printed Pictures and Introduction to the Study of Graphic Art in the West and East).* New York: Crown Publishers, 1937.

————, and GAEHDE, CHRISTA M. *A Guide to the Collecting and Care of Original Prints.* New York: Crown Publishers, 1965.

Page references for illustrations are in **boldface** type.

index